Candlewick

The Jewel Of Imperial

Book II

Mary M. Wetzel-Tomalka

Printed by
Walsworth Publishing Company
Marceline, MO

$26.95
Shipping and handling $3.00 additional

For Additional Copies write

Mary M. Wetzel-Tomalka
P.O. Box 594
Notre Dame, IN 46556

ISBN: 0-9646120-6-2
LIBRARY OF CONGRESS CATALOG CARD NUMBER: 95-60204

PRINTED IN THE UNITED STATES OF AMERICA

This book is

DEDICATED

to all the Candlewick collectors

Who have enriched

my life

with their

friendship

ACKNOWLEDGEMENTS

Lucile Kennedy
Willard Kolb
Margaret & Douglas Archer
Virginia Scott
Hazel Marie Weatherman
Myrna and Bob Garrison
Jean and Jack Fry
Kathy Doub
Kathy Burch
Joan Cimini
Fran and Larry Lodenstein
Ron Doll
Michiana Association of Candlewick Collectors
Ohio Candlewick Collectors Club
National Imperial Glass Collectors Society
GLASS COLLECTORS DIGEST, Marietta, OH
DEPRESSION GLASS DAZE, Otisville, MI
ANTIQUE TRADER WEEKLY, Dubuque, IA

All Candlewick collectors, too numerous to mention, who sent pictures and
information, your help is deeply appreciated.

FRONT COVER:	400/68D 12 in. Ruby Pastry Tray. From the author's collection
BACK COVER:	400/74N Black Lily Bowl. From the collection of Lolly Pinkston, Ft. Worth, TX

Table of Contents

Chapter 1 CANDLEWICK IN THE 90's .9
 Go-Withs .10
 What is glass? "Into the Melting Pot"11

Chapter 2 HISTORY OF IMPERIAL .13
 Early History .13
 Owners of Imperial .17
 Hay Shed .17
 Memories — Hay Shed18
 Save Imperial Red Brick21
 Imperial Labels .21
 Clubs: NIGCS, MACC22
 Lenox Glass Company23
 Rodefer Glass Company24

Chapter 3 CANDLEWICK HISTORY .27
 Candlewick — The Name27
 History of Candlewick — Mr. Willard Kolb28
 Candlewick Catalogs and Brochures33
 Candlewick Patents .34
 Initial Pieces of Candlewick35
 Jewel Tea Connection .39
 Ads .39
 Moulds .45

Chapter 4 CANDLEWICK COLOR .81
 Gold .82
 Ruby and Red .86
 Black .88
 Candlewick Blues .90
 Carmel Slag .95
 Milk Glass .95

Chapter 5 DECORATED CANDLEWICK100
 Metals .101
 Hand Painted .103
 Satin Trimmed .107
 Cuts .109
 Etches .122

Chapter 6 INTRODUCTION TO IRICE 127
 Boudoir Sets 127
 Bottles 128
 Clocks 128
 Puff Jar 129
 Mirrors 129
 Trays 129
 Salts/Peppers 131

Chapter 7 CONFUSING SIMILARITIES 132
 New Candlewick: Dalzell-Viking 134
 Boyd 137
 Berwick (Boopie) 138
 Pegged Bowls and Plates 138
 Confusing Similarities listed by Glass Companies .139
 Lalique's "Andlau" Pattern 143
 Miscellaneous Look-Alikes 143
 Czechoslovakian Relish 146
 References for Other Beaded Patterns 147

Chapter 8 POTPOURRI 149
 Bowls — the F Series 150
 Bowls — Square/Round 151
 Boxed Sets 151
 Coasters: 400/78 152
 DeVilbiss Atomizers 152
 Eagle 154
 Icer Sets: 400/53 156
 Ladles 156
 Lamps and Shades 156
 Pegs 161
 Tid-Bits: 400/270TB and 400/271TB 166
 Unusual and Odd Pieces Listing 166

Chapter 9 NUMERICAL LISTING OF ALL ITEMS AND
 PERTINENT INFORMATION 169

Chapter 10 PRICE GUIDE 231
 General 232
 Colored 247
 Cuts, Etches, Decorated 252

Chapter 11 PICTURE SECTION — BLACK AND WHITE 254

PREFACE

Since this monograph is primarily a research book for Imperial Candlewick collectors, I have drawn on the knowledge and expertise of others in the field to help make this book as informative as possible. Glass experts Virginia Scott, Myrna Garrison, and Kathy Doub have helped tremendously; Virginia and Myrna with the Candlewick story, and Kathy with the Imperial beaded-edge Milk Glass.

Articles by glass experts and former Imperial employees are also included in Book 2, as these people give an insight that only those who were in their positions are able to give.

Many others have contributed their knowledge to help collectors derive the most beneficial information that is available. In CANDLEWICK THE JEWEL OF IMPERIAL Book 1, only verified information from the Imperial Glass Corporation and its files were used. Very little "hear-say" and collectors' input was incorporated into the first book. Now, 15 years later, when there are so many more informed collectors, their views and contributions are also included here. This sharing of information has significant value for all collectors. Collectors must be cautious, however; when information is shared, we assume the contributor has sufficient knowledge to authenticate his contribution. Many of the contributors have written giving information on an article found and giving the description; these I take at the collectors' word. Pictures sometimes accompany letters, but not always. Verification can be very difficult and is impossible in every instance.

Candlewick collecting has come a long way since the first book on Candlewick was published. Very seldom do we see a dealer who is not familiar with our favorite crystal; a decade ago most dealers were totally unaware of the Candlewick we collect. Now, of course, knowledge can also have its drawbacks. We are paying a dear price for many of the most desired items; that's the price of knowledge and progress.

A short summary of what Candlewick has done and will do in the late 90's will be incorporated here, as will the new so-called go-withs in the Candlewick collecting field. An article defining glass is being printed in Chapter I to inform collectors not only about Candlewick but also about the basics of all glass. This is information of which we, as glass collectors, should be aware.

Included in these pages is all the information I have collected on Candlewick since the issuance of Book I. Every source possible has been perused to locate new and significant information. All has been recorded for the past 15 years. Now, finally, Book II is in order. By the lapse of another 10 or 12 years, we will probably uncover as much, if not more information about our collectible as we did in the past years.

My sincere thanks to all who have contributed to this book, no matter how small or how large the contribution; to get the entire story about Candlewick, we need everyone's knowledge and expertise.

It is impossible to list all who have taken the time to contribute their information, for there are so many. I must state here, though, that without your contribution, this book could not have been written.

* * *

The information in this book is not a repeat of Book I; some information, of course, must be restated and enlarged upon. There are many more entries in the listing of Candlewick pieces now than in 1981. Colors are now well known by most collectors; cuts and etches are also known to most Candlewick collectors. Rare and unusual pieces have become available, and collectors know which items they are. Prices have skyrocketed, but so has the value of our collections. There are more collectors now than there were in the early 1980's. Candlewick is sought after by many more people; therefore, it is much more difficult to collect.

As you read this book, my most sincere wish for all collectors is HAPPY CANDLEWICKING!

CHAPTER 1

CANDLEWICK IN THE 90's

Candlewick — that gleaming, beaded crystal produced from 1936 until 1984 by the now defunct Imperial Glass Corporation in Bellaire, Ohio — what has happened to it in the last ten years? What is the future of this collectible in the late 1990's and on into the 21st century?

The first price guide for Imperial's Candlewick Crystal (in CANDLEWICK THE JEWEL OF IMPERIAL) was published in 1981, thus helping to throw this lovely crystal pattern into the realm of collectibility. In the early 1980's, Candlewick was occasionally available at flea markets, yard, and garage sales. Sometimes pieces and sets were offered at auction. Proprietors of antique shops did not consider Candlewick a collectible and refused to handle it in their places of business; in fact, many dealers did not know what Candlewick was. Today, unfortunately, there are still some who fall into that category.

After the price guide became available, ads began appearing in the ANTIQUES TRADER WEEKLY and the DAZE offering Candlewick at moderate prices. Sleepers abounded. Early collectors were thrilled at the windfall that was theirs.

Along with the price guide were pictures of the hundreds of items offered by Imperial in the Candlewick line. Suddenly collectors and dealers alike were able to purchase Candlewick that had been stashed in attics, basements, and dining room and kitchen cupboards. The race for Candlewick was on! Prices began to escalate.

Colored Candlewick at that time was practically unknown; most collectors were not even aware of the black, blue, red, gold, and carmel slag pieces made in earlier years. Gradually information came to the foreground, and when these pieces did become available, prices were erratic. Eventually the colored Candlewick was verified as being authentic. Prices rose.

By 1983 the economic situation at Imperial was on a downward slide. Lenox Glass Company purchased the Imperial plant in 1973 and sold the complex to Arthur Lorch of New York in 1981. Lorch unloaded the ailing plant to Robert Stahl of Minneapolis, Minnesota in 1982. The handwriting on the wall was evident. Rumors circulated that Stahl bought the plant to save Imperial. Employees and collectors dared to hope.

The last piece of Candlewick was produced at the factory in October of 1982. In September of 1983 a new logo was in place: NI for New Imperial. However, within a year bankruptcy followed the new endeavor. The last day of producing Imperial glass was June 15, 1984. Consolidated-Colony (Lancaster Colony Corporation and Consolidated International joint venture) purchased the bankrupt company on December 5, 1984. The liquidation of Imperial glass began on December 12, 1984. By March of 1985 the factory stood empty; hearts were broken. A reference source had been destroyed. Employees and collectors alike shed tears as they looked at the empty Imperial buildings.

Everything was sold — from the pictures on the walls to the hundreds (maybe thousands) of pieces of Imperial Glass saved for an eventual museum. Both moulds and glass were sold in a haphazard manner; no sales records were kept. Numerous unusual and one-of-a-kind pieces were discovered in many patterns in the Imperial basement archives; colored pieces in the Candlewick pattern astounded those who found them in the reserves. All were sold. Imperial, as everyone knew it, was gone!

Maroon Enterprises of Bridgeport, Ohio, purchased the plant in March, 1985.

Now, in the late 90's, years after Imperial's bankruptcy and liquidation, prices for Candlewick have yet to stabilize. Prices for rare and hard-to-find items continue to escalate — some to hundreds and even thousands of dollars. The small collectors, who first started collecting Candlewick not only because of its beauty and appeal but because they could afford to purchase available pieces, were suddenly almost priced out of the Candlewick market. They can no longer afford to significantly enlarge their collections. The harder-to-find pieces are out of the question for them. The hard-to-find, rare, and colored Candlewick Crystal pieces are now only actively being sought by the die-hard collectors and dealers who can afford to pay the higher prices. Candlewick is now found in antiques shops and shows, finally being accepted not as an antique but as a collectible.

Candlewick "Go-Withs"

Today's collectors are not all purists — collecting only the original Candlewick pieces made by Imperial and nothing more. Many branch out in what, in today's jargon, is referred to as "go-withs."

Under such a heading would appear many beaded pieces that are not Candlewick, but do "go with" or resemble to some degree Candlewick Crystal. (See Chapter 7 CONFUSING SIMILARITIES for more information on various patterns.)

Many beaded patterns do complement each other. Some collectors purchase them purposely while others accidentally, confusing them with Imperial's Candlewick.

There is another type of "go-with" that complements any collection: items that advertise or are used with a collection, but are not of the collection. Examples of these Candlewick go-withs are

— Imperial matchbooks advertising Candlewick
— Imperial paperweights
— Imperial table signs: glass, cardboard, plastic
— Imperial/Lenox table signs
— Framed pictures of Candlewick (or advertising Candlewick) obtained at the factory; some are magazine ads. Several are in the author's collection.
— Cookbooks showing Candlewick in use.

(See pages 64, 65, 68, 69, 75).

What is glass?

The following article, INTO THE MELTING POT, gives an overall view of glass, types, and how it is worked. The article was given as a handout by Mr. Richard Ross (Bellaire, Ohio) to those attending the 1990 Imperial Convention. Mr. Ross said he got it at the 1973 Bellaire Glass Festival. The author is unknown.

To thoroughly enjoy glass collectors should be knowledgeable in the basics of glass and its attributes.

Into The Melting Pot . . .

Just what is glass, anyway? It is strong, delicate, clear, frosted, useful, decorative, fire-proof, cheap sometimes, sometimes as expensive as the gems it sometimes resembles.

Glass is sand. But to say that glass is sand is the same as saying a diamond is coal. Chemically they are similar but that is as far as the statement can go.

The glass with which most of us are familiar is generally made from one of the following batches, as mixtures of the necessary ingredients are called:

Soda-lime-silica glass contains silica sand, soda ash, salt cake, lime or limestone, broken glass, called cullet, and other ingredients present in extremely small amounts, such as arsenic. The percentages of each ingredient varies with the purpose for which the glass will be used. But this type of batch makes window glass, plate glass, bottles, inexpensive tableware and some kinds of optical glass.

Flint glass is made of silica sand, red lead or litharge carbonate of potash or soda ash, and cullet. These percentages again vary with the manufacturer. Flint glass is used for optical glass, fine tableware, art objects, and so forth.

Silica, the primary ingredient, is the basis of all clay soils. It is one of the most common elements in the earth's crust. The sand used for commercial glass making must be free of all impurities such as iron and alumina or the glass will be green, or have bubbles or other imperfections. Silica sand for America's glass is found locally in Hancock County, Pennsylvania, and in many other locations throughout the middle-west.

The second ingredient of glass, soda-ash, along with salt cake, lime and arsenic, is used to increase the silica's fusibility. Lead also adds luster and weight. Where potash is used as the alkali in place of soda a finer, harder glass is the result. The use of cullet also aids in the melting. To preserve the proper ratio of proportions, producers of glass generally use only their own cullet in their product.

To make colored glass small amounts of metal oxides are added to clear-glass formulas, producing colors. Ruby or red glass is made by adding metallic Selenium, gold, or copper to the batch. Chrome Oxide or Chrome slats will make green glass, Copper or Cobalt produce blue, nickle colors glass gray, and iron will color brown or green. Various mixtures give various tints.

When the ingredients are thoroughly mixed the batch is put into furnaces which heat the mixture to about 2600 degrees Fahrenheit. Here, in about 35 hours, the ingredients fuse into liquid glass. Glass must be formed while it is

still hot, because it cools quickly and hardens to a point where no further change in shape can take place. From the molten state glass is drawn, blown, poured, or pressed into the form desired. As soon as the forming operation is done the glass must be annealed slowly and carefully, for if it is allowed to cool too rapidly the unequal contraction of different parts (inside and outside, thick and thin) would set up strains that might eventually cause the glass to burst. So the glass is put into a long heated tunnel, called a lehr, where the heat is gradually reduced.

In making hand-blown glass, or hand worked glass, as is done at Bellaire's Imperial Glass Corporation, the batch is fused, then cooled to about 1900 degrees F., and the hot metal workers, or flints, then begin to shape and process the glass into an item. In shaping the glass moulds are used in order to obtain uniformity of shape. In blowing glass a gatherer, a skilled-workman, picks up the exact amount of glass needed on the end of the blow pipe, and hands it to a blower who shapes the glass bubble by blowing air into it. In most cases it is blown into shape in a mould. Sometimes items must be reheated, in a small auxiliary furnace called a glory hole, for further processing, such as adding handles, ornamentation, making fancy shapes, etc. A single piece may be reheated several times during the working of it into shape.

When glass is pressed the technique differs slightly. The gatherer picks up the wad on a rod called a punty and drops it into the mould. The mould has a cavity into which glass is pushed by pressure, either by an iron former, or by use of air pressure. The presser closes the mould to force the glass to flow throughout the mould. It may be chilled with an air blast. The turning-out boy then takes out of the mould the item and may place it in the glory hole to give it a fire polish finish. It is then handed to a finisher to put into final shape. The item is now in its finished shape and a carrying-in boy carries it to the lehr for annealing.

Of course some items must be ground off with pumice and water to remove the iron mark of the holder, either a snap or a handling rod. Ware is either stuck-up (stuck to a rod) or snapped (held in a type of hand-vise) when it is placed in the glory hole for reheating to keep it at workable temperature.

Some glass ware may require further finishing after coming through the lehr. It may be cut, or painted, or etched, or sandblasted.

CHAPTER 2

HISTORY OF IMPERIAL

Probably the most comprehensive history of early Imperial is contained in the 1947 report presented by Imperial Glass Corporation Secretary-Treasurer J. Ralph Boyd during Sales Conference Week in June 1947. It is printed here in its entirety to give an overall view of the early years, which include the first eleven years of Candlewick history.

THE HISTORY OF IMPERIAL GLASS CORPORATION

BY J. RALPH BOYD, Secretary-Treasurer, 1904 – 1947

Presented During Sales Conference Week June 3, 1947

I have been given the subject of Imperial Years. Imperial was organized in 1901 and was more than two years in building and produced the first glassware in January 1904.

The chronology of history is dry and uninteresting, but there is always a background behind the facts so I intend to give you here a rambling account of early events.

The Ohio Valley was the location of many small glass factories in early days — The Bellaire Tribune in its issue of 1884 lists the manufacture of glassware as the town's leading industry, hence the name of the Glass City. Eleven glass factories were in Bellaire, five or six making tableware, one making bottles, one making lantern globes, three making window glass. All hand factories, all small, mostly one-furnace capacity, each employing about 100 workers, and reporting a weekly payroll of approximately $1,000 per factory. It seems incredible that glassworkers those days earned only $10 to $15 per week. The total payroll of the eleven factories was not more than half of Imperial's payroll of today.

But to get back to the events leading up to Imperial. An experienced man, Ed Muhleman, who conceived and built Imperial was in 1892 operating the Crystal Glass Works in Bridgeport, Ohio. A small factory of two furnaces originally, a third built later about 1896. It was a cooperative, the glassworkers buying capital stock — paying by deductions from their wages. The Crystal earned money and the stockholders received dividends. I well remember taking the dividend checks after they had been written to a local printer who printed the head of a laughing man on the back of each check where the endorsement would follow.

William McKinley was elected President of the U.S. in 1896 and business revived and boomed. Big business was in the making. A group of Pittsburgh men started to buy-up table glassware factories to form the National Glass Company. The purchase of the Crystal Glass by the new National Glass Company was consummated. The Crystal was originally capitalized at about $75,000 — about 1897 a stock dividend of 100% in addition to the frequent

cash dividends was declared, each stockholder receiving two shares for one. The National bought at about $300,000.00 or four for one — paying 75% in cash and 25% in its own stock.

Mr. Muhleman was left at the Crystal in charge of operations, but did not remain long. Soon after his resignation from the National Glass Company (which by the way was never successful and failed about 1906) he, with the help of several prominent businessmen of Wheeling and Bellaire, most whom had been directors in the Crystal, had no difficulty in obtaining subscriptions to capital stock in the new Imperial, chartered at $500,000.00.

As originally stated, Imperial made its first glass in January 1904. Mr. Victor G. Wicke who had established a selling agency in New York City and previously sold for the Crystal was hired to come to Bellaire as Imperial's Secretary and Sales Manager. His first sale, pre-arranged as you may suspect, was to the F. W. Woolworth Company. I remember quite well the visit of the old gentleman, Mr. Osborne the buyer. He was shown samples of glassware, still hot, just as the mould were tried out in the factory. A butter dish with cover, a cream pitcher, a pickle dish, a berry bowl, etc. about 20 items in all. A listing was made, prices agreed upon, and before he left Bellaire two or three days later, Mr. Osborne placed orders for each Woolworth store, about 500 stores, I believe, and perhaps $100 to $200 per store. No confirmation was required. Mr. Osborne possessed the authority to buy and shipments were to be made as rapidly as the ware could be manufactured. An opening discount was the key. But the Imperial was then started.

I have previously said that there were numerous table glass factories those days. An association of manufacturers also existed called the American Flint and Lime Glass Manufacturers, and had for its original purpose uniformity in terms of sale, packing charges, etc., and from this organization grew, during the prosperous years of early 1900 the Glass Association, a body with offices in Pittsburgh set up to control selling prices and rebates to customers. Nearly all glass tableware factories were members. Once a year all known retailers and jobbers were submitted a contract agreeing to buy only from factories listed, and offered a rebate to be paid at the end of the year, in size dependent upon their total volume of purchases, the rebate ranging from 1% to a maximum of 10%. Each factory paid into the pool, weekly or monthly, 6% of their sales and at the end of the year a book of all customers under contract was sent to each factory who in turn reported its total sales for the year to each customer, enabling the Glass Association to ascertain and pay out of the Pool, each customer's rebate, and return to the factories their unused contributions with a rate sheet for checking. Minimum prices were established on certain articles and rules for pricing other articles. It was a nice scheme while it lasted, but the Sherman Anti-Trust Act put an end to it.

At that time Imperial was making mostly 5 and 10 cent articles for Woolworth and later for McCrory, Kresge and other syndicates and also enormous quantities of jelly glasses with tin lids and common pressed tumblers with horseshoe bottom, star bottom, and the like. Imperial had molds for six or seven tableware patterns, but as lines they did not sell well.

For a while pressed gas and electric shades for chandeliers sold very well especially in San Francisco and on the Pacific Coast. Heavy stem pressed goblets known as "Railroad Goblets" were bought in carload lots by Jobbers — the Memphis Queensware Company, John McClelland and Company of Houston, Texas, and many other southern distributors.

Records show that Imperial paid a cash dividend of 1% in 1905; 4% in 1906; 3% in 1907; 4% in 1908; and 6% in 1909. Although short of working capital and operating all the time on borrowed money because the entire half million of capital had been spent on the building and equipment, a book surplus was built up totalling, in 1910 when Mr. Muhleman retired, about $190,000.00. It was Mr. Muhleman who ordered early in 1910 the construction of the Gas Producer Building and six hand stocked gas producers, to hold the Natural Gas Company in line. It didn't work and neither did the gas producers until much later when a shortage of natural gas forced their use, and after the producers had been overhauled, modernized and additional pipe lines installed. As a last official act of Mr. Muhleman in 1910, a dividend of 35% was declared by the Board of Directors, payable in Promissory Notes dated July 1, 1910, having a term of ten years with semi-annual interest coupons bearing 6% interest attached. Upon resigning, Mr. Muhleman sold his capital stock of $50,000.00 and completely severed his connection with the company.

Mr. Victor G. Wicke who followed as President of the Company had his hands full. To maintain a yearly cash dividend rate of 6% and meet the interest on the Promissory Notes each year required annual earnings of $40,500.00 besides operating expenses; the surplus shown on our statement had already been wiped out by the 35% Note Dividend. However, the seemingly impossible was accomplished — the manufacture of iridescent glassware was extended, new colors added; a line of expensive molds to produce an imitation of heavy cut glassware was made; the name "Nucut" was copyrighted for the ware. "Nucut" sold well at profitable prices; sales of glassware of premiums were enormous. The Grand Union Tea Company purchased about $15,000.00 per month for several years. Exports, principally of iridescent glassware to the West Indies, South Africa, Australia, New Zealand and even to the Dutch East Indies were heavy, and furthermore a line of iridescent colored and satin frosted electric shades in imitation "Tiffany" style proved both popular and profitable. The cash dividend rate of 6% per year was maintained until 1923 with 2% extra dividends in 1919 and 1920, the years immediately following the end of the first World War, and the Promissory Notes totalling $175,000.00 were completely paid.

I have omitted, so far, to mention an important event in 1912. In that year Mr. Earl W. Newton became Imperial's Sales Agent in Chicago, and adjacent territory and adequately did his share of getting new business. I well remember the Earl Newton of 1912 — tall, slender, and boyish in appearance, and always in those days with a large cigar in his mouth. I would like to recall two other salesmen of earlier days. Otto Bersback, who sold Imperial glassware about 1904 to 1910. Otto was a big operator — would visit the factory wearing a shiny top hat and a frock coat. He maintained selling offices and sample

rooms in Denver, Salt Lake City and San Francisco. Made trips to Montana and to other places. He sold split cars of glassware to Butte, Anconda, and Helena as well as cars to Denver, Salt Lake City and Frisco, and he also represented other factories he had them ship to us for carload consolidation.

Earnest Bersback worked differently — he lived in Milwaukee and worked the states of Wisconsin and Michigan. He acted as buyer for many of his customers — sent orders for what he thought they needed and told them about it later. There were in those days, few real department stores and so far as I remember, no merchandise managers to restrain buyers. Either the buyer made good, or he lost his job.

As I said before the distribution of dividends to the stockholders ceased in 1923. The tide turned then. The demand for glassware during the first World War speeded the development of automatic machine glass. Jelly glasses and cheap tumblers were lost, and 5 and 10 cent retailers went to the machine plants. Wages of the glassworkers had gone up. Imperial was unable to compete with automatic machine production on low-priced articles. In hunting for new merchandise Mr. Wicke reversed his former policy; a shop of highly skilled off-hand glassworkers was hired. Later another shop. These men without help of any molds made beautiful and costly vases, glass baskets, bowls, jelly stands, etc. using the best lead glass in crystal and colors — ruby, blue and green, some articles cased, which means the imposition of one layer of glass over another layer (usually of a different color) and some decorated with glass threads and iridescent frosting. Beautiful and costly to be retailed at $10 and $25 each.

The market could not, or rather did not, absorb the line, and an inventory of about $50,000.00 accumulated. Another venture — the manufacture of glass articles decorated with decals like china was likewise only partly successful.

In October 1924 the company put out a First Mortgage Bond Issue of $250,000.00. Terms, ten years, interest at 6% per annum. Less than half were sold — the balance was used for collateral to guarantee bank loans.

In December 1929 Mr. Wicke, whose health had broken a year before, died. Mr. J. M. DuBois was elected President and a new Sales Manager was hired but the depression was then beginning. The banks called Imperial loans and bankruptcy occurred in February 1931. Mr. DuBois was appointed by the Common Pleas Court of Belmont County as Receiver, with permission to operate. Mr. DuBois with the help of a few of Bellaire's civic-minded citizens and helped also by the Ohio Valley Industrial Corporation of Wheeling started immediately to reorganize Imperial — succeeded in obtaining subscriptions for a new preferred capital stock of $100,000.00 contingent largely upon the glassworkers subscribing approximately $50,000.00 of common stock to be deducted at 10% from their earnings. Earl W. Newton, during this crisis, came to the front. He introduced Cape Cod pattern — came to Bellaire and addressing several audiences spoke glowingly of the possible future for Imperial if reorganized with the old burdens removed. Finally when the reorganization was accomplished, Earl Newton walked in to the first Stockholders

Meeting with the contract of the Quaker Oats Company in his pocket to assure the continued operation of the factory, and was elected President of the new corporation; Mr. DuBois remaining as Receiver for the old company to wind up its affairs.

It is nice to remember that production never ceased during the changeover. To Earl Newton the corporation owes a debt of gratitude. Through his efforts blown stemware was added to Imperial's line of manufacture, and shortly afterward Earl Newton brought us Candlewick. We had some tough sledding 1932 and the years following. The new corporation did not own the factory but leased it from the Bondholders who formed a holding company capitalized at $150,000.00, the amount of the unpaid bond of the old company. In 1936, right after the big Ohio River flood of that year, Mr. Carl J. Uhrmann, hired by Earl Newton who had met him in Chicago, appeared on the scene. His experience, ability and hard work immediately became manifest. More confidence in the future of the new corporation resulted — the Ohio Valley Industrial Corporation who helped in the recapitalization again helped and sent their secretary, a gentleman named Carl W. Gustkey to serve on our Board of Directors. Mr. Gustkey sensing that additional working capital was needed made the application and secured a loan of $124,000.00 from the Reconstruction Finance Corporation, now completely paid off ahead of schedule. From that time in 1939 until today the progress has been steadily upward. Wisely directed advertising, coupled with salesmanship and personality of Carl Gustkey and the technical ability and wide experience of Carl Uhrmann have brought Imperial Glass Corporation today to a leading position in the table glassware industry as all of you in this room well know.

In retrospect I can only say — Imperial's 43 years of continuous operation with no serious labor troubles has been an outstanding blessing to Bellaire and vicinity.

Owners of Imperial Glass Corporation

Listed below are the six successive owners of the Imperial plant.

1904 - 1972	Imperial Glass Corporation
1972 - 1981	Lenox Glass Corporation (purchased Imperial 12-29-72)
1981 - 1982	Arthur Lorch of New York, private investor (purchased Imperial 6-26-81)
1982 - 1984	Robert Stahl, Minneapolis, MN, liquidator (purchased Imperial 9-82)
	Imperial bankruptcy began October 1982
1984 - 1985	Consolidated-Colony (Lancaster Colony Corporation and Consolidated International partnership purchased Imperial 12-5-84)
1985 - present	Maroon Enterprises of Bridgeport, Ohio (purchased buildings and property in March 1985)

Hay Shed Plaque

Affixed to the front of the Hay Shed next to the entrance was a plaque

describing the function of the Hay Shed:

"Since Imperial's earliest days, this site has been known as the Hay Shed. The Imperial Glass factory was built in 1904 and the Hay Shed was erected to store the hay then used for packing protection in shipping cartons.

"In 1962, the Hay Shed was successfully converted to the Old Hay Shed Gift Shop as a retail outlet for bargains in handcrafted Imperial glassware."

In 1992, the Hay Shed was moved inside the refurbished main factory building. The old Hay Shed plaque has the place of honor on the wall next to the glass door entrance of the new Hay Shed Glass Outlet. The old Hay Shed building was razed in 1992.

Memories

Ruth Seaman, former Imperial employee and archivist for the National Imperial Glass Collectors Society (NIGCS) at the time of her death in 1991, stated in an article that "the plant started in 1904 and was in steady production until 1984. The building then was the largest plant under one roof in the world. It had its own cutting shop, decorating department, etching department, and mould shop. In the beginning when the ware was packed in wooden barrels, they (Imperial) made their own barrels."

Ruth was a wealth of information and was always willing to share her knowledge with those who were interested. She resided in Bellaire, Ohio. These next two articles by Ruth were printed in the NIGCS (National Imperial Glass Collectors Society) newsletter, GLASSZETTE, in January 1982 (Hay Shed) and March 1983 (Memories).

The Hay Shed

Imperial Glass has been in operation since 1904, and for almost 60 years hay was shipped in by boxcar and stored in this red brick building until needed for packing glassware. The glass was packed with hay (actually oat straw) in wooden barrels made by Imperial employees, two of whom were the late Ruby Littleton and John Robertson. The railway brought the hay down the main line and it was loaded into a dollie which carried it to the shed by an overhead rail located above the sidewalk.

In 1962 they began selling glass from this building. When the outlet was first opened it had no proper name. Since I was raised near the factory and my father was an employee, I had always referred to this red brick building as the "Hay Shed". As head clerk I continued to call it the "Hay Shed" and the name became official. Twenty years later that name is recognized by many visitors and customers.

Picture from NIGCS GLASSETTE, October 1989

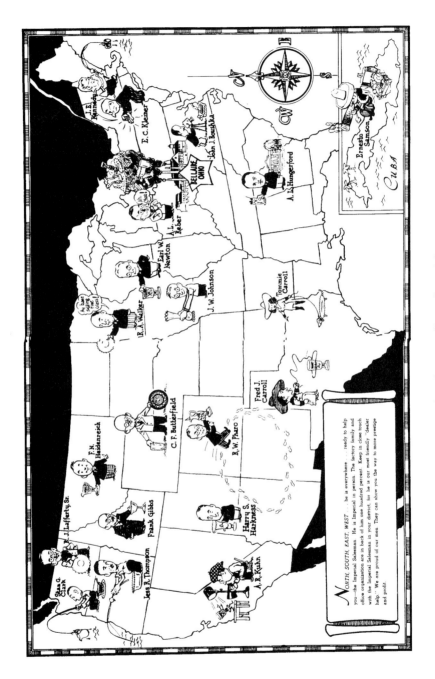

America according to Imperial

Memories of Imperial Glass Co.

The Imperial Glass Corporation has for a long time been a factor in the economic life of Bellaire, Ohio, its importance varying with the health of the business and economic conditions in general. At present only two glassmakers shops are working, with the inspectors, packers, office force, etc. needed by an operation of this size. At times in the past the organization has been much larger. Judge for yourself the number of glassworkers, finishers, inspectors, packers, and others that were needed to provide glassware to be sold by the network of Sales Reps shown on the "Imperial Map of America" in this issue (supplied by another author).

At one time there was a hand decorating shop whose boss was Mr. Fred Wilkinson. His several girls and fellows worked eight hours a day painting patterns and designs on the glassware. This was burned on at a high temperature in a kiln or "oven" as we called it.

There also was a cutting shop, run by Mr. Carl Ottoson in the 30's and 40's. He was knowledgeable and skilled in creating the new designs needed to keep Imperial in the forefront. At one time 20 women and men worked at the cutting wheels, skillfully holding the glass at just the right angle and with just enough pressure to create the design Mr. Ottoson had visualized. A few hand cutters are still at work in some places but most cutting is now done by automatic machines.

Imperial had an etching department, too. Here workers rubbed prints onto the glassware, then outlined them with a wax resist to keep the etching acid from eating into certain parts. Men dipped the pieces, packed in a wire basket, into the acid etching mixture just long enough to etch the pattern to the desired depth.

These are some of my memories of what has been done at the factory during the many years I was employed as a helper and worker at the Imperial Glass Corporation.

"Save Imperial 1984" Red Brick

As the sale of Imperial was being reviewed in the U.S. Bankruptcy Court in 1984, commemorative ruby glass bricks were sold in stores and banks in Bellaire to help the Save Imperial Committee purchase the company.

The red brick is 4″ long, 1 14/16″ in width, 1 7/16″ high. The bottom is smooth, while the rest of the brick is "simulated" rough. The words "SAVE IMPERIAL 1984" are in raised letters on the top; on a few of the bricks the letters and numbers are in gold. It has been rumored that only about 300 bricks were made. They were manufactured by Viking Glass of New Martinsville, West Virginia. (See page 51.)

Imperial Labels

Many Candlewick pieces have been found with the original labels intact; these, also, tell the history of the Imperial Glass Corporation. At least eleven different labels have been used to identify Imperial glass over the years. Many have been found on Candlewick by collectors.

The following descriptions are given here to help Candlewick collectors date their pieces.

1. 1937-1939 Triangular label; has handled candleholder similar to 400/81, round handle. Light blue background. Imperial blue (dark) scallops are edged in silver. Candleholder is silver and dark blue outlined. Lettering is silver. Probably 1937-1939 as label was found in 400/31 Cream and Sugar set with beaded foot, which was manufactured 1937-1939. The style of the cream and sugar was changed in 1939. (Description by Virginia Scott.)

The label has the words "Imperial Candlewick — Hand Made — Design Patented." Later labels say "Hand Crafted." The saucer part of the picture on the label is rolled like 400/79R. There is no Candlewick piece like this shown in Imperial files. Several collectors reported having this label on small dishes.

2. 1938 Label appeared on each page of earliest Imperial catalog. Words are "Product of Imperial Hand Made Quality."

3. 1939-1961 Appeared in Catalogs A and B, 1939-1941. Plain, no ruffles around outer edge. Blue and silver. Also appeared in Catalogs E — 1950, F — 1957, and G — 1961. Words: "Hand Made Imperial USA." Has stemmed glass.

4. 1943 Same as #3, but "Hand Made" is lettered above stemmed glass.

5. 1943-1961 Appeared in Catalogs C and D, 1943-1947. "Hand Crafted" is lettered above glass rim. Silver ruffle added; oval label with blue background; silver letters "Hand Crafted Imperial USA." This design was also used by Imperial for an official paperweight. Also found in Catalogs E — 1950, F — 1957, and G — 1961.

6. 1947 Same as 1943. No ruffle; no "Hand Made" above glass rim.

7. 1969 Same as ruffled #5, except no "Hand Crafted" above glass.

8. 1973-1981 First shown in 1977 Lenox Catalog. Rectangular. In 1973 Lenox operated Imperial, which became a subsidiary of Lenox, Inc.

9. 1978-1979 Catalogs 1978-1979. Black background; two silver lines run parallel around outside of the rectangle; lettering black. Words: "Imperial Hand Crafted Glass by Lenox."

10. 1970's Outline of US map; blue label, red border, found on 1970 Candlewick pieces. Words: "Imperial American Hand Crafted Glass," in white letters.

11. Date Unknown Oval, ruffled. Silver with royal blue background. No stemware. Words: "Hand Crafted Imperial U.S.A."

NIGCS

Ruth Seaman stated in an article that the National Imperial Glass Collectors Society "Was formed in 1977 by Ward and Evelyn Russell and a

group of friends interested in keeping the Imperial Glass Corporation in the public eye. In 1982 the officers for the national society were elected from the Bellaire (Ohio) area."

To join the National Society, write to P.O. Box 534, Bellaire, Ohio 43906. The Society publishes a quarterly newsletter. A convention is held annually in the Bellaire area.

Candlewick Clubs

In the fall of 1979 the idea of a local Indiana and Michigan Candlewick club took root. Several meetings were held with just a few collectors in attendance. On January 25, 1980, an organizational meeting was held after invitations had been issued in late 1979 to collectors in 7 cities in the Michiana area. Today MACC (Michiana Association of Candlewick Collectors) covers 29 states with nearly 400 members.

The Michiana Club has an informational newspaper, THE SPYGLASS, first published in August 1981. The 10 page (largest was 19 pages in July 1991) newspaper is published quarterly.

Information on the MACC club may be obtained by writing to MACC, 17370 Battles Rd., South Bend, IN 46614.

Jean Fry, Ohio club president, attended the Michiana Club meeting in July 1980, to observe the newly formed MACC. Shortly after, Jean organized the Ohio club.

By July 1981, Ohio Candlewickers were organized and held their first meeting. Jean is still president and can be contacted at 613 S. Patterson St., Gibsonburg, Ohio 43431, for information on meetings, membership, and their newsletter.

Other active Candlewick clubs are:
• Candlewick Crystals of Arizona, 2430 E. Sheridan, Phoenix, AZ 85008
• Arizona Candlewick Club, 5000 E. Grant Road SP 104, Tucson, AZ 85712
• Maryland Imperial Candlewick Club, 23 Ashcroft Court, Arnold, MD 21012
• Texas Regional Imperial Glass Group, P.O. Box 467, Saint Jo, TX 76265

Lenox and Candlewick

Lenox Glass Company purchased Imperial on 12-29-72, and sold it to Archer Lorch on 6-26-81. Lenox owned Imperial for 8-1/2 years.

In a 1975 booklet distributed by Lenox, new names were given to various Candlewick items. Some of these names have surfaced over the years, but it did not all come together until the 1975 booklet became available through a Bellaire, Ohio, collector. No reason has been found for the names change Lenox advertised for Candlewick. The term "Candlewick Crystal" is not used anywhere in the booklet.

When collectors are confronted with the names associated with Candlewick made by Lenox in 1975, they know the pieces are genuine Candlewick made by Imperial/Lenox.

To be familiar with these names and know that the 1975 booklet did exist is to prepare oneself in the eventuality someone will be selling Candlewick by

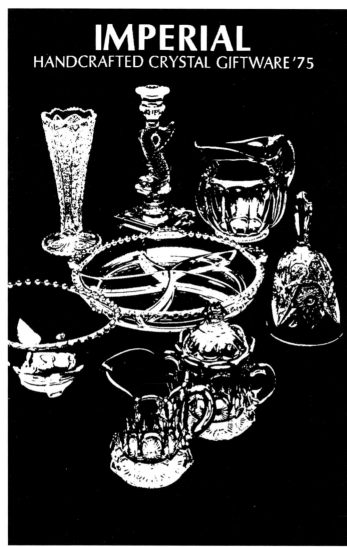

IMPERIAL
HANDCRAFTED CRYSTAL GIFTWARE '75

9.

9. Bordeaux Salt & Pepper. A dainty salt and pepper set with a charming beaded base. 3-1/2 tall.

19.

19. Lafayette Candleholder. A sparkling crys holder to grace any mantel. 3-1/2 in. tall.

25.

25. Normandy Sugar & Cream. The look is artful and the pattern so right for any occasion. 1/2 in. tall.

30.

30. Napoleon Pitcher. An extra-generous two-quart pitcher with classic lines for any serving need.

1975 Booklet cover, courtesy of the Elinor Hammond Estate, Bellaire, Ohio, put out by Lenox while they owned Imperial.

another name. Good pieces and good deals could be passed up merely because of the name change. (See pages 24, 25.)

Imperial and the Rodefer Glass Company

At the 1990 NIGCS Convention, Willard Kolb, former president of National Cambridge Collectors, Inc. for eight years, spoke of doing research with records from the Rodefer Glass Company. He mentioned a definite connection between Imperial and Rodefer.

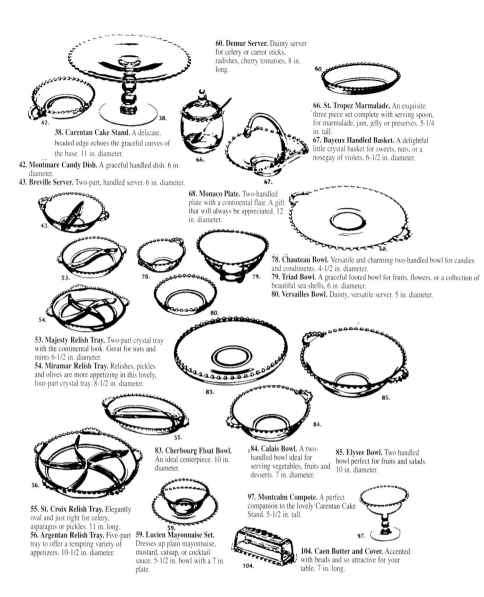

60. Demur Server. Dainty server for celery or carrot sticks, radishes, cherry tomatoes, 8 in. long.

38. Carentan Cake Stand. A delicate, beaded edge echoes the graceful curves of the base. 11 in. diameter.

42. Montmare Candy Dish. A graceful handled dish. 6 in. diameter.

43. Breville Server. Two-part, handled server. 6 in. diameter.

66. St. Tropez Marmalade. An exquisite three piece set complete with serving spoon, for marmalade, jam, jelly or preserves. 5-1/4 in. tall.

67. Bayeux Handled Basket. A delightful little crystal basket for sweets, nuts, or a nosegay of violets, 6-1/2 in. diameter.

68. Monaco Plate. Two-handled plate with a continental flair. A gift that will always be appreciated. 12 in. diameter.

78. Chateau Bowl. Versatile and charming two-handled bowl for candies and condiments. 4-1/2 in. diameter.

79. Triad Bowl. A graceful footed bowl for fruits, flowers, or a collection of beautiful sea shells, 6 in. diameter.

80. Versailles Bowl. Dainty, versatile server. 5 in. diameter.

53. Majesty Relish Tray. Two-part crystal tray with the continental look. Great for nuts and mints 6-1/2 in. diameter.

54. Miramar Relish Tray. Relishes, pickles and olives are more appetizing in this lovely, four-part crystal tray. 8-1/2 in. diameter.

83. Cherbourg Float Bowl. An ideal centerpiece. 10 in. diameter.

84. Calais Bowl. A two-handled bowl ideal for serving vegetables, fruits and desserts. 7 in. diameter.

85. Elysee Bowl. Two handled bowl perfect for fruits and salads. 10 in. diameter.

55. St. Croix Relish Tray. Elegantly oval and just right for celery, asparagus or pickles. 11 in. long.

56. Argentan Relish Tray. Five-part tray to offer a tempting variety of appetizers. 10-1/2 in. diameter.

59. Lucien Mayonnaise Set. Dresses up plain mayonnaise, mustard, catsup, or cocktail sauce. 5-1/2 in. bowl with a 7 in. plate.

97. Montcalm Compote. A perfect companion to the lovely Carentan Cake Stand. 5-1/2 in. tall.

104. Caen Butter and Cover. Accented with beads and so attractive for your table. 7 in. long.

Imperial Handcrafted Crystal Giftware

The connection was obvious because of a souvenir glass ash tray in the author's collection which shows a Candlewick Goblet with the Rodefer company name.

Rodefer Glass Company was situated in Bellaire, Ohio; it was the longest family-owned glass house in the U.S., the oldest of all the glass companies in the area, opening its doors in 1877 and closing them in 1982, just about the time Imperial was in deep trouble financially. Rodefer made glass for Gleason Glass Company on the east coast.

In the late 1950's or early 1960's Rodefer and Gleason merged to become the Rodefer-Gleason Glass Company.

Since there were many glass companies at that time, and glass making was at a high, orders sometimes were difficult to fill on time. Therefore, most of the area glass companies would send their moulds and orders over to Rodefer to have them do the work so they (the glass companies) could catch up on orders.

While Willard was doing his research in the Rodefer Glass Company building he found shards of Candlewick Crystal and also Candlewick stoppers in the attic. It is apparent that Rodefer also helped Imperial play catch-up with its orders.

Rodefer was a private mould company. They designed and made moulds and glass from descriptions and sketches. They made beautiful vases, utilitarian pieces, and commercial wares.

After the merger the company became known for its lighting fixtures. They also made TV tubes. Anything that could be made from glass in a mould, Rodefer could do it.

In 1973 the Bellaire Glass Festival Souvenir honored Rodefer Glass Company of Bellaire, Ohio. This was the first Bellaire Glass Festival and souvenir. It is an ash tray with a combination of satin and clear glass. The round tray is 4 5/8″ in diameter and 11/16″ deep.

"Rodefer-Gleason 1973" is shown on the inside bottom of the tray. A glassblower is shown in action. Around the top of the outside edge, the following is printed: "First Annual All American Glass Festival July 23-28 Bellaire, O". All numbers, letters, and designs are raised. (See page 67.)

What is most interesting to Candlewick collectors is that to the right of the glassblower a 3400 goblet is shown, possibly indicating that the blower is working on a Candlewick goblet. Above the blower is the word IMPERIAL, further proving the connection between Rodefer Glass Company and Imperial Glass Company.

The late Ruth Seaman, former Imperial employee, and archivist for NIGCS at the time of her death, said Rodefer also made glass for companies in Czechoslovakia.

CHAPTER 3

THE HISTORY OF CANDLEWICK

Candlewick — The Name

In an early COUNTRY CRAFTS BETTER HOMES AND GARDENS magazine, Candlewicking is defined:

> "Candlewicking is a traditional mountain craft that flourished in the mid-18th century. And, like all mountain crafts, the materials are commonplace and the technique is easy to do. Just work French knots with soft string on an unbleached muslin background. To work the design, space the knots and rows 1/4″ apart along the design line." (from Scott's newsletter #27, p. 1.)

In Scott's newsletter #28, p. 6, Eileen Wikel, Huron, Ohio describes Candlewicking as a

> "true American form of needlework, created by pioneer women out of their desire to be creative and practical. Because materials were scarce and expensive, the ladies hit upon the idea of using readily available unbleached muslin. On this, they created designs in little tufts with the same cotton 'wicking' that was used for household candles. The designs were simple, like a geometric, a flower, a bird, or a pineapple which was used to symbolize hospitality. The borders of bedspreads were elaborately decorated with many rows of Candlewicking. Our glassware was named Candlewick in remembrance of this beautiful Early American needlework, the beads around the pieces simulating the little tufts of the needlework motifs."

Early stories tell of Earl Newton, president of Imperial after the 1931 bankruptcy, buying a piece of the old French Cannonball pattern with beads in a New York department store. He liked the pattern so much that he took the piece back to Imperial with the idea of making a beaded-edge pattern.

Still other stories abound. Whatever the origin of the pattern, collectors may see a mountain craft, early American needlework pattern, or a lookalike to a French-produced pattern; it doesn't matter. As the old adage reminds us: "Beauty is in the eye of the beholder!"

Early Candlewick History

A very comprehensive history of the Candlewick line appeared in the National Imperial Glass Collectors Society newsletter, GLASSZETTE, in October 1993. It is authored by Willard Kolb, glass historian.

THE "NEW" IMPERIAL CANDLEWICK LINE
INTRODUCED AT THE 1936 WHEELING CENTENNIAL
by Willard Kolb

So indicates one of the 10,000 brochures printed by the Jarvis Engraving Company of Wheeling, West Virginia to be distributed in Booth 29 by Imperial as part of the Chamber of Commerce industrial exhibit for the "Centennial Celebration" held August 17-21, 1936.

The inside front page of the brochure is dedicated completely to promoting the tradition of the famous "Candlewick Quilts" and the fact that the Candlewick line was reproduced from this pattern. This, of course, was merely a promotional ideas, as it is known that Mr. Earl W. Newton used the French "Cannon Ball" line as an inspiration to produce the Candlewick line. You could hardly expect them to advertise that they had copied these pieces.

The inside back cover of the brochure shows a 5 piece setting of

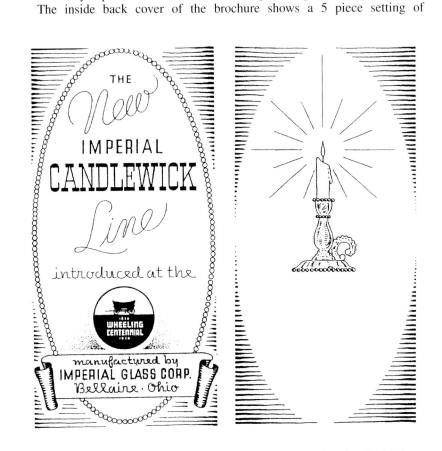

Brochure from the "New" Imperial Candlewick Line introduced at the 1936 Wheeling Centennial. Courtesy of Willard Kolb.

Candlewick. Shown are the 400/10 dinner place, the 400/67B nine inch footed bowl, and the 400/40 three piece mayo set. The 400/67B nine inch footed bowl has the ribbed bowl and foot which means that it was made in a joint mould and predates the 400/67B with a plain bowl which was later made in a block mould. The joint mould 400/67B along with the 400/67D ten inch cake stand appear in what has been determined to be a 1937 general catalog. It appears in the Candlewick "A" catalog both as the footed bowl and flattened out as the 400/67D ten inch low cake stand. The footed bowl disappears in the Candlewick "B" catalog but the 400/67D cake stand is still shown. After this, all versions of the joint mould disappear, which means it was discontinued sometime in 1941. We will discuss the other joint moulds that were used in early production a little later in this article or in another article.

Also listed on the inside back cover of this brochure are the pieces available at the time of the "Centennial". There were six sizes of plates, six sizes of nappies, fancy two handled pieces, comport, cake salver, salad sets,

 EARS ago, along with the kerosene lamp and high-buttoned shoes, Early American furniture and old CANDLEWICK quilts fell into unmerited disuse. Fortunately their practical simplicity was not discarded forever.

Women who love that fine old example of Early American craftsmanship – CANDLEWICK – are showing the same appreciation when they see Imperial's new CANDLEWICK line of glassware.

Faithfully reproducing the fluffy pattern of the old tufted quilts, CANDLEWICK is stimulating tremendous interest, not only in the line itself, but in the tradition of pioneer home life which stands behind the design.

The interest of women in the CANDLEWICK pattern is so widely spread in America as to be almost unanimous. Imperial's adaptation of the CANDLEWICK pattern to glassware is certain to be received with enthusiasm everywhere.

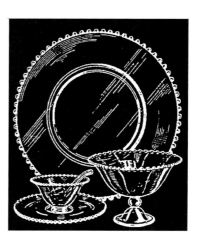

Available in the following:

Plates–6 Sizes • Nappies–6 Sizes • Fancy Two-Handled Pieces • Comport • Cake Salver Salad Sets • Stem Ware • 4 Toed Fancy Bowls • Mayonnaise Set • Sugar and Creamer

CANDLEWICK • An American Tradition

Brochure from the "New" Imperial Candlewick Line introduced at the 1936 Wheeling Centennial. Courtesy of Willard Kolb.

stemware (we'll talk about this later), 4-toed fancy bowls (we'll also talk about this later), a mayonnaise set and sugar and creamer.

The outside back cover depicts a handled candleholder which is probably an artist's concept. It would be nice if it wasn't though. I realize this brochure and most of what I am explaining in this article are probably old hat to the advanced collector and researcher and may bore you terribly. However, with Candlewick perhaps being the fastest growing glass collectible and so many new people wanting to know more about what they are collecting, I would ask you to bear with me. If you study this minute brochure carefully, you should be able to write at least ten pages answering all of the questions it presents.

Somewhere there exist 12 photos of the Imperial Candlewick display at the "Centennial", as attested to be a billing from the Freter Brothers photographers of Bridgeport, Ohio for "12 photographs of the Imperial Centennial display". If one of these were to show up, it may answer many questions that arise from studying the brochure.

Let's begin with the stemware mentioned in the brochure. What was it? It must have been the 400/19 line made by the "central system" (versus the hokey-pokey system, discussed later). However, none of this shows up in what is determined to be a 1937 general catalog. All of the other pieces named in the brochure appear in this catalog. The 400/19 does not appear until the "A" and "B" catalog which means possibly 1939. In the Marshall Field department store ad, also produced by Jarvis Engraving, there is no drink ware shown. Mr. Manion, Imperial's patent attorney, applied for the patent on a tumbler in early May of 1936 and, according to a list of patents secured by Imperial, this would probably be the patent No. 100,579 awarded on 7/28/36. We would have to assume then that the stemware mentioned in the brochure consisted of the 400/19 12 oz. iced tea. Perhaps there was no Candlewick stemware line at the time and the stemware was going to be that of another manufacturer. (Indications of this will come later.) The bowl and plate patents were awarded on the same date, as they had been on the same application as the tumbler patent. The interesting thing is that the original application was for 3 1/2 years for these items and, before the patents were awarded, Imperial had Mr. Manion file for an extension to 7 years.

And now for the controversy of all controversies about Candlewick, when it was first made, the development of the line, and when it was first shipped and sold. What I am about to say here may have a few flaws because it has been pieced together from rather scanty official records. For some reason, the actual development of this line seemed to be a very secretive endeavor. We have to assume that the term "new line" mentioned in correspondence was what later became "Candlewick". The first time I have seen the name "Candlewick" used is mid 1936. Some of the information will be my suppositions, after long study, based on information from Imperial and other glass companies. Sometimes it is better to make information, although incomplete, known in hopes that someone will read it and be able to fill in the voids.

When Mr. Earl Newton agreed to serve as President and General Manager of Imperial during its reorganization in 1931, he put much effort into changing

Imperial's production priorities. Up until this time, Imperial didn't have a very competitive table ware line. This was evidenced by the fact that, although Mr. Newton was one of Imperial's top representatives at Earl Newton and Associates in Chicago, he was also one of Morgantown Glass Company's top representatives and continued as such for much of his tenure at Imperial. He made the statement to other officials of Imperial that to make Imperial again a successful company, they would have to tailor their production after other successful companies of the time. (Although Mr. Newton named these companies, I wouldn't dare mention them in the *GLASSZETTE*.)

So on a trip to New York in 1933 where he was trying to negotiate some contracts for Imperial, he bought a piece of French Cannon Ball glassware and brought it back to the factory with him. The design was discussed and Mr. Charles Oldham, who was head of the mould shop, was instructed to make a mould to simulate the Cannon Ball design. He did so and, in late 1933, Imperial made their first piece of what was later to be Candlewick. There was one problem however. The mould Mr. Oldham had made was a "joint" mould for a 3-toed bowl which was much the same as the later/74 4-toed bowl. They made this bowl both in the b and c shapes. The shapes though did not create the problem. The problem was that the four mould joints showed prominently on the finished piece of glassware. It was later decided that a plain design made by this method would not be a very competitive line of table ware.

The development of Candlewick was sort of put on the back burner at this time as there were other more important issues at hand. Money had become tight and Mr. Newton and management were busy trying to cut costs while trying to get some lucrative contracts making items they had already developed.

In August of 1935, Mr. Newton inquired about applying for a loan of $20,000.00 to develop a new line. It was late 1935 when this loan was secured and $10,000.00 was to be earmarked for new moulds. In this correspondence, he reiterated that the future of the glass business lay in matched lines of tableware. By the way, for those of you who do not know the workings of Mr. Newton at the time he was President of Imperial, 1931-1940 I will explain. He remained in Chicago as head of Earl Newton and Associates and traveled to Imperial for meetings and as otherwise needed. He also spent much time traveling around the country securing contracts for Imperial. He was a very busy man and thus much of his managerial expertise was transmitted to Imperial by letter and phone.

Now, until someone proves me wrong, I will explain to you the scenario that took place after the loan was secured. This has been rather loosely pieced together from fragments of information that I could possibly have misinterpreted. This will explain the development up until March of 1936 when more concrete information was available.

Mr. Oldham or someone at Imperial had decided that they could develop the line in joint moulds by putting ribbings on the glass to cover up the four mould marks. These, in fact, are rather attractive pieces. Two of this type mould were made and they were able to produce from one the 400/74J bowl, 400/74B bowl and the 400/74SC dish, all 4-toed. From the other

mould they were able to produce the 400/67B nine inch footed bowl and the 400/67D cake stand. If you examine these pieces carefully, you will be able to find the joint mould marks in four different places or on every other rib.

Perhaps this still wasn't satisfactory for a clean cut dinnerware line. Is this why Mr. Newton interviewed the plant superintendent of Peltier Glass Co. in Chicago and ultimately hired him to come to Imperial? The man certainly came highly recommended after serving in that position at both Inland Glass Co. in Chicago and the Peltier Glass Co. in Ottawa, IL. Mr. Newton made a proposal to this gentleman, Mr. Carl Uhrmann, on February 19, 1936 and Carl came to work for Imperial on March 15, 1936 as plant superintendent. However, his first contract as plant superintendent was not negotiated until 1937. There are two stories told about Candlewick that I believe are true. One is the workers who came to work by boat during the March 1936 flood and had to enter on the second floor, saw stacks of Candlewick on the tables. The other is that, when Carl Uhrmann reported to work, he also saw Candlewick having been produced. What they saw were the five previously mentioned pieces being produced with possibly some trials.

Mr. Carl Uhrmann was responsible for developing the block mould method of making Candlewick so that the mould marks do not show on plates, bowls, etc. (There are moulds marks on the edges of the beads, however, since the top ring had to be separated from the mould when the piece was pressed. Most of these marks disappear when the piece is reheated and finished to shape.) There were, of course, other type moulds used during the production of Candlewick. Perhaps some time, an article can be written covering all these moulds and their operation.

Remember back when we talked about the "Centennial" brochure and that the "stemware" was probably the 400/19 line? Technically speaking, the 400/19 was not a stemware line. It was a tumbler line. It is obvious from records that Mr. Uhrmann and Mr. Newton disagreed on developing a tableware line without something more elegant for the stemware. Until this time, Imperial did *not* employ the "hokey-pokey" system for any of their stemware lines. It was a very expensive production system which employed, at times, 12 skilled and unskilled workers per shop. The "central system", the method used to make the 400/19 ware, used about half that many workers. (Some glass companies may have used different amounts of workers in these shops as there were different systems within these systems.)

There was another reason for the disagreement. Mr. Newton represented Morgantown Glass at his place of business, Earl Newton and Associates in Chicago and had, I believe, a five or six state territory. He was one of, if not *the* top sales rep for Morgantown, many of the years he represented them. He continued to represent them even after he became President of Imperial as part of the agreement. There was a demand for their ware and especially the elegant stemware they made with the hokey pokey process.

In May of 1936 in a conversation with Morgantown, Mr. Newton discussed the idea of putting in a hokey pokey shop at Imperial. Mr. Newton had a question as to whether he should put Imperial into a lead stemware line at the time.

He called Mr. Uhrmann and again discussed the matter with him but finally decided that things should remain the same. Ike Collins was on Uhrmann's side on the matter also. Mr. Newton explained to Uhrmann that he really didn't want to stand in his way to success but he thought they should go along with way they had been. The discussion was closed by Mr. Newton with this statement, "While I am representing Morgantown we are not going into any hokey pokey shops. If we were flushed with finances it would be different."

And so the Candlewick line was introduced at the "Centennial" in mid August, 1936. It must have drawn a lot of attention because as soon as the showing was over, Newton and Uhrmann traveled to New York to try to sell the line to the department stores. This is a quote from Mr. Newton: "The six leading department stores in New York City purchased our Candlewick line. I received no turn down from a single buyer." We know that Marshall Field in Chicago was also one of the first buyers of Candlewick as Imperial had 100 copies of the Marshall Field ad, promoting Candlewick, printed by Jarvis Engraving in October of 1936. Having used up the loan granted in 1935 for the development of the line, and not being able to gain capital, Imperial applied for and was granted a loan in September of 1936 to be used for the express purpose of promotion of sales.

The Candlewick line must have been the shot in the arm that Imperial needed because Mr. Newton predicted sales of all glassware would be 1 million dollars for 1937, almost double what sales had been for 1936! He fell just slight short of his prediction. Other contracts were also instrumental in increasing the gross, but it seems that Candlewick gave everyone incentive.

Whether it was pressure from Mr. Uhrmann or pressure from the department stores or simply a good business move by Mr. Newton, hokey pokey shops were set up at Imperial to produce lead glass stemware to accommodate the Candlewick line in late 1936 and the 3400 line was born. In November of 1936 Mr. Newton gave up his representation of Morgantown Glass. In February of 1937 announced that the stemware was in the showrooms. With the addition to the first effort in lead blown stemware (other lines of stemware were also developed at the time) they made it possible for any store to buy a full line of table glassware from Imperial.

Everyone who collects Candlewick should already know the rest of the story. As the line developed into hundreds of pieces, Candlewick, for many years, became the life sustaining blood of the company and from all indications it continues to be the life blood of hundreds of collectors.

Catalogs and Brochures

Early Imperial catalogs were not dated. A few have been discovered with hand-written dates. However, under close examination, several of the hand-written dates are thought to be suspect; they probably were guesstimates added years later by salesmen or other Imperial employees.

Therefore, none of the dates can be assumed definite. They were attained by comparing Candlewick items offered in the catalogs with Imperial's lists of items-in-production dates.

The following is a list of Imperial catalogs and company bulletins that solely advertised Candlewick Crystal:

1938 — 4 catalog or bulletin pages
1939 — Catalog A
1941 — Catalog B
1943 — Catalog C
1943 — 7 catalog or bulletin pages
1947 — Catalog D
1947 — 2 catalog or bulletin pages
1950 — Catalog E
1957 — Catalog F
1961 — Catalog G
1973 — Lenox purchased Imperial; replaced mould numbers with computer numbers

The small brochures (Imperial called them "pick-ups") were named in CANDLEWICK THE JEWEL OF IMPERIAL Book I for the people who sent the author originals and copies of brochures that advertised Candlewick. These brochures, or inserts, were used by department and jewelry stores to encourage purchasers to enlarge their sets of Candlewick. Each purchaser received a brochure with the Candlewick order, enabling the buyer to see what other pieces were available. These small brochures were also left on counters so customers could "pick-them-up." The brochures changed over the years as various items in the Candlewick line were added or retired from the line. Today, the brochures themselves are sought after and treasured by Candlewick collectors.

Again, most of the brochure dates were determined by the Imperial lists of items-in-production dates.

These are the brochures found by collectors:

1938 — "Lombardo" Imperial Brochure
1940 — Imperial Brochure
1941 — "Abell-Danielson-Newhouse" Imperial Brochure (3 collectors sent the identical brochure)
1944 — "Dungan" Imperial Brochure
1959 — "Dungan" Imperial Brochure
1965 — "Dungan" Imperial Brochure

Candlewick Patents

The history of a pattern would not be complete without delving into its patents. After having spent several days examining the University of Notre Dame's copies of the OFFICIAL PATENT GAZETTE, only a few Candlewick patents were located.

Sources for this chart of patents are

1. Mr. Jerry Monarch, Toledo, Ohio, contributing author for the DAZE newspaper, sent much of the information listed below.
2. OFFICIAL GAZETTE OF THE U.S. PATENT OFFICE, Notre Dame Library, Notre Dame Indiana.

3. Imperial Files

Patent #	Patent Applied For	Patent Received	Mould #	Current Info	Item
100,577	5/19/36	7/23/36	400/74		3-Toed Bowl
100,578	5/19/36	7/28/36	400/5D		8″ Salad Plate
100,579	5/19/36	7/28/36	400/19		12 oz. Iced Tea Tumbler
104,222	7/6/36	4/20/37	400		Lighting Bowl
127,271	3/25/41	5/20/41	400/48	(400/48F)	8″ Tall Footed Compote
128,113		7/8/41	400/100		Twin Candleholder
128,812	5/24/41	8/12/41	400/68		10″ Handled Pastry Tray
130,486	5/24/41	11/25/41	400/35		Handled Tea Cup
131,250	5/24/41	1/27/42	400/63	(400/63B)	10-1/2″ Bowl
133,955	5/28/42	9/29/42	400	(400/152)	Hurricane Lamp Adapter
134,312	6/24/42	11/10/42		(Eagle 777/2)	Candlestick Adapter

The patent pictures (sketches) were the most interesting. Realizing this type of research would take weeks, only the beginning years of Candlewick history were researched in the PATENT GAZETTEs.

In comparing patent sketches to the actual-produced items, several important facts came to light:

- not all items exactly match the produced piece
- sizes are often varied
- number of beads around bowl rims are different
- number of beads on stem can vary (400/48F — 5 bead on patent; produced as 4-bead stem)
- style may be change slightly

Collectors have reported finding 5 beads on stem of 400/48F; however, most have 4-bead stems. Five-bead stems are rare. Counting the beads around the edge of bowls in the patent sketches can be frustrating as they don't match those of the actual pieces; in fact, not all bowls of the same mould number have the same number of beads. This is attributed to the fact that moulds wore out and new moulds were made; sometimes they varied slightly in size and in bead numbers.

Initial Pieces of Candlewick

The Imperial files show that the first pieces of Candlewick were produced in 1936 for Marshall Field and Company of Chicago, the first piece being the 400/5D 8″ Salad Plate. Six different pieces were sent to Field's in late 1936, including a mayonnaise set and 8″ plate.

An article, "History Facts on Candlewick" was found in the notes written by E. C. Kleiner, long-time salesman for Imperial. In his "Facts," Kleiner states:

"First piece of C'wk produced was 400/74B, /74C and /74S 3-toed bowls, measuring 9″, delivered from a joint mould, year of 1933. Mould was made in our mould shop supervised by the late

100.577
DESIGN FOR A BOWL OR SIMILAR ARTICLE
Earl W. Newton, Chicago, Ill., assignor to Imperial Glass Corporation, Bellaire, Ohio, a corporation of Ohio
Application May 19, 1936, Serial No. 62.723
Term of patent 7 years

100.578
DESIGN FOR A PLATE OR SIMILAR ARTICLE
Earl W. Newton, Chicago, Ill., assignor to Imperial Glass Corporation, Bellaire, Ohio, a corporation of Ohio
Application May 19, 1936, Serial No. 62.724
Term of patent 7 years

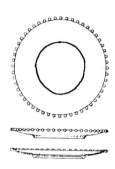

The ornamental design for a bowl or similar article, substantially as shown.

The ornamental design for a plate or similar article, substantially as shown.

100.579
DESIGN FOR A TUMBLER OR SIMILAR ARTICLE
Earl W. Newton, Chicago, Ill., assignor to Imperial Glass Corporation, Bellaire, Ohio, a corporation of Ohio
Application May 19, 1936, Serial No. 62,725
Term of patent 7 years

104,222
DESIGN FOR A LAMP SHADE OR SIMILAR ARTICLE
Earl W. Newton, Chicago, Ill., assignor to Imperial Glass Corporation, Bellaire, Ohio, a corporation of Ohio
Application August 6, 1936, Serial No. 64,278
Term of patent 14 years

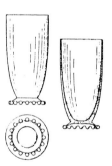

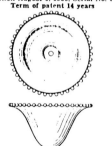

The ornamental design for a lamp shade or similar article substantially as shown.

The ornamental design for a tumbler or similar article, substantially as shown.

Imperial Candlewick Patents

Charles Oldham and since this start was not a thing of beauty delivered from a joint mould, interest was nil. Here it remained until C. J. Uhrmann (Employee in 1936; plant superintendent in early 40's; president of Imperial 1967-1974) arrived on the scene discovering a method whereby C/W could be made in block moulds thereby eliminated all unsightly seams—1937." (from

127.271
DESIGN FOR A COMPORT OR SIMILAR ARTICLE
Carl W. Gustkey, Wheeling, W. Va., assignor to
Imperial Glass Corporation, Bellaire, Ohio, a
corporation of Ohio
Application March 25, 1941, Serial No. 99,872
Term of patent 14 years

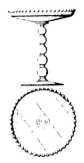

The ornamental design for a comport or similar article, substantially as shown.

128.113
DESIGN FOR A CANDLESTICK OR SIMILAR ARTICLE
Carl W. Gustkey, Wheeling, W. Va., assignor to
Imperial Glass Corporation, Bellaire, Ohio, a
corporation of Ohio
Application May 24, 1941, Serial No. 101,122
Term of patent 14 years

The ornamental design for a candlestick or similar article, substantially as shown.

128,812
DESIGN FOR A PASTRY TRAY OR SIMILAR ARTICLE
Carl J. Uhrmann, Bellaire, Ohio, assignor to Im-
perial Glass Corporation, Bellaire, Ohio, a cor-
poration of Ohio
Application May 24, 1941, Serial No. 101,127
Term of patent 14 years

The ornamental design for a pastry tray or similar article, substantially as shown.

130,486
DESIGN FOR A HANDLED CUP OR SIMILAR ARTICLE
Carl J. Uhrmann, Bellaire, Ohio, assignor to Im-
perial Glass Corporation, Bellaire, Ohio, a cor-
poration of Ohio
Application May 24, 1941, Serial No. 101,126
Term of patent 14 years

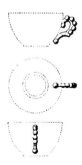

The ornamental design for a handled cup or similar article, substantially as shown and described.

Imperial Candlewick Patents

37

131,250
DESIGN FOR A BOWL OR SIMILAR ARTICLE
Carl J. Uhrmann, Bellaire, Ohio, assignor to Imperial Glass Corporation, Bellaire, Ohio, a corporation of Ohio
Application May 24, 1941, Serial No. 101,125
Term of patent 14 years

The ornamental design for a bowl or similar article, substantially as shown and described.

133,955
DESIGN FOR A HURRICANE LAMP ADAPTER FOR CANDLESTICKS OR SIMILAR ARTICLE
Carl J. Uhrmann, Bellaire, Ohio, assignor to Imperial Glass Corporation, Bellaire, Ohio, a corporation of Ohio
Application May 28, 1942, Serial No. 107,029
Term of patent 14 years

The ornamental design for a hurricane lamp adapter for candlesticks or similar article, substantially as shown.

134,312
DESIGN FOR A CANDLESTICK ADAPTER OR SIMILAR ARTICLE
Carl J. Uhrmann, Bellaire, Ohio, assignor to Imperial Glass Corporation, Bellaire, Ohio, a corporation of Ohio
Application June 24, 1942, Serial No. 107,324
Term of patent 14 years

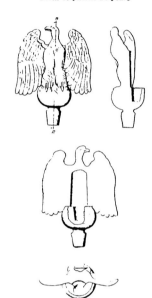

The ornamental design for a candlestick adapter or similar article, substantially as shown.

Imperial Candlewick Patents

Scott's newsletter #43, p. 10)

Kleiner's notes indicate that Candlewick was in the making as early as 1933. To own one of the original seam-obvious 3-toed experimental bowls would indeed make any Candlewick collector happy.

An ad did appear in HOUSE BEAUTIFUL, May 1935, that shows

Candlewick plates (see page 12, CANDLEWICK THE JEWEL OF THE IMPERIAL, Book I).

John J. Boushka, long-time representative for Imperial, spoke at the NIGCS (National Imperial Glass Collectors Society) convention on June 27, 1982. He said that in

> "1936 — the original piece of Candlewick was the dish referred to as the Baked Apple — it was French in design."

Boushka also stated that

> "in due time over 400 pieces were made and that Ralph Boyd (Secretary-Treasurer of Imperial 1904-1947) gave us the #400 after the Boston 400. Mr. Ermine made it all possible for them (Imperial) to handle it (Candlewick)."

He continued with

> "the first Candlewick piece was the mayo set — the bowl. Second was the 7″ plate, and third was the 96 salt and pepper with pressed foot."

This would fit in with what Kleiner said concerning the mayonnaise set. According to Boushka, the mayo bowl was the 400/53X Baked Apple Bowl, which very easily could have been used as the first Candlewick mayonnaise bowl.

The Jewel Tea Connection

Harriett Kurshadt, an historian for the Jewel Tea Company, found the following reference to Candlewick on a 1939 price list:

> #1716 Candlewick Plate 45¢

Harriett states that

> "The item number tells us that the item was a promotional one — offered to our customers for a short period of time — less than 6 months, or until the item was sold out."

Harriett also looked through the next available price lists — 1941 and 1945, but she found no reference to Candlewick.

Candlewick collectors have mentioned the Jewel Tea connection, usually remembering a prized item received. One such collector mentioned the water pitcher received as a premium; another a Candlewick cake stand.

Candlewick Ads

Since the beginning of the rise of Candlewick as a collectible, many collectors have included Candlewick ads as part of their collections. They not only save the Imperial Candlewick ads, any ad showing the use of a piece of Candlewick is also collected. In recent years the desire for advertisement has increased as noted by the constant requests for Imperial ads and cookbooks having pictures with Candlewick being used.

The official Imperial ads are usually found in old popular magazines of the 30's, 40's, and 50's such as the following:

CHINA & GLASS	CROCKERY & GLASS
FAMILY CIRCLE	McCALL'S

GIFT AND ART BUYER WOMEN'S DAY
AMERICAN HOME GOOD HOUSEKEEPING

Many of the Imperial ads were in beautiful color, the ads a work of art. Ad books were found in Imperial's files showing all the different ads used in the following magazines:

BETTER HOMES AND GARDENS HOUSE BEAUTIFUL
HOUSE & GARDEN LADIES HOME JOURNAL
WOMEN'S HOME COMPANION SUNSET
HOLLANDS GUIDE FOR THE BRIDE
THE BRIDES' MAGAZINE GORMET

Also, a special book of ads, called "Advertising Brochures" by Imperial, was given to each employee twice a year to show the advertising campaign that would be used in the above listed magazines. Each book is prefaced with a letter by the president of Imperial to the employees. One set of these ad books (1945-1948) is in the author's collection. There must be many such sets still being saved by former employees and their families. The ad books are 10-1/4″ X 14″ and in full color.

Hundreds of ads have been located by collectors. Many have been categorized by the author, but still many have not been reported. Every old magazine is a wealth of information for ad collectors.

Candlewick advertising has been reportedly found in other places:
- on boxes of cereal
- on old tins
- in many name-brand ads as early as 1939:

Hellman's Mayonnaise (1939) Del Monte
Heinz Borden
Gold Medal Pet Milk
Durkee Certo
Minute Tapioca My-T-Fine
Kool Aid Knox Gelatine
Meadow Gold (ice cream) Hershey
Campfire (marshmallows) Robin Hood (flour)
Kraft A & P
Eatmor (cranberries) Ocean Spray
Jello Cool Whip

Within the past few years, cookbooks with pictures of Candlewick in use have been discovered. Now these books are also being collected. Once Candlewick was discovered in the cookbook, collectors began looking at garage sales and flea markets, and other sources for the inexpensive go-with.

Many such pictures were discovered in the author's own cookbooks, including several books that came with her first refrigerator and stove in 1951. The "ad issue" is leading to an entire new field in Candlewick collecting.

Imperial Ads Found in Magazines

BETTER HOMES AND GARDENS

Dec.	1939	1/8 p., "To Give...To Cherish!"
June	1940	1/8 p., "Give the Bride Loveliness..."
Dec.	1940	Compotes and baskets
Dec.	1940	1/8 p., "'round the clock with..."
May	1941	p. 153, 1/8 p., b&w, "Treasure For the Table"
Dec.	1941	p. 64, 1/4 p., b&w, "Gifty...and Thrifty!"
May	1942	p. 89, 1/8 p., b&w, "Exciting! New! Beverage Sets!"
April	1943	1/8 p., "Sandwich Server"
Nov.	1944	p. 72, 1/4 p., b&w, 400/114A sectioned bowl
June	1945	1/4 p., "Party Time"
Nov.	1945	1/4 p., b&w, "for your most perfect dinners..."
March	1946	p. 76, 1/4 p., b&w, gingerbread cookies
June	1946	p. 141, 1/4 p., b&w, "Resplendent crystal...appetizing salads.."
Sept.	1946	1/4 p., buffet table set-up, 400/103D Cake Plate
Dec.	1946	1/4 p., b&w, dessert plate setting
March	1947	p. 204, 1/4 p., b&w, shows 400/132 Rose Bowl
May	1947	p. 205, 1/4 p., b&w, place setting with salad
Oct.	1947	p. 274, 1/4 p., b&w, "...like a crisp salad..."
June	1948	p. 110, 1/2 p., b&w, "Count on Candlewick For Good Party Support!"
Oct.	1948	p. 253, 1/2 p., b&w, "Your table reflects...gracious... dining.."
Dec.	1948	p. 130, 1/2 p., b&w, "Gifted with Beauty Start-Her Set."
April	1949	p. 257, 1/2 p., b&w, "Easter Dinner Family Style"
Nov.	1949	p. 198, 1/2 p., b&w, "The Perfect Gift...Christmas or any-time"
May	1950	p. 224, 1/2 p., b&w, "Imperial Candlewick Sets the Scene For.."
Oct.	1950	1/4 p., "Right Cue for Entertainment!"
June	1951	
Oct.	1951	p. 312, 1/4 p., b&w, "Table Treasures"
April	1952	p. 182, 1/4 p., b&w, "Brilliant...Every Day"
May	1953	p. 224, 1/2 p., "Partners for Life..."
Nov.	1953	p. 152, 1/2 p., Candlewick/Cape Cod, green wreaths only color
Dec.	1954	p. 115, 1/2 p., b&w, "Holidays and everyday..."
May	1954	1/4 p., "Reflecting Beauty..."
May	1955	p. 142, 1/4 p., b&w, "For Now and Tomorrow..."
Nov.	1955	p. 104, 1/2 p., b&w, "Chosen by Women..."
Dec.	1955	p. 104
March	1956	p. 124, 1/2 p., "For Discriminating Women"

April	1957	1/2 p., in color, water pitcher, 400/19 tumblers — iced tea
Oct.	1957	1/2 p., in color, "Choice of Every Smart Hostess"
May	1958	1/4 p., b&w, "America's Most Wanted Handcrafted Pattern"
Nov.	1958	p. 48, 1/4 p., b&w, place setting
? ?		p. 224, "Buffet Style"
Nov.	?	full page, "Plan Early For Christmas Selling"

HOUSE BEAUTIFUL

Oct.	1942	1/4 p., "Choose and Cherish"
May	1943	1/4 p., "For the Heart of the Well-Dressed Home"
June	1943	full page, combined ad with Theodore Haviland & Co.
March	1946	full page, b&w, "My Candlewick Makes The Table Perfect"
March	1947	full page, "For Every Occasion Imperial Candlewick"
Oct.	1947	full page, b&w, "Dinner at Eight"
May	1948	full page, in color, "Imperial Candlewick Start-Her Set"
Nov.	1948	(or Dec.?) full page, "Christmas Loot for Connoisseurs of Crystal"
Jan.	1949	full page, "First Picture...Valley Lily"
June	1950	full page, "Table Trousseau Treasures", in color
June	1952	full page, Candlewick and Cape Cod
April	1954	1/2 p., "Distinguished for sparkling beauty..."
Nov.	1954	1/2 p., "choose table glassware..."
Oct.	1955	full page, "Candlewick and Music..."
May	1956	full page, "Morning — Noon — Night"
April	1957	full page, "Liveable — loveable — giveable — "
Nov.	1958	full page, Candlewick and Cape Cod
May	1959	full page, "'round the clock — 'round the calendar"
April	1968	(or 58?) 1/2 p., in color, "Imperial Elegance in Crystal or..."
Fall?	?	p. 18 (Xmas items on back of ad)

HOUSE AND GARDEN

May	1943	p. 110, 1/4 p., "For The Heart of the Well-Dressed Home"
Dec.	1943	1/2 p., b&w, "Crystal For Christmas"
June	1944	full page, in color, "Informal Terrace Buffet"
Nov.	1944	
June	1945	full page, in color, "Crystal Cooler" — water pitcher /19 tumblers
Nov.	1945	full page, in color, "Magic at Mealtime"
April	1946	full page, b&w, "Festive Twosome" — dinner setting for two
June	1946	p. 44, full page, "She Fell in Love With Candlewick", in color
Oct.	1946	p. 64, full page, "Morning — Noon — Night"
Nov.	1947	full page, b&w, "The Season's Candlewick Best!"
Nov.	1947	full page, in color, "For Family Feasting"
March	1948	full page, in color, "Beauty and the Feast"

June	1948	full page, in color, "Love Match," playing tennis
Oct.	1948	
July	1949	Floral Cut #279
Aug.	1949	p.1, full page, b&w, Floral Cut Pattern
Oct.	1949	
May	1950	
Oct.	1950	full page, in color, "Starring Candlewick Crystal"
April	1951	p. 156, 1/2 p., b&w, "Show Her With Candlewick"
Nov.	1951	p. 241, 1/2 p., b&w, "Candlewick The Perfect Gift Christmas..."
Oct.	1953	H&G? full page, in color, "Always in Good Company"
?	1958	full page, in color, "Morning — Noon — Night"
?	1959	full page, in color, "Sparkling Candlewick Crystal"

LADIES HOME JOURNAL

May 1	1940	1/8 p., b&w, "Glamour in Glass"
July	1940	1/8 p., b&w, "Always in Good Taste..."
Nov.	1940	1/8 p., "For the Place of Honor..."
April	1941	1/8 p., b&w, "A Masterful Medley in Crystal"
June	1941	1/8 p., b&w, "The 'Bride' Idea in Crystal"
Oct.	1941	1/8 p., "Your Table Needs..."
Nov.	1941	1/8 p., "Smart — for the Heart of Your Home"
Dec.	1941	p. 152, 1/4 p., b&w, "For a Cordial Crystal Christmas..."
May	1942	1/8 p., "Breakfast With Imperial Candlewick"
June	1942	1/8 p., b&w, "Salad Setting"
Nov.	1942	p. 149, 1/4 p., "Design Beautiful..."
Dec.	1942	1/4 p., "...for year'round cheer"
May	1943	p. 133, 1/4 p., b&w, "Dedicated to Better Living"
June	1943	p. 149, 1/4 P., 400/190 Seafood Cocktails
Oct.	1943	p. 172, 1/4 p., b&w, "Our apologies...not included"
Oct.	1944	p. 144, 1/4 p., shows bowl of fruit and 400/28C Vase
Dec.	1944	p. 109, 1/4 p., shows pair of 400/152 lamps
June	1945	p. 126, 1/4 p., b&w, "Too refreshing for words..."
Aug.	1945	1/4 p., b&w, "Crisp salads served on handcrafted Candlewick..."
Dec.	1945	p. 130, 1/4 p., b&w, "Holidays — and dinner guests!"
April	1946	1/2 p., b&w, "Imperial Candlewick...living room" with Cape Cod
June	1946	p. 117, 1/2 p., b&w, Candlewick and Cape Cod
Aug.	1946	
Oct.	1946	p. 162, 1/2 p., b&w, "Smart For the Heart of Your Home"
Dec.	1946	1/2 p., b&w, 2 Christmas wreaths/Candlewick and Cape Cod
May	1947	p. 16, 1/2 p., b&w, "On your dining table..."
Oct.	1947	p. 16, 1/2 p., b&w, "Crystal, clear beauty..."
Nov.	1947	p. 110, 1/2 p., b&w, "...is your type of crystal..."

May	1948	p. 203, 1/2 p., b&w, "The Beginning of a Beautiful Friendship"
Nov.	1948	p. 107, 1/2 p., b&w, "The family coming home..."
May	1949	p. 122, 1/2 p., b&w, "...Is So Engaging!"
Oct.	1949	p. 134, 1/2 p., b&w, "Halloween is Party Time..."
Nov.	1950	
Nov.	1951	p. 155, 1/4 p., b&w, "Dine in Radiant Elegance"
Nov.	1952	1/2 p., "Invitation to Cordiality!"
Nov.	1952	p. 106, 1/2 p., b&w, "...for your table beautiful"
June	1953	p. 25, 1/2 p., b&w, "...'round the clock — 'round the calendar"
?	?	p. 70, 1/8 p., "As informal as a neighborly greeting..."
?	?	1/4 p., "Gifted with Beauty Start-Her Set"
?	40's?	1/4 p., "Crisp salads served on handcrafted Candlewick..."
?	?	1/4 p., large salad on table/many flowers around corner of table
?	?	1/4 p., "Crystal Gazing"

AMERICAN HOME

| Oct. | 1945 | 1/4 p., b&w, "It's not what you serve...but how..." |
| March | 1951 | p. 13, 1/4 p., b&w, "American Artistry in Crystal" |

CHINA AND GLASS

| Aug. | 1942 | full page, "Now — a Complete Merchandising Program..." |
| Aug. | 1942 | 1/2 p., 4 sets Eagle candleholders |

CROCKERY AND GLASS

| Sept. | 1942 | full page, "For Candlelight Time!" |
| Nov. | 1942 | full page, "Gifts in Imperial Candlewick" |

GIFT AND ART BUYER

| Oct. | 1942 | full page, "Gifts by Imperial", includes 1776/5 Federal Mirror |

GORMET

Aug.	1945	p. 32, 1/4 p., b&w, "It's just cool reasoning..."
Dec.	1945	1/4 p., b&w, "Spirit of hospitality..."
Feb.	1946	1/4 p., b&w, "...graces the living room..."
April	1946	1/4 p., b&w, "Friendly hospitality goes with... Candlewick..."

GUIDE FOR THE BRIDE

| Fall | 1942 | full page, "Now — A Complete Merchandising Program..." |
| Autumn | 1947 | full page, in color, "For Family Feasting" |

| Summer 1948 | | full page, in color, "Imperial Candlewick Start-Her Set" |

HOLLANDS

Sept.	1945	1/4 p., b&w, "Your living-room is the 'heart-of-your-home'"
Nov.	1945	1/4 p., b&w, "As versatile as you are..."
March	1946	1/4 p., b&w, "The salad proves the ...skill...chef..."

LIVING FOR YOUNG HOMEMAKERS

| March | 1958 | 1/2 p., "...Choice of Every Smart Hostess" |

SUNSET

| Nov. | 1945 | 1/4 p., b&w, "Drink your toast to 'better days to come...'" |

THE BRIDES' MAGAZINE

Nov.	1945	full page, in color, "Magic for Mealtime"
May	1946	Spring issue, full page, in color, "She fell in love... Candle."
Spring & Summer	1947	p. 81
Winter	1947	full page, in color, "For Family Feasting"
Summer	1948	full page, in color, "Love Match," playing tennis

WOMEN'S HOME COMPANION

Feb.	1948	p. 112, 1/2 p., b&w, "When Hearts Are Trumps"
Aug.	1948	p. 80, 1/2 p., b&w, "Sets the Scene for Gay Hospitality!"
Nov.	1948	p. 179, 1/2 p., b&w, "To The Teen's Taste"
May	1952	1/4 p., "Candlewick Serves You Right"
Oct.	1953	p. 69, 1/2 p., b&w, "Start With a Little...Then Add..."

Imperial Candlewick Moulds

During the 1983 liquidation of Imperial's holdings, all the moulds were sold to anyone who entered the Imperial factory and wanted to buy them. The moulds were sold indiscriminately; no records were kept of the sales. Many of the Candlewick moulds have been traced, and the National Imperial Glass Collectors Society is keeping a record of all the Imperial moulds that are located.

Now that new Candlewick is being produced by Dalzell-Viking of New Martinsville, West Virginia, it is imperative that collectors know just where the Candlewick moulds are. The following list is what is currently known of the moulds:

NIGCS -

| 400/650 | Square Ash Tray Set, 3 pc. |
| 400/651 | 3-1/2" Ash Tray |

| 400/652 | 4-1/2" Ash Tray |
| 400/653 | 5-3/4" Ash Tray |

- Summit Art Glass Co. -

| 1950/170 | Low Leaf Candleholder, single cup. |

The NIGCS has used this mould several times for convention souvenirs. It is the 400/170 Candleholder with variations.

- Collector in Bellaire, Ohio -

Calendar

- Mrs. Anna Maroon, owner of the Imperial plant property owns the 21 moulds listed below. Whether or not she owns more of the moulds is not known at this time.

400/59	Candy Box and Cover
400/68D	11-1/2" Pastry Tray
400/87?	Fan Vase (7" or 8"?)
400/90	5" Handled Candleholder
400/103	Cake Stand/Fruit Bowl
400/110	7" Partitioned Candy & Cover
400/115	3-lite (Bar) Candleholder
400/120	8-1/2" Crescent Salad Tray
400/144	Round Butter Dish and Cover
400/154	Deviled Egg Tray
400/161	1 lb. Butter and Cover
400/169	Gravy Boat and Underplate
400/231	5" Square Bowl
400/232	6" Square Bowl
400/233	7" Square Bowl
400/234	7" Square Relish
400/245	6-1/2" Round Candy Box & Cover
400/259	7" Shallow Candy Box & Cover
400/450	3 pc. Round Ash Tray Set 133, 150, 440

- Boyd's Crystal Art Glass of 1203 Morton Ave., Cambridge, OH, owns 18 Candlewick moulds, although one is not actually Candlewick but has been adopted by collectors. Boyd's is using all the moulds it owns in the Candlewick lines. Their wares consist of limited editions, made in pastel slag colors never used by Imperial in the production of Candlewick. All are marked with B in a diamond. The 1776 Eagle Ash Tray and Eagle Goblet Cigarette Holder although not Candlewick, have been adopted by Candlewick collectors.

400/19	2" Ash Tray, 11 beads
400/33	4" Jelly Dish
400/42B	4-1/2" Handled Bowl
400/64	Nut/Sugar Dip
400/78	4-1/2" Spoke Center Coaster
400/96T	5" Tray for salt and pepper
400/118	B'tween Place Ash Tray
400/134	Cigarette Box and Cover

400/134/1	4-1/2″ Oblong Ash Tray
400/170	3-1/2″ Candleholder
400/172	4-1/2″ Nut Heart
400/173	5-1/2″ Nut Heart
400/174	6-1/2″ Nut Heart
	Above 3 are 400/750 Nested Set
400/176	3-1/2″ Square Ash Tray
400/226	Coaster with Spoon Rest
400/264	Bowl part of Hurricane Lamp
400/287C	6″ Crimped Fan Vase
1776/1	Eagle Ash Tray, 6-1/2″, and Goblet Cigarette Holder (not Candlewick)

- The greatest number of moulds are owned by Mirror Images of Lansing, Michigan. Mirror Images' moulds, numbering over 200, are stored in the basement of the Dalzell-Viking factory. This is a partial listing of their moulds:

400/1D	6″ Bread/Butter Plate
400/10D	10″ Dinner Plate
400/19	Juice Tumbler
400/19	Muddler
400/20	Punch Bowl
400/35	Tea Cup
400/37	Coffee Cup
400/40/0	6-1/2″ Handled Basket
400/53X	6-1/2″ Baked Apple
400/63	5″ Ice Tub
400/67D	10″ Low Cake Stand
400/75B	Salad Bowl/Underplate
400/75	Fork and Spoon
400/77AD	Demi-Cup and Saucer
400/89/3	Marmalade Set, 3 pc.
400/100	Double Candleholder
400/122/29	Cream, Sugar, Tray
400/128	Punch Bowl
400/130	Ladle, Marmalade 4-3/4″, 3-bead handle
400/147	Candleholder, 3-lite
400/156	Covered Mustard
400/165	Ladle, Mayo, 3-bead handle
400/168	7″ Ice Tub, 2 tab handles
400/190	Cordial, 1 oz.
400/196	Epergne Vase
400/276	California Butter
400/1989	Marmalade Set, 3 pc.
*777/1	Eagle, Peg
*777/3	Eagle Base
3400	Goblet

3400	Cordial, 1 oz.
3400	Sherbet
3800	Cordial
4000	Cordial, 1-1/4 oz.
400	Electric Shade

O. J. Scherschligt, owner of Mirror Images, said he also has the moulds for the following pieces:

— all 3400 line
— all 400/19 tumblers
— all cordials in all lines
— various small spoons
— various lids
— all large plates
— all blown lamp shades

*The two eagle items are not Candlewick. The eagle itself has been adopted by collectors because it was made by Imperial and fits into all Candlewick candleholders. The "base" is a bookend into which the peg eagle is inserted.

With Mirror Images over 200 moulds, Maroon's 21, NIGCS 3, and Boyd's 18, 242 moulds are specifically accounted for. However, we must also realize that many of the moulds were used to make several different pieces of Candlewick. The 400/51 series of dishes were all made from the same moulds; at least six different items were made from the one mould. The same with the 400/40 series of candleholders and also the 400/66 candleholders. When one considers these and the many bowls and plates produced from the identical moulds it is obvious that the owners of these particular moulds have far greater control of any future use of the moulds than most collectors realize. It would be quite a task to figure the exact number of moulds Imperial needed to make its entire line of Candlewick.

Several moulds are known to be in the hands of individual collectors. Perhaps the majority of Imperial's Candlewick moulds have been located. Nothing has come of the rumor that a West German firm has some of the moulds. It is known that the firm was interested, but no proof has surfaced that they actually did purchase any of the moulds.

The importance of knowing where the moulds are located is so collectors can be alerted to any new pieces that are found in the marketplace and then pass the word to other collectors. Knowledge is the best protection against purchasing reproductions and/or look-alikes.

*Note: Some moulds, according to former Imperial Glass Company employees were never replaced. Others, like the 400/5D 8" Salad/Luncheon plate, were replaced on an average of three times a year. The 400/5D 8" Plate was the most often produced item. It was made from 1937 to 1984, nearly the entire lifetime of Candlewick production.

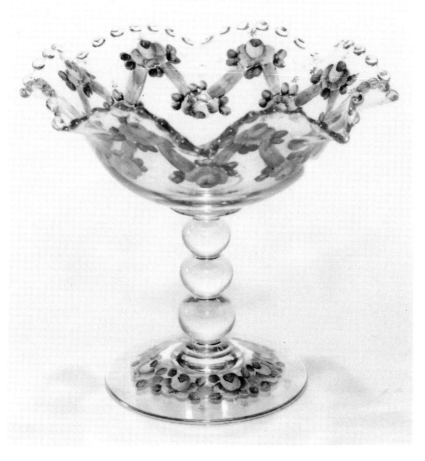

400/103C 10″ Fruit Compote
Hand painted roses and ribbons

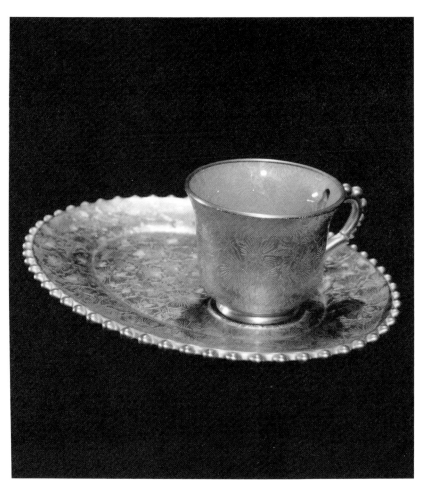

Gold-On-Glass
400/98 2 pc. Party Set, Wild Rose Etch

Ruby Candlewick

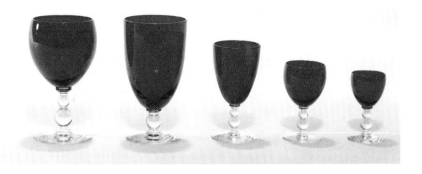

3800 Series Stemware: Goblet, 12 oz. Tumbler, Claret, Wine, Cordial

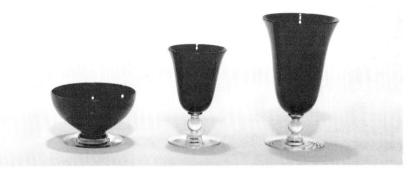

3400 Series Stemware: Finger Bowl, 5 oz. Tumbler, 12 oz. Tumbler

1984 "Save Imperial" Commemorative Red Brick, 4″ long,
400/122 Individual Sugar and Cream

400/72 8-1/2" Bowl
Courtesy of Mr. and Mrs. James Hampton, St. Petersburg, FL

Ruby Candlewick

400/62B 7″ Bowl

400/68D 12″ Pastry Tray

3800 4 oz. Tall Sherbet with platinum covered stem and foot

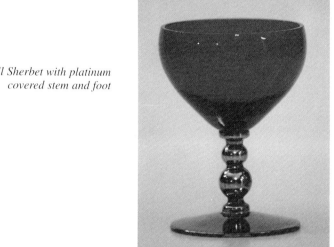

Miniature Hurricane Lamp using 400/279 6 oz. Cruet

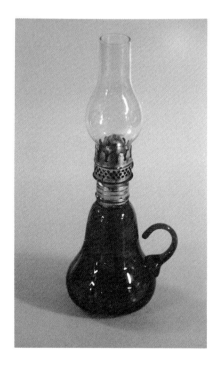

Pictures courtesy of Fran and Larry Lodenstein

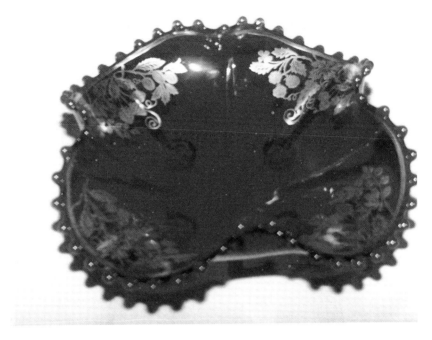

400/74SC Fancy, Square, Crimped Ruby Bowl with Sterling Silver Decoration

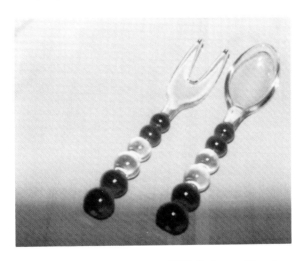

400/75 Fork and Spoon Set with flashed-on red beads

Pictures courtesy of Jane Miller, Schererville, IN

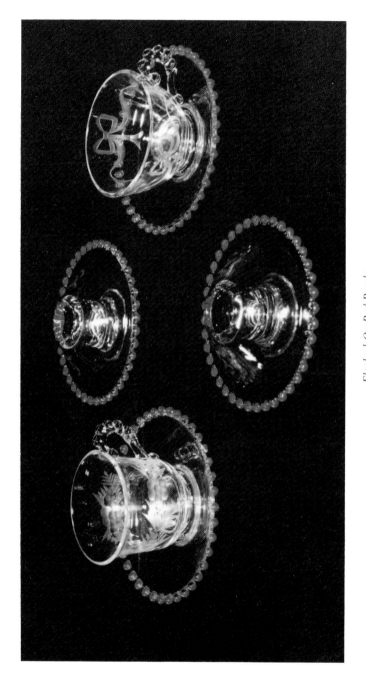

Flashed-On Red Beads

400/35 Tea
Cup and Saucer
Bow Cutting

400/86 Mushroom
Candleholders

400/37 Coffee Cup and Saucer
Floral Cutting

Black Candlewick

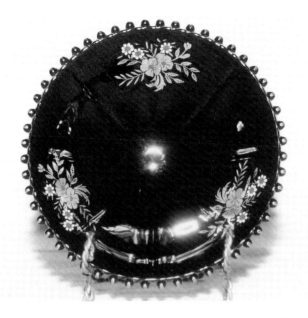

400/74B 8″ 4-Toed Bowl with enameled gold, white, and red floral design
Courtesy of Donna Wise, Mt. Pleasant, Iowa

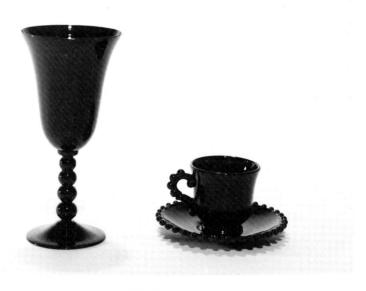

3400 Goblet
400/77AD After Dinner Cup and Saucer

Black Candlewick

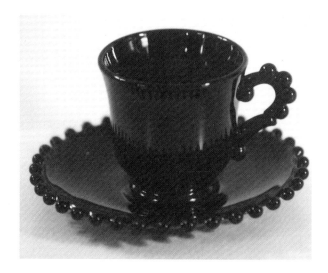

400/77AD After Dinner Cup and Saucer

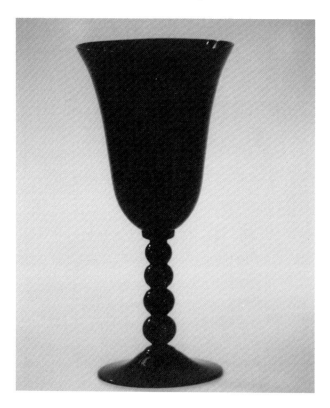

3400 Water Goblet

Pictures courtesy of Fran and Larry Lodenstein

Black Candlewick

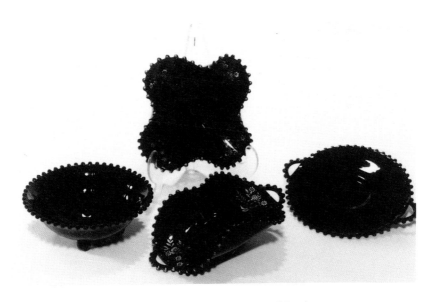

400/74SC Fancy, Square, Crimped Bowl
400/74B 8″ Bowl *400/62D 8-1/2″ Plate*
400/52E 7″ Plate

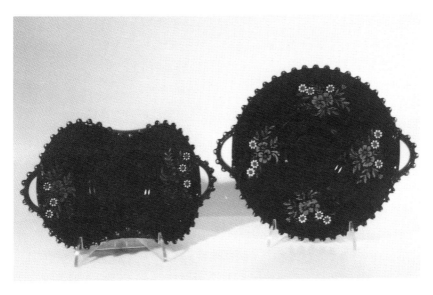

400/52E 7″ Plate *400/52D 7″ Plate*
Pictures courtesy of Fran and Larry Lodenstein

Candlewick Blues

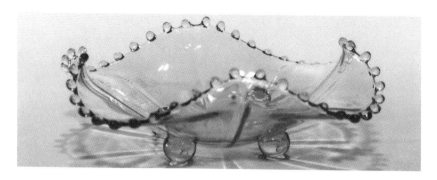

400/74SC Fancy, Square, Crimped Bowl in Viennese Blue

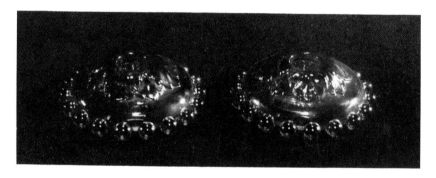

*1978 Convention Candleholder Souvenir, "Low Leaf" pattern,
Ultra Blue Carnival, IG mark, 300 made*

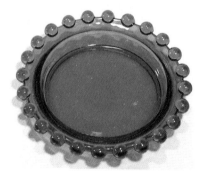

*400/150 6″ Ash Tray
Cobalt Blue*

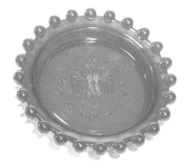

*400/150 6″ Ash Tray
WWII center — eagle on ball with
12 stars*

Carmel Slag

400/256 10-1/2″ Oval Relish

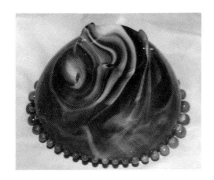

400/182 3-Toed Bowl, 8-1/2″
View from bottom

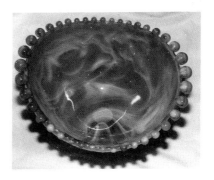

400/182 3-Toed Bowl, 8-1/2″
View — looking into bowl

Pictures courtesy of C & L Antiques, Sarasota, Florida

1994 Imperial Convention Carmel Slag Display

Back to front: 400/145C 12" 2-H Crimped Tray, 400/145D 12" 2-H Plate, 400/52B 6-1/2" 2-H Bowl, 400/52D 7-1/2" 2-H Plate,

Colored Stemware

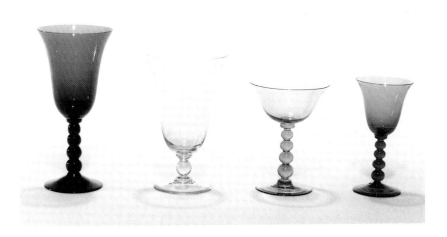

3400 Stemware
Nut Brown Goblet, Sunshine Yellow 10 oz. Tumbler, Verde Champagne,
Ultra Blue Wine

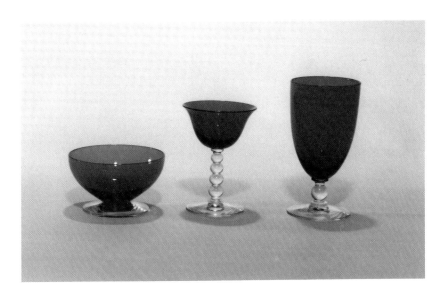

Ritz Blue Stemware
3800 Finger Bowl, 3400 Cocktail, 3800 12 oz. Tumbler

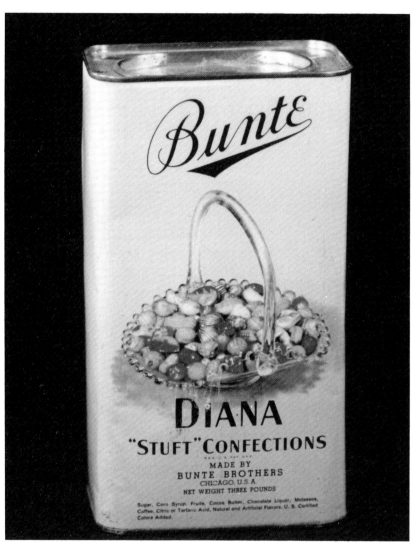

*Bunte Brothers Candies Tin Container, 5-1/2″ high; 400/40/0 Candlewick Basket
filled with Christmas candy on 2 sides*

Ash Trays

5 pc. Gold-Beaded Ash Tray Set
Imperial Matchbooks

400/150 6″ Ash Tray

400/550 colored Nested Ash Tray Set

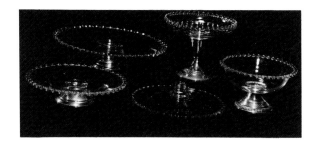

Pegged Bowls and Plates

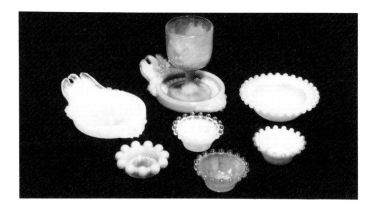

Boyd's Glass Company Candlewick

Annual Bellaire, Ohio Glass Festival Souvenirs:
1973 — frosted; 1974 — blue; 1975 — green; 1976 — milkglass; 1977 — amber

Community Plate "Ballard Set" with 400/49H 5″ Heart

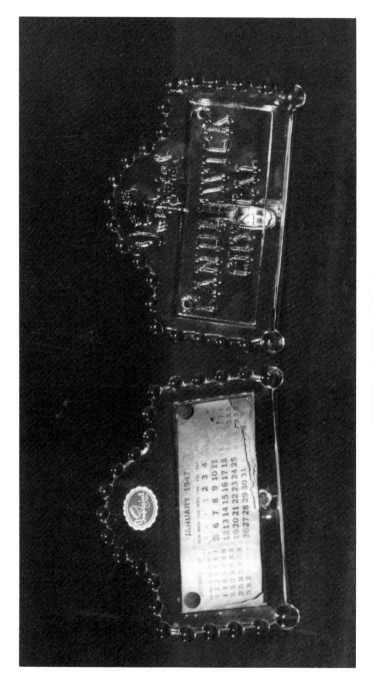

1947 Candlewick Desk Calendar
Candlewick Crystal Desk Sign or Calendar — note holes to connect calendar

#701 Spoon and Fork Set, 9" (early)

Right: 400/64 2-3/4" Nut Cup
Left: Confusing Similarity — no inside ridge, wider than
400/64, beads not defined

400/96 Green Atomizer, 400/247 Aquamarine Salt
400/96 Crystal Atomizer, Flower perfume dispenser

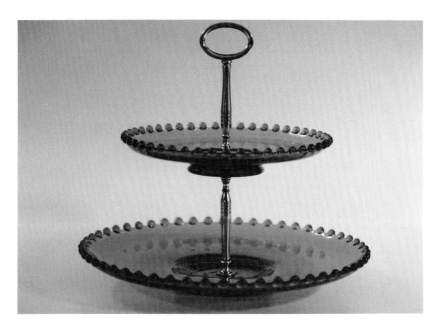

400/2701 Emerald Green Tid-Bit

From the collection of Fran and Larry Lodenstein, Kentwood, Michigan

Desk Mirror and Picture Frame made for IRICE Company

Perfume Bottle and Puff Jar made for IRICE Company
Starlight Cutting #108

400/29 Sugar and Creamer with attached Sterling bases

Candlewick and Sterling

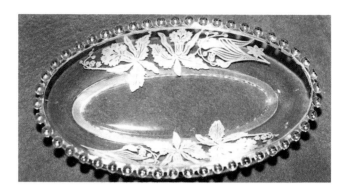

400/58 8-1/2" Oval Pickle-Celery Tray
Sterling Silver Orchid pattern

Note "Sterling" in the stem

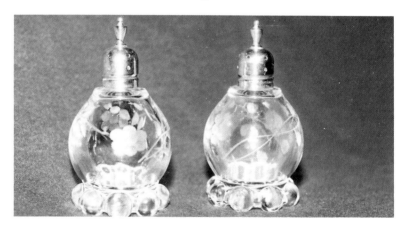

400/96 Salt and Pepper Set
Sterling Silver tops
From the collection of Gerry Reeve, Tipton, Iowa

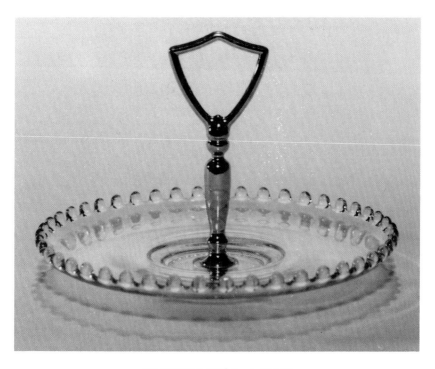

400/270TB 7-1/2″ Single Tid-Bit

3800 Goblet
Optic pattern

400/19 14 oz. Beer Stein
Free-form handle

400/24 80 oz. Water Pitcher
Saved from destruction during Imperial's
bankruptcy sale (to show cutting)

3400 Goblet, Etched and Gold
Decorated

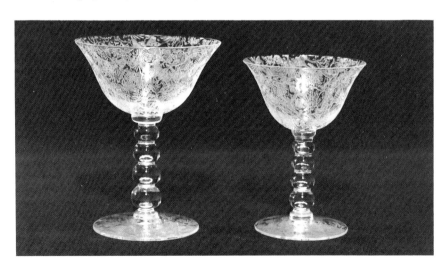

3400 Saucer Champagne and Cocktail in wild rose etch

Decorated Candlewick

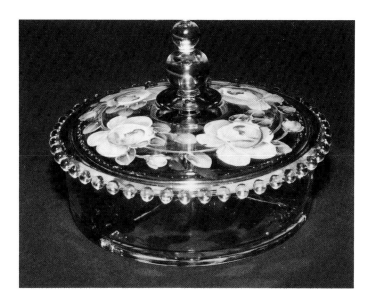

400/110 Covered Candy Box, partitioned. Hand painted roses. Courtesy of Connie Rogers, Cincinnati, Ohio

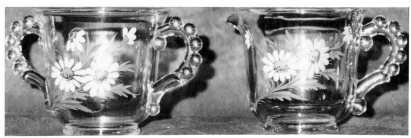

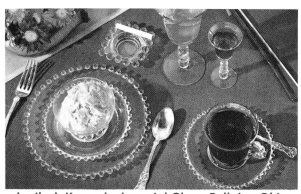

Above: 400/30 Sugar and Creamer, old style Hand painted daisies. Courtesy of Lynn Geary, North Hampton, NH

Lucile J. Kennedy, Imperial Glass, Bellaire, Ohio

GO-WITH
Business card of former Imperial Marketing Manager, Lucile J. Kennedy

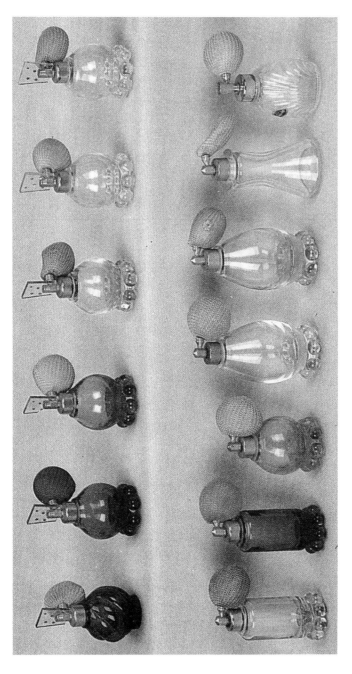

Top Row: 400/96 Shakers in amethyst, green, aqua, and yellow

Bottom Row: 400/247 Shakers in aqua and amethyst 400/96 Shaker in amber 400/167 Shakers in crystal and aqua

Acknowledgment:

Courtesy of GLASS COLLECTOR'S DIGEST, with permission from D. Thomas O'Connor, Editor. Article by Kathy Hamilton,
April/May issue, 1988. For more information see Chapter 8, DeVilbiss Atomizers

Lamp Shades

Candlewick Wall Fixture
400/1A Oval Shade Cut #800

 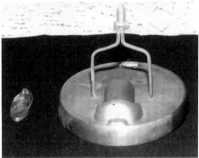

Pictures from Lois Quale, Stoughton, Wisconsin

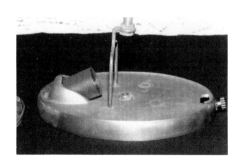

G107 Shade
5″ diameter, 2-1/2″ high

Candlewick Ceiling Fixture

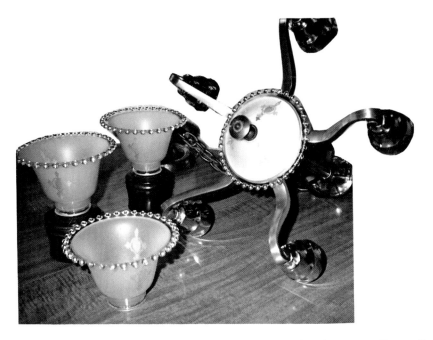

G107 Candlewick shades and Candlewick chandelier plate on ceiling fixture (see Chapter 8)
From the collection of Marlene Bagstad, Minneapolis, MN

Candlewick Shades

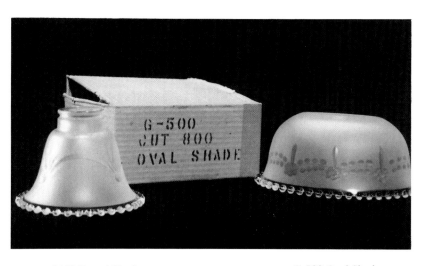

G107 Round Shade *G-500 Oval Shade*

Confusing Similarities

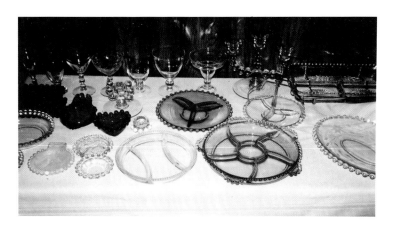

Grouping of look-alikes
Picture taken at a Candlewick Seminar at Fran and Larry Lodenstein's,
Kentwood, MI, 1994

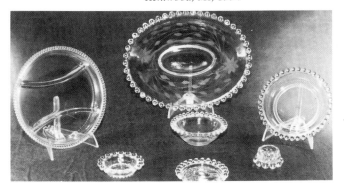

Various Candlewick look-alikes

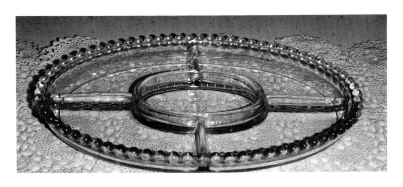

Relish: 13-1/2″ long, oval center 5-1/2″
From the collection of Mary Kinch, Armada, Michigan

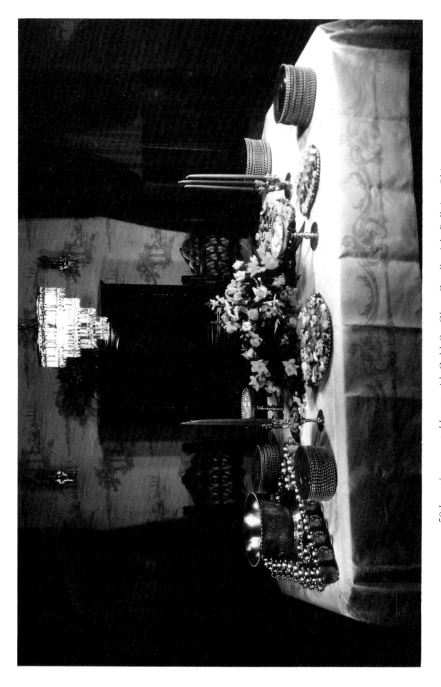

50th anniversary table set with Gold-On-Glass Candlewick, Bellaire, Ohio

CHAPTER 4

INTRODUCTION TO CANDLEWICK COLOR

Colored Candlewick Crystal is in great demand in the 1990's. Imperial occasionally made items of crystal Candlewick in gold, red, blue, black, and carmel slag. Other colors were used, but the five aforementioned colors are the most desired — and the most expensive. Gold-on-Glass items top the most-expensive list, with the punch sets commanding approximately $4,000.00 and more depending on the number of pieces in the set. Ruby Red crystal items are truly a sight to behold, with the larger pieces, i.e. center-handled trays, bringing $250 - $350 and often more. Black Candlewick items, some with enameled decorations, are priced in the $125 to $250 range; however, a few have been found to carry price tags of $500 - $600. A black 3400 goblet (4-bead stem) was sold at auction in 1993 for $200. Carmel Slag pieces usually start at about $100.

Out of the over 600 items produced by Imperial in the Candlewick Crystal pattern only a fraction were ever made in color. As currently known, only 42 different Gold-on-Glass pieces have been discovered, 53 Ruby Red (23 are stemware), 17 black, and 11 in Carmel Slag.

Colored Candlewick is usually at the top of the WANT LIST for collectors. Many colors were used during the production of Candlewick Crystal:

Viennese Blue	Sunshine Yellow	Antique Blue
Ruby Red	Ultra Blue	Cranberry
Ritz Blue	Nut Brown	Emerald Green
Aquamarine	Champagne	Verde Green
Bead Green	Flask Brown	Heather
cobalt	Carmel Slag	amethyst
gold	black	

Blue (#75), Amber (#40), and Pink (#65) were used for the 400/550 Ash Tray Set.

Many of the colors, such as those used for the 3400 stemware from 1977 until 1979 — Ultra Blue, Nut Brown, Sunshine Yellow, and Verde Green, are not being dealt with here as they have been discussed in Book 1 of CANDLEWICK THE JEWEL OF IMPERIAL. Only the most desirable and most sought after colors will be discussed here: Ruby, blue, black, gold, and Carmel Slag. In the late 1970's and early 1980's collectors in general were not yet aware of these very special colored pieces made by Imperial.

Dating colors is difficult, especially since Imperial's records, since bankruptcy, are thought to mostly be in the hands of collectors. Even then, in the formative and early years of many companies, record-keeping did not seem as important as it does to today's collectors. Collecting has become more refined — a science. Collectors want to know everything there is to know about their collectibles.

Mr. Carl Uhrmann, president of Imperial Glass Corporation during the 1930's, and credited with the development of the Candlewick design, noted

that pieces of Candlewick Crystal that have the amber tint were made prior to 1939. Ones with bluish tint, he stated, were produced after 1939.

Collectors must not confuse these hues or tints with the definite color used in the production of some Candlewick pieces.

More information comes from the notes of E.C. Kleiner, a long-time salesman for Imperial. From his "History Facts on Candlewick" we have the following:

"In 1936, 3800 stemware was introduced consisting of eleven pieces, made in all crystal, dropped in 1943 in favor of 3400. Under the direction of E. W. Newton, duplicated from a shape made in France, for Marshall Field and Co., Chicago, Ill. Color combinations were made. Ritz Blue bowls with crystal stems and feet. Also ruby bowl with crystal stems and feet. These color combinations sold well for a long time and finally fizzled out about the year 1945."

The following information, obtained from Imperial's files, was taken from Virginia Scott's newsletter, The Candlewick Collector, #48, p.6:
"Jan. 1, 1951

400/18 5 pint pitcher, colored foot	$54 per dozen
400/19 12 oz. tumblers, colored foot	$10.80 per dozen

The above items are available in :
> Crystal Bowl with Bead Green foot
> Crystal Bowl with Flask Brown Foot
> Crystal Bowl with Heather Foot

These items are not here offered as sets. Build your own on your orders or have the customers compose them.

These colored foot CANDLEWICK items are here offered as a SEASONAL SPECIAL for timely summer retailing.

They will be made only in the first half of 1951 and as of 7/1/51 will be withdrawn from production."

Many collectors have reported finding these pieces with the colored-bead foot.

No doubt there are pieces and color variations yet to be uncovered by determined collectors. However, all that has been reported, since the publication of CANDLEWICK THE JEWEL OF IMPERIAL, Book 1, is listed in this chapter and also in Chapter 9.

Candlewick Gold

GOLD — the desire for it — has been considered the downfall of many. According to prices obtained for gold and gold-trimmed Candlewick, it may well be the same for some Candlewick collectors.

There are many bits of information that will be shared with the collector here, but the main focus will be the Gold-On-Glass Candlewick.

Many Candlewick pieces were decorated with gold: gold bands, gold beading, and gold floral designs among them. According to Sira Ramos, from Florida, as reported in Scott's newsletter #76, speakers at the 1992 NIGCS Convention, former Imperial employees, stated that "all free hand decoration

Plate covered with gold — engraved eagle in center. Courtesy of Virginia Scott

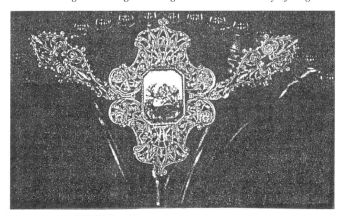

400/87 Fan Vase
Gold decorations only on front of vase.

Base decoration, with three little legs,
goes all around bottom

Courtesy of Darlene Lyon, Woodward, OK

was done at Imperial, including the gold.

"Gold work was dull when applied and was finished with a special chemical from England. It was then fired at 98 degrees. If the process was not done correctly, the gold would melt the glass.

"Gold punch bowl and snack sets were made on special order. 2 coats of gold were applied which made it hard to shine them...

"Gold bead work was difficult to work with because liquified gold was used. Not much was put on Candlewick. Gold etching was done mostly in the late 30's."

A very unique fan vase has been found by a collector in Woodward, OK. It is an overlay gold pattern pre-cut and made to adhere to glass, both at the top and foot of the vase. Items such as this vase are particularly attractive to the collector.

An Imperial brochure dated December 28, 1948, advertised "Hand Fired Bright Gold" sets, and "each set is gift packed in a plastic gift box." These pieces were decorated with hand-fired gold on the beads. The list is as follows:

400/19	8 pc. 2-1/4″ Salt Dip Set
400-19	4 pc. 2-3/4″ Ash Tray Set
400/61	8 pc. 2″ Salt Dip Set
400/64	8 pc. Individual Ash Tray Set
400/78	8 pc. Coaster Set
400/109	4 pc. Salt and Pepper Set
400/176	4 pc. 3-1/4″ Square Ash Tray Set
400/440	4 pc. 4″ Ash Tray Set

Other glass companies purchased Candlewick blanks from Imperial and added their own decorations including bright gold. Lotus Glass Company was one of these "add-on" companies. According to a Lotus ad in the March 1939 CROCKERY AND GLASS JOURNAL, "Gold decorated crystal plate and bowl illustrated above from Lotus Glass Co. have attractive flower borders crowned with beaded gold rims." The plate and bowl were Candlewick. Lotus also decorated Imperial blanks with silver cuttings and etchings.

A large gold plate — completely covered with gold — with an engraved eagle in the center is owned by a Texas collector. The plate has the same Wild Rose pattern as the gold punch set. The center seems clear to show up the eagle, or as Virginia suggests, it could be solid gold with the eagle design cut in. This type of item has not been reported very often. Thank to Virginia for picture and description. (see page 83).

According to a picture album seen in Imperials's files, gold was put on beads from 1950 to 1954.

In other information, a former cutter from Imperial stated to Jean Fry, president of the Ohio Candlewick Club, that "Gold trim was not done in the factory; Mr. DuBois did it in his shop."

We often have conflicting information including dates, but at least we have a general time frame for the gold trim.

The #777/2 Eagle was also produced with gold-on-glass, but the gold was burnished, that is, polished to a dull lustre.

The Gold-On Glass punch set is probably the most sought after of the known gold pieces. According to Virginia Scott's Candlewick newsletters, the "Rose of Sharon" or "Hibiscus" is the name of the etching on the Gold-on Glass punch sets, and that a January 1, 1943 Imperial miscellaneous price list shows the 400/20 D.E. Gold 15 piece Punch Set and the 400/128 D.E. Gold 15 piece Punch Set. Price was $138.90 per set. It also stated they were made

in the late 1940's.

The 400/128 D.E. Punch Set in gold-on-glass is featured on the covers on CANDLEWICK THE JEWEL OF IMPERIAL, Book 1. In a Hammacher Schlemmer ad in the October 1943 Gourmet magazine, the set is described as having the "wild rose etch." The crystal was covered with an etch design before the gold was applied. There has been controversy concerning the etch pattern. Since the words "wild rose" were not capitalized in the ad, some hold that this is a generic term and not the exact pattern name. On a letter found by a collector in her gold punch set, the "etch #436" was written across the top. The Imperial Etch #436 is "Garden Arbor." The flowers in the "arbor" seem identical to those on the gold punch set, but the lattice-work is not etched into the punch set. Myrna and Bob Garrison have the Etch #436 on a 400/250B Peg Bowl. See page 123 for pictures of Etch #436, "Garden Arbor."

Notations on various bulletins and price lists published by Imperial occasionally mentioned a piece of Gold-On-Glass. Most of the following list of Gold-On-Glass pieces have been reported by collectors. There are 42 pieces and sets listed:

400/10D	Dinner Plate, 10-1/2″
400/20B	Punch Bowl, 13″, 6 qt.
400/20 D.E.	Punch Set, 15 pcs.
400/20V	Torte Plate, 17″, cupped edge
400/29/30	Cream/Sugar/Tray — etched birds and floral design
400/35	Tea Cup and Saucer — shown at 1983 Convention
400/36	Canape Set, 2 pc. — Wild Rose design
400/37	Coffee Cup and Saucer — Wild Rose design
400/37	Punch Cup (coffee)
400/38	Salad Plate, 9″, "oval, Gold-On Glass, etched wild rose (11 known — sold at auction 4/29/94)
400/40/0	Basket, floral design, bright gold, 6-1/2″
400/45	Compote, clear stem, gold bowl and foot, etched design, 5-1/2″
400/48F	Compote, 8″, all gold
400/52B	Bowl or Nappy, 6″, 2 handles
400/77AD	Cup and Saucer, etched floral design
400/84	Nappy, partitioned, 6-1/2″
400/88	Cheese Compote, 5-1/2″, flat
400/92D	Plate, 14″
400/94	Buffet Salad Set, etched design
400/98	Party Set, 2 pc., tray and cup, Wild Rose etch
400/107	Bud Vase, floral design, bright gold, 5-3/4″
400/122/29	Sugar/Cream/Tray — etched birds and floral design
400/124D	Platter, oval, 12-1/2″
400/128B	Punch Bowl Base, 10″
400/128D.E.	Punch Set, 15 pcs.
400/188	Ivy/Brandy, etched floral design, bright gold, 7″
400/198	Vase, 6″, Wild Rose design

400/210	Punch Set, 15 pcs.
400/210	Punch Bowl, 10 qt.
400/210	Punch Bowl Base
400/211	Punch Cup
400/242	Rose Bowl, 6″
400/260	Candy Box and Lid, 7″
400/269	Tray or Server, 6-1/2″, Individual
400/287F	Fan Vase, 6″
777/2	Eagle, 5-1/2″ high, peg for candleholder
1776/1	Eagle Ash Tray, 6-1/2″
1776/2	Eagle Picture Frame, 6-1/2″
1776/5	Eagle Mirror, 6-1/2″
-	Calendar, all gold, displayed at the Candlewick seminar at the 1983 Convention

Candlewick Reds

Red Candlewick Crystal — the rarest of the rare. Every collector wants it!

Is red Candlewick really that rare? Many collectors say it is. However, since collectors know about the Ruby Red Candlewick, more red pieces have been appearing in the marketplace. The reason is obvious. Red Candlewick commands an extremely high price. Pieces that have been on sales tables at the annual National Imperial Glass Collectors Society Conventions have not all found new homes; in fact, very few have left the dealers hands. The reason, of course, is the high price tags.

Imperial's Ruby was designated by the prefix #10. Example: 10/400/40H. When the foot of a piece was made in Ruby, it was designated with the #10 in the center, such as 400/10/521. According to the company files, Ruby was made from 1937 to 1941. It was used again in 1981-1983.

Mr. Carl Ottoson, chief chemist and superintendent of the cutting shop at Imperial in the 1930's and 1940's, said in an address at the NIGCS convention in June 1981 that red was only made for three or four months between 1936 and 1940.

We have no verification of this except "what people say" and the timing of Imperial Ruby that appeared on the market. However, a notation was found in Imperial files that in 1962 the red was advertised as "Regal Red" as in the 400/68 Pastry Tray. The color was also advertised as a "Regal Red" Tray on a note dated 1/1/63.

The February 1939 HOUSE AND GARDEN magazine contains an ad showing an Imperial Candlewick salad set with "bright red glass beads." The ad was for Reits Glassware Company of New York. The obvious here is that Reits bought the Candlewick blanks and then decorated the beads with bright red and advertised them as such. Whether they decorated other items, such as the Individual Sugar and Creamer which also has flashed-on red, remains to be determined.

Another company known to have flashed-on-red (cranberry) on Candlewick was the Rainbow Glass Company of Huntington, West Virginia.

Their label reads "Rainbow, Hand Decorated."

Usually when small sections of a piece are red, the red has been flashed on (added). The red pieces made by Imperial Glass Corporation are red glass, not flashed on. Several items are combinations of red and clear crystal: 3800 and 3400 series stemware with Ruby bowls and clear stems and foot, and the 400/40H, 400/51F, 400/51H, 400/51T with clear crystal handles.

Following is a list of known Ruby and red-decorated (flashed on) Candlewick that has been compiled from Imperial's records and also reportedly found by collectors. There are 23 stems and 32 other pieces, a total of 55 pieces in red.

We are not considering here the many pieces found with flashed-on red beads. There are many: vases, salts and peppers, sugar and creams, and plates and bowls, to name a few.

400/17TB	Tid-Bit Set, metal handle, red bowls
400/30	Sugar and Cream, flashed-on red
400/10/21	Vase, 8-1/2″, Ruby foot
400/10/22	Vase, 10″, Ruby foot
400/10/27	Bud Vase, 8-1/2″, Ruby foot
400/10/28	Bud Vase, 8-1/2″, Ruby foot
400/40H	Bon Bon Heart, 5″, clear handle
400/40/0	Basket, 6-1/2″, clear handle
400/49H	Heart, 5″
400/51F	Mint Dish, 6″, clear handle
400/51H	Bon Bon, 6″, clear handle
400/51T	Wafer tray, 6″, clear handle
400/52B	Bowl, 6-1/2″, handled
400/52D	Plate, 7″, 2-handled
400/52/3	Mayo Set, 3pc.
400/61	Salt Dip
400/62B	Nappy, 7″, 2-handled
400/62D	Plate, 8-1/2″, 2-handled
400/64	Nut Cup, clear beads, flashed-on red
400/67B	Footed Fruit Bowl, 9″, 1-bead stem
400/67D	Cake Plate, 10″, ribbed, domed foot
400/68D	Pastry Tray, 11″ — 12″
400/72B	Bowl, 8-1/2″, 2-handled
400/74B	Bowl, 8-1/2″ 4-toed
400/74SC	Bowl, 9″, 4-toed
400/82	Cordial Set, 10 pc.
400/82	Cordial Bottle/Stopper, Ruby foot and stopper
400/82	Cordial (3800), Ruby bowl
400/94	Buffet/Salad Set, flashed-on red
400/122	Sugar and Cream, Individual, flashed-on red
400/142	Juice Tumbler, 3-1/2 oz.
400/143C	Flip Vase, 8″, flashed-on red, clear base
400/440	Ash Tray, 4″, WWII design, patriotic (part of 3 pc. red, white, and blue set)

3400 Series:

Goblet, 9 oz.	Champagne, 6 oz.	Wine, 4 oz.
Juice, 5 oz.	Low Sherbet, 5 oz.	Cocktail, 4 oz.
Claret, 5 oz.	Tumbler, 12 oz.	Tumbler, 9 oz.
Cordial, 1 oz.	Oyster Cocktail, 4 oz.	Finger Bowl

All have clear stem and foot.

3800 Series:

Goblet, 9 oz.	Cocktail, 4 oz.	Tumbler, 9 oz.
Tall Sherbet, 4 oz.	Wine, 4 oz.	Tumbler, 5 oz.
Low Sherbet	Cordial, 1 oz.	Finger Bowl, 8-9 oz.
Claret	Tumbler, 12 oz.	

All have clear stem and foot.

1776/1 Eagle Ash Tray, feasibility piece, sold at 1990 convention auction.

I have charted all the Imperial colors. These are the reds and closely related shades and the dates they were used by Imperial:

Burgundy #53	1960-1961
Cranberry Decorated	1965-1973
Cranberry Ruby	1965-1967
Cranberry Stain	1965-1967
Mulberry	1961
Plum	1938
Rose Pink	1979-1983
Ruby #10	1937; 1960-1973; 1980-1983
Ruby Hand Decorated	1979
Rubigold	1963-1973
Ruby Stain	1965
Sunset Ruby	1970-1973

Several colors were used in the making of Candlewick: Ruby, Ruby Hand Decorated, Rubigold, Cranberry Stain. Whether any of the other hues were also used with Candlewick remains to be determined. Sometimes the shades are so close it is difficult to identify unless a color chart is used.

A red-orange color was used for the

400/40/0	Basket
400/49H	Heart Bowl.

However, at the present time, the exact color name eludes the collector.

Candlewick Black

Black Candlewick seems about as available as red, but most prices have never equaled those attained for Ruby Candlewick. Most black pieces reported have been the early ones, from the late 1930's or early 1940's. An exception is the 3400 Black goblet from the late 1970's.

Collectors have reported numerous pieces found with hand-painted flowers. Some have large and/or small flowers painted in white with gold accents or vise versa. Some of the flowers have red centers and gold leaves. The beading on these decorated pieces is usually touched with gold. This type of dec-

oration has been found mostly on bowls and plates.

In opposition to the shiny surface of black Candlewick, in 1943, Imperial produced a finish on some of its glass products called "Black Suede." It is a "silky smooth, satin-like frosted finish with a two-tone effect," referred to by Imperial as #L4. This was Imperial's version of "Ebonyware." "Because of the proper application of the suede finish, by leaving certain parts of the items in clear shiny black, this decorative method and treatment of the items helps to emphasize the design." Description taken from NIGCS "Glasszette" newsletter of March 31, 1943.

Black Suede is introduced here because rumors persist of the finding of Imperial eagles with this finish. None have surfaced. What is known is that Candlewick collectors have "adopted" the eagle as Candlewick. In reality, the eagles were used by Imperial with many of its glassware patterns.

Most popular, especially during the war years, were the glass eagle bookends. They were produced by Imperial in several colors:

#G/777/3 Burnished Gold Glass Eagles Bookends with gold trimmed "Black Suede" Glass Base. 9″ high. Heavy.

#L/777/3 Lalique finished Crystal Eagles Bookends with 2-tone "Black Suede" Glass Base. 9″ high. Heavy.

According to Imperial's records, only the base was Black Suede, not the eagles. #777 is the mould number for the eagle.

The bookend eagles fit firmly into the bookend by pegs. Some eagles were also reported as frosted. Eagles will be discussed in further detail under EAGLES in chapter eight.

The 6-1/2″ eagle ash tray that was offered during World War II, #1776/1, was also produced in Black Suede; possibly this is where the confusion lies.

The 3400 Goblet in black was reported as produced in the late 1970's. The black goblets seem to have been experimental, did not make the grade for some reason, and were sold from Imperial's Discount Hay Shed. A few have been reported, but they are extremely rare.

To date, these are the 19 pieces of known black Candlewick that have been listed in Imperials's files and all reported by collectors:

	400/52D	Plate, 7″, 2 handles
*	400/52E	Plate, 7″, turned-up sides
*	400/62D	Plate, 8-1/2″, 2 handles (crystal 1939-1968)
	400/62E	Plate/Tray, 8-1/2″, turned-up handles
*	400/72D	Plate/Tray, 10″, 2 handles
	400/72E	Tray, 10″ — 10-1/2″, turned-up handles
	400/74B	Bowl, 8″
	400/74J	Lily Bowl, 7″, ridged, 4-toed, slightly flared top rim
*	400/74SC	Bowl (crystal 1937-1946)
	400/75N	Lily Bowl, 7-1/2″, 4-toed, turned-in top rim (crystal has regular base) *Also found in 6″ with ridges or panels inside bowl; toes are beads.
	400/77AD	Demi Cup and Saucer in opaque black
*	400/145E	Plate, 11-1/2″, turned-up handles

400/145H	Muffin Tray, 11-1/2″, 2 handles
3400	Goblet, solid black, late 1970's, sold from Hay Shed, experimental
* -	Bowl, 4-toed, resembles 400/75N, curved-in top, not in Imperial's files.
* -	Bowl, crimped, large, curved-in top, not in Imperial's files, combination of 400/75N Lily Bowl and has 3-feet like 400/74J
1776/1	Eagle Ash Tray, 6-1/2″, Black Suede
1776/3	Eagle Mirror, Black with gold

NOTE: * indicates found with hand-painted floral decorations, usually with white, gold, and red flowers.

The Candlewick Blues

Trying to identify the various shades of blue in pieces found by collectors is opening a Pandora's Box. Each person describes a shade of blue in his or her own way. Some articles can be identified as having been made in a particular shade if they were listed in Imperial's files. If they were not listed, then the description becomes a guessing game. Even when photographs are sent to this author, it is still difficult to ascertain which shade of blue because not all pictures portray a true color.

And so collectors are left to their own interpretation of the blue shades. One collector may designate a shade "blue" while another calls it "aqua." In going over all the available Imperial records on color, 15 shades of blue were found. Five of these shades were definitely used at one time or another in the Candlewick Crystal line.

Following is a listing of the 15 Imperial blues and a description of each. This listing was complied from Imperial price lists, catalogs, and lists of pieces known to have been made in that color during certain years. No color catalogs before 1966 have been seen by this author. The dates are accurate, but they may not be complete. In other words, Antique Blue, for example, was definitely used with Candlewick in 1966 and 1967. However, it also may have been used prior to 1966 and after 1967.

The five blues preceded by asterisks (*) were used in the production of Candlewick. The other 10 blues were used by Imperial in making other patterns, but no records are available to indicate they were used in Candlewick. The descriptions of the blues are the authors, not Imperial's. The dates indicate when Imperial used the blue shade in its products.

* Viennese Blue (#80 — prefix to mould number indicating color) Very pale blue, but more than a hint or cast. (1937-1938)
* Ritz Blue (#6 color prefix) Deep, rich, bright blue; not as deep as cobalt. (1938-1941)
* Blue #75 (#75 is the color prefix) Believed to be the "Aquamarine" later termed by Imperial (1942-1961)

Royal Cobalt Blue (#95) (1960; 1971-1973; 1980-1981)
* Antique Blue, medium or royal blue. (1965-1975)

Heritage Blue (1965)
Mist Blue, lighter than Antique Blue with overtones of aqua. (1965-1967)
Blue Slag (1965)
Azure Blue Carnival, light baby blue, iridescent (1969)
Azure Blue (1970)
Blue Haze, pale blue. (1969-1975)
* Ultra Blue, subdued blue. (1974-1983)
 Horizon Blue Carnival, medium blue with purplish tinge, iridescent (1979-1980)
Horizon Blue (1980)
Satin Blue, baby blue with slight aqua tinge. (1979-1980)

The following are lists of Candlewick made in the five shades of blue. These lists are possibly incomplete. If a collector or glass dealer has a piece of Candlewick (in shades of blue) not listed, please notify author giving name, number and description of blue if known. Pictures are appreciated. Some type of identification of the shade in needed to place a piece on a particular list; otherwise the item will be added to the Collectors' Finds List.

Viennese Blue

All of these items were made in Viennese Blue in 1937 and 1938 except where indicated. At least 68 items were made in this color. There was no stemware produced in this shade.

Mould Number	Item
400/1D	Plate, 6″
400/1F	Nappy, 5"
400/3D	Plate, 7″
400/3F	Nappy, 6″
400/5D	Plate, 8″
400/5F	Nappy, 7″
400/7D	Plate, 9″
400/7F	Nappy, 8″
400/10F	Nappy, 9″ (1938 only)
400/13B	Console Bowl, 11″
400/13D	Plate, 12″
400/13F	Nappy, 10″
400/13F	Salad Set, 4pc. (spoon and fork not blue)
400/17	Salad Set, 4pc. (spoon and fork not blue)
400/17D	Plate, 14″
400/17F	Nappy, 12″
400/23B	Mayo Bowl, 5-1/4″
400/23D	Plate with Seat, 7″
400/30	Sugar and Cream Set, 6 oz.
400/31	Sugar and Cream Set
400/33	Individual Jelly, 4″
400/34	Coaster or Individual Butter, 4-1/2″

400/35	Tea Cup and Saucer
400/36	Canape Set, 2 pc.
400/36	Canape Plate, 6″
400/36	Cocktail Tumbler, 3-1/2″ (later number — 400/142)
400/38	Plate, Salad, oval, 9″ (1938 only)
400/40	Mayo Set, 3 pc.
400/40B	Finger/Mayo Bowl, 5-1/2″
400/42B	Fruit, 2-handled, 4-3/4″
400/42D	Plate, 2-handled, 5-1/2″
400/42E	Tray, 2-handled, 5-1/2″
400/50	Cream Soup, handled, 5″-5-1/2″
400/51	Mint Nappy, handled, 6″-7″
400/52B	Nappy, 2-handled, 6-1/2″
400/52BD	Mayo Set, 3 pc.
400/52D	Plate, 2-handled, 7-1/2″
400/52E	Tray, 2-handled, 7-1/2″
400/53X	Baked Apple, 6″
400/54	Relish, 2-handled, 6″-6-1/2″
400/55	Relish, 2-handled, 8″-8-1/2″
400/56	Relish, 10″-10-1/2″
400/57	Pickle, 6″
400/58	Celery Tray, 8″
400/59	Candy Box and Cover, 5-1/2″
400/62B	Nappy, 2-handled, 7″
400/62D	Plate, 2-handled, 8-1/2″
400/62BD	Bowl and Plate Set
400/62E	Tray, 2-handled, 8-1/2″
400/63B	Comport, 4-1/2″
400/63D	Compote, 5-1/2″ (same as 400/88)
400/66B	Comport, 5-1/2″
400/67B	Bowl, footed, 9″
400/67D	Cake Stand, 10″
400/72B	Bowl, 2-handled, 8-1/2″
400/72D	Plate, 2-handled, 10″
400/72E	Tray, 2-handled, 10″
400/74	Bowl, 3-toed
400/74B	Nappy, 4-toed, 8-1/2″
400/74J	Lily Bowl, 4-toed, 7″
400/74SC	Dish, 4-toed, 9″
400/80	Candlestick, 3-1/2″
400/81	Candlestick, handled, 3-1/2″
400/86	Mushroom Candlestick
400/87F	Vase, 2-handled, fan shaped, 8″
400/87R	Vase, 2-handled, rolled-top, 7″
400/88	Cheese and Cracker Set

400/88	Compote, 5-1/2″ (400/63D)
400/88D	Plate, 2-handled (400/72D)
400/89	Marmalade Set, 4 pc.
400/89	Marmalade Bowl, Cover, Spoon
400/89	Plate, Marmalade (saucer 400/35)
400/89/3	Marmalade Set, 3 pc.
400/8013B	Console Set, 3 pc.
400/8013F	Console Set, 3 pc. (1938 only)
400/8113B	Console Set, 3 pc.
400/8613B	Console Set, 3 pc.
400/51348	Salad Set, 13 pc.

Ritz Blue

Eleven items were made in the 3800 stemware.

3800	Goblet, 9 oz.
3800	Tall Sherbet, 4 oz.
3800	Low Sherbet
3800	Cocktail, 4 oz.
3800	Wine, 4 oz.
3800	Cordial, 1 oz.
3800	Finger Bowl, 8-9 oz.
3800	Tumbler, footed, 5 oz.
3800	Tumbler, footed, 9 oz.
3800	Tumbler, Iced Tea, footed, 12 oz.
3800	Claret

One item has been found in the 3400 stemware line in Ritz Blue:

3400 Cocktail, 4 oz. No other 3400 in Ritz Blue has been reported.

Blue #75

400/440 Ash Tray, 4″ (for Ash Tray Set 400/550) Listed on price list for 1948 as 75/400/440. Used with Amber (#40) 5″ and Pink (#65) 6″ ash trays. Set issued 1942-1960.

Imperial used a prefix for color identification on its price lists. Example: the 400/440 Ash Tray was written as 75/400/440 to indicate the piece was blue and which shade. The trouble with this is that no description of the #75 shade of blue has been found. We assume it is the Aquamarine color because many of the colored sets exist, and the 4″ is in an aquamarine color. Imperial files show this set was made with a 4″ Ash Tray in Aquamarine in 1954.

Antique Blue

1776 Eagle Cigarette Holder — fits in 1776/1 tray. This is a set, but not Candlewick. The ash tray has been adopted by Candlewick collectors. The tray has a circle of beads around the inside.

| 1776/1 | Eagle Ash Tray, 6-1/2″ (1965) |
| 1776/3 | Eagle Mirror, 6-1/2″ (1942-1950) |

Ultra Blue

400/133	Ash Tray, 5″ (1977) part of 400/550 set
400/150	Ash Tray, 6″ (1977) part of 400/550 set
400/172	Mint Heart or Ash Tray, 4-1/2″ (1974)
400/172	Mint Heart or Ash Tray, 4-1/2″, souvenir: "2nd Annual Glass Festival Souvenir, Bellaire, O. 1974."
400/440	Ash Tray, 4″ (1977) part of 400/550 set
400/550	Ash Tray Set, 3 pc. (1977)
3400	Stemware Series (1977-1979)
	Goblet, 9 oz., Saucer Champagne, 6 oz.
	Wine, 4 oz., Tumbler, 12 oz.

Numerous pieces in shades of blue have been reported by collectors. However, it is extremely difficult to place them on a specific list. Some of them could be Mist Blue, Azure Blue, Blue Haze, Horizon Blue, or Satin Blue. When a production date of a piece is known, often it can be identified in a particular shade of blue if the production dates and blue dates correspond. There is, however, no such thing as definite because Imperial could at any time have married any piece with any color.

Production dates of each piece have been given on the list of Collectors' Finds to help the reader garner an idea of the time period a particular shade of blue would have been in use.

Collectors' Finds in Blue

400/1D	Bread and Butter Plate, 6″ (1937-1977)
400/20	Punch Set, 15 pc. (1937-1979), light blue
400/37	Cup and Saucer (1937-1984), probably Viennese Blue
400/40C	Candleholder, Flower, crimped edge, 5″ (1947-1967)
400/40/H	Heart Bon Bon, handled, 5″ (1939-1984)
400/50	Cream Soup, 2-handled (1937-1955), blue frosted
400/51F	Mint/Candy Dish, handle, 6″ (1941-1979)
400/52	Jelly, 5-1/2″-6-1/2″, divided, handled (1950-1976)
400/74SC	Bowl or Dish, 4-toed, 9″ (1937-1946)
400/87C	Vase, 7-1/2″-8″ (1939-1963)
400/96	Salt and Pepper (1941-1984), light blue
400/138B	Vase, footed, 6″ (1941-1943), probably Viennese Blue
400/145B	Bowl, 2-handled, 10″ (1941-1984)
400/145E	Tray, turned-up handles, 11-1/2″ (1943), probably Viennese Blue
400/167	Salt and Pepper, 4-1/2″ (1943-1970), light blue
400/150	Ash Tray, 4″, patriotic design — WWII (War years 1940-1945), deep blue (set of blue 6″, white 5″, red 4″)
400/9266B	Cheese and Cracker Set, 2 pc. (1937-1951), probably Viennese Blue

#701	Spoon and Fork Set, ribbed handles, 9″, not Candlewick but used with early Candlewick sets (1937-1938), probably Viennese Blue

To date there is no proof that Candlewick was produced in Mist Blue, Azure Blue, Blue Haze, Horizon Blue, Satin Blue, or the other Imperial blues. It is obvious, though, that all Collector's Finds do not fit under the five color categories definitely known to have been used with Candlewick Crystal. Imperial often experimented with pieces in various colors and shades; if the finished piece did not measure up and was not considered appealing enough, the item was sold through Imperial's discount shop, the Hay Shed. These pieces were purchased by townspeople and visitors, and now, years later, many such pieces are showing up at sales and consequently in collections.

Until more information is uncovered, collectors will continue to put their own interpretation on the various shades of blue occasionally used by Imperial in the production of Candlewick Crystal.

Candlewick Carmel Slag

Carmel Slag is another of the rare colors found in the Candlewick Crystal line. The carmel and white slag is a very attractive combination to be seen in Candlewick beading. It is also desired by collectors but not to the extent that red, black, and gold are.

The following 11 pieces have been found in Carmel Slag:

400/42D	Plate, 5-1/2″, 2-handled
400/52B	Bowl, 6″, 2-handled
400/52D	Plate, 7″, 2-handled
400/62D	Plate, 8-1/2″, 2-handled
400/145C	Plate, 12″, 2-handled, crimped
400/145D	Plate, 11″-12-1/2″, 2-handled
400/150	Ash Tray, 6″, round
400/174	Bon Bon Heart or Ash Tray, 6-1/2″
400/182	Bowl, 8-1/2″, 3-toed
400/183	Bowl, 6″, 3-toed
400/256	Relish, 10-1/2″-11-1/2″, 2-handled, oval, divided

Since three of the 4 plates in the 4-piece 2-handled plate set, 400/4272D, consisting of 400/42D, 400/52D, 400/62D, and 400/72D, are found in Carmel Slag, it is not inconsistent to assume that the 400/72D 10″ Plate with 2 handles was also made in Carmel Slag. To date, however, none have been reported.

Carmel Slag was made by Imperial from 1966 to 1977, and again in 1982 and 1983. Slag is shown in the Imperial catalogs, but no Candlewick is shown in Carmel Slag in any of the catalogs.

The total number of Carmel Slag items remains at 11, the fewest number in any of the colors.

Imperial Beaded Milk Glass

Many Candlewick collectors are purists — they only want Candlewick

Crystal pieces in their collections. Others bend a little and are willing to include similar items, look-alikes, and go-withs.

Imperial's Milk Glass with beads falls into a controversial category. The disagreement is there: Is it or isn't it true Candlewick? One side of the argument is that only items made in the Candlewick moulds are indeed Candlewick. The other view states that if Imperial made it, and it has the Candlewick beaded edge, it is Candlewick.

Whether it is or not remains to be determined by the individual collector. Regardless, all collectors should be knowledgeable concerning Imperial's beaded-edge Milk Glass pattern.

An interesting letter, dated 1971, was found in Westmoreland Glass Company's files. It was from Imperial on the company's letterhead. The gist of the letter was a confirmation order based upon a previous phone conversation to make XX number of items of certain Imperial pieces in Milk Glass. Westmoreland also made their own Milk Glass beaded-edge pattern, in plates. To date, no proof has become available to show which items were made by Westmoreland for Imperial. Source for this information is THE DAZE, November, 1987.

The source for most of the other information in this chapter is Kathy Doub, well-known Milk Glass collector and lecturer.

Kathy states that "In the mid 40's through the 50's, Imperial Glass Company manufactured a group of Milk Glass items that had the Candlewick beads. A design of flower and leaves was added to the inner bowl; on stemmed items the leaves go around the sides and top of the base. The bead on the stem also has a design. The pieces were made in both #1950 Gloss finish and the #1952 Doeskin (flat or matte) finish."

The following listing of "Milk Glass Candlewick" has been compiled from Imperial catalogs and reports from collectors. Although many of the collectors' finds have not been seen by the author, they are included here on the word of collectors:

400/49H	Heart Bowl, 9″ (see 1950/52 75H)
400/67B	Fruit, 9″, 1-bead stem (reported by collector)
400/74SC	Bowl, Square Crimped, 9″, 4-toed (owned by Bellaire, Ohio collector)
400/92D	Plate, 14″, flat edge (reported by collector)
400/103F	Fruit Compote, 10″ (reported by collector)
400/109	Salt and Pepper Set (reported by collector)
400/157	Cheese/Jelly Compote, 4-3/4″ (reported by collector)
400/172	Heart Ash Tray, 4″, "4th Annual Bellaire Glass Festival, 1976″ souvenir (see 1950/52 750)
400/250F	Peg Nappy, 5-1/2″, Crown Sterling base (owned by Texas collector) It is "exactly like Candlewick nappy" states the owner who purchased it from the factory in 1984.
400/750	Milk Glass Heart Set, 3 pc. (see 1950/52 750)
776	Eagle Cigarette Holder; "adopted" by Candlewick collectors (see 1950/52 776)

1776/1	Eagle Ash Tray, 6-1/2"; "adopted" by Candlewick collectors (see 1950/52 1776)

The following are the pieces Kathy Doub listed from Imperial catalogs. Other information from Kathy, both from the catalogs and her own observation is included, plus some information reported by collectors.

1950/52 45	Jelly Comport, 5", beaded top edge; 2 styles; no resemblance to Candlewick, except beaded edge. Catalogs B through E. Reported: marked with IG, and unmarked. Two different moulds were used: one mould added small leaves to the inner bowl, and on the exterior there were ridges from the edge of the leaf design to the rim. The other mould had a plain interior and did not have the ridges on the exterior.
1950/52 75C	Fruit Bowl, 11", crimped. Catalog B — not in Catalog C. Not marked; base has a half ball with six sets of lines going to the edge of the base.
1950/52 75D	Buffet or Wall Plate, 11", flower and leaf design (seen at Convention). Catalog B — not in Catalog C. Not marked; base has a half ball with six sets of lines going to the edge of the base.
1950/52 75F	Couped Apple Bowl, 11". Catalog B — not in Catalog C. Not marked; base has a half ball with six sets of lines going to the edge of the base. (Seen at auction at 1989 Convention)
1950/52 75H	Fruit or Dessert Bowl, 9", heart-shaped; no leaves on exterior; flowers and leaf design on interior. (Candlewick 400/49H) Catalog B — not in Catalog C. Not marked; base has a half ball with six sets of lines going to the edge of the base. (Seen at 1986 Convention — with small flowers painted in the interior)
1950/52 103	Fruit Bowl, 10", flower and fruit design on bowl and foot. Colors: Custard Opaque, Blue Opaque, Turquoise Opaque, and Milk Glass. Catalogs B through E. Reported: marked with IG, and unmarked. Two different moulds used: see description for 1950/52 45.
1950/52 170	Low Candleholder, mushroom-shaped, leaf design with candle being the flower; large beads around bottom.
1950/52 196	Epergne Set, 10", 2 pc., crimped, flower and leaf design; (Candlewick 400/196) Catalogs B through E. Made with inset lily rim "crimped plain" or "crimped with beads." Reported: marked with IG, and unmarked.
1950/52 750	Ash Tray/Tid-Bit Set, 3 pc., hearts. (Candlewick 400/750) Same as Candlewick set; smallest of set, 400/172, was made for Glass Festival souvenir in 1976. Only cataloged (Catalog F) pieces found exactly like Candlewick; not marked.

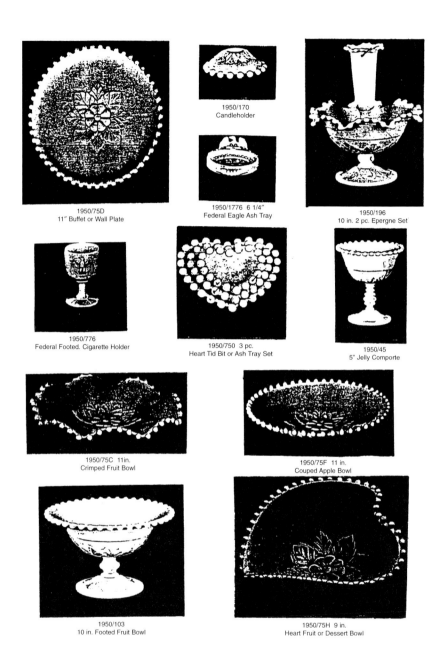

1950/75D
11" Buffet or Wall Plate

1950/170
Candleholder

1950/1776 6 1/4"
Federal Eagle Ash Tray

1950/196
10 in. 2 pc. Epergne Set

1950/776
Federal Footed. Cigarette Holder

1950/750 3 pc.
Heart Tid Bit or Ash Tray Set

1950/45
5" Jelly Comporte

1950/75C 11in.
Crimped Fruit Bowl

1950/75F 11 in.
Couped Apple Bowl

1950/103
10 in. Footed Fruit Bowl

1950/75H 9 in.
Heart Fruit or Dessert Bowl

Cut-outs from original Imperial catalogs

*Pictures from Kathy Doub's article on Milkglass in the National Imperial Glass
Collectors Society newletter, GLASSZETTE, October 1990*

| 1950/52 776 | Federal Footed Cigarette Holder, Catalogs B and C. |
| 1950/52 1776 | Federal Eagle Ash Tray, 6-1/2″, Catalogs B and C. |

Milk Glass Fact Sheet

— Finishes: #1950 Glass (shiny)
#1952 Doeskin (flat or matts)

— Only "as is" from Candlewick moulds of which we have proof are the
400/74SC Bowl, 9″, 4-toed
400/750 Bon Bon Hearts, 3 pc.

— Two styles: a. plain exterior over leaf design and plain interior
b. vertical ribs around upper edge of outer bowl and leaves in the interior.

— Some Milk Glass items were marked with the Imperial IG Trademark.

Kathy states that "According to Imperial's THE STORY OF HANDMADE GLASS booklet, all Milk Glass produced after February 1, 1951 will be marked with the IG Hallmark."

— Imperial Catalogs showing beaded-edge Milk Glass:

Catalog B — mentions the Hallmark — 8 beaded Milk Glass items shown: 1950/52 45, 75C, 75D, 75H, 103, 196, and 750.

Catalog C — 5 beaded Milk Glass items shown: 1950/52 45, 103, 170, 196, and 750.

Catalog D — all Milk Glass catalog. 5 Milk Glass items shown: 1950/52 45, 103, 170, 196, and 750.

Catalog E — 1957 — all Milk Glass catalog. 5 beaded Milk Glass items shown: 1950/52 45, 103, 170, 196, and 750.

Catalog F — 1960 — all Milk Glass catalog. One beaded Milk Glass item shown: 1950/52 750.

*The dates of the early catalogs are not known. Kathy states that none of the items mentioned were listed on Imperial's 1964 price list for Milk Glass.

The page of Imperial's Milk Glass pieces was taken from Kathy Doub's article on Milk Glass in the National Imperial Glass Collectors Society newsletter, *GLASSZETTE*, October, 1990. (see page 98)

A special thank you to Kathy for her input and her editing of this article on Milk Glass.

CHAPTER 5

DECORATED CANDLEWICK

A variety of decorations were used to further beautify Candlewick both before and after 1960: cuts, etches, colors, metals, paints. More information is known about the decorations used on Candlewick later in Imperial history mostly due to the fact that more records, brochures, and catalogs are available. Very few of these paper records are available from 1936 through 1959. However, through research, some of the decorations have been documented.

Lotus Glass Company purchased blanks, as did other glass companies, from Imperial and decorated them with cuts, etches, gold, and silver. In a March 1939 ad Lotus offers a Candlewick bowl and plate set and states they "have attractive flower borders crowned with beaded gold rims."

An etched "wild rose" patterned Candlewick round tray is owned by an avid Texas collector. The etching is gold covered. The center of the plate is clear crystal decorated with a cut eagle design, dated possibly 1940's to commemorate WWII (See page 83).

Satin-Trimmed Candlewick is an early Candlewick offering. Not only were items completely satinized, they were also "touched" with satin, satin bands, satin beads, and satin designs. Imperial designated its totally Satin-Trimmed design as #99.

According to Ron Doll, an Ohio collector and contributing author to articles in the Ohio Club newsletter and Virginia Scott's newsletter, in his role as banquet speaker at the 1991 NIGCS Convention, Willard Kolb, glass researcher, stated that silver overlay designs were applied to Candlewick blanks, such as plates, bowls, and vases, by Silver City Glass in Meridian, CT, not by Imperial. Doll also states in the Ohio Candlewick Club newsletter, CANDLEWICK CAPERS, that Kolb said Cam-Bel Glass of Bellaire, Ohio, decorated and cut patterns into Candlewick as well as Lotus Glass and Wheeling Decorating.

Following is a condensed general listing gleaned from Imperial's files of decorated Imperial glass after 1960. Specifics were not given for any one pattern, but much of the listings does apply to Candlewick as decorated pieces have been found by collectors. It is possible that all of the list applies to Candlewick.

This list encompasses the 20 year span from 1960 through 1980.

1960 — Gold, platinum bands
1961 — Rubigold available
 — Gold and platinum bands
 — Gold decorated
1965 (January)
 — Rubigold
 — Gold decorated and gold bands
 — Fired on gold
 — Platinum bands

- — Candlewick — no colors
- — Cut pitchers, but not in Candlewick
- — 1776 Eagle Ash Tray in Antique Blue
- — 1776 Eagle Cigarette Holder in Antique Blue
- — 1776/2 2 pc. Cigarette Set in Antique Blue
- — 1776 Eagle Cigarette Holder in "Doeskin Crystal"
- — 1776/2 2 pc. Cigarette Set in "Doeskin Crystal"
- — 1776 Eagle Ash Tray in "Doeskin Crystal"

1969 / 1970 (January and July)
- — Rubigold
- — Cut pitchers
- — Gold decorated
- — Fired on gold
- — Gold bands
- — No platinum bands
- — No eagles

1971
- — Rubigold
- — Cut pitchers
- — Gold decorated
- — Fired on Gold
- — No "banding"

1973
- — Rubigold
- — Cut pitchers
- — Gold decorated
- — Fired on gold

1980 — Gold decorated barware

This listing is by no means complete, but it does give the collector a frame of reference for decorating by Imperial.

Metals

Not only were Candlewick Crystal pieces decorated with metals such as platinum, gold, and silver to enhance their beauty, but Candlewick was also made completely covered with both gold and silver: Gold-On-Glass and Silver-On-Glass.

Very few pieces of total Silver-On-Glass have been reported:

| 400/92B | 12″ Bowl, Wild Rose etch pattern |
| 400/98 | 2 pc. Party Set, Wild Rose etch pattern |

The bowl and party set plate and cup are completely etched in the Wild Rose pattern and covered in Sterling Silver, the owner, an Ohio collector, reports. That Imperial made these is documented by Lucile Kennedy, former Imperial executive, who checked with a former decorator at Imperial. He stated that he remembered doing a few pieces in silver.

Several items completely covered with silver but without etching have been reported. One collector has a silver-covered pitcher. Several plain plates are also in collections.

Silver was used to decorate Candlewick with overlay patterns pre-cut and

made to adhere to glass. Some of the silver patterns are marked "Sterling." Silver overlay was popular during the 1930's and 1940's as wedding and silver anniversary gifts — usually serving pieces.

Several decorating companies bought Candlewick blanks to add their own unique techniques to the glass to produce a new and appealing item. Cam-Bel was a Bellaire, Ohio, company that combined glass with silver and other metals or added silver overlay. Cam-Bel is also known for its cutting on glass. J. Morris DuBois owned the company; he was also president of Imperial while it was reorganizing in the 1930's. Silver City Glass Co. of Meridian, CT also applied silver overlay to Candlewick.

Silver and gold decorating was also done on Candlewick blanks by the Lotus Glass Company.

Some items were combined with silver (or other metals) holders or framework. Several collectors have silver tray holders for 2 and 3 Candlewick cruets. A picture of one set appeared in a 1956 BETTER HOMES & GARDENS magazine. The tray has four feet and handles on the far ends.

Boxed Community Silverplate sets have been found by numerous collectors. One is called "Twilight" Community Set. It consists of a 6″ Candlewick ash tray (400/60) and a Community Silverplate butter knife. Community also offered a set called "Ballard." The boxed set has a 5″ heart nappy with a Community Silverplate ladle. Another set by Community is "South Seas", a yellow-boxed set with 400/54 6-1/2″ relish and a "South Seas — Community" knife, and was reported by Marjorie Keller, Missouri.

Farberware was another company that had a relationship with Imperial. Many chrome items were combined with Candlewick to form new and desirable sets. The 400/159 9″ oval Candlewick tray was seated in a Farberware chrome tray. The chrome tray has an oval indent and a cut out design on each of the four corners. Some sets have been reported with a fancy cocktail fork.

Farberware was made by S. W. Farber, Inc. (Farberware ™), not Farber Brothers, but Farber Brothers did purchase Candlewick inserts from Imperial.

There are other chrome pieces combined with Candlewick that have been discovered by collectors:

• Cory 2-part glass coffee pot and Candlewick cream and sugar set. Pot, cream, and sugar have platinum bands. The sugar has a flat cover with a black knob. The collector who has this set says it was a wedding present, circa 1945.

• 400/23B Mayo Bowl with chrome ladle and underplate (with cut out fancy flowers) in the original box and string tag. Four of these Farber Brothers sets were advertised for sale in 1990 for $50 each.

• Three 6-1/2″ diameter and 1-1/2″ high bell-shaped Candlewick bowls with chrome underplates (without cut out fancy flowers) and string tags — by Farber Brothers — were also advertised for sale in 1990, for $35 each set.

• An 8″ cupped Candlewick plate with chrome underplate (cut out fancy flowers) and string tag — by Farber Brothers — was another advertised item at $35.

• A 7″ Candlewick plate with a chrome comport (5-1/2″ high with cut out

fancy flowers) and a string tag — another Farber Brothers product — was available for sale at $35.

- 400/13B Bowl with 3-wire clip-on chrome handle was discovered by a Texas collector.
- An 8″ Candlewick cupped Toast Plate (400/123) is also found in a set. It has a Farberware domed top — 6-3/4″ across and a Farberware 9″ plate with floral decoration on the rim. The Candlewick plate fits exactly into the seat of the Farberware plate.

Other collector finds with metal consist of a 6-1/2″ round Candlewick dish on a decorated tray. The dish has a metal lid with a knob handle. Also reported is a round metal tray with a mayo dish and a metal spoon.

Copper, too, compliments Candlewick. A 400/134/1 Ash Tray was reported in a copper holder with cut out design on the handles on each end. The tray is marked "Viking Plate Made in Canada E. P. Copper." (See page 67 for pictures of sets.)

Hand-Painted Candlewick

Hand-painted Candlewick was offered by Imperial as early as 1939, according to Brooklyn Ross who spent his early years working at Imperial.

Sira Ramos, a collector, wrote in a report in Virginia Scott's newsletter #76, that at the 1992 NIGCS Convention, in the seminar given by former Imperial employees, they stated that "all free-hand decoration was done at Imperial; all banding was done by hand, 50 or 60 dozen pieces a day by each worker...black and white flowers with red and yellow middles were made in the 30's."

Another collector has documentation of painting being done from 1947 to 1949. According to Myrna Garrison of Arlington, Texas, co-author with her husband Bob of books on Imperial's Cape Cod and Milk Glass patterns, hand-painted Imperial was still offered by Imperial in 1953. Her documentation is a 1953 Imperial catalog which identifies some of the patterns also found on Candlewick. The following information on the hand-painted floral designs done by Imperial on Candlewick is from the Garrisons.

According to Imperial records that the Garrisons have, Imperial put the following hand-painted patterns on their glass, including Candlewick:

"Western Rose"	"Western Apple"	"Rose of Sharon"
"Imperial Susan"	"Narcissus"	"Hawthorne"
"Bamboo"		

Again, according to Garrisons' documentation, Imperial put the following hand-painted decorations on its glassware, SOME of it Candlewick:

"Magnolia"	"Thistle"	"Golden Harvest"
"Yellow Poppy"	"Desert Rose"	

On the Imperial file, it was noted "Excellent to tie-in with the flat lines of Franciscan Dinnerware having these decorations."

Also found on an Imperial Bulletin page was "Western Wild Flower" and "Western Apple"; these painted on designs were used in 1960.

The Garrisons have the 400/142 3-1/2″ Tumbler with the Imperial Narcissus pattern and also the Hawthorne floral pattern on the 400/142. The

Imperial Decorated Stemware

Magnolia Hawthorne Western Apple Western Rose Yellow Poppy Susan Narcissus

luscious apple design

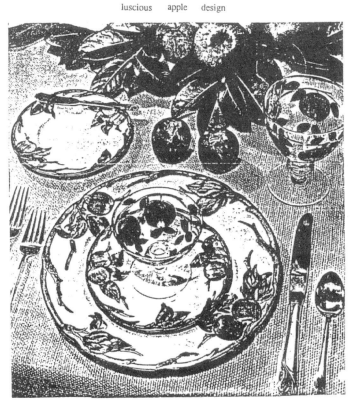

Reprinted from an issue of House Beautiful dated May 1943

Golden Harvest

Thistle

Bamboo

Imperial Decorated Stemware

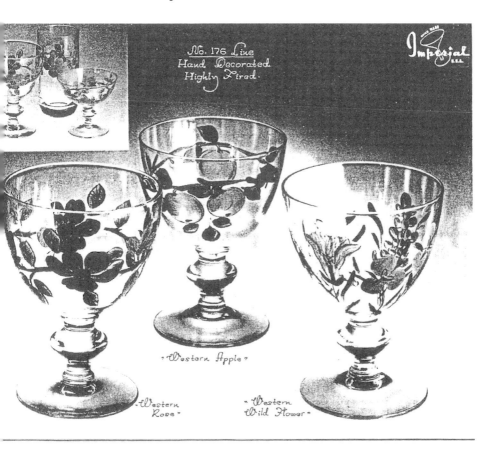

Original Imperial File
Photo – No. 176 Line

Susan and the Western Apple patterns are on their 400/119 cruets.

Another hand-painted item reported by collectors is the 400/103C 10″ footed Fruit Bowl. This particular piece was found with a label on the underside of the base: "Charleton Hand Decorated 4630." In Scott's newsletter #73, page 3, Lois Quale, Wisconsin, states that on pages 76-78 of COLORS IN CAMBRIDGE GLASS by the National Cambridge Collector, Inc., pieces of Cambridge Crown Tuscan and Coral painted by "Charleton" were shown. A footnote on page 76, states Lois, reads: "Note: Charleton is the registered trademark for a class of hand decorations done by Abels, Wasserberg and Co., Inc., of New York." The pictures on pages 77 and 78 show the same pattern as found on Candlewick 400/103C. Lois has a 400/149D Mint Tray with the same painted design. This pattern has also been found on the 400/30 Sugar and Cream and the 400/103D Cake Stand.

The label is gold on black. The decoration consists of hand-painted pink flowers with green leaves, linked by blue ribbons, with 8 painted gold stars among the flowers. Each bead is gold; a gold band separates each bead on the stem and around the top and bottom of the base. The bowl has 16 roses, one under each scallop, one under each point, joined by blue ribbons. There seem to be 6 roses around the base; some have 8 roses. One collector says the flowers are more like Rose of Sharon than true roses. The collector who gave the description said that the lady from whom she purchased it received it as a wedding gift in the early 1960's, and the people who gave it as a gift had it in their china cabinet for several years. This information would perhaps date the hand-painting to the middle 1950's. The fruit compote was offered by Imperial from 1943 to 1955. The description of the hand-painting on the 400/103C is taken from Scott's newsletter.

A 400/149D 9″ handled mint tray is owned by Bette Hulmes of Illinois. Bette describes her tray as follows: "Beads are gold, base of handles are gold leaves. Around the base are 4 clusters of pink roses, lavender violets, green and gold leaves. Between clusters of roses and violets are blue bows, giving the effect of ribbon connecting the floral clusters. It is professionally done and reminiscent of a design I have seen on satin bowls." Bette's description seems to follow very closely the decorations found on the 400/103C Footed Fruit Bowls. For a picture of the 400/103C in the author's collection, see page 49.

The possibility here is that not only the 400/103C was decorated by Charleton, but also Bette's 400/149D and the Satin Bowls she has seen.

In Scott's newsletter #71, page 4, numerous items are listed that collectors have found with hand-painted patterns:
— 400/119 Cruet with Franciscan Apple
— Several pieces with strawberries, including the 400/51T Wafer Tray and possibly a relish
— Plate and cup and saucer with pink roses, and leaves
— 400/152R Hurricane Lamp globe painted with Western Rose design
— Fingerbowl and Oyster Cocktail with daisy design
— 400/79 Candleholder with vine and flowers

In Scott's newsletter #73, page 8, Sira Ramos wrote that while in New York

in a store called Stupell's the owner invited the Ramos' to his home to see his glassware including Candlewick. He has Candlewick with gold beads, silver beads, all done at his mother's factory, Sira stated. Also, she said he had demitasse cups and saucers decorated in splatter paint, popular in the 40's and 50's. Sira bought a green splatter-paint cup and saucer and also a set that looks like it had been sand blasted.

Satin-Trimmed Candlewick

Numerous pieces of Candlewick have been reported with satin trim: satin beads, satin bands, all satin. The all-satin line was referred to by Imperial as Satin-Trimmed. The number Imperial used to designate Satin-Trimmed was #99, such as 400/99/1D; the decoration number was placed between the line number (400) and the mould number (1D). Forty-five pieces of Satin-Trimmed Candlewick were listed on an Imperial price list dated January 1, 1937. This is the only price list found offering this decoration. However, four more items (preceded by asterisks in the following listing) have been reported by collectors, and therefore, have been added to the list. Whether these three items were also satinized in 1937 is unknown, but they were produced in clear crystal at that time. Some knowledgeable Candlewick collectors guesstimate the Satin-Trimmed Candlewick years as January 1, 1937 to 1943.

Listed below are the forty eight pieces known to have been made with the Satin-Trimmed decoration.

400/99/1D	6" Plate
400/99/1F	5" Nappy
400/99/3D	7" Plate
400/99/3F	6" Nappy
400/99/5D	8" Plate
400/99/5F	7" Nappy
400/99/7D	9" Plate
400/99/7F	8" Nappy
400/99/13B	11" Console Bowl
400/99/13D	12" Plate
400/99/13F	10" Nappy
400/99/17D	14" Plate
400/99/17F	12" Nappy
400/99/31	Sugar and Cream Set
400/99/33	4" Individual Jelly
400/99/34	4-1/2" Coaster
400/99/35	Tea Cup and Saucer
400/99/36	Canape Set, 2 pc.
400/99/40	3 pc. Mayo Set
400/99/42B	4-3/4" Fruit, 2-handled
400/99/42D	5-1/2" Plate, 2-handled
400/99/42E	5-1/2" Tray, 2-handled
400/99/51	7" Nappy, handled
400/99/52B	6-1/2" Nappy, 2-handled
400/99/52D	7-1/2" Plate, 2-handled

400/99/52E	7-1/2" Plate, 2-handled
*400/99/55	8-1/2" Relish, 4-sectioned, 4-handled
400/99/62B	6" Nappy, 2-handled
400/99/62D	8-1/2" Plate, 2-handled
400/99/62E	8-1/2" Tray, 2-handled
400/99/63B	4-1/2" Comport
400/99/66B	5-1/2" Comport
400/99/67B	9" Bowl, footed
400/99/67D	10" Cake Stand
400/99/72B	8-1/2" Bowl, 2-handled
400/99/72D	10" Plate, 2-handled
400/99/72E	10" Tray, 2-handled
400/99/74B	8-1/2" Nappy, 4-toed
400/99/74SC	9" Nappy, 4-toed
400/99/74J	7" Lily Bowl, 4-toed
400/99/80	3-1/2" Candlestick
400/99/81	3-1/2" Candlestick, handled
*400/99/84	6-1/2" Nappy, partitioned
400/99/86	Candlestick
400/99/87F	8" Vase
400/99/87R	7" Vase
400/99/88	Cheese and Cracker Set
*400/99/92D	14" Plate
*400/99/94	Buffet Salad Set, 4 pc. (Includes 400/99/84 and 400/99/92D)
400/99/8613B	Console Set, 3 pc. (Includes 400/99/86 (2) and 400/99/13B)
1776/3	Eagle Mirror, 6-1/2" (1942-1950) Reported by collector.

Notice the following:
— Candleholders were referred to as "candlesticks" in 1937.
— Compotes were "comports".
— Bowls were "nappies".
— A single mould was used for several items: nappy, plate, and tray. In the E series trays, the handles turn up.

In conclusion, be aware that this certainly is not the end of the list of decorating that was done on Candlewick Crystal. One often-found decoration is colored beading. On some pieces every other bead was painted; on others every other bead was a different color. Many colors were used on the beading: yellow, red, blue, green, gold, and shades of each.

Hand-painted decorations were also put on Satin-Trimmed pieces. Company logos were placed in the center of ash trays and other small Candlewick items. Many pieces were given gold highlights around the rim, around the foot, on tops of beads, and between large beads on the stems.

The variety of decorations found on Candlewick Crystal is a tribute to the imaginations of the artisans who created the new and appealing designs.

Introduction to Cuts

It is impossible to study a single-glass pattern like Candlewick without studying the manufacturer and ultimately at least touch on the factory's other patterns. Such is the story with Imperial's cuts. The most predominant cuts used on Candlewick are well known and have been documented by company records. However, there are many cuts collectors have found on Imperial Candlewick that do not fit the few documented Candlewick cuts. This is where the problem lies.

It's easy to say variants occur due to changing the artisans and their different cutting styles. The bottom line, however, is that there are many variants — florals, for example. There are many cuts found on Candlewick that have not been identified.

Some, of course, were cut by glass companies that bought Imperial blanks and cut their own design on Candlewick. The greatest probability is that many of the cuts are Imperial's own. Imperial obviously had hundreds of cuts.

Imperial did much of its own cutting. The Imperial cutting shop had its birth in 1913. Around 1931 the shop was moved out of the plant and taken to the site of the Novelty Stamp Company. The name given to Imperial's cutting shop was Crown Cut Glass Co., and it was in the same location for a year or two. Then it was moved back to the plant, and the Crown name was dropped.

When Crown opened it was considered a subsidiary of Imperial. Machinery from the Elite Glass Works in Bellaire, Ohio, was used in the Imperial cutting shop. This information is from the NIGCS GLASSZETTE.

According to Willard Kolb, glass researcher, cuts were also made on Imperial glass by Cam-Bel Glass Works of Bellaire, Ohio, and Lotus Glass Co., and Wheeling Decorating Co. of Wheeling, West Virginia.

In compiling a list of cuts, all available Imperial price lists, brochures, and catalogs were used; the cut patterns' names and production years are given when known. Descriptions are those of the author to help in some small way to identify cuts by more than just a number. The asterick (*) indicates that cut is listed by Imperial as having been used on Candlewick.

IMPERIAL CUT #'S	DESCRIPTION
2	6 rounded-petal flowers on 2 stems with 4 leaves each (1904-1937)
3	chevron style
5	diamonds (like C427) and ? design
6	diamonds and ? design
7	grapes (1904-1937)
7-1/2	wide panels, "Fluted", (1965-6; 1969; 1971; 1973)
10	flowers and leaves on stem (1904-1937)
12	connected balloon design (1904-1937)
13	dahlia or mum (?) design, stems (1904-1937)
20	square rose (?) and stems; leaves pointed and curved (1904-1937)

28	similar to cuts 2 and 90 but has centers in flowers (1904-1937)
30	flower with 12 pointed petals and (?) design (1904-1937)
57	ribbon and leaves (1904-1937)
61	leaves on stem (1904-1937)
63	edge design (1904-1937)
66	leaves like cut 61 and extended (1904-1937)
70	thumbprint
71	paneled
73	paneled & partial diamond
88	flowers with 12 petals and leaves; flowers same as cut 30 (1904-1937)
90	same flower as cut 2 but extended and more leaves (1904-1937)
93	flowers and leaves on stems (1904-1937)
94	flowers and leaves on stems (1904-1937)
95	flowers and leaves on stems (1904-1937)
98	flower sprays (1904-1937)
99	flower sprays (1904-1937)
*100	"Dots" (1937-1946)
101	Stars, 8 point (1904-1937)
*101	"Polished Dots" (1941)
102	stars designed (1904-1937)
103	stars designed (1904-1937)
104	grapes (1904-1937)
105	fans and diamonds (1904-1937)
106	stars, large, many points (1904-1937)
*108	"Starlight" (1937-1961)
110	flower sprays and butterflies (1904-1937)
112	flower sprays (1904-1937)
113	side stars (1904-1937)
114	flower sprays (1904-1937)
115	flowers, leaves, stars (1904-1937)
125	flower design, Crown Cut (1914-1937)
128	flower design, Crown Cut (1914-1937)
129	flower design, Crown Cut (1914-1937)
147	dots & connecting lines in a diamond pattern
160	panels & waffling
177	intricate floral designs (1904-1937)
204	intricate floral designs (1904-1937)
256	"Laurel", Crown Cut (1914-1937)
259	"Anniversary" by Crown (1914-1937)
259	"Anniversary" by Imperial (1914-1937)
261	"Belmont Hills," floral pattern
261	"Allard," Crown Cut (1914-1937)
263	flower design, Crown Cut (1914-1937)
264	flower design, Crown Cut (1914-1937)
265	flower design, Crown Cut (1914-1937)

269 "Corona," Crown Cut (1914-1937)
270 "Primrose," Crown Cut (1914-1937)
272 flowers and leaves, Crown Cut (1914-1937)
273 flowers and leaves, Crown Cut (1914-1937)
274 flowers and leaves, Crown Cut (1914-1937)
275 flower design, Crown Cut (1914-1937)
*279 "Floral" (1938-1961)
280 "Danube," Crown Cut (1914-1937)
300 small stars (1904-1937)
301 cherries (?) and leaves (1904-1937)

HAND CUTTING

ALL GENUINE HAND ENGRAVINGS.

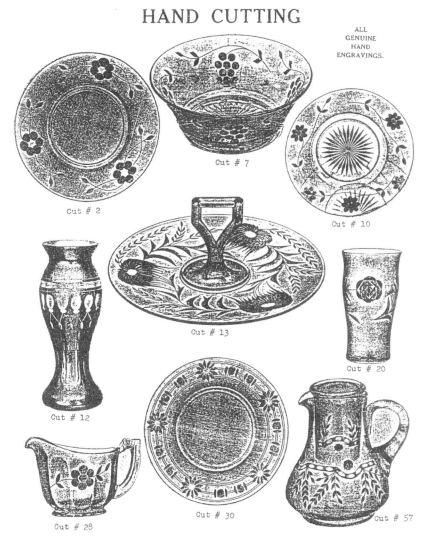

Cut # 2

Cut # 7

Cut # 10

Cut # 12

Cut # 13

Cut # 20

Cut # 28

Cut # 30

Cut # 57

*406 "Wreath" (1937-1938)
427 waffling & small, elongated ovals
428 deep, long elongated ovals & small diamond waffling
451 "Monticello" Ringing Rock Crystal Pattern, Crown Cut (1914-1937)
453 "Canadian Wreath", Crown Cut (1914-1937)
454 flowers, dots, and lines, Crown Cut (1914-1937)
455 "Flora", Crown Cut (1914-1937)

Hand Cutting

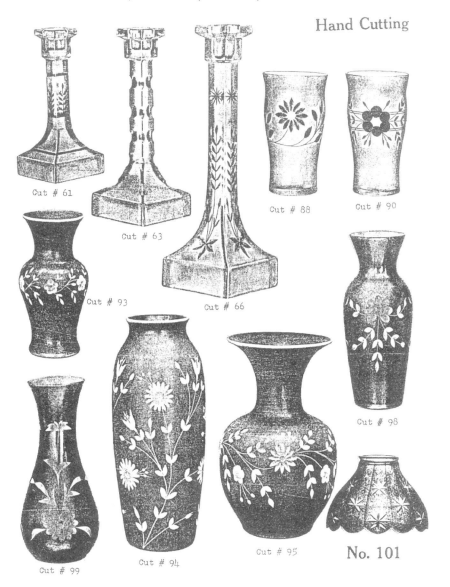

Cut # 61

Cut # 63

Cut # 66

Cut # 88

Cut # 90

Cut # 93

Cut # 98

Cut # 99

Cut # 94

Cut # 95

No. 101

457 "Catham", Crown Cut (1914-1937)
458 "Navarro" Rock Crystal Pattern, Crown Cut (1914-1937)
459 "Oak Leaf", Crown Cut (1914-1937)
460 "Regina", Crown Cut (1914-1937)
465 "Viking" Rock Crystal Pattern, Crown Cut (1914-1937)
526 small diamond design & elongated ovals (1965-7; 1970; 1971; 1973)
527 (1965-7; 1970; 1971; 1973)

Hand Cutting

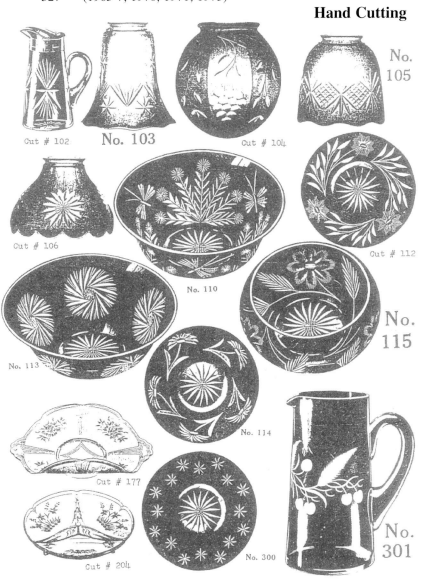

Cut # 102 No. 103 Cut # 104 No. 105

Cut # 106

Cut # 112

No. 110

No. 113

No. 115

Cut # 177

No. 114

Cut # 204

No. 300

No. 301

Fine Rock Crystal Cuttings By Crown

Hand Cutting

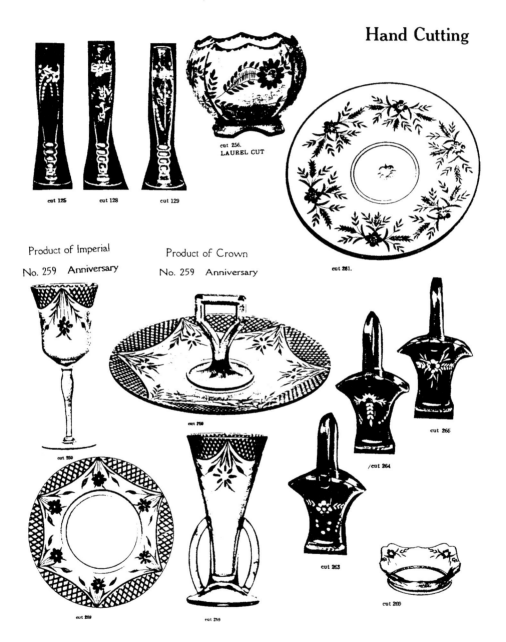

cut 256.
LAUREL CUT

cut 125 cut 128 cut 129

cut 261.

Product of Imperial

No. 259 Anniversary

Product of Crown

No. 259 Anniversary

cut 259

cut 260

cut 259

cut 259

cut 263

cut 264

cut 266

cut 269

Hand Cutting

Product of Crown

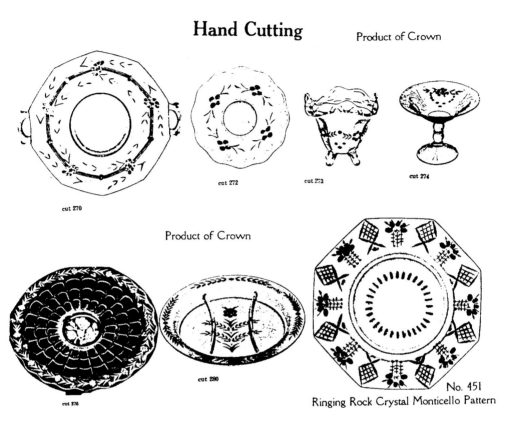

cut 270

cut 272

cut 273

cut 274

Product of Crown

cut 276

cut 280

No. 451
Ringing Rock Crystal Monticello Pattern

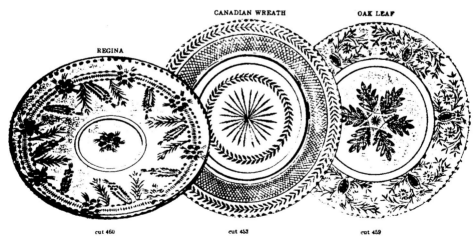

CANADIAN WREATH

OAK LEAF

REGINA

cut 460

cut 453

cut 459

Hand Cutting

Product of Crown

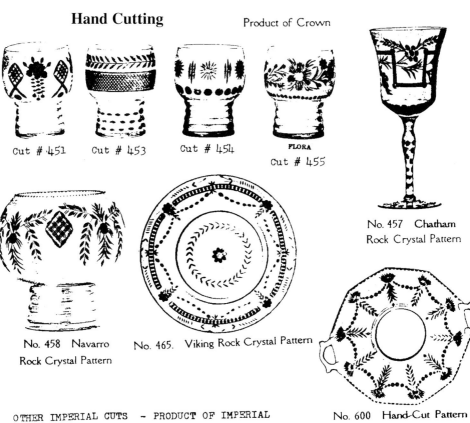

Cut # 451

Cut # 453

Cut # 454

FLORA
Cut # 455

No. 457 Chatham
Rock Crystal Pattern

No. 458 Navarro
Rock Crystal Pattern

No. 465. Viking Rock Crystal Pattern

No. 600 Hand-Cut Pattern

OTHER IMPERIAL CUTS — PRODUCT OF IMPERIAL

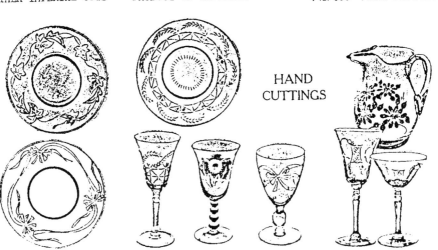

HAND
CUTTINGS

IMPERIAL CUT CRYSTAL

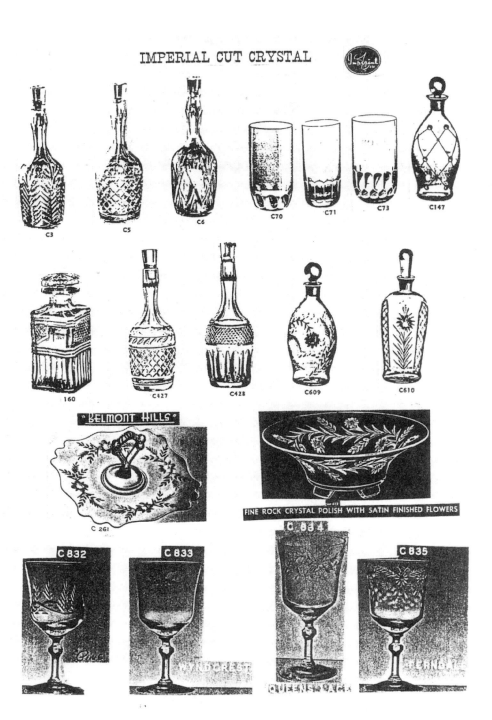

C3

C5

C6

C70

C71

C73

C147

160

C427

C428

C609

C610

"BELMONT HILLS"

C 261

FINE ROCK CRYSTAL POLISH WITH SATIN FINISHED FLOWERS

C 832

C 833

C 834

C 835

529	"Lancelot", 4 point stars — bottom point extended (1965-1967)
530	(1971)
531	(1971)
535	"Crown", bands of tall, thin painted ovals (1965-7)
545	single leaves intertwined on thin line branches (1965-7)
548	"Tulip Tub", circles & ovals (1965-7; 1970; 1971; 1973)
552	"Chimney Pot", circles & diamond waffling (1965-7)
555	(1965)
558	rope and thumbprint design (1965-7)
560	"Frieze", blocks (1966-7)
600	leaves and thistle, connected by looped beads, Crown Cut (1914-1937)
*601	(1938-1941)
609	bending stem with leaves, many-petaled filled-in open flowers
610	tall stems, line leaves, open flowers with extended centers
*611	(1938-1941)
690	(1969; 1970; 1971; 1973)
691	(1969; 1970; 1971)
*800	"Valley Lily" (1948-1957)
*801	"Fantasy" (1944-1949)
*802	"DuBarry" (1944-1949)
*803	"Princess" (1944-1957)
811	"Serenade" (1960-1961)
812	"Winter Berry" (1960-1961)
819	"Dawn" (1960-1961)
820	"Silver Spray" (1960-1961)
821	"Nosegay" (1960-1961)
822	"Elegance" (1960-1961)
823	"Springtime" (1960-1961; 1965)
824	"Rose Motif" (1960-1961)
824/DEC	"Rose Motif" and Platinum Band (1960-1961)
824/DEC	"Rose Motif" and Gold Band (1960-1961)
828	"Spruce" (1960-1961)
829	"Snowflake" (1960-1961)
830	"Regency" (1960-1961)
831	"Nobility", simplistic leaf design leading into line (1960-1961; 1966)
831	"Radience" (1970)
832	"Pine"
833	"Wyndcrest"
834	"Queen's Lace"
835	"Ferndale"
837	"Denise" (1970-1971)
842	"Elizabeth II" (1960-1961)
843	"Bridal Wreath" (1960-1961)
844	"Celestial" (1960-1961)

845	"Kimberly" (1960-1961)	
903	"Forever" (1960-1961)	
950	"Meander"	
951	"Celeste"	
952	"Today"	
953	"Sophisticate"	
954	"Valencia"	
955	"Variant"	
956	"Vanessa"	
957	"Valerie"	
958	"Leehouse"	
959	"Laureate"	
961	(1965; 1970; 1971; 1973)	

This listing shows 134 Imperial and Crown Cuts. There may have been many more. It is important to remember that the dates given are known production dates. Each cut could have been used more often than the dates indicate.

Harry Hain of Harrisburg, PA sent copies of a wheat pattern. He also sent a picture of a 400/42D 5-1/2″ 2-handled plate with a "dramatic cut design of stars, comets, and moons. The moons do not show too well in the photo or on the plate. They are ovals located between the stars and just after the stars, if you draw an arch through each pair of stars," stated Henry. This plate is now in the author's collection. This was Imperial's "Planetarium" cut. For picture see p. 20, Price Guide II.

Many of the pictures of Imperial cuts that are shown are not of the best quality for printing in a book. However, a collector appreciates what he can find, regardless of quality. Most pictures of the Cuts are from the NIGCS newsletter the GLASSZETTE, December 1985, March 1988, December 1988, and February 1991.

Imperial used the Optic pattern (vertical lines) on Candlewick in the late 1930's. The following 11 pieces with Optic pattern were found on price lists from 1937 and 1938, all having the #406 Cut "Wreath."

3400 Series:	Goblet	Saucer Champagne	Wine
	Claret	Low Sherbet	Cocktail
	Fingerbowl	Cordial	5, 9, 12 oz. Tumblers

According to research done by Willard Kolb, 14 3400's carried the Optic pattern with the Cut #406 "Wreath." That would also include, then, the remainder of the 3400 series stemware: Seafood Cocktail, Oyster Cocktail, and the Parfait.

The Optic pattern consists of a series of vertical lines on the bowl part of the stemware. In 1938 Imperial filled orders for 3800 Stemware with Optic patterned bowls for the Hunt Glass Works of Corning, NY, according to an Imperial memo. Here again, in the 3800 Stemware series, 11 pieces were listed as having the Optic pattern on the bowl:

Goblet	Low Sherbet	Cordial
Tall Sherbet	Cocktail	5, 9, 12 oz. Tumblers
Claret	Wine	Fingerbowl

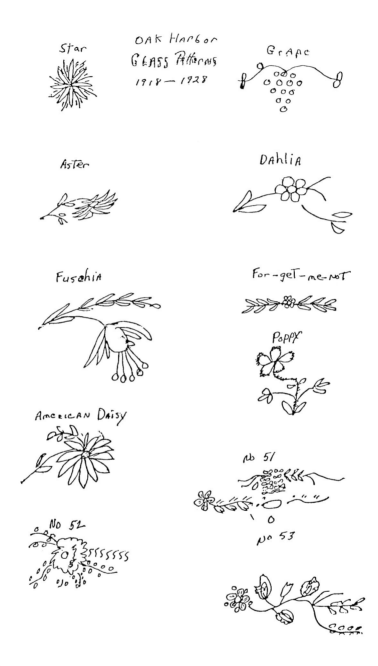

OAK Harbor
GLASS Patterns
1918 — 1928

Star

Grape

Aster

Dahlia

Fusehia

For-get-me-not

Poppy

American Daisy

No 51

No 52

No 53

However, a collector has found the 3800 Seafood Icer with the Optic patterned bowl, which brings the total of 12 pieces of the 3800 Stemware with Optic patterned bowls. See page 73 for picture of optic pattern.

The cuts used on Candlewick by Imperial will not be discussed here in detail, only listed, as they were dealt with extensively in CANDLEWICK THE JEWEL OF IMPERIAL, Book 1. They include the following:

C100	Dots	1937-1946	
C101	Polished Dots	1941	
C108	Starlight	1937-1961	
C279	Floral	1938-1961	
C406	Wreath	1937-1938	cut on 14 different Candlewick pieces
C601		1938-1941	cut on 34 different Candlewick pieces
C611		1938-1941	cut on 33 different Candlewick pieces
C800	Valley Lily	1948-1957	
C801	Fantasy	1944-1949	
C802	DuBarry	1944-1949	
C803	Princess	1944-1957	

Fact Sheet on Cuts

— Starlight pattern was called "Gray Stars" in 1943-1948. The stars have 6 or 8 points; 6 is prevalent. Eight point stars have an extra long point through the center.

— 400/103 Tall Cake Stand — seen with deep cut designs on the 3 large beads in the stem.

— "Mallard" Cut found on Candlewick consists of geese and rushes and was cut at Imperial.

— "Tied Ribbon Bow" Cut reported by collectors. Unofficial name.

— E. C. Kleiner, salesman for Imperial, states in his notes that patterns #601 and #611 did not have official names — just numbers.

— "Rock Crystal" is a term applied to a polished cutting.

— "Gray Cut" is the term used for an unpolished cut.

— Polishing makes a design sparkle and is done with acid or by polishing with cork wheels.

— Candlewick blanks were sold to companies which put cut designs of their own pieces or combined the blanks with silver and other metals or added silver overlay. One such company in Bellaire, Ohio, was Cam-Bel, owned by J. Morris DuBois, president of Imperial while it was reorganizing in the 1930's.

— Lotus Glass Co. purchased Imperial blanks for cutting and etching.

— The W. J. Hughes Co., Canada, bought glass from Imperial and other companies and put the Canadian Corn Flower cut on them. The company began in 1912 with originally designed hand cuts and put them on quality glass. Glass was bought in the U.S. and cut in the basement workshop of Mr. Hughes' home. The company was formed later. In 1975 the company was still in business as W. J. Hughes and Sons. Written as "Corn Flower," it is a delicate design of 12 petal flowers and leaves on line stems. The center of the flower had diagonal cross-hatching. The labels were shiny gold foil with dark blue writing: "Genuine Corn Flower by W. J. Hughes." Their cut and these

labels have been found on the 400/40 Mayo Set, 400/66B Compote, and the 400/30 Sugar and Cream. (information from Scott's newsletter, #57, p.2)

— A fish cut (7 fish) has been reported on a Candlewick 400/79R Candleholder.

— Joan Cimini, collector/dealer in Ohio, received a sheet of Oak Harbor Plant glass patterns from Clyde Cloud of Ohio, who got it from one of the cutters. The plant was a small one and has been out of business for a long time. The Fuschia, For-Get-Me-Not, Star, and Dahlia have appeared on Candlewick. The dates are wrong for Candlewick but maybe someone took over and used the design or bought them to use or just copied, Joan states. The sheet was dated 1918-1928 and had sketches of 11 cut patterns, which also include "Grape," "Aster," "Fuschia," "American Daisy," "Poppy," "No. 51," "No. 52," "No. 53." See page 120 for a copy of the Oak Harbor Cuts sheet.

Etches

The etching process begins after a design has been placed on a piece of glass by a special process. The rest of the item receives a protective covering of wax. The glass is then dipped into an acid bath. The unprotected glass is etched, leaving the wax-protected sections plain.

Probably the best example of etching on Candlewick is the Gold-On-Glass Punch Set. It is "etched wild rose pattern, encrusted with hand-burnished inlaid gold on glass." Thus states a Hammacher Schlemmer ad in GOURMET magazine in 1943. The 15 piece set was advertised for $125.00.

The Gold-On-Glass set was also made in 1953 for the 50th anniversary of Local Union No. 13 of the American Flint Glass Workers International Union. The anniversary celebration was held in Bellaire, Ohio.

On an Imperial Bulletin of January 31, 1949, the set is listed as 400/128/D.E. We assume the initials are Decorated and Etched. The DE have been used by Imperial on many other occasions to denote their decorated and etched glass.

About a dozen of these Gold-On-Glass sets have been reported by collectors across the country.

"In 1936, 3400 was born, nine patterns, pressed stems. It was offered in etched patterns as follows:

#6	Catawba
#10	Dalmally Thistle
#410/2	Fernwood
?	Rose of Sharon
?	Rose of Sharon garnished with bright gold

Not one of the patterns made the price list 1941."

The above paragraph (Scott's newsletter #44, page 2) from the notes of E. C. Kleiner, a longtime salesman for Imperial, gives some basic information on etches used on Candlewick Crystal. Below is a listing of the known etches to be used on Candlewick. There are perhaps many more, but names, num-

IMPERIAL GLASS CORPORATION, BELLAIRE, OHIO

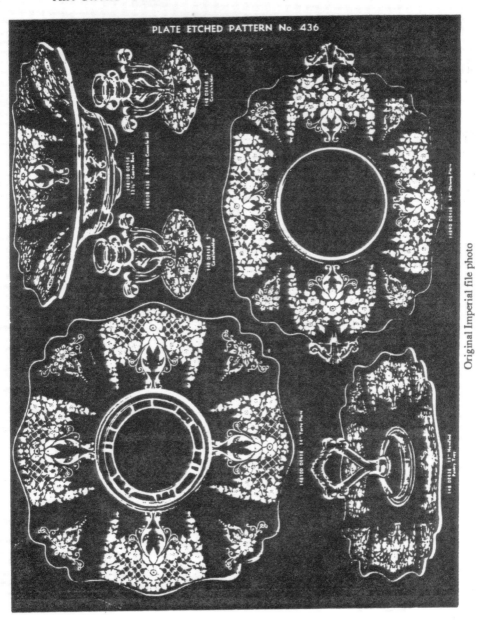

From NIGCS GLASSZETTE, February 1991

These are sketches from Imperial Glass Corporation files.
They show the "Garden Arbor" etch on a 9-1/2″ vase and an 8-1/2″ vase.
These sketches have been reduced 50% due to space.
The flowers look identical to the Gold-On-Glass etched punch bowl,
except there is no arbor on the punch set.
Etch #436, "Garden Arbor" This file photo is copied from the NIGCS's
GLASSZETTE, February 1991

bers, and dates have not surfaced.

#6	Catawba	1936-1940
#10	Dalmally Thistle	1936-1940
#410/2	Fernwood	1936-1940
# ?	Rose of Sharon	1936-1940
# ?	Rose of Sharon, Gold	1936-1940
#74E	?	1937
#481	?	1937
#603	?	1937
#440	Nora	1938

The remainder of the above information was taken from Imperial price lists and bulletins.

Myrna Garrison, Arlington, Texas, has an Imperial memorandum dated 6-15-48 that refers to the 3 etches — "Catawba", "Dalmally Thistle", and "Fernwood" as having been put on 9 items of 3400 stems — in each etch pattern.

. The dates of the first five etched patterns are guesstimates derived from the Kleiner notes. Perhaps the Rose of Sharon is the proper name for the wild rose pattern on the gold punch set. Wild rose also could be a generic name for the rose pattern.

No records have been found on the etches for 1939-1940.

Fact Sheet on Etches

— "Rose of Sharon" is also listed as a *decoration* used on Candlewick.
— "Rose Point" etching was used on Imperial glass in 1970; perhaps it was also put on Candlewick.
— Several collectors have reported a strawberry pattern etch.
— Richard Ross of Bellaire, Ohio, states that a flower and leaf design was done on Imperial ware by Franz Hess. Hess did deep etching on vases, bowls, etc. Richard saw the 400/68D Pastry Tray with Morning Glory Etch done by Hess.

Trader Vic Etched Logo

Jerry Gallagher, author and publisher of the Morgantown Newscaster (a quarterly journal of Morgantown Collectors of America) wrote in the February 1992 issue of THE DAZE about the connection between Morgantown Glass and Imperial. He states that Imperial did a lot of glass work for the two Morgantown Glass Works. In an interview he did with a former Morgantown executive, the executive is quoted as saying that "Imperial probably represented the company which we did the most production for." Mr. Gallagher continues, "This brings to point the main reason for this month's article: the Polynesian Bis MAI TAI Stem by Morgantown and the TRADER VIC Stem by Imperial".

As to the TRADER VIC logo, he states "The Imperial Glass Company of Bellaire, Ohio, took over the Trader Vic Restaurant account in 1962 and, with Morgantown's production assist, continued to supply the restaurant chain with this distinctive stem line..." According to Mr. Gallagher, the Morgantown executive explained that Imperial would issue a yearly contract to Morgantown for, say two hundred dozen—50 dozen to be shipped to Bellaire now, another 50 dozen in three months, and so on. He said huge numbers of these stems were constantly needed since Trader Vic allowed anyone who ordered a drink to "confiscate" the stem when they were finished. He stated that it was a high class giveaway program.

Now as to the connection to Candlewick — we know that the Morgantown stem and the Imperial Trader Vic stem are one and the same, thus proving there was an Imperial Morgantown marriage in the Trader Vic line. A number of col-

lectors have found the Trader Vic logo on Candlewick. This author has one on the 400/330 13 oz. pitcher. We must assume that some of the pieces collectors are finding with the Trader Vic logo were made for Morgantown Glass Works since items like the 400/330 pitcher were made by Imperial between 1950 and 1954. Imperial didn't take over the account until 1962, so Imperial must have been filling orders for Trader Vic Restaurants by supplying its wares to Morgantown Glass Works. The 400/330 might have been used in the Trader Vic Restaurants as regular utilitarian ware.

Often collectors refer to the Trader Vic logo as a "knight."

Page from April/May 1957 Imperial spiral Memo Calendar.
The bowl in the picture has been turning up occasionally in the past few
years. Now we have definite proof that the Hostess Set is Candlwick.
It is 12″ in d., 2-1/4″ deep, center seat is 2-1/2″ to receive 400/40B 5-1/2″
Dip Bowl. See p. 253 for picture of calendar cover.
Information is from Myrna Garrision; calendar is in her collection.

CHAPTER 6

INTRODUCTION TO I. RICE

Imperial designed and produced crystal pieces in the Candlewick pattern for Irving W. Rice and Company, 15 W. 34th Street, New York. Irving Rice's logo was IRICE, which is sometimes found on labels on Candlewick mirrors, perfumes, powder jars, dresser trays, clocks, and boudoir sets.

According to Roserita Ziegler, in her article in the National Imperial Glass Collectors Society newsletter, GLASSZETTE, of August 1983, entitled "Irving W. Rice Perfume Bottles Made By Imperial Glass Company U.S.A.", World War II had a great effect on glass making in the U.S. because "the scarcity of chemicals and other vital ingredients caused some companies to fall on hard times. But some glass companies flourished because of the demand for certain types of glass that could no longer be imported. One such company was the Imperial Glass Company." Sketches found in Imperial's archives showed the Irving W. Rice name, thus proving the link that existed between Imperial Glass Company and IRICE.

Other articles written by Ziegler give still more information on the IRICE Imperial connection. This information is taken from Ziegler's articles of August 1983 and February 1984 entitled "Imperial Art Glass Company, Irving W. Rice Account, 1941-1945." These articles were printed in the NIGCS newsletter, GLASSZETTE.

The author states that sketches of perfume bottles, colognes, powder jars, salts and peppers, found in Imperial's files in 1982, were dated 1941 through 1945.

One page, says Ziegler, was dated 4/20/41. Several items were labeled "Tray Handles" which verifies what is already known — that dresser trays were part of the IRICE line.

The listing of items made for IRICE by Imperial is as follows:

— powder jars — cologne/lotion bottles
— clocks — Boudoir sets with 400/151 mirrored trays
— hand mirrors — standing mirrors
— handles for dresser trays — salts and peppers (no proof other than sketches found)

For some of these items collectors have offered various bits of information derived from actually having the article in question. Combining all the information received, each item is discussed separately.

Boudoir Sets

These sets consisted of two 6-1/2″ cologne bottles, a puff jar, 4″ clock, and a dresser tray. Not all sets had five pieces. Sometimes the sets were offered with only one bottle; sometimes without a tray, and other times without a clock. In an ad in BETTER HOMES & GARDENS in the June 1942 issue, the five piece set was shown. The caption reads: "Imperial Candlewick design

from Irving Rice & Co., 15 W. 34th St., New York."

The Boudoir Sets were offered from 1940 to 1942, as far as can be determined from ads and Imperial's files.

Bottles

The perfume bottles, also called colognes, could be used as lotion bottles. The bottle is 6-1/2"-7-1/2" high. Large beads surround the base; the stopper has four beads with the largest at the base of the stopper. The bottle was no doubt made from the same mould as the 400/25 Bud Ball Vase.

Various decorative cuts, mostly Starlight, have been found on the bottles. The perfume bottles have been found with base and stopper beads painted gold.

The bottle is part of the Boudoir Set. This piece is thought to have been produced from 1940 to 1942.

Imperial made perfumes and stoppers in many other patterns. Their stoppers were interchangeable. Other companies also made stoppers for Imperial's colognes. Several of these companies are Gunderson-Pairpoint Glass Company, and Rene Lalique of France. Imperial files never showed that any company other than Imperial made the Candlewick pieces for IRICE. However, it is presumed that Rodefer Glass Works of Bellaire made some bottle stoppers for Imperial for IRICE. Willard Kolb, former president of the National Cambridge Collectors, while doing research in the Rodefer Glass Works building in Bellaire in the late 1980's discovered some Candlewick bottle stoppers. See Rodefer Glass Works (Chapter 2) for more information on this company.

Clocks

Owning a Candlewick clock made by Imperial is one of the dreams of any devoted Candlewick collector.

There are not many official pictures of the clock Imperial made for IRICE. Pictures of the clock are shown in Imperial ads in BETTER HOMES & GARDENS magazines of December 1940 and June 1942.

By late 1985 clocks were selling to collectors between $200 and $275. Today they are in the $400-$500 range.

The Boudoir Clock is 4" in diameter. Large beads surround the face. From all accounts it seems the clock dates 1940-1942. A second style is owned by an Ohio collector; hers is made with the 400/34 4-1/2" plate. The plate edging has the regular small beads. This clock has the New Haven mark on the face. Both style clocks have identical mechanisms, so it might be assumed they were produced during the same years.

Still another style Candlewick clock (with a double row of beads) has been located. It is marked "New Haven — Made in U.S.A."

The standing easels for the clocks are metal, the approximate thickness of a coat hanger. The easel is attached to the sides at the back and has small metal pins which act as pivots to tip the easel out to set the clock up or to fold it flat. (Description taken from Virginia Scott's newsletter, #49, p.3)

Puff Jar

The Puff Jar made for IRICE has a three-bead finial on the cover. It is also part of the Boudoir Set. The jar is not the 400/149 Sherbet although it looks identical. The Puff Jar base is larger; the jar is taller, and wider at the rim, than the Sherbet. It was made approximately 1940-1942.

Mirrors

Numerous mirrors have been discovered by collectors and attributed to Imperial's Candlewick. However, only 3 have been authenticated as Candlewick: a desk mirror, a hand mirror, and a mirror with the 400/18 base.

The desk mirror is round, 4-1/2″ in diameter, has two feet, large-bead edge, and question-mark stand like the coffee cup handle. This mirror has been found with a silver and black shield shaped label: "An IRICE Product." All known mirrors have a magnifying surface.

Some of the desk mirrors have been found with a spring-wire to hold the mirror in place. Other mirrors are glued.

This item has also been found without the mirror, perhaps as a frame for a picture. Whether this was a separate item or a change-over is not known.

Lucile Kennedy, former Marketing Manager for Imperial, said Imperial made a hand mirror for IRICE Company.

At least half a dozen mirrors made with the 400/18 base have also been discovered by collectors (IRICE #E55). They hold a brass two-sided flip-over mirror. It is a stand-up double mirror encased in brass; the base is the 400/18 Cocktail base.

Flip-over hand mirrors have also been found by collectors with "Japan" labels. They have 3-1/2″ 5-bead glass handles with a brass holder or frame holding the mirror. A brass swivel is used to flip the mirror over from regular to magnifying. This mirror was reported as early as 1979.

Trays — Perfume? Dresser?

Lucile Kennedy said that Imperial made handles for dresser trays for IRICE. One of the trays, 400/159, was fitted with a mirror insert for the Boudoir Set.

Several different IRICE dresser trays with Imperial-made handles have been found by collectors. One such style is owned by a Logansport, Indiana collector. Each handle is a semi-circle with the rounded edge having very large Candlewick beads. The inside edge is straight with 2 holes for fastening to an oblong mirrored tray. This is IRICE #E917.

Some of the IRICE trays are advertised as perfume trays: "Smart Modern Perfume Trays for Bottle Ensembles." Pictures of four styles were shown in an IRICE advertising booklet found in Imperial's files. One is a round 10-1/2″ Candlewick tray with mirrored center (IRICE #E666), and the other three have Imperial beaded handles.

The IRICE advertising booklet page with the tray pictures is courtesy of the Elinor Hammond Estate, Bellaire, Ohio.

Descriptions of the other two oblong trays are as follows:

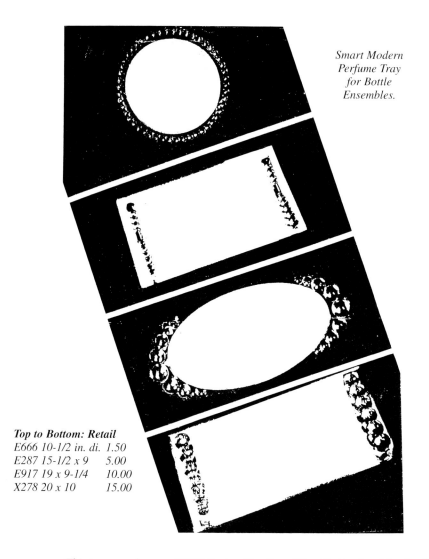

*Smart Modern
Perfume Tray
for Bottle
Ensembles.*

Top to Bottom: Retail
*E666 10-1/2 in. di. 1.50
E287 15-1/2 x 9 5.00
E917 19 x 9-1/4 10.00
X278 20 x 10 15.00*

*This is a page from an IRICE (Irving Rice Co. of New York) advertising booklet.
Many IRICE products were made by Imperial.*

1. The mirrored tray is 18″ X 9-7/8″ (IRICE #278). IRICE ad shows this tray is 20″ X 10″. The glass beads, the size of the largest bead on the puff jar, are screwed onto the tray from the bottom. The areas from the beads to the edge is not silvered. The area between the two sets of beads is silvered for a mirror.
2. This tray is also oblong, 14″ X 10″ (IRICE #E287). IRICE ad shows this

tray as 15-1/2″ X 9″. The crystal, beaded handles have brass centers.

Another "Candlewick" tray has been reported by several collectors, but no attribution has been determined. It is possible, of course, that it is also an IRICE product.

The tray is a 15″ plate with a 1″ pedestal base. It has a cut floral pattern around a 10-1/2″ mirror which is bright blue. The tray has "hanging clips" on the back for hanging the mirror. The crystal is drilled to secure the mirror by four brass screws and clips. Three of these hanging mirrors have been reported by collectors. One mirror had an extra piece attached to hold a plant or candle.

Salt and Pepper

The only information known about salts and peppers made for IRICE is the reference by Roserita Ziegler in her article mentioned at the beginning of this chapter.

Although it seems quite a bit of information is already available about the Imperial IRICE connection, there is still much more to be uncovered. Copies of the IRICE brochures, bulletins, and advertising booklets would prove invaluable in completing this information.

CHAPTER 7

CONFUSING SIMILARITIES

INTRODUCTION

When it comes to confusing similarities to Candlewick, an entire book could be written on the subject. Beads hung from large shades in the 20's. Clothes also sported beads and beading — many dresses were decorated with beads. The 30's and 40's were also characterized by beads: Candlewicking in crafting was in. Beaded glassware was offered by most glass companies. Many Candlewick collectors use the term "copies" or reproductions. Most beaded glass of the 1930's and 1940's are not Candlewick reproductions. They merely show the style of the period. Granted, companies copied from each other; artisans worked for one company, then became employed by another, taking ideas and designs with them.

This chapter, therefore, is called confusing similarities — it is a listing of look-alikes that are out there and need careful scrutiny before considering a purchase.

The following is a listing compiled from the letters and stories from many Candlewick collectors. It may help someone who has found that unusual piece that looks suspicious.

— **Bowl.** While a guest speaker at the Lakeland Glassaholics Club in Lakeland, FL, I saw a display of Candlewick items. In the center of all that glass was a piece I didn't recognize. The small sauce bowl was approximately 7″ in diameter. The beads looked authentic, but there was the "Czech" ridge just below the beads inside the rim. The bottom was unusual in that it was totally rounded. The base was slight and fit right in with the roundness of the outside. The base ring was polished. The owner of the sauce bowl said she has a set of six.

— **Stemware.** Carmen #3103 by Cambridge has similar characteristics to Candlewick. The wafer under the bowl seems identical; however, under the wafer is a small section or circle of 8 vertical panels. That section is very small, but it can easily be felt. The stemware was also made with ruby bowls, thus making them a highly confusing similarity. Cambridge made the following pieces of stemware in the Carmen pattern: 10 oz. goblet, 6 oz. low sherbet, 3-1/2 oz. cocktail, 3 oz. wine, 4-1/2 oz. claret, 5 oz. oyster cocktail, 1 oz. cordial, 12 oz. footed iced tea, and 5 oz. footed tumbler.

— **Creamer & Sugar.** Laura Murphy, Pasadena, CA, found a creamer and sugar set that was suspect. The cut pattern, she felt, was of inferior quality. The handles are the familiar question mark type. On the bottom of each piece Laura found "FRANCE" in raise letters. Could these be the original old French Cannonball pattern that Mr. Earl Newton, president of Imperial after their 1931 bankruptcy, bought in New York and from which came his inspiration for the Candlewick pattern?

— **Salad Set.** A confusing salad set with fork and spoon was seen in a gift shop in Ontario, Canada. The bowl looked like Candlewick. The label read "Made in Europe." The fork and spoon were not look-alikes. Similar patterns are marketed in Europe, possibly Boule or Lalique. Two different collectors reported these sets; both saw them in Ontario, one as early as 1980.

— **Coaster.** Beaded-edge coasters have been seen with various center designs: leaves, fruit, and red roses and bright green leaves. Some were sold at Zayre Department stores. I purchased one with fruit in Wheeling, West Virginia; Kathy Burch, Ithaca, Michigan, found hers in California. Kathy's has the painted red roses and green leaves. An inscription moulded into the glass in Kathy's says "made in GERMAN DEMOCRATIC REPUBLIC." Kathy saw these in boxed sets of four.

— **Mayo Set.** Myrna Garrison, Arlington, Texas, reported examining look-alike 400/23 2 pc. mayo sets. The owner had 10 sets. On the bottom of one liner plate the following was found in acid etching: TCHECOSLO-VAQULE. Myrna was told that was the French spelling for Czechoslovakia. Myrna also noted that only two of the liner plates were marked out of the 10 plates and 10 bowls.

— **Cake Plate.** Myrna has an 11″ plate fastened to an inexpensive chrome base about 2-1/2″ tall. She states the most distinguishing thing about the plate is that it has the same wavy effect around the outer edge where the beads attach. It also has a ground bottom with an indention.

— **Bowl.** George Ruskell, Sullivan, Missouri, reports a small beaded bowl resting on a Mikasa plate. It was advertised as a chip-n-dip set. The bowl is a real fooler, looking like the 400/23 mayo bowl.

— **Tiered Tid-Bit.** Shown in the Ohio Candlewick Newsletter of January, 1992, was a picture of a 3-tiered tid-bit in a Peter Pan Peanut Butter ad from the November, 1961, issue of McCALL'S MAGAZINE. It looks like Candlewick in milk glass. The center post has a circle ring at the tip. The middle and lower plates are cupped; the smaller top plate is almost flat.

— **Relish Tray.** A large, 5-sectioned relish tray has been reported. The center round section is for a mayo or dip dish; beads around the edge of the tray are very close together.

— **Lamps.** Elinor Eaton, Aurora, Colorado, found an unusual pair of lamps at an antique show. The base looks like the 5″ ash tray upside down, Elinor says. The center rod is silver encased in a crystal cover with a cut design. A 3″ ball (somewhat like a candle socket) connects the base and the rod. In all, the lamps are 15″ high. Elinor was told by the seller that the lamps originally came from a jewelry store that sold Candlewick. Another dealer added that there was a lamp company in California that made a lot of lamps from crystal.

— **Relish.** Collectors have reported quite a number of the oval 6-sectioned relishes. Attribution has not been established. Sizes vary from 13-3/4″-14″ long, 9″-9-1/2″ wide, 1″-1-1/2″ deep, with an oval center 5-1/2″ long.

It is very heavy glass. Collectors have found the piece in a fancy chrome tray with a chrome cover on the center section; relishes have also been located without the chrome accents. Rim beads are closer together than Candlewick beads.

New Candlewick
Dalzell-Viking Candlewick

The Dalzell-Viking Glass Company of New Martinsville, West Virginia, has been producing Candlewick from the Imperial moulds since 1990. The moulds are owned by Mr. O.J. Scherschligt of Lansing, Michigan, also owner of Mirror Images. The moulds were purchased by Scherschligt when Imperial was liquidated in 1984. (See Chapter Three, Moulds, for more information.)

New Candlewick is being sold through Dalzell-Viking factory stores, gift shops, jewelry stores, and department stores. A company executive said that none will be sold through discount stores.

New Candlewick was first introduced in November 1990 with a five piece setting in crystal and in colors. A setting consisted of a 10-1/2″ dinner plate, 8-1/2″ salad/dessert plate, 6″ bread and butter plate, and a tea cup and saucer. The settings were available in Crystal, Cobalt, Evergreen, Ruby, and Black. Suggested retail price for a five piece setting was $75; Ruby $95.

Comments from those who have seen the Dalzell-Viking Candlewick are varied:

— $10.20 for an 8″ plate? — Round beads/seem larger
— Weight not bad — Ground bottoms — not the best
— Color is good — Looks good
— Weight heavier — Awful job of attaching handles to cup
— Clearly marked — Not marked
— Acid-etched DX on — Good quality
 seconds is very hard to see

Virginia Scott gave the dimensions in one of her Candlewick newsletters:

	8-1/2″ Candlewick Plate	Dalzell-Viking Candlewick
Diameter:	8-1/2″	8-1/4″
Number of Beads:	50 (1/4″ d.)	45 (5/16″ d.)
Weight:	11-1/2 to 12 oz.	17 oz.
Summary:	lighter, more and smaller beads	heavier, fewer and larger beads

More information on the new Dalzell-Viking Candlewick can be obtained by writing to Dalzell-Viking Corporation, PO Box 459, New Martinsville, West Virginia 26155. Kenneth Dalzell, former president of the Fostoria Glass Company is the owner.

The following have been produced by Dalzell:

Plates:	6″, 8″, 10″, 12″
Tea Cup and Saucer	
2-Handled Bowls:	5″, 6″
2-Handled Trays:	5″, 7″, 8″
* Divided Relish:	10″ (five part, 5 handles)

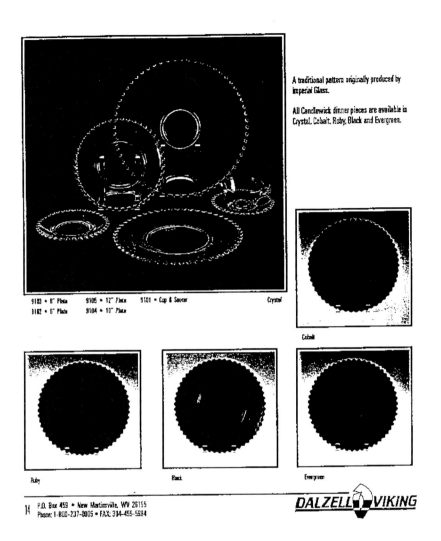

Page from a Dalzell-Viking advertising catalog

Bowls: 6-1/2″, 7″, 7-1/2″, 8″, 8-1/2″, 10-1/2″, 12″
* This is the 400/56 5-part Relish with the round center compartment for a condiment jar — making this a 6-part relish.

Over 200 Candlewick moulds are owned by Scherschligt; there has never been a complete listing of the moulds made available to collectors. These moulds, stored in the basement of the Dalzell-Viking plant, could all eventually be used to produce more Dalzell-Viking Candlewick.

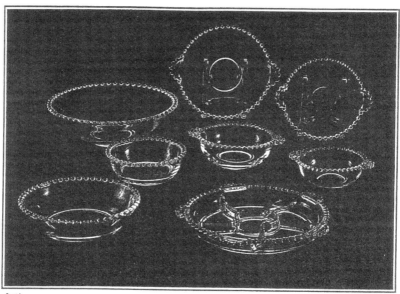

Crystal

9113 • 10 1/2" Bowl
9109 • 8" Two-Hdl. Tray
9107 • 7" Two-Hdl. Tray
9112 • 8 1/2" Bowl
9111 • 6 1/2" Bowl
9108 • 6" Two-Hdl. Bowl
9106 • 5" Two-Hdl. Bowl
9110 • 10" 5-Part Relish

Candlewick serving pieces are available in Crystal only.

P.O. Box 459 • New Martinsville, WV 26155
Phone: 1-800-237-0005 • FAX: 304-455-5984 15

Page from a Dalzell-Viking advertising catalog

A collector from Burlington, Iowa, reported buying a 400/72D 8-1/2″ handled plate with a rye cut pattern from the Warsaw Cut Glass Company in Warsaw, Indiana in April 1991. The price was $22.00. The tray is Dalzell. The cut glass company buys the blanks, adds the cuts, and then sells the cut pieces.

All Dalzell-Viking Candlewick is marked with DALZELL, according to Mr. Kenneth Dalzell. However, collectors have found many unmarked Dalzell Candlewick pieces.

In 1993 Dalzell was making Candlewick in Crystal and Cranberry Mist (a very pale cranberry) only. All other colors had been dropped.

PRICE COMPARISON — 1991

Imperial Mould #	Viking Order#		Item	Retail Prices for Bl., Cry., Cob. Ever.	Retail Price for Ruby	Imp. C'wk Pr. in Cry
400/1D	9102	6"	B&B Plate	$12	$15	$5-7
400/5D	9193	8"	Salad/Dessert	$17	$22.50	$6-13
400/10D	9104	10"	Dinner Plate	$23	$30	$25-32
400/13D	9105	12"	Service Plate	$32	$40	$23-30
400/35	9101-3		Tea Cup	$11	$14	$4-8
400/37	9101-4		Saucer	$11	$14	$2-6

A 5 piece setting of Imperial Candlewick in Crystal cost approximately $65 to $96.

A 5 piece setting of Dalzell's new Candlewick in Crystal, Black, Cobalt, or Evergreen cost $106 if purchased by the piece ($75 in set); Ruby cost $135.50 if purchased by the piece ($95 in set).

Boyd's Candlewick

Boyd's Crystal Art Glass Company, 1203 Morton Avenue, Cambridge, OH, owns numerous Imperial moulds, including 18 Candlewick. Their ware is considered "Boyd's Candlewick" by collectors. All of their pieces are marked accordingly:

1978-1983	B inside diamond
1983-1988	B inside diamond; line under diamond
1988-present	B inside diamond; lines both underneath and above diamond — this present mark will be used for 5 years

Boyd's uses many colors in their wares including the following which have been used in the production of Boyd's Candlewick:

Alexandrite	Heliotrope (opaque, iridescent purple)	Plum
Amberina Red	Indian Orange (opaque, pale orange)	Ritz Blue
Autumn Beige	Lemonade	Rosewood
Azure Blue (opaque bright blue)	Lilac (opaque purple)	Rubina
Bermuda Slag	Lime	Rubina Blue
Black	Mauve	Ruby (red)
Budding Pink (opaque pink)	Milk White Opal (opalescent white)	Seafoam (bottle green)
Cambridge Blue (Crystalline pink with tint of blue)	Misty Vale (opaque light-blue gray)	Shasta
Carmel Slag	Mulberry Mist	Spinnaker Blue
Carmel	Oleander	Sunflower
Cobalt	Olde Lyme	Touch of Pink

(Crystalline blue)

Brown Tuscan	Orange Spice	Vaseline
Custard	Pistachio	Winter Blue
(light yellow)		

Winter Swirl (opaque white slag with colors)

For more information on Boyd's, see Chapter 3, Moulds, Boyd's.

Anchor Hocking "Berwick" (Boopie)

Berwick is a pattern produced by the Anchor Hocking Glass Corporation of Lancaster, Ohio. This is their 700 Line. It was introduced in 1951 in crystal glass. It was first advertised as the "Berwick" pattern in Hocking's 1965 catalog and offered in crystal only. The 700 Line was advertised as early as 1950 in Belnaps Catalog; then it was called "Cornet," and it was shown in crystal decorated with a gold band.

In 1975 the Line was sold at Woolworth stores with the "Berwick" label. This Line was also made in colors:

E-700	Emerald Green	1954
M-700	Dessert Gold	1961
R-700	Royal Ruby	1963
?	Bright Blue	?

All items had crystal feet regardless of bowl color.

The candleholder often seen in the same style is also Anchorglass by Hocking.

Much of this information was taken from an article in the October 1976 GLASS REVIEW magazine.

Many pieces of the "Berwick" pattern have been found with various decorations: gold trim, cuttings.

The "Boopie" name was given to the "Berwick" pattern by Hazel Marie Weatherman in her book COLORED GLASSWARE OF THE DEPRESSION ERA, Book 2, page 147.

There is no real similarity to Candlewick's 400/190 series other than the beads around the base for both patterns. However, the novice collector, especially, must study the differences to be able to discern which pattern is which.

Pegged Bowls and Plates

Pegged pieces are very desirable items to collectors. They often bring top dollar, especially if the base is sterling silver. So it behooves the collector to be certain a combination glass and metal piece is truly Imperial Candlewick.

Listed below are pegged items that have been confused with Candlewick, as reported by collectors.

— 4-1/2″ bowl, 1″ deep, fluted
— 6″ plate
— 6-3/4″ plate with sterling base
— 8″ plate

— 10-1/2″ cake plate with star design center; peg stem is 3/8″; 4-1/2″ high; beaded edge

These items have been found married to various metals: sterling, silverplate, brass, chrome, and unknown-metal bases. In one of Virginia Scott's newsletters, she shows an ad from an Old Croydon Silvermart catalog. The ad contains a "Convertible Crystal and Crystal Cake Stand." Shown is the pegged plate with a sterling base that converts to a candleholder. "Diamond pattern with beaded edge" is the way the design is described. These pegged plates and bowls are sometimes permanently affixed in the metal bases. This pattern is similar to the depression glass pattern "Anniversary" which was made for the first time in 1947 by the Jeanette Glass Company. Whether these pegged pieces were also made by Jeannette remains to be determined.

As an added note: if a collector buys a pegged Candlewick piece without a base, then purchasing a look-alike with a base, if not too expensive, makes good sense. The pegged piece of glass can usually fit in other bases, and the Candlewick pegged item is then complete.

Confusing Similarities by Glass Companies

PADEN CITY GLASS MANUFACTURING CO. was in existence from 1916 until 1951. Their 1503, #444 "Alexander," and #444 "Vale" are often confused with Candlewick candleholders. Their #1504 center bead-handle tray is also anther confusing similarity.

Canton Glass Company, Marion, Indiana, was taken over by the Paden City Glass Company. Following is a more detailed account of the Paden City/Canton similarities to Candlewick:

— #555 Line, "Vermillion," 10-1/2″ round 5-sectioned relish. This tray has a round center to receive the jar. One big difference that should be noticed immediately is that every so many beads there is a large bead. This pattern with the large bead continues around the rim of the relish.

— #555 Line "Vermillion," 11″ 3-sectioned relish. The design is similar to the Candlewick 400/56 10-1/2″ 3-long-sectioned relish. Again it has the small bead/large bead pattern.

— #1504 11″ "Chaucer" sandwich tray and 10″ nut tray have graduated three-bead center handles; beads are small at tray to large at top of handle.

— #1503 #300 Line 2-3/4″ single candleholder with thick flat base and candle well in a large rimless bead. This is confused with Candlewick 400/280. The Candlewick candle well is rimmed. The Paden City candleholder has a "riser" for a stem.

— #444 Line "Vale," 4-bead candleholder, candle well is round ball with no extra rim; flat footed, 6″ single candlestick which resembles Candlewick 400/175, which is slightly domed and has a slight rim around the candle well. The 400/175 has a three-bead stem, while the Canton has a 5-bead stem.

— #444 Line, "Alexander," 5″, 2-way candleholder has 2 candle wells,

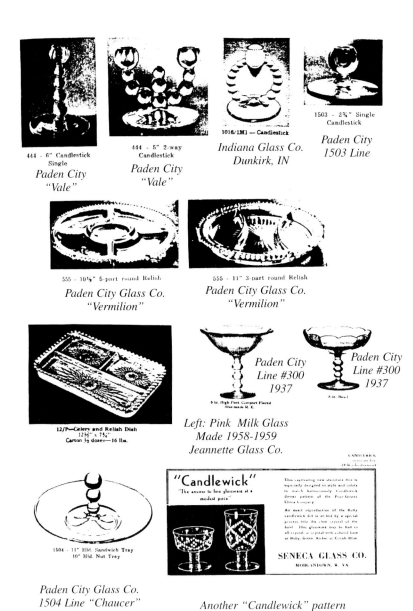

444 - 6" Candlestick Single
Paden City "Vale"

444 - 5" 2-way Candlestick
Paden City "Vale"

1016/1M1 — Candlestick
Indiana Glass Co. Dunkirk, IN

1503 - 2¾" Single Candlestick
Paden City 1503 Line

555 - 10¼" 5-part round Relish
Paden City Glass Co. "Vermilion"

555 - 11" 3-part round Relish
Paden City Glass Co. "Vermilion"

12/P—Celery and Relish Dish
12½" x 7¼"
Carton ½ dozen—16 lbs.

8 in. High Foot Compact Flared
Also made R. E.
Paden City Line #300 1937

8 in. Bowl
Paden City Line #300 1937

Left: Pink Milk Glass Made 1958-1959 Jeannette Glass Co.

1504 - 11" Hld. Sandwich Tray
10" Hld. Nut Tray
Paden City Glass Co. 1504 Line "Chaucer"

"Candlewick"
"The answer to fine glassware at a modest price"

SENECA GLASS CO.
MORGANTOWN, W. VA.

Another "Candlewick" pattern

These pictures are from Hazel Marie Weatherman's series of GLASSBOOKS

Anchor Hocking

The Seneca Glass Co. has brought out this new shape in a combination crystal bowl with colored stem and foot, especially suitable for novelty items, such as the brandy, cordial, and cocktail glasses illustrated. Six colors are available, a light and a dark green, a light and a dark blue, amber, and amethyst.

"BAUBLES"
glassware line,
1931 trade journal

Seneca Glass Co. Weatherman, Book 2, p. 311

"BOOPIE" Tumblers
9-oz, 4-oz, 3½-oz, 6-oz

Anchor Hocking Glass Co. Formal name "Berwick" Weatherman, Book 2, p. 147

Unidentified look-alikes — From Virginia Scott's newsletter "Candlewick Collector," Athens, Georgia

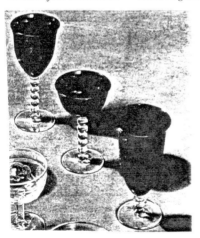
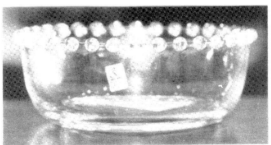

ABOVE: From the collection of Myrna and Bob Garrison, Arlington, Texas. Purchased at T.S. Maxx for $7.99.

LEFT: Line #720 Bryce Brothers Glass Co. Ruby and Crystal Stemware. Weatherman, Book 2, p. 271

COLORED GLASSWARE
Carmen

3103
10 oz. Goblet

3103
6 oz. Low Sherbet

3103
3½ oz. Cocktail

3103
3 oz. Wine

3103
4½ oz. Claret

3103
5 oz. Oyster Cocktail

3103
1 oz. Cordial

3103
12 oz. Ftd. Ice Tea

3103
5 oz. Ftd. Tumbler

555
7½ in. Salad Plate

152-C

Cambridge, Ohio - - - U. S. A.

From a Cambridge Glass Co. advertising catalog

1 at each end of a semi-circle of beads. The center has 2 more beads pointing upward without a candle well on top. The base is flat. This has been confused with Candlewick's 400/147.

BRYCE BROTHERS GLASS COMPANY, Mount Pleasant, PA, produced a beaded stemware pattern that is cautiously similar to Candlewick's beaded-stem series. The stems are shown for comparison.

CAMBRIDGE GLASS COMPANY, Cambridge, Ohio, introduced a look-alike to Candlewick's 3800 series. This series is a dead ringer for the 3800 goblet and other items in the 3800 Imperial line. The difference is not obvious: the #3103, "Carmen" series has 8 vertical ridges, making panels, directly under the bottom of the bowl on the wafer.

INDIANA GLASS COMPANY, Dunkirk, Indiana, has a #1016/1M circle Candleholder.

JEANNETTE GLASS COMPANY, Jeannette, PA, manufactured an oblong 3-sectioned relish that has been reported by numerous collectors. Size reported varies: 7″ X 10″, and 7-3/4″ X 12-1/2″. The piece is very heavy glass with a pressed floral pattern on the underside. One collector reported the design has 22 points or petals and also red flashing. The design has also been referred to as "rays" or a "sunburst" in each of the three section of the relish. Various colors have been noted by collectors: crystal, flashed-on red, pink milk glass, clear with sprayed-on colors, flashed-on blue, and amber.

The information on these glass companies is from Hazel Marie Weatherman's *Colored Glass of the Depression Era Book 2*.

Lalique's "Andlau" Pattern

In early 1988 Harriet McDermaid, Portland, Oregon, wrote that she had seen dessert plates in an antique shop that were marked "Lalique" and looked just like Candlewick. The top of each plate was 6-3/8″ and the bottom base 4-1/2″. The plates were heavy crystal. The signature "Lalique-France" could be seen on the tops of the plates.

After obtaining the name of the U.S. distributor for the French company, information was requested. Mr. Paul Lerner of Jacques Jugeat, Inc. of New York answered the request. He said the plates had been manufactured by Cristal Lalique and that they had been in production since the 1950's. At that time a Lalique dessert plate was selling for $97.00. The 8-1/2″ luncheon plate was priced at $175.00.

Mr. Lerner felt that the similarity between the two patterns was just "a chance happening."

Characteristics of the Lalique plate are the large center and the smaller diameter rims. Beads seem very similar. The signature is on the edge of the inside center rim.

Miscellaneous Look-Alikes

— Shaker with GERMANY label — very much like 400/96 only 3/4″ taller, slightly wider.

— Sugar and Creamer with cutting. Laura Murphy, Pasadena, CA, has

the set; she says the cut pattern seems inferior; FRANCE is on each piece in raised letters on the bottoms. They have the question mark handles.

— Bowls, green — both light and dark, have been reported by collectors. This author saw a set of three which sold, at a show in Michigan around 1988, at a very high price. They all resembled Candlewick. Various sizes have been available: 5-3/8″, 6-3/8″, and much larger. Some have been reported where the top rim turns in slightly, others with beads straight up, and still others where the beads are on the outside of the rim. The set of three referred to above was supposedly purchased from a dealer in New York. By the time the author saw the set, it had been sold three times, finally at a price over $300 to a very young, inexperienced Candlewick collector. He asked for verification, which could not be made. Consequently, with a little urging from this author, the young collector received his refund — with a warning: if in doubt, don't — unless it is very reasonable.

Beware of these bowls. Imperial did make an Emerald Green Tid-Bit and maybe a few other items in the Candlewick line, but other pieces have not been authenticated.

According to Joan Cimini, Belmont, Ohio, dealer and collector, as stated in the GLASSZETTE, April 1988, it had "been brought to our attention of the reproduction of Candlewick in Depression Green. We have rumors of the Viennese Blue also being done, but no confirmation. The items in question were a 10″ bowl and a 5-1/2″ bowl. The glass is very heavy, with a ground bottom but not polished (yet). There is an approximate 1/4″ lip on the inside edge of the beads. The quality is not the greatest and there were pit stones in the glass. It was a very nice shade of Depression type green. These two items were deliberated over by many people here and finally taken to the factory chemist (Imperial Glass Corporation in Bellaire, Ohio) and the consensus of opinion was that it was definitely a reproduction.

"We do not know who and where it is coming from, but we have been told it may be Mexico. We can only say, know your dealer well and if you suspect something is wrong or the look is not just right, maybe you best think twice before buying it. If you want the item just make sure you don't pay the very high price demanded for colored items in question. I have also heard some *crystal* is coming in from Mexico."

— **Bowl.** Myrna Garrison bought a bowl at T. J. Maxx for $7.99. Be aware of this one. It's different but if you don't know your shapes, you might be fooled.

— **Milk Glass** items made by Consolidated Lamp & Glass Company, Corapolis, PA, in the 1950's. Look-alikes have beaded edges. See picture in CANDLEWICK THE JEWEL OF IMPERIAL, Price Guide I.

— **Perfumes and Mirrors** — the only authenticated perfumes and mirrors are discussed in Chapter 6, IRICE items made by Imperial. There are many Imperial perfume stoppers with beads, but there was

only one in the Candlewick line made for IRICE — the Boudoir Lotion or Perfume Bottle with 4-bead stopper; beads are graduated with the smallest at the top.

Perfumes were made by Imperial, and other companies also made bottles for Imperial. Imperial then used their own stoppers on other companies' bottles and on their own. The same was true with stoppers made by other glass companies and put on Imperial bottles. See Chapter 6 for more information on perfumes made for IRICE by Imperial. See Chapter 10, Picture Section, for pictures of Imperial Lotion/Perfume/Cologne Bottle.

Beaded mirrors seem to proliferate. They have come from everywhere once the word was out that Imperial indeed did make mirrors in the Candlewick line. A number have been reported with stickers indicating they came from Japan. There are only three made by Imperial for IRICE that collectors are currently aware of: the 400/18 base mirror, the 4-1/2″ standing desk mirror with the question mark stand, and a hand-held flip-over mirror. See Chapter 6, IRICE, for more information.

— **Tid-bits** with 5″ and 6″ round ash trays have been reported by several collectors. The ash trays are authentic Candlewick, but the "put together" version was not made by Imperial, or so this author was told at Imperial Glass Company several years ago. Since several have been found it is presumed that another company bought these ash trays, joined them together, with the 5″ ash tray at the top, with a center glass rod. A single glass-ball finial sits at the very top of the rod. The tid-bit is 7-1/2″ tall in its entirety.

— **Czechoslovakian cruets** — in Virginia Scott's newsletter #16, page 1, April 1980, she shows a pair of Czech cruets — carbon copies of the 400/119 Candlewick cruets, except for the lip which seems to extend downward. This comparison is just from pictures — not having seen the cruets themselves. They were cut or etched with a Vintage Grape pattern. The ad is from an early 1940's Magazine.

— **Coaster/ash trays** — the look-alike beaded-edge ash trays or coasters have long been a topic of discussion among the Candlewick collecting crowd. To buy them as go-withs is fine. To buy them because someone said they are Candlewick is a rip-off. These items have turned up with embossed fruit in the bottoms, also with hobnails, and fruit and flowers.

Joan Kiefer of Montrose, PA, writes in Scott's newsletter #49, page 3 that she has "a set of 3 sizes, of bubble ashtrays. They are round bubbles — not sharp as I think of hobnails. They were purchased at our local gift shop in November 1947."

In Scott's newsletter #64, page 3, Leah Simmons, Mansfield, Ohio, found a "coaster at Zayre in a box marked 'Forever Crystal'". There is no company name on the box, but Scott says the coasters have "Made in German Democratic Republic" pressed into the glass on the inside. The design, rose and leaves, is impressed on the bottom. Scott also has one with a fruit design: a pair, an apple, leaves and large and small hobnails — she feels the hobs

might be the grapes. These coasters have been found with red roses and bright green leaves. Some have the writing and some do not. Kathy Burch, Ithaca, Michigan, bought hers in a California store in 1989. Hers has the red roses and green leaves. The inscription on hers, moulded into the glass, says "made in GERMAN DEMOCRATIC REPUBLIC." Your author purchased the fruits coaster in late 1980 at a glass outlet in Wheeling, West Virginia, while attending an Imperial Glass Convention. The buyer at the outlet refused to reveal the name of the supplier of the stacks of fruit coasters in their store.

Recently a gift to this author was in a "Forever Crystal" box. The piece of crystal had a sticker "24% Lead Crystal Made In Yugoslavia CRYSTAL GLASS INDUSTRIES." It's possible that "Forever Crystal" is a name a U.S. company uses on its import glass, and that the glass comes from many different glass producing countries.

Czechoslovakian Relish

At the 1993 Imperial Glass Convention seminar featuring a group of retired Imperial Glass Company employees, this author asked the big question to which all Candlewick collectors want to know the answer. Some of the employees had been with Imperial 42 years; some were involved with the production of Candlewick. The question: Do any of you know about the Czech 3-sectioned tid-bit? Everyone answered "No." They said they'd never seen it in the Imperial factory. Several said they'd never seen it before the seminar. Yet this relish still is being bought and sold as Candlewick by less than knowledgeable collectors and dealers.

The Czech relish plates with three short risers and wavy pattern in the glass around and inside the beaded edge have turned up all over the country in several sizes and numerous colors. They have been reported in the following colors:

turquoise blue (light and dark)	amber
green (light and dark)	orchid
crystal	mauve
purple	lavender
blue	

Virginia Scott has a copy of a letter sent to Barbara Shaeffer, former editor of the GLASS REVIEW, concerning Czech glass. Mr. Francis N. Allen of Hyattsville, Maryland, wrote that "an identical pattern, fittingly called Boule (ball), was designed by R. Schrotter and made at Rudolfova Hut at Inwald, Czechoslovakia in 1935."

As to the divided relish with the clip-on handle and fork, the author has one with an Imperial sticker. One other collector sent a picture of hers, and it is identical. Both are clear crystal with the Imperial labels. Scott also received illustrations from a Czech trade journal.

In an article in the NIGCS newsletter, GLASSZETTE, Myrna Garrison, Arlington, Texas, writes that she had found a bowl and underplate set. It looked suspicious. On the bottom of the liner the following word was etched: TCHECOSLOVAQULE. Myrna later discovered this is the French spelling

for Czechoslovakia. She said, "The 5″ bowl and the 7″ plate are the same dimensions as the 400/23. The beads on the import are a little larger and the bowl has 36 beads versus 37 on the Imperial. The imported plate has 36 beads and the Imperial plate has 44 beads. The bottom of the imports are both very flat. They are not ground nor do they have a ring or indentation as do the Imperial pieces. The bowl has a wide thick edge at the top with the beads extending toward the outside. This seems to be the same characteristics as some of the questionable pieces collectors have run into. The edge of the plate has the wavy effect that has indicated to some of us that some of the questionable pieces are imports".

Myrna states: "Now let's compare the plate to the three divided, usually colored, relishes that we have all come to accept as being imported. The plate and one of the relishes are the same size. They both have 36 beads and the relish has the same wavy effect around the edge as does this plate liner. There is one big difference. The divided relish has a ground and polished bottom edge with the underneath center slightly indented. As stated above, the liner plate has a very flat bottom (2-3/4″) not ground and without indention."

In Scott's Newsletter #57, page 13, Diana Persha, Portland, Oregon, writes that her mother found the Czech relish with a label: foil with yellow and gold. "Bohemia Glass Made in Czechoslovakia" was printed in gold on the label.

Although several of the relish plates with metal handle and hanging metal spoon or fork have been found in crystal with Imperial stickers, that still doesn't mean Imperial made the tid-bit plates. Stickers are easy to acquire. Unscrupulous people have switched labels before. Until definite proof is found otherwise, the relishes are considered Czech by collectors. After hearing the rejection by the former Imperial employees, it would be difficult to convince Candlewick collectors these relishes are not imports. See pictures on page 79.

In conclusion, there is so much that could be said about Candlewick look-alikes that an entire book could be written on just this one aspect of Candlewick collecting. This is not unique to any one type of collecting. There will always be confusing similarities in any field of collecting. What is most important is that collectors school themselves in what IS Candlewick. If this is done, collectors will always know what ISN'T Candlewick.

References for Other Beaded Patterns

— Bryce Brothers Company, Mount Pleasant, PA, #720 Line, 1930 (see Hazel Marie Weatherman's COLORED GLASSWARE OF THE DEPRESSION ERA, book 2, page 271)

— CANDLEWICK THE JEWEL OF IMPERIAL, book 1, pages 27-31, Chapter 5, "Confusing Similarities"

— Duncan & Miller Glass Company, Washington, PA, "First Love" (Weatherman, book 2, page 89)

— Duncan & Miller Glass Company, "Teardrop" (Weatherman, book 2, pages 76, 77)

— Libbey Glass Company, Toledo, OH, "Nob Hill" pattern (CAN-

DLEWICK THE JEWEL OF IMPERIAL, book 1, pages 29, 31)
— Lotus Glass Company, Barnesville, OH, #24 Line (Weatherman, book 2, page 239)
— Morgantown Glass Works, Morgantown, W. VA., #7955 (Weatherman, book 2, page 284)
— Seneca Glass Company, Morgantown, W. VA., "Baubles," 1931 (Weatherman, book 2, page 311)
— Seneca Glass Company, "Candlewick" pattern (Weatherman, book 2, page 311) no similarity to Imperial's Candlewick pattern
— Victorian patterns "Cannon Ball, "Atlas," and "Candlewick" (CANDLEWICK THE JEWEL OF IMPERIAL, book 1, pages 28, 29, 31)

CHAPTER 8

Potpourri

INTRODUCTION

There has been a wealth of information on Candlewick that has surfaced since the publication of my first book on Candlewick in 1981. It is impossible and impractical to try to incorporate every morsel of information in this book. However, certain bits of information lend themselves to the enhancement of the collectors' knowledge and understanding of Imperial's history in general and Candlewick in particular.

Incorporated in this section is a potpourri of many such bits of information. Attribution is noted where appropriate.

— Richard Ross of Bellaire, Ohio, owns a tie with the Imperial logo. The ties were given to salesmen and directors at the plant for a special Imperial Glass show in Pittsburgh. Ross says, "You would be surprised at how many different items were put out with the Imperial logo on them."

— "Grinder wheel" marks were put around pieces to be kept as samples in the sample room so workers wouldn't take them home. To achieve the marks workers ran pieces against the wheel.

— According to the speaker at the 1991 Convention Seminar on glass decorating at Imperial: "Glass decorators were not hired for their pre-existing artistic talents. Most learned to paint during a brief fifteen minute training session. Believe it or not, they were paid 45¢ an hour. The decorating shop was actually independent of the factory. The decorators worked for the glass distributor (who was buying and selling the glass) rather than Imperial itself." Taken from a column by Ron Doll on the convention in the July 1991 Ohio Candlewick Club newsletter.

— "The brownish 'sun tint' common in old pieces of Candlewick can NOT be removed through refiring as once believed." Another item learned by Ron Doll at the 1991 convention.

— "Imperial 'cutters' served a four year apprenticeship. They considered cutting salt and pepper shakers one of the toughest jobs. Their small size required a difficult underhand technique. They were still able to do a batch of twenty dozen (240) shakers a day." Learned by Doll and written in a column in the Ohio newsletter, July 1992, after the convention. Banquet speaker was noted glass researcher Willard Kolb.

— "Cutting department workers started at .22¢ per hour in 1937." (Doll — July 1992 column)

Some items have lend themselves to confusion. Eleven of these confusing Candlewick topics are dealt with in this chapter to help clarify problems collectors may have:

Bowls — the F series
Bowls — round/square
Boxed sets
Coasters, 400/78
DeVilbiss Atomizers
Eagle, #777
Icer Sets, 400/53
Ladles
Lamps and Shades
Pegs
Tid-bits, 400/270 and 400/271

The final topic in this chapter is a listing of unusual and odd pieces of Candlewick discovered by collectors.

Problems With the F Series Bowls

Bowls in the F series have small-rimmed bases, turned-in beaded top rims, and shallow bowls. They were offered by Imperial from 5″ to 12″, according to their records (5″, 6″, 7″, 8″, 9″, 10″, 12″). However, bowls have been found in the F series style, by collectors, in the 11″ and 13″ sizes.

The 400/17 is the largest at 12″. Since Candlewick was hand made, it stands to reason that exact measurements could not always be adhered to. Also, when new moulds were made, the size would have been altered slightly — either larger or smaller. This would account for the many discrepancies found in various Candlewick pieces.

During the 1993 NIGCS Convention, former Imperial employees stated that many moulds were re-made numerous times as they wore out. This could also contribute to the variation of sizes.

The 400/18F 10″ Nappy eludes collectors. Possibly it is the same as the lower bowl in the 400/18 3-Hi Snack Rack. A collector wrote with descriptions of her top bowl at 5″, and her center bowl at 6″, but the bottom bowl was missing. In this instance, it had to be the 7″. Speculating, though, the Snack Rack could have been assembled with the 8″, 9″, and 10″ F series bowls, the bottom bowl being the 400/18F 10″.

Early in Imperial history, the number of each piece in a set was given the same mould number but different letters to designate a different item or part of the set. This procedure could apply here.

It is also possible that at one time Imperial made a 400/14F or 400/15F 11″ bowl but never listed it in their records. Imperial records list only the following F series bowls:

400/1F	5″ Bowl
400/3F	6″ Bowl
400/5F	7″ Bowl
400/7F	8″ Bowl
400/10F	9″ Bowl
400/13F	10″ Bowl
400/17F	12″ Bowl or Nappy

Square/Round Bowls Puzzle Solved

Thanks to Virginia Scott (Athens, Georgia) and Helen Clark (Bellaire, Ohio), the square/round bowls puzzle is pretty well solved. Helen sent a two-page listing dated January 26, 1954 to Virginia. The listing was from Imperial and originally sent to W. J. Hughes & Sons, LTD of Canada. The Hughes Company is known for its "Canadian Corn Flower" cut on Imperial Candlewick Crystal.

The listing includes the following:

400/53C	6″ Crimped Bowl
400/53H	5-1/2″ Heart-shaped Bowl
400/53S	5″ Square Bowl
400/53X	6-1/2″ Baked Apple
400/53/3	3 pc. Icer Set

Candlewick collectors are familiar with all the 400 series numbers, except for the 400/53S. Collectors can conclude that Hughes & Co. put their "Canadian Corn Flower" cutting on these 5 400/53 series blanks, and that since Imperial made the 5″ square/round bowl, they also made the bowl in other sizes. This would explain the various sizes that have been found by collectors.

Dates for these 400/53 series are items as follows:

400/53C	1950-1955, Bowl, Crimped, 6″
400/53H	1950-1955, Bowl, Heart-shaped, 5-1/2″
400/53S	1954(?), Bowl, Square/round
400/53X	1937-1960, Bowl, Baked Apple, 6-1/2″
400/53/3	1950-1955, Icer Set, 3 pc.

Other information on these square/round bowls was supplied by collectors:

— found in sizes 4-3/4″, 5-1/2″, 5-5/8″, and larger
— corners are pulled out and down
— some sides turn up more and corners down more
— found with Imperial labels
— 2-1/4″ high
— 44 beads

These bowls are called "square/round" because the base is round and the top beaded rim is square.

Boxed Sets

A number of collectors have reported boxed sets containing one or more pieces of Candlewick. Following is a listing of those that have been reported:

— Relish Tray Set: consists of 400/60 6″ or 7″ relish and a butter spreader or a spoon in the "Twilight" pattern. "Community Twilight" is printed on the box. The "Twilight" pattern was patented in May 1956. Boxes are found in both blue and green.
— Heart Nappy Set: consists of a heart nappy and a silverplated ladle by Community. The ladle is in the "Ballard" pattern. "Ballard" was patented in December 1957. The fancy box is black and silver. An Oneida Community sticker on the box states "Ballard in Community,

the Finest Silverplate."
— Relish Set: consists of 400/54 6-1/2" relish with a knife and a spoon marked "South Star Community." The box is imprinted with "South Star in Community, The Finest Silverplate." (information from Jeanne Haley, Hopatcong, NJ)
— Relish Set: consists of 400/268 8" oval relish with Imperial sticker, and a fork and a spoon labeled Community. The fork and spoon match the utensils in the previous set. The red-lined box is imprinted with "Community. The Finest Silverplate."
— Relish Set: consists of 400/54 Relish and Community "Morning Star" pickle fork. "Morning Star" pattern was patented August 1948. (information from Myrna Garrison, Arlington, TX)
— Relish Set: consists of 400/268 8" 2 sectioned relish with 1881 Rogers "Baroque Rose" pickle fork and relish spoon. "Baroque Rose" was patented in 1971. Oneida got the 400/268 relishes from Imperial 1969-71 and no doubt made other sets with their silver patterns, also. (information from Myrna Garrison, Arlington, TX)
— Ashtrays Set: consists of four 400/118 ashtrays with cigarette rests. (information from both Jeanne and Myrna) Jeanne's set has the Imperial logo imprinted on the box and a gold sticker with the following words: "Robert J. Beitl, Jeweler, Optometrist, Catasaugua, PA."

400/78 Coasters

The 400/78 Coaster was produced at Imperial for 30 years, discontinued in December 1970. The Coaster was advertised in Catalog B as 4-1/2" and in Catalog F as 4".

Only in a 1940 Imperial Brochure advertising Candlewick was the Coaster shown with five rays instead of the usual 10 rays (or spokes) collectors are most familiar with.

One collector in Washington state found a set of 6 coasters in a 6-sectioned red box. The 6 coasters have a pattern of large and small "bumps" on the bottom.

Gold-beaded coasters were made from 1950 to 1954.

In 1980, 200 of the 10 spoke coasters were transformed into ring holders and marked LIG on the top surface. This is the only known marked piece of Candlewick.

See Chapter 7 for information on coaster look-alikes.

DeVilbiss Atomizers

Numerous atomizers made with Candlewick containers have been found. The containers are the various salts from the Candlewick line.

The DeVilbiss Company was located in Toledo, Ohio, but the perfume division was moved to Somerset, PA, when DeVilbiss established a Medical Division in 1951.

According to Kathy Hamilton in her article "Adventure in the World of

DeVilbiss" published in the April/May 1988 edition of GLASS COLLEC-TOR'S DIGEST, "the DeVilbiss Company began making the atomizers in the 40's. They discontinued making the atomizers in 1968. DeVilbiss did not make the glass containers; they purchased custom-made bottles from glasshouses in America and Europe. DeVilbiss supplied and assembled the hardware: bulbs, tubes, and metal spray equipment."

Kathy Hamilton had purchased over 500 perfumes from a DeVilbiss employee who "faithfully brought a perfumer home to his wife several times a month for 30 years."

The page showing the DeVilbiss atomizers made with Imperial containers is printed here with the permission of D. Thomas O'Conner, editor, GLASS COLLECTOR'S DIGEST.

The atomizer top pictured on the items in the middle row was a 1952 DeVilbiss patent. It features a plexiglass piece inserted into the notched top of the head. Although added as a decoration, it did facilitate removal of the top for refilling. DeVilbiss ads called this piece a "star-studded crown."

According to Hamilton, all atomizers had DeVilbiss paper labels. Some black and white labels have "Made in USA" typed on them; often the stock numbers were also found on the labels.

Virginia Scott received, from Kathy Hamilton, a copy of the patent for the bottles which have the plexiglass insert with stars. The patent states "Patent 168,003, designed by Carl W. Sunberg for the DeVilbiss Co., filed June 28, 1952."

The Candlewick atomizers have been found with the stock numbers S-200-10, S-200-12, S-200-14, S-200-15, S-200-17, and S-250-9, and S-250-13. The latter number is apparently the color reference number. The colors used with the Candlewick containers were as follows:

400/96	S-200-10	Green (has plexiglass insert)
400/96	S-200-12	Deep Yellow
400/96	S-200-14	Clear (label on bottom bearing stock number — found by Kathy Burch, Ithaca, MI)
400/247	S-200-15	Turquoise
400/247	S-200-17	Amethyst

Five Candlewick containers have the 200 stock number.
Two Candlewick containers carry the 250 stock number:

| 400/167 | S-250-9 | Clear |
| 400/167 | S-250-13 | Amethyst |

The 400/96, 400/247, and 400/167 Salts were used for atomizers in the following colors:

400/96	Amethyst, green, deep yellow, aqua, amber, and clear
400/247	Aqua, amethyst
400/167	Aqua, clear

Numbers 11 and 16 are missing. The light yellow atomizers in the Hamilton collection were missing labels, so one of the two missing numbers could conceivably be the light yellow.

Hamilton wrote to Scott that from her sampling, it appears that the plexi-

glass insert was used on the 400/96 salt containers only. However, Scott heard from a collector in California who reported finding a 400/167 perfume with the plastic insert.

The DeVilbiss stock #200 apparently was used on the Candlewick salt containers 400/96 and 400/247. The stock #250 seems to have been used for the 400/167 salt.

DeVilbiss wrote the following to Irene Newhouse, a California collector, about the atomizer: "The DeVilbiss Co. discontinued manufacture of the perfume atomizers in 1968. We have no records to refer to in identifying this atomizer as it was manufactured prior to the opening of our plant in Somerset, PA, in 1950." No mention was made of Imperial supplying containers. The atomizer in question was made with the 400/109 salt container; up until this time the 400/109 has not been reported as being used as an atomizer.

Hamilton adds that "color, creative glass finishes, techniques of decorative application and embellishment of the atomizer were used to add appeal to the basic pieces."

DeVilbiss purchased the 400/96, 400/167, 400/247, and the 400/109 shaker containers, minus the tops, to be used as atomizers. Replacement bulbs, according to several collectors, can be purchased for the Candlewick/DeVilbiss atomizers from Paradise & Co., Box 1284, Millville, NJ 08322.

Since the plexiglass insert was patented in 1952, all Candlewick containers with that insert had to be made between 1952 and 1968. Apparently all the plain bulbed atomizers using Candlewick salts 400/96, 400/167, and 400/247 were manufactured from the 1940's until 1952. However, there currently is no proof that manufacturing of the plain atomizers stopped in 1952 after the plexiglass inserts became available. This is simply conjecture.

The Imperial Eagle #777

The Imperial Eagle, although not strictly a Candlewick item, is a most desired addition to any collection.

The eagle, mould #777, was made in two styles:

1. #777/2 Without the candle cup or well — to be inserted into the Imperial bookend base and into Candleholders. The eagle has a peg beneath the eagle to fit into the candle cup. The eagle with no candle cup is the same one used for inserts in the bookend base.
2. #777/1 With the candle cup — the eagle candleholder adapter is hallowed out in the back of the eagle starting just below the wings and down into the crystal base which holds the candle (description by Virginia Scott).

The bookend eagle peg firmly fits into the bookend, while the peg candleholder adapter with no candle cup fits directly into the candleholder candle cup. A gray ribbed gasket fits around the peg to hold it firmly in place in the candleholder. The eagle in the bookend was fastened with a fixative.

The bookend bases were made in Crystal, "Lalique-finish" (frosted), and gold-trimmed Black Suede (color #L4). The eagle inserts were listed by Imperial as "Lalique Finish Crystal Eagles" and "Burnished Gold Glass Eagle."

IT'S NEW! IT'S DIFFERENT!
"Black Suede" GLASS

Imperial

No. L/777/3 — Lalique finished Crystal Eagle Bookends, with two-tone "Black Suede" Glass Base. 9" high, heavy. Approx. retail $7.50 pair. (Small figure shows front view)

No. L4/1943 — Two-tone "Black Suede" Glass Candy Jar with Cover. 7" tall. Approx. retail $2.00.

No. G/777/3 — Burnished Gold Glass Eagle Bookends, with gold trimmed "Black Suede" Glass Base. 9" high, heavy. Approx. retail $10.00 pair. (Small figure shows front view.)

No. L4/1943 — 6-1/2" Pipe Bowl in two-tone "Black Suede" Glass. Companion for the Humidor Jar. Approx. retail $1.00.

Without cover the "Black Suede" Glass Candy Jar makes a beautiful vase for short-stemmed flowers.

No. L4/1943 — Tobacco Humidor Jar in two-tone "Black Suede" Glass. Holds pound. Sponge in cover. Approx. retail $2.00.

No. L4/1943 — 5-pc. Cigarette Set in two-tone "Black Suede" Glass, Mug type Holder; 4 3-1/2" Nesting Ash Trays. Approx. retail $2.00 set.

No. L4/1943 — Combination Cigarette Server and Ash Tray in "Black Suede" Glass. Rack holds 3 smokes. Approx. retail 65¢

No. L4/1776/1 — 3 Pc. Cigarette Set in two-tone "Black Suede" Glass Goblet-type Holder; 2 Federal Eagle Ash Trays. Approx. retail $2.50 set.

IMPERIAL GLASS CORPORATION • BELLAIRE, OHIO

IN NEW YORK:
107 Broadway

IN CHICAGO
1563 Merchandise Mart

IN LOS ANGELES
656 Los Angeles St.

IN PORTLAND, ORE.
The Vinton Building

155

As far as is known, the eagles were never made in Black Suede, only the bases.

The eagles are actively sought after by Candlewick collectors. They were adopted by Candlewick collectors because Imperial used its eagles in so many Candlewick candleholders during the war years (c.1943).

For more information on the eagles, see Chapter 4 "Black Candlewick", and Chapter 3 "Patents".

400/53 Icer Sets

There is confusion concerning the 400/53 items. The following information should clarify this.

400/53 Bowl, fluted, 5-1/2", beaded-top rim. No risers. Imperial Bulletin dated 6-20-52 lists the 400/53 Bowl.

400/53C Bowl, Icer (1950-1955), 5-1/2"-5-3/4", fluted, beaded-top rim; crimped or scalloped. 3 risers to hold sherbet insert in place. Shown in Imperial Catalog E (1950). Old is more flared; new is deeper.

400/53/C Icer Set, 3 pc. (1950-1955), Consists of #530 Sherbet (not Candlewick) and #530 5-1/2 oz. Tumbler (also not Candlewick). Shown in Imperial Catalog E.

See pictures on page 157.

Candlewick Ladles

Determining which is a Candlewick ladle can sometimes be difficult. The following information is from Myrna Garrison of Arlington, Texas. It is included here to help collectors with measurements for comparison.

- 1-bead ladle — 5-1/2" long with a prominent 7/16" bead on handle with a 1-1/4" d. spoon/ladle for dipping.
- 1-bead ladle — 6-1/2" long with 3/8" prominent bead on handle (11/16") and a tiny 3/4" spoon/ladle.
- #176 Cocktail Stirrer, 11" long; stirrer end is waffled and is 1-1/4" in d. The very definite round bead on the end is 9/16" d.
- Stirrer bought from Imperial factory in 1984 — 12" long; stirring end is flat, round 9/16" d. with flat straight lines on it with faint 3/8" bead top.

 The latter two are definitely known to be of Imperial manufacture. The #176 was used with the 400/19 Martini Pitcher.

Although it is sometimes difficult to ascertain which are Candlewick ladles, the collector should make himself knowledgeable as to which are authentic. Several ladles used by Candlewick collectors were not made as Candlewick but to compliment the Cape Cod pattern sets. (see page 157)

See ladles under individual mould numbers in Chapter 9 for more information.

Lamps and Shades

Numerous lamps and shades with beaded edges have been attributed to the Candlewick line, but only several have proven authentic. Reports from collectors are many concerning lamps and shades.

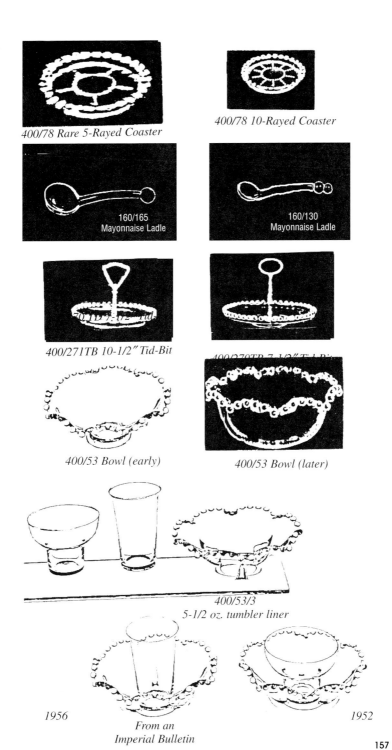

400/78 Rare 5-Rayed Coaster

400/78 10-Rayed Coaster

160/165
Mayonnaise Ladle

160/130
Mayonnaise Ladle

400/271TB 10-1/2″ Tid-Bit

400/53 Bowl (early)

400/53 Bowl (later)

400/53/3
5-1/2 oz. tumbler liner

1956

1952

From an
Imperial Bulletin

157

Following is a listing of those lamps and lighting fixtures that have been seen by the author or reported by collectors:

— Lightolier lamp at the 1990 Imperial Convention. The lamp was two piece — the top section looked like the 6″ ash tray with a hole in it. Douglas Archer, author and museum curator, says it is a Candlewick shade made for Lightolier Lighting Company of New York on a 1950 Vinelf candlestick holder. Doug displayed the lamp.

— Myrna and Bob Garrison, authors of Imperial Cape Cod and Imperial Milk Glass books, have a number of Candlewick lamps: 4 Candlewick chandeliers, oval Candlewick ceiling globe, and Candlewick globe on an Imperial Vinelf lamp.

— One collector found a Candlewick ash tray, 400/133, affixed to a lemon yellow frosted base: 5″ across and 3-1/2″ high. The base is straight and has a collar. It fits the 400/24 Candlewick candleholder.

— Mollie Bilyeu, Torrance, California, has a lamp that is 14-1/2″ from end of hanging chain, affixed to ceiling, to bottom of fixture. One section is the 400/155 lamp base made for the Lightolier Co. of New York. Possibly the entire lamp was put together by Lightolier and sold with the Imperial part.

— 400/155 lamp base used in a Depression Glass Iris pattern hanging lamp is pictured in Hazel Marie Weatherman's COLORED GLASSWARE OF THE DEPRESSION ERA. It is labeled the "Iris Light Fixture."

Iris light fixture
Courtesy of Hazel Marie Weatherman, PRICE TRENDS 1978, p. 49

— Hanging lamp fixture with 5 arms with lights has been reported by several collectors. Each light is covered with a round Candlewick frosted and designed shade. The metal arms connect to a single rod topped by a small cupped Candlewick plate. Other collectors that have reported this fixture also note variations: arms are different metal, arms are more ornate, and no Candlewick plate above the spot where the arms converge.

— Hanging lamp fixture reported by 2 collectors: uses 400/155 base; large Candlewick bowl with rim rolled outwards, frosted on inside, and major portion of shade has concentric rings and raised floral design.

— Hanging light fixture, 15″ Starlight Cut plate with 3 globes beneath it; 2 have been reported. One collector did not have the light globe; the other's globes are round, partially frosted and beaded.

— Candlewick chandelier — Kathleen Tucker, Akron, Ohio, reported in Scott's newsletter, #42, page 3: "The globes are round, frosted on the inside, with three medallions spaced on the sides. The same motif is on a cupped plate on the bottom of the fixture. There are also two beaded disks in the center post — heavier than Candlewick with pronounced mold marks — probably not Candlewick. The rest of the fixture is brass and enameled metal — a cream color." The fixture has three arms into which the shades fit. Kathleen is convinced the fixture is Candlewick.

— Candlewick chandelier — Marlene Bagstad, Minneapolis, MN, reports her 5 shade chandelier. "The globes are round, frosted, gold band and scroll design. There is a matching glass piece on the bottom covering the switch. The fixture itself is either bronze or copper with chrome cups to hold the globes." See picture of Marlene's fixture on page 78. This chandelier sounds just like the one owned by Kathleen (previous paragraph). Marlene took a shade and the domed plate to a MICHIANA ASSOCIATION OF CANDLEWICK COLLECTORS meeting in 1994. It was a consensus that these shades and domed plates are Candlewick.

— Candlewick wall fixture — Lois Quale, Stoughton, Wisconsin, sent pictures of her wall fixture made with the 400/1A Oval Shade, #800 Cut. See pictures on page 77 for breakdown of the fixture. She also included a picture of the #G107 round frosted shade which is 5″ in diameter and 2-1/2″ high. This number was found taped to another collector's identical shade and is probably the Cut number.

In Virginia Scott's newsletter #69, pages 2 and 3, she printed pages she received from Ms. Norma P. H. Jenkins, Head Librarian of the Rakow Library in the Corning Museum of Glass. Pages 12 and 13 were taken from the 1941 "Residential Lighting" catalog of the H. A. Framburg Company of Chicago, Illinois. The pages were entitled IMPERIAL CANDLEWICK. The Candlewick Crystal pieces were shown being used with "Colonial Cut Chimneys and Prisms." Candlewick domed pieces are shown in various positions in the pictures on pages 160 and 161: above and below the center glass "vases", under

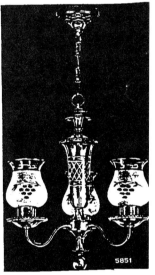

IMPERIAL CANDLEWICK

The Simplicity And Grace of These Designs Are the More Charming Because of Candlewick Glass

1044: Frosted clear polished cut design chimney and candlewick glass trim. Turn switch. 1 Lt. Back 4⅜" Diam. Extension 5⅜".

1045: Frosted clear polished cut design chimney and colonial prisms. Turn switch. 1 Lt. Back 4⅜" Diam. Extension 5⅜".

5846: Clear crystal candlewick glass trim. Shades not furnished. 5 Lts. Length 42". Width 20".

5850: Frosted clear polished cut design chimneys and candlewick glass trim. 5 Lts. Length 42". Width 20".

5851: Frosted clear polished cut design chimneys and candlewick glass trim. 3 Lts. Length 36". Width 16".

Finishes: Marine Brass; Polished Brass; Pewter.

PAGE THIRTEEN

Page from 1941 "Residential Lighting"
Catalog of the H.A. Framburg Company, Chicago, Illinois.
Note the Candlewick domed chandelier plates and cups above and below
"vases," under chimneys, under candles.
Courtesy of Virginia Scott, who received these pages from Norma P.H. Jenkins,
Head Librarian, Rakow Library, Corning Museum of Glass.

candles, and under chimneys.

Many collectors have reported finding these domed pieces being shown in catalogs and magazines. Still other collectors have been lucky and have found the actual chandeliers.

More shades, globes, fixtures, and chandeliers will continue to surface. Each will have to be examined and researched for its Candlewick connection.

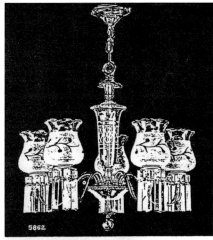
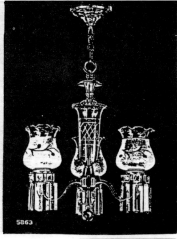

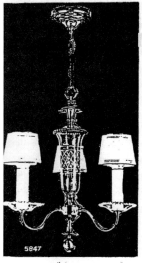

IMPERIAL CANDLEWICK

Candlewick Glass Combined With Original Colonial Cut Chimneys And Prisms Reflects The Unusual

1739: Frosted clear polished cut design chimney and candlewick glass trim. 1 Lt. Length 12". Width 9".

1743: Frosted clear polished cut design cylinder. 1 Lt. Length 7". Width 6".

5847: Clear crystal candlewick glass trim. Shades not furnished. 3 Lts. Length 36". Width 16".

5862: Frosted clear polished cut design chimneys with candlewick glass trim and colonial prisms. 5 Lts. Length 42". Width 20".

5863: Frosted clear polished cut design chimneys with candlewick glass trim and colonial prisms. 3 Lts. Length 36". Width 16".

Finishes: Marine Brass; Polished Brass; Pewter.

PAGE TWELVE

WE KEEP YOU INFORMED

Page from 1941 "Residential Lighting"
Catalog of the H.A. Framburg Company, Chicago, Illinois.
Note the Candlewick domed chandelier plates and cups above and below
"vases," under chimneys, under candles.
Courtesy of Virginia Scott, who received these pages from Norma P.H. Jenkins,
Head Librarian, Rakow Library, Corning Museum of Glass.

Candlewick Pegs

A peg is merely an extended piece of glass added to an item so the piece will fit (screw) into a base to make another desirable item. There are several types of pegs in the Candlewick line such as the Peg Adapter, 400/152, but here we are discussing the pegs that were used on bowls and plates which fit into various metal bases. The metals used for bases were Sterling, chrome, brass, silver-on-brass, and no doubt other metals, such as nickel, that we have

not yet identified.

A suggestion, especially for new collectors: buy the peg, plate or bowl, even if the base is not with it. Most of the pegs seem to be interchangeable. Some collectors have found pegs with original Imperial number tags still affixed to them. These tags are treasures hopefully to be used by glass researchers.

A caution to collectors: always check the pegged item for damage – be sure the screw is not cracked or badly chipped. Tiny chips are not desirable, but the item can still be used.

Many Candlewick collectors do not recognize the Candlewick pegs. Many were made and many are still undocumented. No sketches, notes, pictures, or related materials on pegs were found in Imperial's files. So, collectors must rely on the information and pictures provided by other collectors. Below are listed all the known pieces reported by collectors, and their descriptions when known, and also those listed on the original Candlewick checklist from Lucile Kennedy, former Marketing Director for Imperial.

Nappy, 5-3/4″ diameter, 3-1/2″ high base, "Crown Brass" (A)

Plate, 9″ (B)

Plate, 6-3/4″ — 7″, low brass base, also found in Sterling silver (C)

Float Bowl, 10-1/2″, Silver base, 5″ high

Plate, 6-1/2″, "Crown Sterling Weighted" base 1-1/2″ high, 2-3/4″ diameter

Plate, 10″, on Chrome base

Nappy, divided, 5-1/2″ wide, 2-1/2″ high, "Crown Sterling" base

Bowl, divided, 3-1/2″ high (including base), 6″ diameter; base is 2-3/4″ diameter and 1″ high, "Crowned Weighted Sterling". This is possibly the 400/52 6″ Jelly without the handles. (D, E, and F)

Cake, Plate, 12″, base marked "Yeoman Silver on Brass, England". Two questions are important here: Is this Candlewick? Was the base made for a company that purchased the Candlewick blanks?

Lily, Bowl with peg, (experimental?) This piece was seen at one of the National Imperial Glass Collectors Society Conventions during a Candlewick seminar.

Bowl with high chrome base, picture sent by collector. (G)

400/240	Nappy
400/240D	Nappy, 7″
400/240F	Nappy, 5-1/2″-6″
	— found 5-1/4″
	— found with "Crown Silver, Inc." Sterling base
400/241	Nappy, partitioned
400/250	Nappy
400/250B	Bowl, 7-1/4″
	— found with silver base and tag with "400/250B/436″ cutting number
400/251D	Cake Plate, 11-1/2″, flat
	— found with "Mammoth Silver," small-bead edge plate
	— found with "Mayflower" Sterling base

Pegs

Figure A
Nappy, "Crown Brass"

Figure B
9″ Plate

Figure C
Brass Base

Figure D
"Crown Weighted Sterling"

Figure E
"Crown Weighted Sterling"

Figure F
"Crown Weighted Sterling"

Figure G
Chrome Base

Cambridge Arms

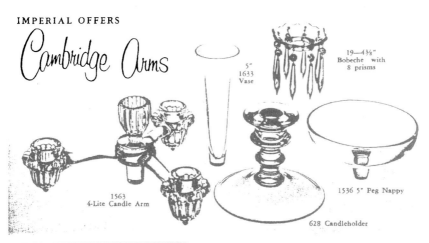

5"
1633
Vase

19—4⅜"
Bobeche with
8 prisms

1563
4-Lite Candle Arm

1536 5" Peg Nappy

628 Candleholder

#42/6

#43/11

Cambridge Arms

The Most Versatile Centerpiece Ever Conceived
America loves and wants Cambridge Arms—graceful, crystal decorative table accessories so adaptable to the creation of unique, clever arrangements. Cambridge Arms permits SO MANY unusual groupings—from simple centerpiece to a most elaborate table decoration.

SWEETMEAT TREE 6 Piece Set

For Cocktail Nuts & Tid-Bits, Sweetmeats & All Candies, Caviar & Seafood Spreads, Cheese Dips, Buffet Relishes & Condiments, Sweets & Sours, Jellies, Jams & Preserves at Buffet and Hunt Breakfasts, Gourmet Pickle Server, "USAGE HORIZONS" unlimited! Suggest a Candle in Center Hole or flowers in the Vase when being used as described and feature for use as a four-Candle Holder for the Dining Table.

VERSATILITY SET 11 Piece Unit

This is the Senior Set in famed Cambridge Arms —a sparkling new idea in table center decorative arrangements! SCORES of DIFFERENT centerpieces can be put together with these gleaming crystal-clear glass items. Consumers can do countless plain, simple, casual or elaborate arrangements with the parts in this Set—"VARIETY IS THE SPICE" in Table Settings!

400/251X Bowl, 9-1/2", small-bead edge

— found with silver base; mould number on item

— found with Sterling silver weighted base marked "Mayflower"

After viewing the preceding page, Cambridge Arms by Imperial, it seems obvious that Imperial put together the "Candlewick Arms" set.

The candleholder in both sets is identical. The arms' holders are open in the Candlewick Arms but closed in the Cambridge Arms. The design of both the Cambridge and Candlewick Arms is very similar. The Cambridge Arms page is from Margaret and Douglas Archer's book GLASS CANDLESTICKS, p. 20.

Pictures of the "Candlewick Arms" set are from Sheela Dolle, Vancouver, Washington.

The following have been found without Imperial numbers. They do not fit the descriptions above.

Another part of the peg picture is the "Candlewick Arms", or is there any such item as "Candlewick Arms"?

The pictures were sent by Sheela Dolle from Vancouver, WA. The question of course is "Is this Candlewick?" The peg vases apparently are. Any company or an individual could have put this set together. The big question is: Did Imperial put the set together?

On page 20 of Margaret and Doug Archer's book GLASS CANDLE-STICKS, Cambridge Arms are shown in detail as made by Imperial after having acquired the moulds of the Cambridge Glass Company.

These are not the screw-in type pegs that are being discussed here; they are the set-in type used as vases. (See pages 164, 165)

The arms holders are open in Sheela's picture, but closed in the Imperial picture. The bottom of each holder gives the bowls a more finished look as the pegs do not show. However, in Sheela's set, part of each vase and peg does show. The design of Sheela's arms is the Cambridge design in most respects. Imperial could have easily put this set on the market.

Pegs are an interesting part of the Candlewick story. They are difficult to find and fun to collect. The pegged pieces still pose a number of questions for the Candlewick-peg collector to answer.

Tid-Bits: 400/270TB and 400/271TB

The single-plate handled tid-bits have appeared from time to time. Questions have been asked whether these plates are from broken 400/2701 Tid-Bits sets. Some collectors feel these are left-over plates used as "put-togethers" by collectors. This author feels that these single-plate tid-bits have not just been adapted by collectors as a result of a broken 400/2701 set. All the tid-bits examined looked authentic and some have the Imperial sticker.

The center posts are found in both silver and gold colored metal, usually 4-3/4" or 5" in length. The post handle unscrews. The finger openings at the tips of the handles are oval or triangular.

The single tid-bit sets have been found with the 400/270 7-1/2" plate and also the 400/271 10-1/2" plate. Because these have appeared so many times, and obviously made from the 400/2701 Tid-Bit plates, in this book they are referred to as the 400/270TB 7-1/2" Tid-Bit and the 400/271TB 10-1/2" Tid-Bit. Each has been found with both oval and triangular finger openings at the tips of the center post handles. There is sufficient information now available to assume that these sets were indeed made and sold as single-plate tid-bits by Imperial. The 400/270TB and 400/271TB are the obvious numbers that might have been used to designate these sets.

Unusual Items Reported By Collectors

There are many items reported by collectors that do not fit into the usual Candlewick categories. They are listed here for study and comparisons by the collector. Much of this information came from collectors.

— Ash Trays, 400/440, silhouettes of man and woman in bottom; several sets reported with various sized silhouettes
— Ash Trays, 400/133 and 400/150, used as tid-bit; holes drilled in center of each; metal rod runs through each and a glass ball is permanently attached to the top; two pieces of metal tubing are over the metal rod to hold the ash trays apart; originally there were two glass tubes in place of the metal ones; 7-1/2″ high; never made at Imperial; ash trays are Candlewick
— Ash Trays, "Fresh Air Candle" from Lenox; uses Candlewick ash trays as base
— Ash Tray, green with crackle finish
— Bowl, large, 4 crimps, sold at 1990 Imperial convention for $450; probably 400/92B 12″ bowl
— Bowl, Float, similar to 400/74 Lily Bowl, has peg
— Bowl, 7-1/2″, square, floral cut on 2 sides and bottom; leaves on other 2 sides
— Bowl, 3-toed, shaped like original patent sketch; 3 toes are not round beads; sides of bowl do not flare out — are straighter than 400/74J Lily bowl; 8-1/2″ wide, 4″ high, possibly experimental 3-toed bowl as mentioned as first piece of Candlewick
— Bowl, 6″, 6 crimps on edge; looks like flower candleholder; no candle cup
— Bowl, 3-toed, center slot; 2 reported
— Bowls, screwed into brass bases, similar to 400/3F; several reported
— Bowl, Mayo, has chrome base marked "Continental Silver Co., Inc."
— Bowl, 7-3/4″, heart-shaped center handle that has red-flashed beads; too small to be 400/68F 10″ Fruit Tray or 400/149D 9″ Mint
— Bowl, 400/40C, not crimped
— Cake Stand, 3-arched beaded stems; small size, about 5″ diameter
— Candleholder, piece (re-formed handle?) to hold candle upright (in place)
— Coaster, ringholder made from 400/78 Coaster with 10 spokes or rays; marked LIG, from 1980, 200 made
— Compote, identical in appearance to 400/48F 8″, but is only 4-3/4″ tall, 5-1/2″ wide
— Cruet, 400/119, free-form handle like 400/70 Cruet
— Cup, crackle design; reported in Bellaire, Ohio, Imperial experimented with crackle glass about 1951; at least a dozen items were produced — none listed by company in Candlewick
— Cup, 400/19 Old Fashioned with free-form handle
— Ladle, Punch, 3 bead handle
— Plate, banana, no base
— Plate, 7″, turned-up sides like banana boat; mounted on 3/4″ high silver base
— Plate, 12″, mirror fastened to plate using 4 clips; vase in aluminum bracket also attached to plate; plate has 400/92D seat; black felt cov-

ers back of mirror; bottom of plate painted black; vase resembles peg vase in 400/40CV; also reported without vase; some have suggested this piece with vase was made for funeral homes

— Plate, Torte, 14″, has beveled-edge mirror (10-1/2″) inserted in center; holes drilled in mirror; piece of aluminum attached to hold candle or wall plant
— Punch Set, Family, 9″ bowl with handles
— Salad Set with fork and spoon and wooden underplate; has blue and silver Imperial label; wood marked "KeystoneWare — Handmade Woodcraft"
— Salad Set, with fork and spoon on wooden tray
— Shakers, 400/109, wooden tops
— Sherbet, 3400 Tall, light green
— Tid-Bit, 2 tier, Forest Green or Emerald Green, reported with handpainted roses
— Tid-Bit with glass rod instead of metal or wood
— Toast, 6″ ash tray with 5″ glass dome — resembles 400/123 Toast only smaller
— Toast and Cover, smaller dome, 4″ wide, 3″ high, not hollow like toast dome
— Tray, Wafer, 400/51T, 6″; reported with candle cup
— Tumbler, Juice, 400/142, free-form handle like 400/70 Cruet
— Tumblers, 12 oz., 400/19 (3 in set); words: "YOU AND ME"; ME has an American flag; YOU has a British flag; one set sold at 1990 convention; from WWII era; several sets reported.
— Vinegar or oil, silver tops; openings not ground, so good fit
— Plate, 14″, possible 400/92D; has 11-1/8″ centered mirror; section between the beads and mirror has cutting — some floral design, others leaf design. Carol William a collector from Newark, Ohio, says hers has a floral design and has a 5/8″ deep base which is 4-3/4″ in diameter, and 4 screw-type devices hold the mirror in place. Two of these devices have round hooks which could be used to thread a wire so that the piece could be hung and used as a wall mirror. Other hanging mirrored plates that have a floral holder attached to the mirrors have been reported. The information on Carol's mirror is in Scott's newsletter #20, p.2. Additional information: some of the mirrors are blue, and some are 15″ plates.
— Stein, 400/19, 14 oz., Tumbler with free-form handle

CHAPTER 9

NUMERICAL LISTING AND PERTINENT INFORMATION ON EACH PIECE

This chapter is written to present to collectors all information currently known about each piece not only in the Candlewick Line but also for related items such as Imperial Milkglass made with the Candlewick edging. Sets assembled by other companies using Candlewick items are listed but by no means should this listing be assumed to be complete.

Much of the information in this chapter has been acquired from collectors. In Book I, most of the information came from the Imperial Glass Corporation files. Here, however, collectors have researched; they have discovered items with information from tags, labels, boxes, and a myriad of other sources. Since Book I was first offered in 1981 every piece of information, no matter how insignificant, has been recorded. This chapter is a compilation of that information.

To make this reference source as easy as possible for the collector numerical order is employed. The picture section (Chapter 11) is perhaps the best way to study groupings.

All Candlewick was made in Crystal color. When COLORS are noted for each entry, it means those documented as having been used by Imperial. The colors only reported by collectors are listed under REPORTED. When a color is known to be Viennese Blue, it is listed as such; however, if a collector states a piece was found in light blue, the collector's description is used. A REPORTED item does not mean an authentic item. Trying to authenticate each reported piece is nearly impossible, although many of the reported items have had pictures accompany them. REPORTED are collectors "finds." Dates are given, as accurately as possible, when known.

The regular 400 Candlewick Line has been listed first in its entirety. Then the series of stemware (3400, 3800, 4000). That is followed by several items with the Lenox computer numbers, and then the Imperial Milkglass series. Next in the numerical listing are those items that were not originally made to be used with Candlewick, but somewhere in the production of Candlewick a need arose, and Imperial filled that need with an item from another Line. Finally, the unnumbered section ends the list of 747 entries. These items fall into several categories: items that didn't have mould numbers; those whose mould numbers have yet to be uncovered; items made for other companies and only listed by name; special gift items produced for company representatives and Imperial employees.

Every effort has been expended to make this listing as accurate as possible; however, because humans are human and machines are programmed by humans, errors may be detected. An appreciative author would like to be informed should a collector find an entry to be suspect.

400	Lighting Bowl; Lampshade (1936-1937 ?), for ceiling. Patent #104,222, received 4-20-37. Willard Kolb, glass researcher, says it is a 12″ light shade made for Mid-West Chandelier Company and that the mould later was used for many other Candlewick pieces. Reported: with three holes for hanging with chain.
400/1A	Lighting Shade (1937- ?), oval, with Cut #800, 7-1/2″ long, 5-1/4″ wide, 3″ high, 44 beads around edge; all satin except beads and narrow rim above beads. Original box states: "G-500 Cut 800 Oval Shade." See entry SHADE in unnumbered section at end of this listing for info on another shade in the G series. Stickers found on one shade read "Candlewick" and Patents 100,577, 100,578, 100,579, 100,222." Patent awarded 4-20-37. Satin- Trimmed items were made only in 1937, according to Imperial's files. Hole in top of shade is used for securing it to a lamp. Reported: as wall fixture; with wire holder inside to fit over light bulb.
400/1D	Plate, Bread and Butter (1937-1977), 6″, round. Part of 400/63/104 19 pc. Chilled Fruit Set, 400/313 13 pc. Breakfast Tray Set. Colors: Satin-Trimmed; Viennese Blue.
400/1F	Bowl; Nappy; Fruit (1937-1984), 5″, round. 1980 design change — straight slant from top to base rather than graceful curve, base heavier, 3/8″ taller. Colors: Satin-Trimmed; Viennese Blue; frosted beads. Reported: in blue in metal holder.
400/3D	Plate, Salad (1937-1984), 7″, round. Part of 400/83 2 pc. Strawberry Set. Colors: Satin-Trimmed; Viennese Blue.
400/3F	Bowl; Nappy; Fruit (1937-1967), 6″, round. Colors: Satin-Trimmed; Viennese Blue. Reported: before 1986 — 2 green bowls with silver bases.
400/5D	Plate, Salad; Luncheon (1937-1984), 8″-8 1/2″, round. Patent applied for May 19, 1936, received July 28, 1936; #100,578. Part of 400/13 15 pc. Luncheon Set, 400/313 13 pc. Breakfast Tray Set, 400/316 16 pc. Luncheon Set, 400/51340 13 pc. Salad Set, Colors: Satin-Trimmed; Viennese Blue. 1940's — 50 beads; 1960's-45 (larger) beads.
400/5F	Bowl; Nappy (1937-1964), 7″, round. Colors: Satin-Trimmed; Viennese Blue.
400/7D	Plate, Luncheon (1937-1967), 9″, round. Colors: Satin-Trimmed; Viennese Blue.
400/7F	Bowl; Nappy (1937-1942; 1957-1964), 8″, round. Colors: Satin-Trimmed; Viennese Blue.
400/10D	Plate, Dinner (1937-1984), 10″ — 10-1/2″. Reported: gold; Sterling Silver; gold beads.
400/10F	Bowl (1938-1964), 9″. Color: Viennese Blue — 1938.
400/13	Luncheon Set (1938), 15 pc. Consists of 400/5D 8″ Salad Plates (4), 400/13D 12″ Plate, 400/31 Sugar and Creamer

	(beads around base), 400/35 Cups (no beads on handles) and Saucers (4 sets).
400/13B	Bowl, Center (1937-1941), 11″. Also part of 400/8013B 3 pc. Console Set, 400/8613B 3 pc. Console Set. Colors: Satin-Trimmed; Viennese Blue.
400/13D	Plate, Service (1937-1962), 12″, round. Also part of 400/13 5 pc. Luncheon Set, 400/13FD 2 pc. Salad Set, 400/75 4 pc. Salad Set. Colors: Satin-Trimmed; Viennese Blue. Reported: red beads.
400/13F	Bowl; Nappy (1937-1940; 1954-1960), 10″ — 10-1/2″, round. Also part of 400/13FD 2 pc. Salad Set, 400/8013F Console Set. Colors: Satin-Trimmed; Viennese Blue.
400/13F	Salad Set (1937), 4 pc. Also referred to as 400/13 and 400/13FD. Consists of 400/13F 10″ Bowl, 400/13D 12″ Plate, 9″ fork and spoon with flat tip handles. Colors (plate and bowl only): Satin-Trimmed; Viennese Blue.
400/13FD	Salad Set (1937-1938) 2 pc. Consists of 400/13D 12″ Service Plate, 400/13F 10″ Bowl. Also part of 400/51340 13 pc. Salad Set. Also referred to as 400/13F and 400/13. 1937 — 4 pc. set including spoon and fork with flat tip on handles.
400/15	Tumbler (1962-1963), 6 oz., footed. This tumbler and the following two were shown on Imperial Price List #63, January 1, 1962. They never appeared in any Imperial catalog. Note found in Imperial's files: "Fate of this one (series) same as 400/195 in 1952."
400/15	Tumbler (1962-1963), 10 oz., footed. See previous entry for more information.
400/15	Tumbler (1962-1963), 13 oz., footed. See entry 400/15 6 oz. Tumbler for more information.
400/16	Pitcher (1950-1968), 6″ high, 1 pint, beaded handle, shorter than 400/19 Pitcher, regular spout.
400/17	Salad Set (1937-1938), 4 pc., Lombardo Brochure. Consists of 400/17F 12″ Bowl, 400/92D 14″ Plate, #701 Fork and Spoon Set. Color: Viennese Blue.
400/17D	Plate, Torte (1937-1967), 14″, flat edge; also used under salad bowl. Colors: Satin-Trimmed; Viennese Blue. Reported: yellow.
400/17F	Bowl; Nappy (1937-1942), 12″-13″, round. Colors: Satin-Trimmed; Viennese Blue.
400/17TB	Tid-Bit Set (1943), 2-deck Bon Bon, cupped plates, wooden handle held in place by wooden screw or peg. Consists of 400/1F 5″ Top Bowl, 400/7F 7-1/2″ Bottom Bowl, Handle 4-5/8″ (1-1/8″ d. top of knob). Reported: with red bowls and metal handle.
400/18	Cocktail (1947-1951), 3-1/2 oz., domed foot, beads around base.

400/18 Old Fashioned, Cocktail (1947-1951), 7 oz. domed foot, beads around base. Also part of 400/8918 3 pc. Marmalade Set.
400/18 Parfait (1947-1951), 7 oz., domed foot, beads around base.
400/18 Sherbet (1947-1951), 6 oz., domed foot, beads around base. Shown in BETTER HOMES AND GARDENS in Oct. 1951, page 312.
400/18 Tumbler, Juice (1947-1951), 5 oz., domed foot, beads around base.
400/18 Tumbler, Water; Goblet (1947-1951), 9 oz., domed foot, beads around base.
400/18 Tumbler, Water; Iced Tea (1947-1951), 12 oz., domed foot, beads around base.
400/18 Bottle, Cordial and Stopper (1947-1951), 18 oz., domed foot, beads around base.
400/18 Sugar and Cream Set (1954-1955), domed foot, large beads around base. Creamer has attached handle without beads; Sugar has no handle.
400/18 Pitcher, Manhattan (1947-1955), 40 oz., beaded footed base. Color: yellow beads.
400/18 Pitcher, Jug (1947-1955), 80 oz., 5 pint, beaded footed base. Reported: green beads (1953); yellow beaded base; light amber beads; light amber. Bead Green foot, Flask Brown foot, and Heather foot were produced during the first six months of 1951.
400/18F Bowl; Nappy, 10″ (Same style as all F bowls).
400/18TB Tid-Bit Set (1943), 3 Hi Snack Rack, cupped bowls, wooden handle. Top section 4-5/8″ high; ball top 1-3/4″ d., 1-1/2″ high. Other sections of handle 4″ high each, 1-1/8″ d. at top and bottom. Top dish 5-3/16″, 1-1/4″ high. Center dish 6″, 1-1/2″ high. Bottom dish is possibly 7″ d. These are probably the 400/1F, 3F, and 5F bowls. Reported: with metal handle instead of wood.

The 400/19 series is characterized by the large beads around the base, straight sides; referred to as low footed. Tumblers have been reported with amber beads and with green beads.

400/19 Cocktail (1943-1961), 3 oz. — 3-1/2 oz., footed.
400/19 Old Fashioned (1941-1968), 7 oz., footed. Part of 400/1929 Cigarette Set, 6 pc. (Used as Cigarette Jar — 1948 price list).
400/19 Sherbet; Dessert (1941-1979), 5 oz., low footed. Also part of 400/63/104 19 pc. Chilled Fruit Set.
400/19 Tumbler, Juice (1941-1975), 5 oz., footed. Also part of 400/313 13 pc. Breakfast Tray Set. Reported: with convex foot.
400/19 Tumbler, Water (1941-1973), 10 oz., footed. Foot found flat, convex, and domed. Reported: yellow beads.
400/19 Tumbler, Iced Tea (1936-1979), 12 oz., footed. Patent date 7/36. Also part of 400/24/19 7 pc. Cool Drink Set. Colors: Bead

	Green foot, Flask Brown foot, and Heather foot offered by Imperial first six months of 1951. Three of these goblets were used in sets during WWII: One has the American Flag and blue ME, the second shows AND, the third shows the British flag and YOU.
400/19	Tumbler, Iced Tea (1943-1973), 14 oz., footed.
400/19	Wine (1943-1961), 3 oz., footed. Also part of 400/29/6 6 pc. Cigarette Set, 400/1639 8 pc., Wine Set.
400/19	Ash Tray (1943-1961), 2-3/4″, 11 beads around edge, round. Also part of 400/19 4 pc. Ash Tray Set with gold beads (1948 and also 1950-1954).
400/19	Ash Tray Set (1948), 4 pc., round, 2-3/4″, ash trays with "Hand Fired Bright Gold." Beads are gold. Each set was "gift packed in plastic box." Set listed on bulletin dated December 28, 1948.
400/19	Egg Cup (1941-1960), 6 oz., 2 styles: Catalog B, 1941, base is slightly domed with small beads; Catalog C, 1943, base has large beads-regular 400/19 style. Also part of 400/313 13 pc. Breakfast Tray Set.
400/19	Muddler (1943-1955), 4-1/2″. Used to stir short drinks like Old Fashioned; 5 graduated beads on handle.
400/19	Mustard, Cover (?), sometimes spoon. Same size and shape as 400/19 Cocktail, only 1/4″ shorter — reported by collector.
400/19	Salt Dip (1943-1963), 2-1/4″, round, usually 9 large beads around rim. Also part of 400/19 8 pc. Salt Dip Set with "Hand Fired Bright Gold." Listed on bulletin dated December 28, 1948. Each set "gift packed in plastic gift box." Beads are gold.
400/19	Salt Dip Set (1948), 8 pc., 2-1/2″. "Hand Fired Bright Gold Beads." Listed on Imperial Brochure dated December 28, 1948. Each set "gift packed in plastic gift box."
400/19	Pitcher, Martini; Juice; Cocktail (1943-1967), 40 oz. Uses #176 12″ Stirrer; taller and slimmer than 400/24. Regular spout.
400/19	Pitcher, Liliputian (1943-1949; 1950-1967), 16 oz. low footed. Variations: found with both small and large beads around base.
400/19/89	Marmalade Set (1941-1943), 3 pc., same as 400/1989. Consists of 400/19 7 oz. Old Fashioned Cocktail, 400/89 Marmalade Cover, 400/89 Marmalade Spoon.
400/20	Punch Set (1937-1979), 15 pc. Consists of 400/20B 13″, 6 qt. Punch Bowl, 400/20V 17″ Cupped-edge Plate, 400/37 Punch Cups (12), 400/91 Punch Ladle, large, all glass. Color: Viennese Blue. Reported: on wooden tray as set. In some records, ladle listed as 400/20.
400/20	Punch Set, Jamboree Cut (1970), 12 made. Special promotion for JAMBOREE U.S.A. in Wheeling, W.VA. Presented to

major Western Music stars as they appeared at the JAM-BOREE in 1970. Same description as 400/20; all same component parts.

400/20 D.E. & Gold
Punch Set (1940's — ?), 15 pc. Same component parts as 400/20. (Decorated, Etched, and Gold)

400/20B Punch Bowl (1937-1979), 13″, 6 qt. Also part of 400/20 Punch Set, 400/128 Punch Set, 400/128 D.E. Etched-in-Gold Punch Set, 400/20 D.E. & Gold Punch Set.

400/20D Plate, Torte (1937-1973), 17″, flat edge; 1938 Lombardo Brochure shows cupped edge; Catalog A shows flat edge-1939. Reported: green with flat edge.

400/20V Plate, Torte; Sandwich (1939-1961, 1967-1968, 1973, 1976 1979), 17″, cupped edge. Also part of 400/20 Punch Set. Reported: Gold, etched with Wild Rose.

400/21 Vase (1939-1951), 8-1/2″, beaded base, plain flared top rim, footed, shaped like 3400 Tumblers. Color: Ruby foot-1941.

400/22 Vase (1939-1950), 10″, beaded base, straight sides, no beads on top rim, footed. Same style as 400/19 series. Color: Ruby foot — 1941.

400/23 Mayo Set (1939-1978), 3 pc. 1973-1978 offered as 2 pc. without ladle; 1941 Newhouse Brochure shows as 2 pc. set with handled plate and bowl and no ladle; 1942 Brochure shows handled bowl and plate, and 2-bead ladle. 1959 Dungan Brochure and also Catalog C show 3-bead ladle. Has same underplate as 400/50/23 Cream Soup Set. Consists of 400/23B 5-1/4″ Mayo Bowl, 400/23D 7-1/2″ Plate with Seat, 400/165 3-bead Ladle. Color: Viennese Blue.

400/23B Mayonnaise Bowl (1939-1978), 5-1/4″. Also called Fruit. Early, called Finger Bowl. Several styles — some more flared, some with more distinct base. Old style: 4-3/4″ with straight sides. Also part of 400/23 3 pc. Mayo Set, 400/313 13 pc. Breakfast Tray Set. Colors: Viennese Blue. Reported: blue bowl in metal holder with handle; blue bowl on 3″ silver stand marked "Continental Silver Co., Inc."; on 1″ silver base marked "Sterling"; in metal holder with spoon; gold beads.

400/23B Juice Set (1943), 3 pc. Consists of 400/23 Bowl and Plate Set and #841 4 oz. Juice Tumbler.

400/23D Plate with Seat (1939-1977), 7″. Also part of 400/23 3 pc. Mayo Set, 400/49 3 pc. Mayo Set, 400/50/23 Cream Soup Set, 400/733 2 pc. Salad Dressing Set. Color: Viennese Blue.

400/24 Pitcher, Water, Ice (1940-1967), 80 oz., 5 pint, 6 bead handle, elongated spout. 1955 changed to 64 oz. Also part of 400/24/19 7 pc. Cool Drink Set. Reported: in silver.

400/24/19 Cool Drink Set (1943), 7 pc. Consists of 400/19 12 oz. Tumblers (6) and 400/24 80 oz. Pitcher.

400/25	Vase, Bud Ball (1939-1961), 3-3/4″ — 4″, low-footed, crimped and flared top rim; mould used for Lotion Bottle.
400/25C	Vase (1948), 3-3/4″, footed; shown on 1948 Price List; possibly same as 400/25 with C being dropped later.
400/26	Lamp, Hurricane (1943), 3 pc. Base looks like kerosene lamp, beaded base. Does not have candle cup. Consists of 400/26 Shade or Chimney (there might have been a 400/26C as some of the lamps had crimped shades), and 400/152 Adapter without peg — fits into hole in top of lamp base.
400/26	Chimney; Shade (1943-1955); crimped and plain. Bottom of chimney is very small — approx. 2″ in d., has bulge — then narrows to fit into adapter. Also part of 400/1753 Hurricane Lamp with Prisms.
400/27	Vase (1939-1943), 8-1/4″ — 8-1/2″, beaded base, no beads on top rim, slightly curved sides leading to smaller top opening. Color: Ruby foot-1941.
400/28	Vase (1939-1941), 8-1/2″, beaded base, ball leading to narrow vase opening, flared top, no beads on top rim. Color: Ruby foot — 1941. Reported: with attached silver rim.
400/28C	Vase (1941-1965), 8-1/2″, same as 400/28 except top rim is crimped (scalloped). Footed, ball above short, round, beaded base; vase extends upward into flare.
400/29	Tray (1941-1984), 6-1/2″ — 7-1/4″, oblong. 2 Styles: with 2 seats and without seats. Also part of 400/29/6 6 pc. Cigarette Set, 400/29/30 Sugar/Cream/Tray Set, 400/29/64 6 pc. Cigarette Set, 400/29/64/44 6 pc. Cigarette Set, 400/111 Tête-a-Tête, 400/122/29 Sugar/Cream/Tray Set, 400/701 5 pc. Condiment Set, 400/2794 3 pc. Oil and Vinegar Set, 400/2911 3 pc. Oil and Vinegar Set, 400/2989 3 pc. Twin Jam Set, 400/2990 5 pc. Condiment Set, 400/5629 3 pc. Mustard and Catsup Set. Reported: gold, etched bird and flower design.
400/29/6	Cigarette Set (1943-1955), 6 pc. Consists of 400/19 Cigarette Holder (3 oz. Wine), 400/29 6-1/2″ Oblong Tray, 400/64 2-3/4″ Nut Cups (4).
400/29/30	Cream, Sugar, Tray Set (1941-1984). Consists of 400/29 6-1/2″ Oblong Tray, 400/30 Cream and Sugar Set. Also part of 400/316 16 pc. Luncheon Set. Colors: gold beads; all gold with bird and flower etched design; all gold with etched doves — old style cream and sugar. Style changed in 1943.
400/29/64/44	Cigarette Set (1941-1943), 6 pc. Number taken from 1940 Brochure. Consists of 400/29 6-1/2″ Oblong Tray, 400/44 Cigarette Holder, 400/64 2-3/4″ Ash Trays (4).
400/30	Cream and Sugar Set (1937-1984), 6 oz. Ounces given in 1938 Lombardo Brochure. Style changed in 1943. Early — blunt, flat base; addition of 400/37 type foot or base; Catalog C and

before — rounder and smaller lip, later — taller and slimmer with larger lip. Color: Viennese Blue. Reported: red flashed; Amber; gold; Sterling silver bases; with "Charleton" hand-decorated with roses and ribbons. Also part of 400/29/30 Cream, Sugar, and Tray Set. 1938 — both cream and sugar were 2-7/8″ high. After change, cream 3-1/2″ high, sugar 3-1/8″ high.

400/31 Cream and Sugar Set (1937-1967), 8 oz., footed. Style change - 1939: early — beaded foot with plain handle, later — beaded handle with plain foot. Early shown in 1938 Lombardo Brochure. Stem differences: some are short and squatty, others tall and slender, still others are thicker. Cream 5″ high, sugar 4-1/2″ high — variations. Colors: Satin-Trimmed; Viennese Blue. Reported: with silver bases; Amber.

400/32 Lamp, Hurricane (1943), 16″, beaded base. Base also made for Lightolier Lighting Company. Same as 400/155 Eagle Candleholder. Number was changed. Base is 4-1/4″ high without adapter; 5-7/8″ high with adapter. For more information see 400/155 Hurricane Lamp and 400/155 Lamp Base. Consists of 400/152 Adapter and 400/152 Chimney. Same as Hurricane Lamp 400/155.

400/33 Ash Tray; Jelly; Individual (1937-1943), 4″, round. Colors: Satin-Trimmed; Viennese Blue. Reported: with "Handmade Imperial" etched on bottom.

400/34 Plate; Ash Tray; Coaster; or Individual Butter (1937-1955), 4-1/2″, round. 1948 — listed as Butter; 1937-1955 listed as Coaster and Ash Tray. Colors: Satin-Trimmed; Viennese Blue. Reported: dark green beads.

400/35 Cup, Tea (1937-1975), 3-1/2″ at opening. 2 styles: 1937-1938 cup has no beads on handle; later — beaded question-mark handle, 1939. Sandra Handler, Canada, says her..."cup has a sculptured handle. It is plain but the glass has two divergencies, one near where the handle joins the cup, the other at the top where the handle begins to curve downward — both on the outside edge of the handle." Patent applied for 5/24/41 and received 11/25/41. Patent #130,486. Also part of 400/13 15 pc. Luncheon Set, 400/313 13 pc. Breakfast Tray Set, 400/316 16 pc. Luncheon Set. Colors: Satin-Trimmed; Viennese Blue; gold and etched.

400/35 Saucer (1937-1984), 5-3/4″. Also part of 400/13 15 pc. Luncheon Set 400/89 4 pc. Marmalade Set, 400/313 13 pc. Breakfast Tray Set, 400/316 16 pc. Luncheon Set, #14437 (400/37) Coffee Cup and Saucer Set. Some saucers have a slightly built-up cup ring; this is an early saucer used to hold the cup, and also for the 400/89 Underplate. Colors: Satin-Trimmed; Viennese Blue.

400/35	Tea Cup and Saucer Set (1937-1975). For more information, see 400/35 Cup and 400/35 Saucer above.
400/36	Plate, Canape (1937-1977), 6″ — 6-1/4″, with small off-center seat. 2 styles seats: 2″ seat and 2-1/2″ seat, listed on 1948 Price List. Also part of 400/36 2 pc. Canape Set (2″ seat), 400/91 2 pc. Cocktail Set (2-1/2″ seat), 400/97 2 pc. Cocktail Set (2-1/2″ seat). Colors: Satin-Trimmed, Viennese Blue, gold and etched.
400/36	Canape Set (1937-1950), 2 pc. Consists of 400/36 Canape Plate (2″ seat) (1948 Price List), and 400/142 3-1/2 oz. Cocktail Juice Tumbler. Colors: Satin-Trimmed; Viennese Blue; gold and etched.
400/37	Cup, Coffee; Punch (1937-1984), 5-3/4″. Uses 400/35 Saucer. Taller, straighter sides than 400/35 Tea Cup; top rim of cup flared. Question-mark handle. 1973 Computer number (Lenox) is #14437. Cup part of 400/20 Punch Set, 400/20 Jamboree U.S.A. Cut Punch Set, 400/20 D.E. and Gold Punch Set, 400/98 2 pc. Party Set, 400/128 Punch Set, 400/128 D.E. Etched-In-Gold Punch Set. Colors: Viennese Blue; gold and etched. Reported: with Crackle pattern; gold beads. Imperial experimented with the Crackle pattern in 1951.
400/38	Plate, Salad (1938-1944), 9″, oval. Color: Viennese Blue.
400/39	Plate, Cocktail (1937-1943), 6″, off-center seat — 2-1/2″. Same as 400/36 Canape Plate with large seat. Also part of 400/91 Cocktail Set and 400/97 Cocktail Set. See 400/36 for more information.
400/40	Mayo Set (1937-1941), 3 pc. Lombardo Brochure (1938) shows belled bowl, ladle without beads, and underplate. Bowl thought to be first Candlewick item made, and 7″ plate the 2nd item. Also part of 400/51340 13 pc. Salad Set. Colors: Satin-Trimmed; Viennese Blue.
400/40	Vase, Miniature, Peg (1947-1955), fits all flower candleholders. Catalog D — 1947 — plain, no beads, crimped top. Catalog E — 1957 — beads on top rim. 4 styles:

 1. 2 beads on stem; beaded top; 8″ high — for 400/196 Epergne

 2. no beads on stem; plain, crimped top — 1947 — for 400/40CV

 3. no beads on stem; beaded top 4-1/2″ — for 400/40S or 40CV

 4. no beads on stem; beaded top 6″ — for 400/40S

This information is from Myrna Garrison of Arlington, Texas. Also part of 400/40CV 2 pc. Flower Candleholder, 400/40S 2 pc. Flower Candleholder, and 400/196 2 pc. Epergne. Reissued 8/31/59 for Globe Silver Company.

400/40B Finger Bowl; Mayo (1937-1941), 5-1/2″. Also part of 400/40 Mayo Set. Color: Viennese Blue. Reported: with silver base.

400/40C Candleholder, Flower (1947-1967), 5″, crimped edge. Also part of 400/CV Flower Candleholder. Reported: with silver base; red.

400/40CV Candleholder, Flower (1947-1955), 2 pc. Miniature vase variations: plain, crimped rim, beaded rim. Consists of 400/40 Miniature Vase, 400/40C Flower Candleholder.

400/40D Plate (1937-1955), 7-1/2″, round, slanting sides, 1″ deep, beaded edge, used under 400/50 Cream Soup. Plate is more like an "underbowl." Shown in 1938 Lombardo Brochure. 2-3/8″ seat; 2-3/4″ foot. Later: more plate-styled, used as underplate.

400/40F Candleholder, Flower (1947-1960), 6″, round, cupped.

400/40H Bon Bon, Heart (1939-1984), 5″, handled. Same as 400/40/H. Colors: Imperial Red with crystal handle; Viennese Blue; silver. Reported: totally covered with silver, signed Rockwell.

400/40HC Candleholder, Flower, Heart (1947-1951), 5″, handle.

400/40H/23D Mayo Set (1941), 3 pc. Listed on 6/7/41 Imperial Price List. Consists of 400/40H 5″ Heart, 400/23D 7-1/2″ Mayo Plate, #615 Mayo Ladle.

400/40/0 Basket (1939-1984), 6-1/2″, plain handle. Variations: some bowls turned up more than others; 33 and 44 beads; definite base on some, others almost no base; handles — some have rosettes at connection, some have beads, some have several missing beads at connection, several found with handles more than 2″ higher than average. Colors: Gold — at least 3 have been reported; Imperial Red with clear handle. From Imperial's files: handle "made stuck up." Handle was in an upright position with fork at tip to hold candle in place. One reported — basket candleholder? Reported: beads on underside of handle; very high base; in metal holder.

400/40S Candleholder, Flower (1947-1951), 5″ — 6-1/2″, square. Difference in size — sides of bowl are turned up more.

400/40V Vase, Miniature, Peg (1947-1955), see 400/40 Vase, Miniature for more information. Believe "V" was later dropped.

400/42B Bowl or Nappy, Fruit (1937-1978), 4-1/2″ — 4-3/4″, round, handled. Also part of 400/42/3 3 pc. Mayo Set, 400/4272B 4 pc. 2-Handled Bowl Set. Colors: Satin-Trimmed; Viennese Blue. Reported: with silver base attached; #1107 printed on inside of silver base.

400/42D Plate (1937-1973), 5-1/2″, round, handled. Also part of 400/42/3 3 pc. Mayo Set, 400/4272D 2-handled Plate Set. Colors: Satin-Trimmed; Viennese Blue; Carmel Slag (mid-'70s).

400/42E Tray (1937-1943), 5-1/2″, round, E series — with turned-up handles or turned-up plate sides. Listed on 1943 Imperial

	Price List as Lemon Tray. Colors: Satin-Trimmed; Viennese Blue.
400/42/3	Mayo Set (1943-1971), 3 pc. Consists of 400/42B 4-3/4″ 2-handled Nappy, 400/42D 5-1/2″ 2-handled Plate, 400/130 Marmalade Ladle.
400/44	Cigarette Holder (1941-1943), 3″, beaded base. Found 2-1/4″ & 2-3/4″ high and 1-7/8″ & 2-1/4″ d. From Virginia Scott's newsletter #29, p. 1, 3 styles are listed: early — domed foot, round bowl, small beads; large bowl, flat bottom, with 400/19 type beads; more slender bowl, flat bottom, large beads — 400/19 type.
400/45	Compote (1939-1967), 5-1/2″, 4-bead stem. Early — Catalog A, 1939 — 5″ high, bowl more rounded and cupped — 5-1/2″. Later — Catalog B, 1941 — bowl flared. Colors: Black; Gold with clear stem — designed; Gold-on-Glass — December 1958 BETTER HOMES & GARDENS magazine, Pet Milk ad. Reported: looks like 400/48 bowl but is smaller — like 400/45, and beads are like scallops — they stand straight up instead of being along the outer edge.
400/46	Relish; Celery Boat (1939-1943) 11″, oval.
400/48F	Compote (1939-1954; 1963), 8″, 4-bead stem. Patent shows 5-bead stem. In 1940 BETTER HOMES & GARDENS magazine, 5-bead stem was advertised. Some have been reported. Patent applied for 3/25/41, received 5/20/41 — #127,271. Color: Gold-on-glass.
400/49	Mayo Set (1941-1967), 3 pc. Consists of 400/23D 7″ Underplate, 400/49/1 5″ Heart Bowl, 400/165 Mayo Ladle.
400/49H	Bowl, Heart (1939-1955), 9″, no handle. Also part of 400/4975 4 pc. Salad Set. Color: Milkglass. Reported: Milkglass with hand-painted flowers.
400/49H	Bowl, Heart (1939-1951), 5″, no handle. Believed changed to 400/49/1. Color: Ruby.
400/49/1	Bowl, Heart; Fruit (1950-1967), 5″, no handle, 2-1/4″ high, flat base, 2-5/16″ d. 2 styles: Catalogs B & C — have base; 1967 Catalog — flat, no base. Also part of 400/49 3 pc. Mayo Set. In "Ballard" Community Silverplate Set with silverplate ladle. 400/49H shown in Catalogs, A, B, C, D. 400/49/1 shown in Catalogs E, F, G, 1966, 1967. Believed number changed from H to /1 to avoid confusion between 5″ and 9″ heart bowls.
400/50	Bowl, Cream Soup (1937-1955), 5″ — 5-1/2″, handles. 1938 Lombardo Brochure — bowl smaller in diameter and deeper, with belled sides. Also part of 400/50/23 Cream Soup on Plate Set, 400/50 3 pc. Cream Soup on Plate Set. Color: Viennese Blue. Reported: blue frosted.
400/50	Plate, Center; Soup (1941-1955), 8″, 3-1/2″ seat, 4-1/2″ indent.

400/50	Cream Soup on Plate Set (1937-1955), 3 pc. Consists of 400/10D 10-1/2″ Dinner Plate, 400/40D 7-1/2″ Underplate, 400/50 5″ — 5-1/2″ Cream Soup Bowl.
400/50/23	Cream Soup on Plate Set (1943-1955), 2 pc. Consists of 400/23D 7″ Plate with Seat, 400/50 5″ Cream Soup Bowl.
400/51	Candy Dish; Nappy; Mint (1937-1941), 6″, vertical handle. Same as 400/51F. Later called Handled Mint. Colors: Satin-Trimmed; Viennese Blue. Reported: gold beads.
400/51C	Candy Dish (1943), 6″, vertical handle, crimped, beaded rim.
400/51F	Candy Dish; Mint (1941-1979), 6″, vertical handle, round. Same as 400/51. Earlier called Handled Nappy. Colors: red with clear handle. Reported: blue.
400/51H	Candy Dish; Bon Bon (1943-1968), 6″, vertical handle, heart shaped, shallow. Color: red with clear handle.
400/51M	Tray, Card (1943), 6″, vertical handle.
400/51T	Tray, Wafer; Heart (1943-1973), 6″, center handle — from center of bowl to dip in top of heart. Color: red with clear handle. Reported: red handle; with candle cup in center; with hand-painted gold flowers, green leaves, and strawberries — 1947-1949.
400/52	Bowl; Jelly (1950-1976), 5-1/2″ — 6″, divided, 2 handles, round. Color: blue. Found on Crown Sterling base: 6″ d., base 2-3/4″ d., 1″ high, entire piece 3-1/2″ high, no handles.
400/52B	Bowl; Nappy (1937-1973), 6″ — 6-1/2″, 2 handles, same as 400/52 except no divider, round. Also part of 400/52/3 3 pc. Mayo Set, 400/4272B 4 pc. 2-Handled Bowl Set. Colors: Satin-Trimmed, Viennese Blue; Carmel Slag. Reported: blue with frosted beads; gold; with beads and handles 1/4″ below edge of bowl, beads are frosted.
400/52BD	Mayo Set (1939-1943), 3 pc., looks like 400/52/3 — # could have been changed from BD to 3. Variations: 1940 Brochure shows handles on plate and bowl — none on ladle; 1941 Newhouse Brochure — no handles; Catalog A shows 1-bead ladle. Consists of 400/52B 6-1/2″ 2-handled Bowl, 400/52D 7-1/2″ 2-handled Plate, 400/165 Mayo Ladle.
400/52C	Plate; Tray (1950-1968), 6-3/4″, crimped, 2 handles.
400/52D	Plate (1937-1968), 7″ — 7-1/2″, 2 handles, round. Also part of 400/52/3 3 pc. Mayo Set, 400/4272D 4 pc. 2-Handled Plate Set. Colors: Satin-Trimmed; Viennese Blue; Carmel Slag; black; red.
400/52E	Plate (1937-1941; 1950-1968), 7″ — 9″, round. Variations: Catalog B — 7-1/2″ Tray, handles turn up, sides of plate don't; Catalog E — 7″ Plate, sides of plate turn up, handles don't; Catalogs F & G — 9″ Plate, sides of plate turn up, handles don't. Colors: Satin-Trimmed; Viennese Blue; Black — sides turn up.

400/52/3	Mayo Set (1943-1968), 3 pc. Consists of 400/52B 6-1/2" 2-Handled Bowl, 400/52D 7-1/2" 2-Handled Plate, 400/165 Mayo Ladle — 1948 Imperial Price List shows 400/135 Ladle. Reported: red; irridized beads — red with gold and ruby-flashed plain-handled spoon.
400/53	Bowl (1952), 5-1/2", no risers, beaded top rim.
400/53C	Icer (1950-1955), 5-1/2" — 5-3/4", fluted, beaded top rim; 3 risers to hold sherbet insert. Also part of 400/53/3 3 pc. Icer Set. Variation: old is more flared; new is deeper.
400/53/3	Icer Set (1950-1955), 3 pc. Information from June 20, 1952 Imperial Bulletin: consists of 400/53C Icer Bowl (Bulletin shows it as 400/53), #530 Sherbet Lining — not Candlewick, #530 5-1/2 oz. Tumbler — not Candlewick.
400/53H	Bowl, Heart (1950-1955), 5-1/2", deep.
400/53S	Bowl, Round-Square (1954-?), 5", square, crimped, beaded top rim; round base and bowl. Much controversy has arisen since the round-square bowls have been "discovered" in the past few years. Finally, the puzzle has been solved, thanks to Helen Clark (Bellaire, OH), and Virginia Scott (Athens, GA) who printed the info in her Candlewick newsletter, CANDLEWICK COLLECTOR. A listing from Imperial sent to W. J. Hughes & Sons, Ltd, of Canada, known for their "Canadian Cornflower" cut pattern on Candlewick, showed 400/53S 5" Square Bowl. Helen has the list, dated January 26, 1954. There are several sizes of the round-square bowls that have been found by collectors. Found: 4-3/4" d. and much larger, with Imperial labels, 2-1/2" high, 44 beads, variations in sizes of sides and corners turning up (crimped). Currently dates of production are not known, but the 1950's is an educated guess.
400/53X	Bowl, Baked Apple (1937-1960), 6" — 6-1/2". Also called Baked Apple Server. Variations in bowl shape and beads placement. 1938 Lombardo Brochure shows 8" underplate. Color: Viennese Blue.
400/54	Tray, Relish (1937-1984), 6-1/2", 2 sections, 2 handles, divider, round. Curved divider shown reversed in Catalogs 1971, 1975-1976. Colors: Viennese Blue; odd brown/green. Reported: in boxed set with spoon — from Community Silver Co.; with pickle fork and flat server with roses on handles; with Canadian "Corn Flower" Cut by W. J. Hughes.
400/55	Tray, Relish (1937-1984), 8-1/2", 4 sections, 4 handles, round. Early shown with 2 handles; shown as a set using 400/20D 17" Underplate. Color: Viennese Blue. Reported: lavender; all satin; in a metal holder — labeled "Hand Forged Everlast Metal" — has grouping of leaves on each corner of holder.
400/56	Tray, Relish (1937-1979), 10-1/2", 5 sections, 5 handles, round.

Variation: 3 elongated sections, no handles — Catalog B. 5-section style introduced October 18, 1948. Color: Viennese Blue. Reported: gold beads; inserted in chrome tray.

500/57 Tray, Pickle; Celery; Relish (1937-1943), 6" — 7-1/2", oval. Advertised in 1937 as 6", in 1938-1941 as 7-1/2". Color: Viennese Blue.

400/58 Tray, Pickle; Celery; Relish (1937-1976), 8" — 8-1/2", oval. 1939 Lombardo Brochure shows 8-1/2" Celery Tray and 7-1/2" Pickle Tray. 1959 Dungan Brochure shows 8" Relish. Color: Viennese Blue.

400/59 Candy Box, Covered; Jelly (1937-1967), 5-1/2" — 6-1/2", round, with lip. Early — covered jelly — had knob instead of 2-bead finial on cover. Knob: 1937-1949; 2-bead finial: 1950-1967. 2-bead finial cover 4-3/4" d., will also fit 400/144 round butter.

400/60 Tray, Relish (1939-1941), 7", round, beaded edge, slanting sides, 42 beads, 1" high. Sides more flared than Ash Tray — this number used earlier for ash tray — see next entry. Reported: in boxed "Community Twilight" Set with spoon; with butter spreader in green gift box.

400/60 Ash Tray (1937-1938), 6", round, beaded edge, slanting sides, 42 beads, shallow — 1" deep. Center riser and indentation for matchbook; side risers and indentations for 2 cigarettes. Center later eliminated for 400/60 7" Relish — see above entry. 1938 Lombardo Brochure shows the 400/60 6" Ash Tray.

400/61 Salt Dip (1941-1967), 2", 18 beads — small, some 16 beads, round. Also part of 400/61 8 pc. Salt Dip Set with Bright Gold Beads, 400/616 16 pc. Individual Salt Set. Color: Red. Reported: set of 4 salts with 4 brass spoons, each with different figure at the tip of handle.

400/61 Salt Dip Set (1948), 8 pc. "Hand Fired Bright Gold Beads," listed on Brochure dated December 28, 1948. Each set "gift packed in a plastic gift box."

400/62B Bowl; Nappy (1937-1984), 7", 2 handles, round. Also part of 400/4272B 4 pc. 2-Handled Bowl Set. Colors: Satin-Trimmed; Viennese Blue. Reported: Ruby; gold on beads; when Satin-Trimmed — bowl has raised ridge base.

400/62BD Bowl and Plate Set (1937-1941), 2 pc. Consists of 400/62B 7" 2-handled Bowl or Nappy, 400/62D 8-1/2" 2-handled Plate. Colors: Satin-Trimmed; Viennese Blue. Reported: Ruby.

400/62C Plate; Tray (1947-1968), 8-1/2", 2 handles, crimped.

400/62D Plate (1937-1968), 8-1/2", 2 handles, round. Also part of 400/4272D 2-Handled Plate Set. Colors: Satin-Trimmed; Ruby; Viennese Blue; Black — also with hand-painted flowers; Carmel Slag. Reported: when satin beads, base has raised

ridge.

400/62E Tray (1937-1943), 8-1/2″, turned-up handles, round. Colors: Satin-Trimmed; Viennese Blue; Black — also with gold beads, white flowers — variations. Reported: 5/8″ frosted band around edge with frosted beads; in Viennese Blue-sides and handles all turn up.

400/63 Ice Tub (1940-1948), 5-1/2″ deep, 7″ — 8″ d., beaded top rim, larger beads on two sides of rim for handles. Also part of 400/63/104 19 pc. Chilled Fruit Set.

400/63B Bowl, Belled (1937-1970), 10-1/2″, graduated beads on two sides for handles. Patent picture shows 400/63 without the B. Also part of 400/63B/81 3 pc. Console Set, 400/63B/170 3 pc. Console Set, 400/6300B 3 pc. Console Set, 400/8063B 3 pc. Console Set. Early: 9-1/2″ d., 3-5/8″ deep. Patent applied for May 24, 1941, received January 27, 1942, #131,250. Reported: red flashed-on beads.

400/63B Compote (1937-1941), 4-1/2″, earlier called comport. Early style — rounded bowl. Later style — less rounded and slopes to stem. 2 style stems: no bead on stem; "bulge" on stem. Colors: Satin-Trimmed; Viennese Blue. Reported: with ruffled top rim.

400/63B/81 Console Set (1939-1941), 3 pc. Full page ad from Imperial's files show 1″ Crystal beads in Console Bowl. Consists of 400/81 2 — 3-1/2″ Handled Candleholders, 400/63B 10-1/2″ Belled Bowl.

400/63B/170 Console Set (1948), 3 pc. On 1948 Price List. Consists of 400/63B 10-1/2″ Belled Bowl, 400/170 2 — 3-1/2″ Candleholders.

400/63D Comport (Compote), Cheese (1938), 5-1/2″. Same as 400/88 — see that entry. Color: Viennese Blue.

400/63/104 Punch Set (1943?), 11 pc. Consists of 400/37 Punch Cups (7), 400/63 8″ Ice tub, 400/104B 14″ Bowl, 400/139 Ladle. Ice Tub sits in bowl, surrounded by ice.

400/63/104 Chilled Fruit Set (Dessert Set) (1943), 19 pc. Similar to previous entry. Consists of 400/1D 6″ Plate (8), 400/19 Footed Fruit (8), 400/63 8″ Ice Tub, 400/104B 14″ Bowl, #139 Glass Ladle — no beads. Ice Tub sits in bowl, surrounded by ice.

400/64 Nut Cup; Nut Dip; Nut Dish; Sugar Dip; Ash Tray (1941-1967), 2-3/4″, round, beaded edge — 18 beads (also 16). Looks like salt dip only a little larger. Part of 400/29/6 6 pc. Cigarette Set, 400/29/64 (400/29/64/44 same) 6 pc. Cigarette Set, 400/64 8 pc. Individual Ash Tray Set with "Hand Fired Gold Beads", 400/83 2 pc. Strawberry Set. 16-bead Dip fits Strawberry Set perfectly; 18-bead Dip slides around. Colors: red flashed-on with clear beads; gold beads; red beads.

400/64 Ash Tray Set, Individual (1948), 8 pc. "Hand Fired Bright

Gold," beads are gold. Listed on Brochure dated December 28, 1948. Each set "gift packed in plastic gift box." Imperial Bulletin with pictures shows dates for gold beads 1950-1954 with 8 in a set.

400/65 Candy Box; Dish; Covered (1939-1943), 8", partitioned, lid sets in, round, 2-bead finial, beaded lip. Believe this to be changed from 400/65/2. Cover interchangeable with 400/140 Candy, 400/158 Candy, 400/260 Candy. Some lids are ringed (edged) on the underside, some are ground, and some are plain. Info from Ron Doll, Holland, Ohio. On Price List 1/1/43 400/65/1 is Covered Vegetable, 400/65/2 is Partitioned Covered Candy Box.

400/65/1 Bowl, Vegetable; Candy; Covered (1940-1951), 8", cover sits in, round, 2-bead finial, beaded lip. Same as 400/65 except not partitioned. Cover interchangeable with 400/140 Candy, but looks more domed. Cover also fits 400/139/1 Covered Snack Jar.

400/65/2 Candy Box, Covered (1939-1943), 8", partitioned. Same as 400/65 — see that entry.

400/66B Compote (1937-1980), 5-1/2", the most controversial of all the compotes. 1938 Lombardo Brochure shows plain stem, flat base, referred to as Compotier. Catalogs B & C (1941 & 1943) show plain stem, beads only around rim of bowl, referred to as Comport, domed base. Catalog D (1947) shows beaded stem and flat base. Changed plain stem to 2-bead between 1944 and 1946. 1969-1971 show slightly domed foot. Also part of 400/9266B 2 pc. Cheese and Cracker Set. Colors: Satin-Trimmed; Viennese Blue. Reported: gold decorated with roses; gold beads, gold band on base; no beads around top rim.

400/66C Candleholder, Flower (1947-1955), 4-1/2", 2-bead stem, crimped bowl.

400/66F Candleholder, Flower (1947-1951), 4", 2-bead stem, beaded bowl.

400/67B Bowl, Fruit, Footed; Compote (1937-1960), 9", 1-bead stem, beaded bowl. Early: ridged (ribbed) bowl — 8 ribs, domed foot. Later: flat base. Colors: Ruby; Satin-Trimmed; Viennese Blue. Reported: white milkglass; blue milkglass.

400/67C Bowl, Fruit; Compote (1950-1956), 9", 1-bead stem, crimped, plain foot. Same as 400/67B except for crimped edge. Looks identical to 400/196FC Epergne, except for candle cup in Epergne bowl.

400/67D Plate, Cake; Stand; Salver (1937-1967), 10", 1-bead stem. Catalog B (1941) ribbed plate, squashed bead, domed foot. Catalog C (1943) no ribs and flat base. 1959 Dungan Brochure slightly domed foot. Colors: Satin-Trimmed;

	Viennese Blue. Reported: Ruby with ribs and domed foot.
400/67D	Banana Stand, 1 bead. One reported. Made from cake plate.
400/68D	Tray, Pastry (1939-1967, 1973-1976), 11-1/2″ — 12″, center-heart handle. Patent applied for 5/24/41; received 8/12/41 for 400/68 Pastry Tray. Patent #128,812. Catalog A (1939) shown as 400/68O. Catalog B (1941) shown as 400/68D. 400/68O is then used as Hurricane Lamp. 1943 Bulletin shows 400/68O. Catalog E (1950) shows 400/68D as 12″. Also part of 400/316 16 pc. Luncheon Set. Colors: Regal Red — advertised in 1962, discontinued "Regal Red Tray" 1/1/63. Reported: gold beads; wide and thin gold bands; silver over-lay.
400/68F	Tray, Fruit (1939-1943), 10″ — 10-1/2″, center heart handle, cupped edge. Also listed as 10-1/2″ Fruit Bowl. Same as 400/68D Pastry Tray, except 400/68F beaded edge is cupped. Reported: cranberry flashing on beads.
400/69B	Bowl, Vegetable (1947-1984), 8-1/2″, round.
400/70	Cruet and Stopper (1940-1941), 3-4 oz., handled, 3-bead stop-per. Also part of 400/701 (400/70/71/29) 5 pc. Condiment Set.
400/71	Cruet and Stopper (1940-1941), 6 oz., handled, 3-bead stopper. Also part of 400/701 (400/70/71/29) 5 pc. Condiment Set.
400/70/71/29	Condiment Set (1940-1941), 3 pc. 1940 Brochure shows this number. Same as 400/701 5 pc. Dates for the 400/701 are 1941-1943. Believe number changed in 1941. Both sets iden-tical, with the earlier set counting only the tray and two cruets and not their stoppers. Consists of 400/29 6-1/2″ Condiment Tray, 400/70 4 oz. Cruet, 400/71 6 oz. Cruet.
400/72	Bowl, Jelly (1950-1963), 8-1/2″, divided, 2-handled, round.
400/72B	Bowl (1937-1976), 8-1/2″, 2-handled, round. Also part of 400/4272B 4 pc. Handled Bowl Set. Colors: Satin-Trimmed; Ruby; Viennese Blue.
400/72C	Plate; Tray (1947-1973), 10″, crimped, 2-handled.
400/72D	Plate (1937-1976), 10″, 2-handled, round. Also part of 400/88 2 pc. Cheese and Cracker Set, 400/95 4 pc. Salad Dressing Set, 400/4272D 4 pc. 2-Handled Plate Set. Colors: Satin-Trimmed; Viennese Blue; Black.
400/72E	Plate; Tray (1937-1943), 10″ — 10-1/2″, handles turn up. Colors: Satin-Trimmed; Viennese Blue; Black. Also part of 400/88 2 pc. Cheese and Cracker Set.
400/73DF	Bowl (?), 10-3/4″. Factory numbered and tagged. Information from CANDLEWICK CAPERS, Ohio Candlewick collec-tors' newsletter. Bells up from base; beads stick straight up — not out; does not curve in at top. Foot like some mayo bowls; 2-1/2″ deep at center; 2-7/8″ from bottom to top bead. Experimental? 1 known.

400/73H	Bowl, Heart (1939-1955, 1973, 1977-1978), 9″ — 10″, handled, for fruit or flowers. Also part of 400/735 3 pc. Salad Set, 400/7375 4 pc. Salad Set.
400/73/0	Basket (1939-1960, 1973, 1977-1978), 11″ — 12″, plain handle. 2 styles: old — sides of bowl turn up considerably, new -turn up slightly. Reported: with high base.
400/73TB	Tid-Bit Set (1943), 2-deck, wooden handle — maple. Plates are flat. Reported: with silver handle instead of maple.
400/74	Bowl (1936-?), 3-toed. Patent applied for 5/19/36, received 7/28/36. Patent #100,577. Color: Blue — probably Viennese.
400/74B	Bowl; Nappy (1937-1941), 8″ — 8-1/2″, 4-toed, ribbed, round. Patent (see previous entry) is for 3-toed, but this could be variation of same patent. 3″ — 4″ deep, 8-1/2″ d., 27″ top circumference — info from Kathy Burch, Ithaca, Michigan. Colors: Ruby; Satin-Trimmed; Viennese Blue; Black. Reported: gold beads.
400/74J	Bowl, Lily (1937-1941), 7″, 4-toed, round, beaded small-flared rim, ribbed (8 sections). Colors: Satin-Trimmed; Viennese Blue; Black.
400/74SC	Bowl; Dish (1937-1946), 9″, 4-toed, crimped, fancy-square shaped, ribbed (8 sections). Colors: Ruby; Satin-Trimmed; Viennese Blue; Black. Reported: red flashed-on; pink feet and beads; alternating red, yellow, and blue beads; red beads and feet; cobalt; cobalt beads; milkglass.
400/75	Fork and Spoon Set (1939-1967), 6 graduated beads — largest at handle tips. Also part of 400/17 4 pc. Salad Set, 400/75B 4 pc. Salad Set, 400/106B/75 3 pc. Salad Set, 400/735 3 pc. Salad Set, 400/925 4 pc. Salad Set, 400/4975 4 pc. Salad Set, 400/7375 4 pc. Salad Set. Reported: 1st two and last 2 beads are red — 2 in-between are clear; 2 beads at tip are gold.
400/75B	Salad Set (1939-1967), 4 pc. Consists of 400/75 Fork and Spoon Set, 400/75B 10-1/2″ Salad Bowl, 400/75V 12-1/2″ — 13″ Torte Plate with cupped edge; also used 400/13D 12″ Flat Plate. Catalogs A and B show flat-edged plate; 1940 Brochure also shows flat edge; 1943 Catalog C changed to cupped edge. 1966 Catalog shows cupped-edge plate.
400/75B	Bowl, Salad (1939-1967), 10″ — 10-1/2″, round. Also part of 400/75B 4 pc. Salad Set, 400/8075 3 pc. Console Set. Reported: red beads.
400/75B	Bowl, Peg (?), 10″ — 10-1/2″, has silver base. One known.
400/75D	Plate (1943), 13-1/2″, flat edge. Possibly same as 400/75V.
400/75F	Bowl, Float (1939-1975), 10″ — 11″, cupped edge. Part of 400/75F/150 Bowl on Base Set, 400/244 5 pc. Hostess Helper, 400/7570 4 pc. Console Set.
400/75F/150	Bowl on Base Set (1948), 2 pc., on 1948 Price List. Consists of 400/75F 10″ — 11″ Float bowl, 400/150 6″ Ash Tray —

	when used with bowl, bottom of ash tray is indented 1/2″ to receive bowl. Also part of 400/7570 4 pc. Console Set.
400/75N	Bowl, Lily (1939-1941), 7-1/2″, round, beaded top rim — turned in at edge, plain base. Rim is deceptive — since beads "roll in" there is virtually no space between beads. Colors: Black; gold beads and flowers. Reported: black with 4 toes with white and red flowers and gold leaves — gold also on beads around edge of bowl; black, crimped, 3-toed like 400/74J.
400/75V	Plate, Torte (1939-1984), 12-1/2″ — 13″, cupped edge, cupped more than 400/92V Torte Plate. Also part of 400/75B 4 pc. Salad Set, 400/7975 4 pc. Salad Set.
400/76	Lamp, Hurricane; Candlelamp (1939-1941), 2 pc. Consists of 400/76 Chimney, 400/81 Candleholder.
400/76	Shade; Chimney (1939-1940), part of 400/76 Hurricane Lamp.
400/77	Cup (1939-1955), 4 oz. Also part of 400/77AD After Dinner Cup and Saucer Set, 400/111 Tête-a-Tête, 400/139/77 11 pc. Family Punch Set.
400/77	Saucer (1939-1955), 5″, 1-1/2″ seat. Part of 400/77AD After Dinner Cup and Saucer Set.
400/77AD	Cup and Saucer Set, After Dinner (1939-1955), 4 oz. Color: Black. Reported: black opaque; frosted pink; gold with etched flower pattern.
400/78	Coaster (1940-1970). 4″ — 4-1/2″, normally 10 spokes in designed bottom — also found with 5 spokes shown in 1940 Brochure. Also part of 400/78 Coaster Set. Reported: gold beads; set of 6 coasters in 6-sectioned red box — all coasters have pattern of small and large "bumps" on bottom. In 1980 Imperial made 200 ringholders using the 400/78 Coaster mould — with 10 spokes, marked LIG.
400/78	Coaster Set (1948), 8 pc. "Hand Fired Bright Gold" — beads are gold. Listed on Brochure dated 12/28/48. Each set "gift packed in plastic gift box." Consists of 8 coasters with gold beads. Imperial Bulletin shows dates for gold beads as 1950-1954.
400/79	Lamp, Hurricane; Candlelamp (1939-1962; 1973, 1977-1979), 2 pc. Consists of 400/79 9″ — 10″ Shade, 400/79R Rolled Candleholder. Reported: 400/79B (flat edge), red, shade and candleholders with gray floral cut; flashed-on red, beads on base and candle cup are crystal; cranberry decoration around the base of the candleholder and on the chimney — bird and leaves; cranberry flashing on chimney with clear etch or cut; tulip pattern and no birds — gold leaves; total ruby flashing on both holder and chimney; wide band of red flashing around candle cup.
400/79	Shade; Chimney (1939-1962; 1973; 1977-1979), part of

	400/179, 2 pc. Hurricane Lamp. Reported: red, flashed-on; gold beads; "Cranberry Decorations fired with tracings of gold on the cranberry leaves and birds. Bohemian Crystal Shade." Information from Scott's newsletter, #63, p. 5.
400/79B	Candleholder (1939-1943), like 400/79R except edge is flat, not rolled. Part of 400/101/79B 5 pc. Float Bowl Console Set. Variations: Catalogs A and B — candle cup is plain; Catalog C and after have rim or flange around top of candle cup. Reported: beads rolled down so they appear to be underneath the base; holder stands on beads.
400/79R	Candleholder (1939-1979), 3-1/2", rolled edge. Part of 400/79 2 pc. Hurricane Lamp, 400/79R/2 Eagle Candleholder, 400/152R 3 pc. Hurricane Lamp, 400/9279FR 3 pc. Hurricane Lamp. Lenox Computer #14990 2 pc. Candlelamp is 400/79 Hurricane Lamp. Variations: Catalogs A and B — slightly rolled edge, candle cups plain, no rim; Catalog C — rolled edge more defined, rim of flange around top of candle cup. Reported: red flashed-on all except candle cup; red bands on saucer area and candle cup; red band 1" wide on rolled-up edge.
400/79R/2	Candleholder, Eagle (1950), 2 pc. Consists of 400/79R Candleholder, #777/1 Crystal Eagle with candle cup.
400/80	Candleholder (1937-1976). 3-1/2" — 4", low footed, 1-bead stem, base looks like inverted dish. Part of 400/80/2 Eagle Candleholder, 400/8013B 3 pc. Console Set, 400/8063B 3 pc. Console Set, 400/8075 3 pc. Console Set. Colors: Satin-Trimmed; Viennese Blue. Reported: gold beads; with blue stain and silver overlay and instructions "DO NOT WASH."
400/80/2	Candleholder, Eagle (1943-1950), unhandled. Consists of 400/80 Candleholder, #777/1 Crystal Eagle with candle cup.
400/81	Candleholder (1937-1943), 3-1/2", handled, same as 400/80 except for handle. Part of 400/63B/81 3 pc. Console Set, 400/76 Hurricane Lamp, 400/81/2 Eagle Candleholder. Colors: Satin-Trimmed; Viennese Blue.
400/81/2	Candleholder, Eagle (1943-1950), handled. Consists of 400/81 Candleholder, #777/2 Crystal Eagle with no candle cup.
400/82	Bottle, Cordial, Stopper (1940-1941), 15 oz., handled. Part of 400/82 10 pc. Cordial Set, 400/82/1 10 pc. Cordial Set. It's unclear if these two sets are identical. Color: 1941-Ruby foot and stopper.
400/82	Cordial Set (1940-1941), 10 pc., Cocktail Set, Consists of 400/82 handled Bottle with Stopper, 3800 Cordials (8). Color: Ruby foot and stopper.
400/82/1	Cordial Set (1943-?) 10 pc. Same as 400/82. Description same as 400/82 Cordial Set. Listed on Imperial Price List 1-1-43.
400/82/2	Bottle, Cordial, Stopper (1943), 15 oz., unhandled, 3-bead stop-

per, beaded base. Part of 400/82/2 9 pc. Cordial Set. Color: Ruby foot and stopper.

400/82/2 Decanter Set (1943), 9 pc., 15 oz. bottle. Consists of 400/82/2 Decanter, 3800 1 oz. Cordials (8).

400/83 Strawberry Set (1939-1948), 7″, Dessert Set, 2 pc. Catalog C - called Seafood Set. Consists of 400/83D 7″ Plate with Seat (400/3D), 400/64 2-3/4″ Sugar Dip. 16 bead Sugar Dip fits strawberry plate perfectly; 18 bead slides around.

400/83D Plate with Seat (1939-1943), 7″, for Strawberry Set. Has indent or seat in center to receive sugar dip. Part of 400/83 Strawberry Set.

400/84 Mayo Set (1937-1960), 4 pc. Consists of 400/84 6-1/2″ Divided Bowl, 400/84D 8″ Plate with Seat, 400/165 2 3-bead Mayo Ladles. 1938 Lombardo Brochure — ladle has no beads; Catalog A — ladle has 1 bead; 1943 Bulletin — ladle has knobs; 1948 Price List shows 400/135 Ladle. Plate indent 4-1/4″ leading to 3-1/2″ seat. Reported: with gold beads.

400/84 Bowl; Nappy (1937-1960), 6-1/2″, partitioned. Part of 400/84 4 pc. Mayo Set, 400/94 4 pc. Buffet Salad Set, 400/95 4 pc. Salad Dressing Set, 400/— 12 pc. Salad Set (Lombardo Brochure). Color: Satin-Trimmed. Reported: gold; gold decorated.

400/84D Plate with Seat (1937-1960), 8″. Part of 400/84 4 pc. Mayo Set. Underplate only used with this set — divided Mayo Bowl. Plate has very distinctive indent; most noticeable when comparing it to a regular 8″ Salad Plate.

400/85 Bowl, Cottage Cheese (1947-1961; 1976-1984), 6″, deep. Same as 400/84 except 400/85 has no partition.

400/86 Candleholder, Mushroom (1937-1941), flat edge. Variation: rolled over to match the 400/92R Mushroom Bowl — possibly 400/86R. Part of 400/8613B 3 pc. Console Set, 400/8692L 3 pc. Console Set. Colors: Satin-Trimmed; Viennese Blue. Reported: alternating yellow, red, and blue beads.

400/86R Candleholder, Mushroom, Rolled Edge (dates ?). Since Mushroom Bowl in Console Set 400/136 is shown with rolled-edge Urn Candleholders, it's probable that the 400/86R Candleholder was early and not well received, so few were made.

400/87C Vase (1939-1963), 7-1/2″ — 8″, crimped top rim. Handle styles: 1939-1941, 2 arched handles with 7 beads on each handle; 1943, 6 graduated beads attached to 2 sides of vase plus 1/2 bead attached at top and bottom of "handle". Rim styles: 1939-1941, 30 beads on rim; 1943 no rim beads; 1950, beading again added to rim. Base is more domed in early vases. Variations found as to number of beads. Color: Viennese

Blue. Reported: uncrimped, but beaded top.

400/87F Vase, Fan (1937-1963), 8″ –– 8-1/2″. 3 styles: 1937-1940, small beads edge 2 solid arched handles; 1941 large beads form 2 arched handles; 1943, beads attached to sides of base to form 2 handles. Colors: Satin-Trimmed; Viennese Blue. Reported: light blue beaded rim; blue beads; yellow beads; red beads, handles, rim; with ruffled beads; with casing of gold filigree — medallion in center of casing pictures a couple dressed in 18th Century clothes, foot of vase has 3 little feet, the gold decoration goes all around the bottom.

400/87R Vase (1937-1943), 7″ — 7-1/2″. 2 styles: 1937-1939, small beads edge 2 arched solid crystal handles; 1940-1941, 7 large beads arched to make up handles on 2 sides of vase. Vase base more domed-early. Colors: Satin-Trimmed; Viennese Blue. Reported: blue with satin trim; every other bead blue — painted on; blue beaded top with small- bead handles; cobalt beads; rim more rolled on some; plain (not rolled) beaded top, small beads on handles; handle-less vase.

400/88 Cheese and Cracker Set (1937-1967), 2 pc. Consists of 400/72D 10″ Handled Plate (1938 Lombardo Brochure used 400/72E 10-1/2″ Tray), 400/88 5-1/2″ Cheese Compote. Colors: Satin-Trimmed; Viennese Blue. Reported: light blue with frosted dots; blue with frosted beads.

400/88 Compote, Cheese (1937-1967), 5-1/2″ — 5-3/4″, flat base, 1-bead stem, flat beaded plate. Part of 400/88 2 pc. Cheese and Cracker Set. Early: called comport; number was 400/63D; shorter; 34 beads around plate; 2″ high; bulge on stem instead of bead; found with scalloped beads; found with Sterling base. Later: 6″ d.; 32 and 36 beads reported; 5-3/4″ d.; 2-1/2″ high; large round bead on stem. Colors: Satin-Trimmed; Viennese Blue. Reported: gold; gold beads, red beads.

400/88D Plate (1937), 10″, 2 handled. Seems to be same as 400/72D. Color: Viennese Blue.

400/89 Bowl, Marmalade, Cover (1937-1967), 2 pc. no base, 2-bead finial on cover. Bowl is 400/19 7 oz. Old Fashioned. Lombardo Brochure shows domed lid with dimpled or indented finial, spoon has shell bowl (ribbed) and small bead at tip of handle. 1940 Imperial Brochure shows long ladle without beads. 1943 Bulletin shows lid with 2-bead finial and long spoon with 3 beads. Catalog C and 1959 Dungan Brochure show short ladle with 3 beads. Part of 400/89 4 pc. Marmalade Set, 400/89/3 3 pc. Marmalade Set, 400/148/1 6 pc. Condiment Set (unconfirmed), 400/148/5 8 pc. Condiment Set, 400/204 5 pc. Butter 'N Jam Set, 400/1112 4 pc. Relish and Dressing Set, 400/1589 3 pc. Twin Jam Set, 400/1786 4 pc. Condiment Set, 400/2989 3 pc. Twin Jam Set,

	400/5996 5 pc. Condiment Set, 400/8918 3 pc. Marmalade Set. Colors: Viennese Blue; gold beads; red beads. "Dimpled" cover was shown in an ad in LADIES HOME JOURNAL, May 1, 1940.
400/89	Marmalade Set (1937-1967), 4 pc. Consists of 400/89 Underplate (just like 400/35 Saucer except has extra ridge — seat — to hold marmalade jar, saucer seems more cupped), 400/89 Covered Marmalade Bowl, 400/130 Marmalade Ladle — 3 bead. Lombardo Brochure shows 5-1/2" spoon with ribbed bowl. Early: uses long ladle/spoon, shell shaped; small round bead at tip of handle. Color: Viennese Blue. Reported: flashed-on red beads. Also called Condiment Set.
400/89	Underplate (early), same as 400/35 Saucer except has an extra ridge to hold the 400/89 Marmalade Jar. Listed in early Imperial Component Parts Price List as 400/89 Underplate.
400/89/3	Marmalade Set (1937-1967), 3 pc. Dates are a guesstimate, both bowl and cover were made at that time. Consists of 400/89 Covered Marmalade Bowl, 400/130 Ladle. Color: Viennese Blue.
400/90	Candleholder (1947-1967), 5", beaded question-mark handle. Early: deep-cupped base (bowl effect) — Catalogs D and G. Later: more shallow-cupped base — 1967.
400/91	Cocktail Set (1937-1943; 1976-1977), 2 pc. Consists of 400/36 6" Cocktail Plate with 2-1/2" seat, 3400 4 oz. Oyster Cocktail.
400/91	Ladle, Punch (1939-1984), large, crystal, no beads. Same as 400/20 Ladle. Part of 400/20 15 pc. Punch Set, 400/128 15 pc. Punch Set, 400/210 15 pc. Punch Set, 400/128D.E. 15 pc. Etched Gold-On-Glass Punch Set. (Ladle is not Gold-On-Glass).
400/92	Cheese and Cracker Set (1943-1948), 3 pc. Consists of 400/92D 14" Plate, 400/144 Butter Cover (1948 Price List), 400/157 Cheese Compote.
400/92B	Bowl (1943-1951), 12". Part of 400/925 4 pc. Salad Set. Reported: in silver with "Wild Rose" etch.
400/92D	Plate with Seat (1937-1967), 14", round. Part of 400/94 4 pc. Buffet Salad Set, 400/925 4 pc. Salad Set, 400/7375 4 pc. Salad Set, 400/9266B 2 pc. Cheese and Cracker Set. Reported: gold decorated with roses and other decorations; milkglass.
400/92F	Bowl, Float (1943-1967), 11-1/2" — 12". Part of 400/92F/150 Bowl on Base Set, 400/920F Console Set, 400/9275 4 pc. Console Set, 400/9279FR 3 pc. Console Set. Reported: gold beads.
400/92F/150	Bowl on Base Set (1948), 2 pc. 1948 Price List. Consists of 400/92F 12" Float Bowl, 400/150 6" Ash Tray. Part of

	400/9275 4 pc. Console Set. When used in this set, bottom of ash tray is indented 1/2″ to receive bowl.
400/92L	Bowl, Mushroom Center (1938-1943), 13″ — 13-1/2″, edges of bowl roll up slightly. Part of 400/127L 4 pc. Console Set, 400/8692L 3 pc. Console Set.
400/92R	Bowl, Mushroom Center (1943), 12″ — 12-1/2″, this seems to be the same as 400/92L except this bowl is rolled down on the edges. It does not turn up like the 400/92L. Part of 400/136 4 pc. Console Set.
400/92V	Plate, Torte (1938-1967), 13-1/2″, cupped edge but less than 400/75V Plate. Has seat to receive bowl. Part of 400/4975 4 pc. Salad Set.
400/93	Bowl, Mayo (1938), 6-1/2″, divided. Price List 1-1-38. Possibly 400/84 Bowl with later number change.
400/94	Salad Set, Buffet; Dressing (1937-1961), 4 pc. 1938 Price List shows Salad Dressing Set with #615 Ladles. Lombardo Brochure — 1938 — shows no beads on ladles. 1941 uses #615 Ladles. 1948 Price List shows 400/135 Ladles, same in 1951. Called Buffet Set, Buffet Salad Set, Salad Dressing Set. Consists of 400/84 6-1/2″ partitioned Bowl, 400/92D 14″ round Plate, 400/165 Mayo Ladles (2). Color: Satin-Trimmed. Reported: gold; gold decorated, flashed-on red. Shown in LADIES HOME JOURNAL, April 1940, p. 31.
400/95	Mayo Set; Salad Dressing Set (1937-1941). 4 pc. Mayo Set: 1937-1938. Salad Dressing Set: 1939-1940. Both shown with ladles without beads. Consists of 400/72D 10″ 2-handled Plate, 400/84 6-1/2″ partitioned Bowl, 400/165 2 3-bead Ladles.
400/95	Cheese Set, Individual (1943), 3 pc. No other info. Possibly bowl and 2 ladles — same as Mayo Set (400/95) but without plate.
400/96	Salt and Pepper Set (1941-1984), 3-1/2″. Plastic tops until 1948; chrome — 1949. Early: beads and bottom are flat; top of shaker is ground. Early: 9 beads around bottom; 8 beads on base 1943-1984; takes slightly larger top. Plastic tops were used because of scarcity of metal during the war. One early salesman said this was the 3rd item made by Imperial in the Candlewick Line. Part of 400/96/3 3 pc. Salt, Pepper, Tray Set; 400/1510 Lazy Susan Condiment Set; 400/1596 5 pc. Condiment Set; 400/1769 4 pc. Condiment Set; 400/1786 4 pc. Condiment Set; 400/2769 4 pc. Condiment Set; 400/2796 5 pc. Condiment Set; 400/5996 5 pc. Condiment Set. Reported: amethyst; Emerald Green; aqua; Sunshine Yellow; amber; gold tops; light blue.
400/96	Atomizer (1952 DeVilbiss patent). Uses 400/96 Salt, Pepper Shaker. Imperial sold shakers to DeVilbiss Company to be

made into Atomizers. Colors: amethyst, green, aqua, amber, light yellow, dark yellow.

400/96 Salad Set (1940), 10 pc. Consists of 400/5D 8-1/2″ Plate (6), 400/84 6-1/2″ divided Bowl, 400/92D 14″ Plate, #615 Ladle (2).

400/96 Salad Set (1941), 12 pc. Same as 400/96 10 pc. Salad Set except for 8 400/3D 7″ Plates.

400/96/3 Salt, Pepper, and Tray Set (1943-1967), 3 pc. 1948 Imperial Price List refers to set as 400/96. Consists of 400/96 Salt and Pepper Set (chrome tops), 400/96T 5″ Tray.

400/96T Tray (1943-1967), 5″. Early referred to as 400/96. Part of 400/96/3 3 pc. Salt, Pepper, Tray Set; 400/2296 Sugar, Cream, Tray Set; 400/7796 3 pc. Vinegar and Oil Set.

400/97 Cocktail Set (1940-1943), 2 pc. Consists of 400/39 6″ Cocktail Plate with 2-1/2″ seat, #111 1-bead stemmed goblet — same as goblets in 400/139 Cocktail Set.

400/98 Party Set (1939-1966; 1973; 1978), 2 pc. Consists of 400/37 Cups, 400/198 9″ oval Plate with Seat. Reported: gold, Silver with "Wild Rose" etch.

400/98 Plate (1939-1966; 1973; 1978), 9″, oval, seat. Part of 400/98 2 pc. Party Set; 400/99 2 pc. Snack Set. Color: Gold-On-Glass.

400/99 Snack Set (1939-1943), 2 pc. Consists of 400/98 9″ oval Plate with Seat, 400/142 3-1/2 oz. Cocktail Tumbler — no beads.

400/100 Candleholder, Twin (1939-1968). Patent application May 24, 1941; received July 8, 1941. Patent #128,113. Part of 400/127L 4 pc. Console Set, 400/920F 3 pc. Console Set, 400/1004B 3 pc. Console Set, 400/1006B 3 pc. Console Set, 400/6300B 3 pc. Console Set. Early 4-3/4″ high; later 4-1/4″ high. Domed base — early. Colors: amber; smoke; gold beads; pale pink; yellow; Rubigold, Charcoal — probably made in 1962 — 1965 when 400/655 charcoal Candy Jars were made.

400/100/2-2 Candleholder, Eagle, Twin (1941-1950), 2-light. Consists of 400/100 Candleholder, #777/1 2 Crystal Eagles with candle cups in back.

400/101 Bowl, Float (1939-1943), 13″, 1-1/4″ deep, straight sides. Part of 400/101/79B 5 pc. Float Bowl Console Set.

400/101/79B Console Set, Float Bowl (1939-1941), 5 pc. Consists of 400/79B Candleholders (4), 400/101 13″ Float Bowl.

400/102 Tray, Relish (1939-1960), 13″ — 13-1/2″, 5 sections, round. Shown in ad in BETTER HOMES AND GARDENS, January 1952, page 62, with 4 5 oz. 3400 Juice Tumblers in center section — serving juice and appetizers.

400/103C Compote; Fruit Bowl (1943-1955), 10″, crimped, 3-bead stem. Early: domed foot. Later: flat foot. Reported: marked "Charleton", hand decorated with roses and ribbons.

400/103D	Cake Stand (1939-1981), 11″, 3-bead stem. Reported: with domed foot; marked "Charleton", hand decorated with roses and ribbons.
400/103E	Banana Stand (1943), 10″, 3-bead stem. Two sides of plate turn up. Reported: in blue.
400/103F	Bowl, Fruit; Compote (1939-1943), 10″, 3-bead stem. Reported: Milkglass. All 400/103 items are made from the same mould; differences are in the treatment of plate.
400/104B	Bowl, Belled (1939-1943), 14″ — 14-1/2″, graduated beads on 2 sides for handles; some bowls more shallow than others. Part of 400/63/104 19 pc. Chilled Fruit Set, 400/1004B 3 pc. Console Set, 400/1474 3 pc. Console Set.
400/105	Tray, Celery (1939-1967), 13-1/2″, oval, 2 open handles. Reported: red beads; lavender — Scott's newsletter.
400/106B	Bowl, Belled (1939-1961), 12″ — 12-1/2″, graduated beads on 2 sides for handles, round. Part of 400/106B/75 3 pc. Salad Set, 400/1006B 3 pc. Console Set, 400/1476 3 pc. Console Set. Reported: with satin beads.
400/106B/75	Salad Set (1939-1941), 3 pc. Consists of 400/75 Fork and Spoon Set, 400/106B 12″ Belled Bowl.
400/107	Vase, Bud, Miniature (1939-1967), 5-3/4″, low-footed, flared - fancy top rim, no beads on rim. 2 styles: 1939-1949, small beads around raised base; 1950-1967, large beads form base. Before war — some vases known to be covered with 22K gold (Gold-on-Glass) and with etched-all-over flowers. Several vases known to be "lunchbox" pieces, completely covered with bright gold.
400/108	Bell, Table (1939-1981), 5″, 4 graduated-bead handle with largest at tip. Variations reported: 5-3/4″ — beads measure same, but wafer is different: 5″ high bell has 3/16″ wafer (5-3/4″ circumference); 5-1/4″ high bell has 1/16″ wafer (6″ circumference).
400/109	Salt, Pepper Set, Individual (1940-1973), small, almost oval; plastic tops — 1941-1948; chrome tops — 1949-1973. Plastic used because of scarcity of metal during war. 8 — 9 beads around bottom. Neck of shaker larger when using plastic top. Part of 400/313 13 pc. Breakfast Tray Set, 400/2990 5 pc. Condiment Set, 400/109 4 pc. Salt/Pepper Set with "Hand Fired Bright Gold." Reported: gold beads; milkglass. Reported: used as atomizer by DeVilbiss Company — not authenticated. Note found in Imperial files stating Devilbiss purchased 400/109 shakers.
400/109	Atomizer (before 1950). Reported: collector claims to have one — not substantiated. Reported: note found to prove DeVilbiss did purchase 400/109 shakers.
400/110	Candy Box, Covered (1941-1963), 7″, 3 sections, round, base of

box 7″, top of box 7″. 2 styles risers: 1-1/4″ — 1-3/4″; some are straight across but lower than rim, others are arched — start lower than rim and arch up in center where they are same height as rim. Reported: with 4 large painted pink roses and green leaves on lid; with red flashing on cover and sides and gold painted flowers and lines decorating sides — geometric design with crossed lines and dots (info from Scott's newsletter #73, p. 6).

400/111	Tête-a-Tête (1941-1948), 3 pc. Consists of 400/77AD Cup, 400/111 6-1/2″ Oblong Tray with 2 seats (400/29 Tray with seats), 3800 1-1/2 oz. Brandy.
400/111	Tray (1941-1948), 6-1/2″, oblong, 2 seats — otherwise same as 400/29. Seats are like the 400/83 Strawberry Plate rings. Part of 400/111 Tête-a-Tête Set.
400/112	Tray, Relish (1941-1963), 10-1/2″, round, sectioned. Variations: early — 3 sections with center well to receive mayo jar, only 400/89 Mayo Bowl will fit center well; later — 5 sections with center well and 5 tab handles. Reported: gold beads. Part of 400/1112 4 pc. Relish and Dressing Set.
400/113A	Bowl, Deep (1941), 10″ d., 2-1/4″ deep, 2 handles, round.
400/113B	Bowl (1941-1955), 12″, round, 2 handles.
400/113C	Plate (1947-1951), 14″, crimped, 2 open handles.
400/113D	Plate (1941-1967), 14″, round, 2 handles.
400/113E	Plate; Buffet Tray (1941-1943), 14″, round, 2 turned-up handles.
400/114A	Bowl, Dessert, Deep (1941-1943), 10″ — 11″, partitioned, 2 open handles. Shown in 1943 advertising pages with 2 "Glass Serving Ladles"; same as 400/114/2 3 pc. Dessert Set. Shown in catalogs and advertisements with two styles dividers: top of divider straight across and just below rim; divider is scalloped and curved with highest point in center, placed lower in bowl.
400/114A/2	Dessert Set (1943), 3 pc. Same as 400/114A. Consists of 400/114A Bowl, 400/255 Ladles (2).
400/114B	Bowl (dates ?), 2 sections, 2 handles. Since 400/113A is 10″, 400/113B is 12″, 400/114A is 10″ divided, possibly 400/114B is 12″ divided. No other info.
400/115	Candleholder (1941-1943), 3 lites in a row, beaded rectangular base. Part of 400/1531B 3 pc. Console Set.
400/115/1	Candleholder, Eagle (1942), holds two eagles and 1 lite, candle in center candle cup. Consists of 400/115 Candleholder, #777/2 Crystal Eagles (2).
400/116	Salt, Pepper Set (1941-1943), 1-bead stem, found with both plastic and metal tops. Advertised in June 1946 BETTER HOMES AND GARDENS, but was not shown in Imperial Catalogs after 1941. Catalog B shows plastic tops. Found

without threads to hold top — has two 3/8" long grooves in place of threads. Reported: with plastic-like substance molded onto the top of the shaker with a metal band over it which has the threads to hold the plastic tops, but no threads on glass. 400/116 takes slightly smaller top than early 400/97 Shaker. Reported: completely covered with silver. Part of 400/148/1 6 pc. Condiment Set, 400/148/2 7 pc. Condiment Set, 400/148/4 7 pc. Condiment Set, 400/148/5 8 pc. Condiment Set.

400/117 Bottle, Bitters (1943-1954), 4 oz., metal tube, beaded base. Mould also used for 400/117 and 400/167 salts and peppers. Consists of bottle and 400/117 Squirt Tube.

400/118 Ash Tray, B'tween Place (1941-1957), place for cigarettes and sometimes matches. Part of 400/118 4 pc. Bridge Ash Tray Set. Reported: red; red section for cigarettes; red flashed-on; red sides, clear bottom.

400/118 Ash Tray Set, Bridge (1947-1970), 4 pc. gift boxed. Consists of 400/118 Ash Trays (4), places for 2 cigarettes on each.

400/119 Cruet and Stopper, Oil or Vinegar (1941-1950), 6 oz., no handle. Part of 400/148/1 6 pc. Condiment Set, 400/148/2 7 pc. Condiment Set, 400/148/4 7 pc. Condiment Set, 400/148/5 8 pc. Condiment Set, 400/1567 5 pc. Condiment Set, 400/1596 5 pc. Condiment Set, 400/1769 4 pc. Condiment Set, 400/2911 3 pc. Oil and Vinegar Set, 400/5996 5 pc. Condiment Set. Reported: pointed stopper and free-form handle like handle on 400/70 Cruet.

400/120 Plate, Crescent Salad (1941-1950), 8-1/4", crescent shaped.

400/121/0 Cruet, Oil (1941-1950), etched "OIL", no handle. Also written as 400/121. Reported: with Sterling Silver stopper.

400/121/V Cruet, Vinegar (1941-1950), etched "VINEGAR", no handle. Also written as 400/121. Reported: with Sterling Silver stopper.

400/122 Cream and Sugar Set, Individual (1941-1973; 1977-1980), early - slightly smaller bowl with smaller lip; later — larger turned-up spout, taller and slimmer; style change in 1943, Catalog C. Part of 400/122/29 Cream, Sugar, Tray Set; 400/313 13 pc. Breakfast Tray Set; 400/2296 Cream, Sugar, Tray Set. Colors: Rubigold with clear handles; gold. Reported: with Sterling bases; red-flashed beads; "Marigold" was advertised for sale. Label on ruby-flashed set reads: "Fleetwood J.W. Co., N.Y."

400/122/29 Cream, Sugar, Tray Set (1943-1976), 3 pc. Consists of 400/29 6-1/2" oblong Tray, 400/122 Cream and Sugar Set. Reported: gold with etched bird and flower design.

400/122/111 Cream, Sugar, Tray Set (1943), 3 pc. Same as 400/122/29 except tray has 2 seats to receive cream and sugar. Consists of

	400/111 6-1/2″ Tray with 2 seats, 400/122 Individual Cream and Sugar Set.

400/123 Toast, Cheese, Butter, and Cover (1941-1951), 2 pc. Tray has cupped beaded edge. Variations: tray — round, 7-3/8″ — 8″. Cover — 2-1/2″ high, 4″ — 5″ high with knob, d. 5-3/4″ — 6″. Part of 400/313 13 pc. Breakfast Tray Set. Reported: with chrome cover; with round knob on cover instead of hollow "bubble".

400/124 Plate (1943-1967), 12-1/2″, oval.

400/124A Bowl (1941-1943), 11″, oval.

400/124D Platter (1941-1964; 1973; 1976-1978), 12-1/2″ — 13″, oval. Color: Gold-on-Glass.

400/125A Bowl (1941-1943), 11″, 2 sections.

400/126 Cup, Bouillon (1941-1943), 2-handled. Mould also used for 400/126 and 400/153 Cream and Sugar Sets.

400/126 Sugar, Cream Set (early 1940's). Uses 400/126 Bouillon Cup — same as 400/153 Cream and Sugar. Set has question-mark handles.

400/127B Bowl, Belled; Console Base (1941-1943), 7-1/2″, flat bottom. Part of 400/127L 4 pc. Console Set, 400/136 4 pc. Console Set.

400/127L Console Set (1941-1943), 4 pc. Consists of 400/92L 13″ Mushroom Centerbowl (edge rolled up), 400/100 Twin Candleholders (2), 400/127B 7-1/2″ Bowl as Base.

400/128 Punch Set (1941-1960), 15 pc. Consists of 400/20B 13″, 6 qt. Punch Bowl, 400/37 Punch Cups (12), 400/91 Ladle, 400/128B 10″ Belled Bowl as Base (1943, 1948, 1950 Catalogs and Bulletins show 400/128 Bowl as Base — letter B probably added later).

400/128B Bowl, Belled (1941-1960), 10″, flat bottom, used as punch bowl base. Early: referred to as 400/128. Part of 400/128 15 pc. Punch Set, 400/128D.E. 15 pc. Etched-in-Gold Punch Set. Color: Gold-on-Glass.

400/128/D.E. Punch Set, Decorated and Etched (1943-1953), 15 pc. Same component parts as 400/128 Punch Set, except for all-over Gold-on-Glass. Etched design is floral.

400/129R Candleholder, Urn (1941-1943), 6″, 1-bead stem, large rolled beaded lip. Part of 400/136 4 pc. Console Set.

400/130 Ladle, Marmalade (1943-1970), 4-3/4″, 3-bead handle. Part of 400/42/3 3 pc. Mayo Set, 400/89 4 pc. Marmalade Set, 400/89/3 3 pc Marmalade Set, 400/148/1 6 pc. Condiment Set (unconfirmed). 400/148/5 8 pc. Condiment Set (unconfirmed), 400/1112 4 pc. Relish and Dressing Set, 400/1786 4 pc. Condiment Set, 400/1989 3 pc. Marmalade Set, 400/2989 3 pc. Twin Jam Set, 400/5996 5 pc. Condiment Set, 400/8918 3 pc. Marmalade Set.

400/131B	Bowl, Centre (1941-1951), 14″, oval, flat bottom. Part of 400/1531B 3 pc. Console Set.
400/131D	Platter (1941-1955), 16″, oval.
400/132	Vase, Rose Bowl (1943-1950), 7-1/2″, ball-shaped, large-bead base, plain rim.
400/132C	Vase, Rose Bowl (1941), 7-1/4″, crimped extended lip; ball-shaped, large-bead base. Identical to 400/132 except for rim treatment.
400/133	Ash Tray (1941-1968; 1973; 1978-1979), 5″, Crystal, round. Part of 400/450 3 pc. Nested Crystal Ash Tray Set.
400/133	Ash Tray (1943-1960), 5″, colored. 1948 Price List — 40/400/133 Amber; Champagne, 1-1-54; Ultra Blue, 1977; Nut Brown, 1977: Smoke; Cobalt. Part of 400/550 3 pc. Nested Colored Ash Tray Set. This piece was often used for souvenirs with company or organization logo printed in bottom of ash tray.
400/133	Ash Tray, Patriotic (war years), 5″, WWII design — shield of stars and stripes — on inside bottom. Color: white; amber. Part of 400/550 Patriotic Ash Tray Set.
400/134	Cigarette Box, Cover (1941-1963), 5-1/4″, oblong, domed cover. Part of 400/134/6 6 pc. Cigarette Set, 400/134/440 6 pc. Cigarette Set. Reported: pink; gold beads; flat top, blue mirrored with crystal grapes, made for New York company; with high domed (arched) cover; with copper colored mirror with grapes; dog in grass — in silver overlay — on top of cover, four corner beads silver.
400/134/1	Ash Tray (1943-1963), 4-1/2″, oblong. Part of 400/134/6 6 pc. Cigarette Set. Often used for advertising with company logo on inside bottom.
400/134/6	Cigarette Set (1943-1963), 6 pc. 1948 Price List refers to set as 400/134. Consists of 400/134 5-1/4″ Cigarette Box and Cover, 400/134/1 Ash Tray (4).
400/134/440	Cigarette Set (1943-1963), 6 pc. Consists of 400/134 5-1/4″ Cigarette Box and Cover, 400/440 4″ Ash Tray, round (4).
400/135	Luncheon Sets (1937-1939), 15, 21, 27 pc. sets. Contains 8″ and 12″ plates.
400/135	Ladle, Mayo (1943-1951), 6-1/4″ — 6-1/2″, 2-bead handle — smallest at tip, front edge of bowl shaved.
400/136	Console Set (1941-1943), 4 pc. Consists of 400/92R 13″ Mushroom Centerbowl (edge rolled down), 400/127B 7-1/2″ Belled Bowl as Base, 400/129R 6″ Urn Candleholders (2).
400/137	Compote (1941-1943), 11″, oval, domed foot, 1-bead stem. Seems to be the 400/46 oval Celery Boat on stemmed base.
400/138B	Vase (1941-1943), 6″, footed, 1-bead stem, beaded top rim has slight flare. Reported: Viennese Blue (dates do not coincide).
400/139	Ladle, Punch (1943-?), small, no beads on handle, pour spout.

	Same as #139 — Catalog C. Part of 400/63/104 19 pc. Chilled Fruit Set, 400/139 11 pc. Cocktail Set, 400/139/77 11 pc. Family Punch Set.
400/139	Cocktail Set (1941-1950), 11 pc. Consists of 400/139 Ladle, 400/139/1 Covered Snack Jar, #111 1-bead stem Wine (8). 1943 and 1948 Bulletin and Price List show 400/255 Ladle. 1943 Shows 400/139/2 Jar. Wines are same as in 400/97 Cocktail Set.
400/139/1	Snack Set (1943-1950), 2 pc. Also called Snack Jar and Cover. Same as 400/139/65. Uses 400/65 6-3/4″ d. Candy Cover. Cover also fits 400/65/1 8″ Covered Vegetable bowl. Part of 400/139 11 pc. Cocktail Set, 400/139/2 Covered Punch Bowl and Ladle Set, 400/139/77 11 pc. Family Punch Set, 400/1930 11 pc. Cocktail Set.
400/139/2	Punch Bowl Set (1943-1950), 3 pc. Consists of 400/139/1 Covered Snack Jar, 400/255 Punch Ladle with double spout. Notched cover.
400/139/19	Cocktail Set (1943), 11 pc. Consists of 400/19 3-1/2 oz. Cocktail (8), 400/139 Ladle — single pour spout, 400/139/2 Covered Cocktail Bowl.
400/139/65	Snack Jar, Covered (1943-1948), 2 pc. Snack Set. Same as 400/139/1 Snack Set. Consists of 400/65 Candy Cover, 400/139/1 Snack Jar. Bowl is 6-1/4″ high, 5″ beaded base.
400/139/77	Punch Set, Family (1943-1948), 11 pc. Consists of 400/77 4 oz. Cup (8); 400/139 Ladle, no beads, single pour spout (1948 and 1950 Bulletin pages show 400/255 Ladle with double pour spout); 400/139/1 Covered Snack Jar (1943, 1948, 1950 show 400/139/2). Conclusion might be drawn that 400/139/1 has plain cover, and 400/139/2 has notched cover for punch sets. There doesn't seem to be any consistency in Imperial's numbers, descriptions and dates for the 400/139 series.
400/140	Candy Dish, Cover (1943-1960), partitioned, also Jar or Box, 1-bead stem, 2-bead finial. 3 styles: Catalog A shows beaded, domed base rising to 1-bead stem; Catalog E, 1950, shows base change — plain, flat base, no beads around foot; domed foot without beads. Early has a flange or collar around beaded top edge; later reported without divider, no 1/2″ flange or collar, but has beads on edge. Reported with 2-bead stem, domed foot, no beads on base or rim of bowl.
400/142	Tumbler, Juice (1937-1948), 3-1/2 oz. Part of 400/36 Canape Set, 400/99 2 pc. Snack Set. Reported: red; Nut Brown; Viennese Blue; with free-form handle like handle on 400/70 Cruet.
400/142K	Vase, Rose Bowl (1943), 7″ extended beaded lip. Part of 400/142-K/H.L. 3 pc. 15″ Hurricane Lamp.
400/142-K/H.L.	Lamp, Hurricane (1952), 3 pc., 15″ high. Listed on Imperial

	Bulletin 6-20-52; also listed as 400/142K/HL. Consists of 400/142K 7″ Rose Bowl, 400/152 Adapter, 400/152 Chimney. This lamp and the 400/26 do not have candle cups. Adapter found without peg to insert into top of vase.
400/143A	Vase, Flip (Possibly 1943-1955), 8″, beaded top rim, not crimped. Same as 400/143C except for crimping.
400/143C	Vase, Flip (1943-1955), 8″, crimped, beaded top rim. Reported: red flashed, clear bottom; gold beads.
400/144	Butter, Cover (1943-1967; 1973; 1976-1980), 5-1/2″, round, handled, cover sits in, beads are on bowl, 2-bead finial. Reissued 1976 as Covered Box. Cover used on 400/157 Cheese Compote; used for 400/59 Candy (4-3/4″ d. cover). Reported: finial and beads in amber.
400/145	Cheese and Cracker Set (1943), 2 pc. Consists of 400/157 Cheese Compote, 400/145D Tray.
400/145B	Bowl (1941-1984), 10″, 2-handled, round. Color: blue.
400/145C	Plate; Tray (1947-1968), 12″, crimped, 2-handled. Color: Carmel Slag. Reported: with marked Sterling base and no handles.
400/145D	Plate (1941-1984), 11″ — 12-1/2″:, 2-handled. Color: Carmel Slag.
400/145E	Tray (1943), 11-1/2″, 2 turned-up handles. Reported: Viennese Blue, but dates do not coincide; black with hand-painted flowers; light blue.
400/145H	Tray, Muffin (1943), 11-1/2″, 2-handled, sides of tray turn up. Color: black.
400/147	Candleholder (1943-1965), 3 lites, 1-bead stem.
400/147/2	Candleholder, Eagle (1943), 3-lite. Consists of 400/147 3-lite Candleholder, #777/1 Eagle Adapter.
400/148	Tray, Condiment (1943), 5-1/4″ x 9-1/4″, oval, 4 seats. Part of 400/148/1 6 pc. Condiment Set, 400/148/2 7 pc. Condiment Set, 400/148/4 7 pc. Condiment Set, 400/148/5 8 pc. Condiment Set, 400/1567 5 pc. Condiment Set.
400/148/1	Condiment Set (1943), 6 pc. Consists of 400/89 Mustard (Marmalade Jar) and Spreader (unconfirmed); 400/116 Footed Salt and Pepper with plastic tops; 400/119 6 oz. Oil Cruet (unconfirmed); 400/130 Spoon — Marmalade Ladle, 3-bead (unconfirmed); 400/148 Condiment Tray with Seats.
400/148/2	Condiment Set (1943), 7 pc. Consists of 400/116 Salt and Pepper Set with plastic tops, 400/119 6 oz. Cruet (2), 400/148 Condiment Tray with 4 seats.
400/148/4	Condiment Set (1943), 7 pc. Consists of 400/116 Salt and Pepper with metal tops, 400/121 Cruets (2), 400/148 Condiment Tray with 4 seats.
400/148/5	Condiment Set (1943), 8 pc. Consists of 400/89 Mustard (Marmalade), 400/116 Salt and Pepper with plastic tops,

	400/119 Vinegar Cruet, 400/130 Ladle, Marmalade (1-1-43 Imperial Price List shows 400/89 Ladle — probably same with number change), 400/148 Condiment Tray.
400/148/6	Condiment Set (1943), 9 pc. Consists of 400/89 Bowl (2), 400/89 Cover (2), 400/89 Ladle (2) (probably 400/130), 400/116 Salt and Pepper, 400/148 Tray.
400/149D	Tray, Mint (1943-1967), 8″-9″, round, heart-shaped center handle. Reported: gold beads; gold decorated; with "Charleton" hand-decorated with roses and ribbons; rolled edge and painted with flowers.
400/149F	Bon Bon (1943 ?), 7-1/2″, heart-shaped center handle. Possibly same as 400/149D 9″ except with rolled edge. No picture available. Reported: 7-1/2″, cupped like 400/68F Fruit Tray, beads stand straight up, plate stands 1-1/4″ high, has amber cast. I believe this find is the missing Bon Bon.
400/150	Ash Tray (1943-1968; 1973; 1977-1980), 6″ Crystal, round. Part of 400/75F/150 Bowl on Base Set, 400/92F/150 Bowl on Base Set, 400/450 3 pc. Crystal Ash Tray Set, 400/1503 3 pc. Lazy Susan, 400/7570 4 pc. Console Set (base), 400/9275 4 pc. Console Set, 14994 2 pc. Hurricane Lamp. According to records, this ash tray has a 1/2″ indent to receive the bowl in the 400/9275 Console Set, and an indent in bottom to receive the ring of metal bearings in the 400/1503 Lazy Susan. However, the 400/133 5″ Ash Tray has an indent to receive the bearings and fits perfectly, so the question is whether the two were interchangeable or whether the 6″ ash tray with indent is a myth; 5″ ash trays with indents have been found by collectors. Reported: with cattails etched in bottom, and dome like 400/123 Toast and Cover, dome is clear, ash tray has lavender cast; tray with underside covered with "bubbles"; with metal Farberware handle; with metal center handle — to be used as tid-bit.
400/150	Ash Tray (1948-1960), 6″, colored. Part of 400/550 3 pc. Colored Ash Tray Set. Colors: Pink, Imperial #65/400/150, Imperial Price List 1948; Cranberry, 1-1-54; Ultra Blue, 1977; Nut Brown, 1977; Cobalt Blue with WWII design. Reported: cobalt; carmel slag; dark lavender; amethyst; green.
400/150	Ash Tray, Patriotic (WWII era), 6″, round. Colors: Cranberry; Cobalt blue. WWII design: Eagle on ball surrounded by 12 stars. Part of 400/550 Patriotic Set in Cranberry, light blue, and amber; 400/550 Patriotic Set in Ruby Red, Milkglass White, and Cobalt Blue.
400/151	Tray (1943-1948), 10″ round. Variation: plain bottom; concentric circles design; mirrored for dresser set for IRICE Company; 1/2″ stippled band around 3-1/2″ center on top of

	plate to cover groove (and 3″ ball bearing ring) when used for Lazy Susan. Part of 400/1503 3 pc. Lazy Susan, 400/1510 Lazy Susan Condiment Set. For more information see entries: 400/1503; unnumbered section *Tray* #E666.
400/151	Base for Lazy Susan (1951), 6″ 400/150 Ash Tray mould. 1/2″ indent in bottom to receive ball bearing ring. Controversy as to 400/150 being the right tray as 400/133 5″ Ash Tray has been found, by Collectors, with the 1/2″ indent. 400/150 is listed on some Imperial's Component Parts lists, but 400/133 fits the indent.
400/152	Lamp, Hurricane (1943-1960), 3 pc. Consists of 400/79R Candleholder, 400/152 Adapter, 400/152 Chimney, crimped top rim. Some chimneys have bulge that fits into adapter.
400/152	Adapter, Lamp (1943-1950), 28 beads around rim. Patent #133,955. Applied for 5-28-42, received 9-29-42. 3 styles: 7 holes around adapter for 4″ prisms, wires inserted to hold prisms, holes are on smooth glass behind bearing; no holes for prisms; no peg to insert into candleholder, other styles have pegs that fit into candleholders. Adapter dimensions: 4″ d.; peg is 13/16″ d., length of peg 3/4″. Opening of adapter in 2-1/4″ d. to receive the chimney or candle. Bottom of the chimney (shade, globe) must be smaller than 2″ to fit into the adapter. Early chimneys have bulge above part that fits into the adapter. The bulge holds the chimney steady. Later chimneys do not have the bulge. Also part of 400/26 Hurricane Lame, 400/32 16″ Hurricane Lamp, 400/152 3 pc. Hurricane Lamp, 400/152R 3 pc. Hurricane Lamp, 400/155 3 pc. Hurricane Lamp, 400/680 5 pc. Hurricane Lamp, 400/1752 Prism Candleholder, 400/1753 3 pc. Hurricane Lamp with Prisms. Uses for adapter: new design — to make candleholders taller; turn candleholders into hurricane lamps.
400/152	Chimney; Shade; Globe (1943-1960), crimped. Shade has bulge on part that fits into adapter; also made without the bulge — then just sits into adapter but not as sturdy (see previous entry). Part of 400/32 Hurricane Lamp, 400/152 Hurricane Lamp, 400/155 Hurricane Lamp, 400/680 Twin Hurricane Lamp.
400/152R	Lamp, Hurricane (1943-1952), 14″, 3 pc. Consists of 400/79R Candleholder, 400/152 Adapter, 400/152R Chimney, plain top.
400/152R	Chimney, Shade (1943-1952), plain top; very small bottom — less than 2″ d., but more than 1-1/2″ to fit over candle cup inside adapter. Chimney has bulge like 400/152, then it narrows to fit into the deeper recess around the candle cup. Part of 400/142K/HL Hurricane Lamp, 400/152R Hurricane Lamp, 400/680 Twin Hurricane Lamp.

400/153	Cream and Sugar Set (1942-1943), same as 400/126. No covers; question mark handles; look like cups with handles.
400/154	Deviled Egg Server (1941-1963), 11-1/2″-12″, center heart handle, holds 1 dozen eggs.
400/155	Lamp, Hurricane (1942-1950), 16″, 3 pc. Consists of 400/152 Adapter, 400/152 Chimney, 400/155 Base. Same as 400/32 Hurricane Lamp. Number changed by Imperial.
400/155	Base, Lamp (1942 or 1943), 4-1/4″ without adapter, 5-7/8″ with adapter. Part of 400/32 16″ Hurricane Lamp, 400/155 Eagle Candleholder, 400/155 Hurricane Lamp. Reported: combined with Depression Glass Iris pattern ceiling fixture; part of some hanging lamps; boudoir lamp base. Also made for Lightolier Lamp Company.
400/155	Candleholder, Eagle (1943), 9-1/2″, 2 pc. Consists of 400/155 Lamp Base, #777/1 Crystal Eagle. Candle cup on back of eagle to hold candle. Same base as 400/32 Hurricane Lamp.
400/156	Ladle, Condiment (1943-1967), 3-1/2″ long, also called Mustard Spoon. On a 10-18-48 Price List, the 400/616 Salt Spoon is listed as the same as the 4000. On the Imperial Component Parts Price List of 1-1-56, the 400/156 and 4000 are listed as the same. Assuming Imperial did not change designs or sizes between 1948 and 1956, all three spoons would be the same. Collectors have reported different sizes, which could be accounted for if several moulds were used. In pictures, all three look alike. See 400/616 for more information.
400/156	Condiment Jar, Cover (1943-1967), low-footed, beaded base, 2-bead finial on cover, spoon. Uses 4000 Salt Spoon (400/156 Ladle). Part of 400/5629 3 pc. Mustard and Catsup Set. Imperial's files also show the 400/156 Condiment Set using either the 400/156 Spoon or the 400/600 Spoon. No other information on the 400/600 — could be the 400/616 with a number change.
400/157	Compote, Cheese; Jelly; Honey; Cover (1943-1955), 4-3/4″. Catalog A — no cover; Catalog C — no cover, called cheese; Catalog D — cover, called Jelly or Honey; Catalog E — cover. Cheese was uncovered; Jelly and Honey were covered. Cover is listed as from 400/144 Butter and Cover on 1948 Price List. Part of 400/92 3 pc. Cheese and Cracker Set, 400/145 2 pc. Cheese and Cracker Set. Reported: Jelly in milkglass.
400/158	Candy Box, Cover (1943), 7″, 3 sections, round. Reported: lid fits 4 candy boxes — 400/65, 400/140, 400/260; 6 3/8″ d.
400/159	Tray (1943-1967), 9-1/4″ x 5-1/4″, oval, same as 400/148 except for seats in 400/148 Tray. Variations: mirrored glass insert for dresser set — shown in May 1943 HOUSE BEAUTIFUL;

with concentric circles in bottom; plain bottom. Part of 400/1574 5 pc. Condiment Set, 400/1589 3 pc. Twin Jam Set, 400/1596 5 pc. Condiment Set, 400/2796 5 pc. Condiment Set, 400/5996 5 pc. Condiment Set. Reported: in Farberware metal holder; on a metal tray with cut-out corners, marked "Farberware, New York, NY"; with chrome liner.

400/160 Plate, Birthday Cake (1943-1951), 13″-14″ for 72 candles. Candle holes were referred to as recesses by Imperial in its catalogs.

400/161 Butter, Cover (1943-1984), 1/4 lb., oblong. 9 graduated beads on top of cover — largest in center, lengthwise. Part of 400/204 5 pc. Butter 'N Jam Set (cover only). Reported: top beads in amber; cover with 5 rows of beads — down center and all edges, lengthwise.

400/162 Vase (1943), 10-1/2″, footed. Possibly similar to 400/163 Decanter without stopper.

400/163 Decanter, Stopper (1943-1951), 26 oz., beaded base, stopper has one large open-ended bead or bubble. Part of 400/163 9 pc. Wine Set, 400/1630 8 pc. Wine Set, 400/1639 8 pc. Wine Set.

400/163 Wine Set (1943-1948), 9 pc. Consists of 400/19 (?) Low-Footed Wines (8) (if so, then same set as 400/1639 except 400/1639 has only 6 wines), 400/163 26 oz. Decanter.

400/164 Cruet, Oil, Stopper (1943-1951), 4 oz., no handle, 3-bead stopper, beaded base. Part of 400/1574 5 pc. Condiment Set.

400/165 Ladle, Mayonnaise (1943-1970), 5 — 3/4″ long. 3-bead handle. Part of 400/23 3 pc. Mayo Set, 400/49 3 pc. Mayo Set, 400/52/3 3 pc. Mayo Set, 400/84 4 pc. Mayo Set — 2 ladles, 400/94 4 pc. Buffet Set, 400/95 4 pc. Salad Dressing Set, 400/623 2 pc. Mayo Set. Reported: red beads and bowl.

400/166 Cruet, Vinegar, Stopper (1943-1951), 6 oz., unhandled, 3-bead stopper, beaded base. Same as 400/164 except has 2 oz. more capacity.

400/167 Salt, Pepper Set (1943-1970), 4-1/2″ high, chrome tops, elongated — taller than 400/96 or 400/109 Sets. Imperial files show that 400/167 and 400/117 Bitters Bottle made with same mould. Imperial also used this mould to make containers for DeVilbiss atomizers. Part of 400/1567 5 pc. Condiment Set, 400/1574 5 pc. Condiment Set. Colors reported: aqua; blue; Verde Green; yellow; amethyst; light blue.

400/167 Atomizer (before 1950), put together and marketed by DeVilbiss Corp. For more information see entries for 400/96 and 400/247. Colors: clear; amethyst.

400/168 Ice Tub; Bucket (1943-1954), 7″, 2 tab handles, beaded rim.

400/169 Sauce Boat and Plate Set (1943-1967), 8″, for gravy. Consists of 400/169 8″ Oval Plate, 400/169 Sauce Boat.

400/169	Sauce Boat (1943-1967), no beads. Also part of 400/169 Sauce Boat and Plate Set.
400/169	Plate (1943-1967), oval, 8″, with seat to receive boat. Part of 400/169 Sauce Boat and Plate Set.
400/170	Candleholder (1943-1961; 1978-1984), 3-1/2″, beaded-domed base. Part of 400/63B/170 3 pc. Console Set, 400/7570 4 pc. Console Set, #14996 2 pc. Hurricane Lamp. Lenox stickers found on holders that are 1/2″ taller than usual. Lenox took over Imperial in 1973. Part of mould used for 1978 Convention souvenir. See 1950/170 for more information.
400/171	Tray (1943-1960), 8″, beaded edge. Part of 400/1769 4 pc. Condiment Set, 400/1786 4 pc. Condiment Set, 400/2769 4 pc. Condiment Set.
400/172	Heart, Mint; Ash Tray (1943-1963), 4″ — 4-1/2″. Mould used for annual glass festival souvenir in Bellaire, Ohio, for 4 years 1974-1977: 1974 — blue, 1975 — green, 1976 — milkglass, 1977 — amber. See entry for #1950/750 for milkglass in glossy and doeskin finishes. Part of 400/750 3 pc. Heart Tid-Bit Set. Reported: frosted bottom.
400/173	Heart, Nut; Ash Tray (1943-1963), 5-1/2″. Part of 400/750 3 pc. Heart Tid-Bit Set in milkglass.
400/174	Heart, Bon Bon; Ash Tray (1943-1963), 6-1/2″. Part of 400/750 Tid-Bit Heart Set in milkglass. Reported: Carmel Slag; pink; pink satin.
400/175	Candleholder (1943-1955), 6-1/2″ high, plain base, 3-bead stem. Part of 400/1752 Prism Candleholder, 400/1753 3 pc. Hurricane Lamp, 400/9275 3 pc. Console Set.
400/176	Ash Tray (1943-1961), 3-1/2″, square. Part of 400/176 4 pc. Square Ash Tray Set with "Hand Fired Bright Gold."
400/176	Ash Tray Set (1948-1954), 4 pc., square. Consists of 4 ash trays with "Hand Fired Bright Gold." Beads are gold. Each set "gift boxed in plastic gift box." Listed on Bulletin June 28, 1948. Imperial Bulletin shows pictures with gold beads 1950-1954, 4 in a box.
400/177	Luncheon Sets (1937-1939), 15, 21, 27 pc. sets. Contain 9″ and 14″ plates.
400/177	Cruet, Oil, Vinegar; Stopper (1943-1955), 4 oz., 3-bead stopper, beaded base. Part of 400/2990 5 pc. Condiment Set, 400/7796 3 pc. Vinegar and Oil Set. Reported: 2 oz.
400/178	Lamp, Hurricane (1943-1950), 11-1/2″ high, 2 pc. 2 styles: inner circle of beads an inch or so outside candle cup which is recessed, chimney fits just inside the circle of beads; with 6 risers which hold chimney in place. Consists of 400/178 Bowl to receive candle and chimney, 400/178 Chimney.
400/178	Candleholder, Low Bowl (1943-1948), 7-1/2″ d, 1-3/4″ deep, beaded rim. Part of 400/178 2 pc. Hurricane Lamp. For more

info see previous entry.

400/178 Chimney; Shade (1943-1948), flat top rim, 10-3/4″ high. Part of 400/178 2 pc. Hurricane Lamp. For more info see 400/178 Hurricane Lamp entry.

400/179 Bell, Table (1943-1951), 4″, 4-bead handle — graduated with largest at tip. Made from 3400 Cordial.

400/181 Bowl; Nappy (dates ?), 6-1/2″, partitioned. This could be the same as 400/183 except with a partition, size is the same.

400/182 Bowl (1960-1968), 8-1/2″ d., 5-1/2″ high, 3-toed. Color: Carmel Slag. Reported: with low 1-3/4″ curved divider in bottom, beads graduated with largest on ends, sides lopsided — could have been experimental and a reject and sold from Hay Shed.

400/183 Bowl (1961-1975), 6″, 3-toed. Color: Carmel Slag. Part of 400/623 2 pc. Mayo Set.

400/185 Vase, Bud (1943-1955), 7″, plain top, domed foot — same as 400/186, 187, 188, 192, 193, 194. Reported: crimped top rim.

400/186 Vase, Bud (1943-1955), 7 ", plain top, domed foot — see previous entry.

400/187 Vase, Bud (1943-1950), 7″, plain top, domed foot — see entry 400/185.

400/188 Bowl, Ivy; Brandy (1943-1961), 7″, plain top, domed foot — see entry 400/185. Reported: 22K bright gold, "lunchbox" piece, made before the war, etched with all-over flowers.

400/189 Vase, Bud (1943-1950), 9″, plain top, has 400/190 belled base.

400/190 Goblet (1943-1967), 10 oz., belled and beaded foot.

400/190 Cocktail (1943-1967), 3-1/2 oz. — 4 oz., belled and beaded foot. Part of 400/1930 11 pc. Cocktail Set.

400/190 Sherbet, Tall; Saucer Champagne (1943-1967), 5 oz., belled and beaded foot.

400/190 Wine, Dinner (1943-1967), 5 oz., belled and beaded foot. Part of 400/1630 8 pc. Wine Set.

400/190 Cordial (1947-1967), 1 oz., belled and beaded foot.

400/190 Cocktail, Seafood; Icer; Coupette (1943-1960), belled and beaded foot.

400/190 Salt, Pepper Set (1943-1967), chrome tops, belled and beaded foot, takes slightly smaller top than the early 400/96. Container used by DeVilbiss Company for atomizers, tops are interchangeable. Color: Sunshine Yellow. Reported: in black gift box.

400/192 Vase (1943-1950), 10″, plain top, domed foot — see entry 400/185.

400/193 Vase (1943-1950), 10″, plain top, domed foot — see entry 400/185.

400/194 Vase (1943-1951), 10″, plain top, domed foot — see entry 400/185. Shown in ad in BETTER HOMES AND GARDENS in November 1949.

400/195	Goblet, Water (1952), 11 oz.; thick, hollow stem encircled by large beads. All 7 items in the 400/195 Series were offered only in 1952, and were never shown in any Imperial catalogs. Their fate was the same as the 400/15 Series. Note in Imperial files: "This line never offered in printed price list, added by bulletin in price list in 1952 and ended there." This does not include the three tumblers.
400/195	Dessert (1952), 6 oz. See previous entry.
400/195	Iced Drink (1952), 14 oz. See entry for 400/195 Goblet.
400/195	Old Fashion (1952), 9 oz. See entry for 400/195 Goblet.
400/195	Juice (1952), 6 oz. See entry for 400/195 Goblet.
400/195	Wine (1952), 2 oz. See entry for 400/195 Goblet.
400/195	Cocktail (1952), 4 oz. See entry for 400/195 Goblet.
400/195	Tumbler (1950-1954), 8 oz. The three tumblers in this series have beads around the foot; the beads make the base; the tumblers are similar to the 400/19 series except the 400/195 series has a rounder bowl and turned-in rim.
400/195	Tumbler (1950-1954), 12 oz. See previous entry.
400/195	Tumbler (1950-1954), 16 oz. See entry 400/195 Tumbler, 8 oz.
400/196	Epergne Set (1947-1960), 2 pc.; vase 7-3/4″ with 2-bead stem and peg. See entry 400/40 Miniature Vase for more info on vase. Consists of 400/40 Miniature Vase, 400/196FC 9″ Flower Candleholder. See entry 1950/196 for information on Epergne Set in milkglass.
400/196FC	Centerpiece, Flower Candle (1947-1955), 9″, 1-bead stem, plain base, crimped bowl. Looks almost identical to 400/67C 9″ Fruit Bowl; Candleholder not as deep as fruit bowl — conclusion derived from pictures. Part of 400/196 2 pc. Epergne Set.
400/198	(1950-1954), 6″, no base, beaded and extended lip. Part of 400/242 6″ Rose Bowl with flower holder insert. Reported: gold.
400/200	Heart Set (1955-1960), 3 pc., handled. Consists of 400/201 4-1/2″ Handled Heart, 400/202 5-1/2″ Handled Heart, 400/203 6-1/2″ Handled Heart. Handles are not attached to inside of heart, only to outside.
400/201	Heart (1955-1960), 4-1/2″, handled. Part of 400/200 3 pc. Heart Set.
400/202	Heart (1955-1960), 5-1/2″, handled. Part of 400/200 3 pc. Heart Set.
400/203	Heart (1955-1960), 6-1/2″, handled. Part of 400/200 3 pc. Heart Set.
400/204	Butter 'N Jam Set (1960-1963), 5 pc. Seats for butter cover and marmalade set. Consists of 400/89 covered Marmalade Jar, 400/130 Marmalade Ladle, 400/161 1/4 lb. Butter Cover, 400/204 3-sided Tray.

400/204	Tray (1960-1963), 3 equal sides — rounded — triangular shaped; 2 seats: 1 rectangular shape to receive 1/4 lb. cover, 1 round for jar. Part of 400/204 5 pc. Butter 'N Jam Set.
400/205	Bowl (1960-1967), 3-toed, 10″.
400/206	Bowl (1960-1967), 3-toed, 4-1/2″, beaded top rim.
400/207	Candleholder (1960-1967), 3-toed, 4-1/2″, beaded top rim. Same bowl as 400/206 except 400/207 has candle cup.
400/208	Relish (1960-1971), 10″, 3 sections, 3-toed, beaded top rim.
400/209	Relish (1959-1961), 13″ — 13-1/2″, 5 sections, beaded edge. Reported: part of a Kromex Lazy Susan; in a chrome tray with a black glass spoon, 9-1/2″ long, ridged handle with a fanned ridge top — sounds like the #701 spoon from the Salad Spoon and Fork Set. Imperial did make ladles/spoons in black glass in the 1950's.
400/210	Punch Set (1947-1955), 15 pc. Consists of 400/91 Large all Glass Ladle, 400/210 10 qt. Punch Bowl, 400/210 Belled Base, 400/211 Punch Cups (12). Listed on Imperial memo 1943 as made in gold.
400/210	Bowl, Punch (1947-1955), 10 qt. Part of 500/210 15 pc. Punch Set.
400/210	Bowl, Belled (1947-1955), used as punch bowl base. Part of 400/210 15 pc. Punch Set.
400/211	Cup, Punch (1947-1955), 5 oz., 6 bead handle. No question mark handle, no large bead at base of handle. Part of 400/210 Punch Set.
400/213	Tray, Relish (1950-1961), 10″, 2 tab handles, oblong. Variations: no dividers, 4 sections — 3 equal on 1 side — 1 long on other side; 3 sections — all equal. Part of 400/214 Covered Vegetable Dish.
400/214	Dish, Vegetable, Covered; Preserve; Cheesespread (1953-1954), 10″, oblong, 3-4 sections, 400/213 with cover. Cover has high curved 5-bead handle in center, lengthwise.
400/215	Relish (1947-1961), 12″, oblong, 4 sections, 2 tab handles.
400/216	Dish, Cover (1953-1954), 10″, oblong, partitioned. Information given me states this is 10″; however, if it was 12″ with cover it would make more sense. 400/213 is 10″ without cover; 400/214 is 10″ *with* cover; 400/215 is 12″ without cover; 400/216 could be *12″ with* cover.
400/217	Tray, Relish; Pickle (1947-1967), 10″, oval, 2 open curved handles.
400/220	Compote (1947-1967), 5″, 3 part beaded-arched stem on plain base.
400/221	Tray, Lemon (1947-1967), 5-1/2″, 3 part beaded-arched center handle.
400/222	Tray, Bon Bon (1950), 8″, 3-part beaded-arched center handle on 8″ plate. Rare: several reported.

400/223	Tray, Cake (1950), 12″, 3-part beaded-arched stem on plain base. Imperial called it Cake Stand.
400/22?	Candleholder (date ?), 3-part beaded-arched stem, slightly domed beaded-edge foot. Candle cup has rim but no beads. Drawings found in Imperial's files with drawing of other items that are very rare but have been located by collectors. Mould number not given, but it is the 200 series stem. Reported: 1 — about 6-1/2″ high, plain base, beads do not arch out as much as in other 400/200 series. At least 8 beads on each arch.
400/224	Candleholder (1947-1955), 5-1/2″, plain base, 3-part beaded-arched stem, cupped beaded-edge bowl for candle cup. Part of 400/264 Hurricane Lamp.
400/225	Goblet (date ?), 6-1/2″, 3-part beaded-arched stem on plain foot. I put the number with the item as it was produced by Imperial, but records do not show the mould number; this was the only number in the 200's not assigned to other Candlewick items. This piece has been found in clear and also with an optic design on the bowl. Drawings show the bowl with circle design.
400/226	Coaster (1950-1967), with spoon rest, designed (rayed) bottom, large beads on edge.
400/227	Vase (1959-1961), 8-1/2″, handle, pitcher style, 400/19 foot.
400/228	Chip and Dip (1959-1961), tid-bit set, 14″, 1 pc., divided-center bowl for dips, round, beaded edge.
400/231	Bowl, Square; Nappy (1957-1967), 5″, beaded top edge.
400/232	Bowl, Square; Nappy (1957-1967), 6″, beaded top edge.
400/233	Bowl, Square; Nappy (1957-1967), 7″, beaded top edge.
400/234	Relish (1957-1967), 7″, square, 2 sections-diagonal divider, 1-1/2″ deep.
400/235	Relish (dates ?), 8″. No other info. Possibly square and just like 400/234 without divider. Imperial listed size and whether an item was divided. All info available on this one was mould number, relish, and 8″, thereby assuming it was not with a divider.
400/236	Liner. No other info on this item. If it is the liner for the 3400 and 3800 Icers, then the dates would be 1939-1961.
400/240	Peg Nappy. No other info on this item. The item was used with a metal base. Made for another company who combined the piece with a metal base to produce a new item.
400/240D	Peg Nappy, 7″. No other info. See previous entry.
400/240F	Compote, Peg Nappy, 5-1/4″ — 6″, Sterling base, low, "Crown Silver, Inc." base. See 400/240 entry.
400/241	Peg Nappy, partitioned. No other info.
400/242	Rose Bowl with Insert (1950-1954), 6″, flower holder. Consists of 400/198 6″ Vase, Insert to hold flowers (frog).

400/243	Bowl, Sauce; Sauce Dish (1959-1963), 5-1/2″, beaded top rim. Part of 400/244 5 pc. Hostess Helper.
400/244	Hostess Helper; Tid-Bit Set (1959-1963), 5 pc., 12″. Consists of 400/92F 12″ Float Bowl, 400/243 5-1/2″ Sauce Bowl, 3 metal cups with hooks for toothpicks — hooks clip over side of bowl.
400/245	Candy Box, Cover (1957-1963), 6-1/2″, round bowl with square beaded-lip, no beads around edge of cover (2-bead finial). Cover also fits the 400/259 Candy.
400/247	Salt, Pepper Set (1947-1984), straight sides, chrome tops. Takes slightly smaller tops than early 400/96. Containers made in various colors for atomizers by DeVilbiss. Reported: salts in aqua; green.
400/247	Atomizer (before 1950), 400/247 Salt, Pepper containers made for DeVilbiss Company for their atomizers. Colors: amethyst (S-200-17), Aqua/Turquoise (S-200-15), Yellow — deep (S-200-12), Clear (S-200-14), Green (S-200-10). Numbers in parenthesis are DeVilbiss stock numbers. All DeVilbiss atomizers had paper labels, some with the stock numbers.
400/250	Peg Nappy. No other info. See entry 400/240 for info on pegs.
400/250B	Peg Bowl (dates ?), 7-1/4″. Reported: screwed into Silver base, nappy has sticker 400/250B/436. #436 is Imperial Etch "Garden Arbor." Information given here is from collector Joan Cimini of Ohio who found this bowl with its markings intact. Joan's bowl is 7-3/8″ d., 2-1/2″ deep in center, peg is 3/4″ long, 1/4″ lip on base of bowl, beads turn out on edge of bell-shaped bowl. Information from Ohio newsletter, 3-15-83.
400/251D	Peg Cake Plate (dates ?), 11-1/2″ d., flat plate with peg, small-bead edge. Reported: collector Myrna Garrison of Arlington, Texas, found one with the mould number on it, also marked Monmouth Silver on the silver base. Another reported with "Mayflower" Sterling base.
400/251X	Peg Nappy; Bowl (dates ?), 9-1/2″ d. bowl with glass peg that screws into metal base, small-bead edge. Myrna Garrison also found one of these peg nappies, with a silver base, marked with the mould number. Reported with Sterling Silver weighted base marked "Mayflower".
400/255	Ladle, Punch (1943-1950), small, no beads, all glass, 2 pour spouts. Part of 400/114A/2 3 pc. Dessert Set (1938 Brochure), 400/139 11 pc. Cocktail Set (1948 Price List), 400/139/2 Covered Punch Bowl and Ladle Set, 400/139/77 Family Punch Set (1948 Price List), 400/1930 11 pc. Cocktail Set.
400/256	Relish (1954-1984), 6-1/2″ X 10-1/2″ — 11″, oval, handled, 2 sections (curved divider lengthwise). Color: Carmel Slag —

6-1/4″ X 11″.

400/259 Candy Box, Cover (1947-1970), 7″, round, 2-bead finial. More shallow than 400/260 Candy Box. Lid 5-5/8″ d. also fits the 400/245 Candy box. Reported: with chrome cover; with platinum beads.

400/260 Candy Box (1950-1960), 7″, 2-bead finial, rounder and deeper than 400/259 Candy Box, 3 sections. Lid 6-3/4″ d. also fits 400/65, 400/140, 400/158 Candy Boxes. Reported: gold.

400/262 Tray, Relish (1969-1971), 10-1/2″, oval, 3 sections, same as 400/262 Butter and Jam Set, 2-handled. Reported: dividers slanted.

400/262 Butter and Jam Set (1959-1970), 10-1/2″, oval, 2-handled, 3 sections, same as 400/262 Relish.

400/264 Lamp, Hurricane (1950-1955), 2 pc. Consists of 400/224 5-1/2″ Candleholder, 400/265 Chimney with straight sides.

400/265 Chimney; Shade (1950-1955), straight sides. Part of 400/264 Hurricane Lamp.

400/266 Tray (1960-1961), 6-1/2″, triangular, 6 segments make a circle, beading on outer edge of each piece, 11 beads on each edge.

400/266 Plate (1960-1961), 7-1/2″ widest part, seat 2-7/8″, triangular, nearly flat. Part of 400/496 3 pc. Mayo Set.

400/268 Tray, Relish (1961-1984), 8″, oval, 2 sections, curved divider.

400/269 Tray, Individual; Server (1961-1966), 6-1/2″. Controversy continues over this piece and also the 400/2696 Hospitality or Tid-Bit Set (6 400/469 Trays) as no pictures of either are available. Tray is listed on Price Lists from 1961 and 1962. Some think it is the same as 400/266 and that the 400/2696 set is the complete set of 6 segments that make a circle. Reported: gold.

400/270 Plate, Tid-Bit (1947-1968, 1973, 1977-1978), 7-1/2″ — top plate in set, center hole for metal handle. Part of 400/2701 Tid-Bit Set. Reported: with high base.

400/270TB Tid-Bit Set (somewhere in these dates: 1947-1968; 1973; 1977-1978). These are the dates for the complete 400/2701 Tid-Bit Set, which includes both the 400/270 and 400/271 plates. 7-1/2″ cupped plate, 1 tier, 2-3/4″ d. stand-up collared base, 1/2″ high base — includes wafer above collar, 4-3/4″ — 5″ center handle with silver or gold-colored metal, center-post handle — topped with triangle or oval or circle ring, post unscrews.

400/271 Plate, Tid-bit (1947-1968; 1973; 1977-1978), 10-1/2″, bottom plate in set, center hole for metal handle. Part of 400/2701 Tid-Bit Set.

400/271TB Tid-Bit Set (see dates for 400/270TB), 10-1/2″, 1 tier, cupped plate with center hole, metal handle tipped with oval, circle, or triangular ring.

400/273	Basket (1950-1963), 5″, beaded handle, basket made both round and oval.
400/274	Cruet, Oil, Stopper (1947-1961), 4 oz., no handle, 3-bead stopper. Part of 400/2794 3 pc. Oil and Vinegar Set, 400/2796 5 pc. Condiment Set.
400/275	Cruet, Vinegar (1947-1961), 6 oz., no handle, 3-bead stopper. Part of 400/2769 4 pc. Condiment Set, 400/2794 3 pc. Oil and Vinegar Set, 400/2796 5 pc. Condiment Set.
400/276	Butter, California, Covered (1947-1968), taller, not as long as 400/161 1/4 lb. Butter. 2 styles: 1950-1966, plain top — no beads; 1966-1968, 5 graduated beads lengthwise across top — largest bead in center. This butter dish fits the size of the butter sections sold in California.
400/277	Bottle, Salad Dressing, Stopper (1947-1960), 1-bead stopper with open bead or bubble, no handle, raised words "Oil" and "Vinegar" to show fill lines.
400/278	Cruet (1950-1967), 4 oz., 3-bead stopper, top of handle not attached to side of bottle.
400/279	Cruet (1950-1967), 6 oz., 3-bead stopper, top of handle not attached to side of bottle. Reported: no lip, used as vase, experimental.
400/280	Candleholder (1950-1955), 3-1/2″, plain base, 1-bead stem, lip around candle cup.
400/287C	Vase (1950-1963), 6″, 5 graduated beads attached to 2 sides of vase, largest at top, crimped, smaller than 400/87C Vase.
400/287F	Vase (1950-1963), 6″, fan-shaped, 5-6 graduated beads attached to 2 sides of vase — largest at top, smaller than 400/87F Vase. Reported: pair of Gold-on-Glass Vases; gold with Wild Rose all-over etching; "overlayed with a gold floral pattern in relief". Imperial records show 6 beads on sides of vase, Imperial ad from May 1953 shows 5 beads. Collectors have reported both 5 and 6 beads.
400/289	Marmalade Set (1947-1984), 3 pc., 2-bead finial, no base. Dimensions: 3-1/4″ — 3-1/2″ tall, bottom 1-1/2″ — 2-1/4″, top 3″ d., 11″ circumference. Ladles/Spoons: 1961 catalog — no beads; 1966 catalog — 3 beads; 1971, 1979, 1980 Catalogs — metal spoons. Beaded edge on cover. Consists of bowl, cover, spoon.
400/289	Ladle, Marmalade (dates ?). This is listed as a plastic ladle in Imperial files. See previous entry; the 1961 Catalog no-bead spoon could be plastic.
400/311	Breakfast Set (1943), 11 pc. Consists of 400/1D 6″ Bread and Butter Set, 400/5D 8″ Luncheon Plate, 400/19 5 oz. Juice Tumbler, 400/19 Egg Cup, 400/23B 5-1/4″ Cereal Bowl, 400/35 Cup and Saucer, 400/122 Individual Cream and Sugar Set, 400/123 7-1/2″ Covered Toast.

400/313	Breakfast Tray Set (1943-1951), 13 pc. Same as previous entry with the addition of the 400/109 Salt and Pepper Set.
400/316	Luncheon Set (1943-1951), 16 pc. Consists of 400/5D 8″ Plates (4); 400/29/30 Cream, Sugar, Tray Set; 400/35 Cups and Saucers (4); 400/68D 12″ handled Sandwich Tray.
400/322	Luncheon Set (1943), 22 pc., service for 6. Consists of 400/5D 8″ Salad Plates (6), 400/29 6-1/2″ Tray, 400/30 Cream and Sugar, 400/35 Tea Cups and Saucers (6), 400/68D 11-1/2″ Center Handled Serving Tray.
400/328	Luncheon Set (1943), 28 pcs., service for 8. Same as previous entry with the addition of 2 sets of cups and saucers and 2 salad plates.
400/330	Pitcher (1950-1954), 13-14 oz., short, round, no beads. This pitcher is from Imperial's Svelte Line, but it was also given a Candlewick mould number and used in the Candlewick Line. Part of 400/733 2 pc. Dressing Set. Reported: with "Trader Vic" Restaurant logo etched into side.
400/416	Pitcher (1968-1975), 20 oz., no beads on handle or base.
400/419	Pitcher (1968-1977), 40 oz., no beads on handle or base.
400/424	Pitcher (1968-1977), 80 oz., no beads on handle or base, changed to 64 oz. in 1974. Reported: gold handle and base.
400/440	Ash Tray (1943-1967; 1973; 1978-1979), 4″, Crystal, round. Part of 400/134/440 6 pc. Cigarette Set, 400/440 4 pc. 4″ Ash Tray Set with "Hand Fired Bright Gold," 400/450 3 pc. Nested Crystal Ash Tray Set. Reported: gold beads.
400/440	Ash Tray (1942-1960), 4″, Colored, round. Part of 400/550 3 pc. Colored Ash Tray Set. Colors: blue, 75-400-440, 1948 Price List; aquamarine, 1-1-54; Nut Brown, 1977; Ultra Blue, 1977. Reported: red; light aqua; cobalt.
400/440	Ash Tray, Patriotic (WWII years), 4″, WWII design — "V" surrounded by 12 stars. Colors: aquamarine, Ruby. Part of 400/550 Patriotic Ash Tray Set.
400/440	Ash Tray Set (1948), 3 pc., round, 4″ ash trays with "Hand Fired Bright Gold," beads are gold. Each set was "gift packed in plastic gift box." Set listed on bulletin dated December 28, 1948.
400/450	Ash Tray Set (1943-1967; 1973; 1978-1979), 3 pc., nested, round, Crystal. Consists of 400/133 5″ Ash Tray, 400/150 6″ Ash Tray, 400/440 4″ Ash Tray.
400/465	Ladle, Marmalade (1960 ?), called Marmalade Ladle on early Imperial list — other lists just call it Ladle. Part of 400/496 3 pc. Mayo Set — this set also shown with 3-bead ladle. This could be the early plastic ladle, as I did find reference to a plastic ladle used with Candlewick.
400/496	Mayo Set (1960-1961), 3 pc. Consist of 400/49/1 5″ Heart Fruit Bowl, 400/266 7-1/2″ Triangle Plate with seat, 400/465 Ladle

	— Catalog G uses 400/165 3-bead Ladle. Measurements taken from Scott's newsletter, #21: Plate, 7-3/4″ across widest part; 2-7/8″ d. seat; Bowl, 4-7/8″ wide, 1-3/4″ high, flat base, heart-shaped.
400/550	Ash Tray Set (1942-1960), 3 pc., nested, round, colored. First colors listed in 1942 Catalog C. Consists of (from 1948 Price List) 75/400/440 4″ Ash Tray — blue, 40/400/133 5″ Ash Tray — amber, 65/400/150 6″ Ash Tray — pink. Another set consists of 400/133 Champagne, 400/150 Cranberry, 400/440 Aquamarine. Colors: blue, amber, pink — 1948; Champagne, Cranberry, Aquamarine — 1954; Ultra Blue Set and Nut Brown Set — 1977; cobalt set. Reported: amber — 6″, purple — 5″, aqua — 4″.
400/550	Ash Tray Set, Patriotic (WWII era), 3 pc. Made in two distinct color sets: 400/150 6″ Cobalt Blue, 400/440 4″ Ruby, 400/133 5″ Milkglass White; also 400/150 6″ Cranberry, 400/440 4″ Aquamarine, 400/133 5″ Champagne. Designs: 400/150 — 6″, Eagle on ball surrounded by stars; 400/133 5″, shield with stars and stripes; 400/440 4″, V surrounded by stars.
400/616	Spoon, Salt (1950-1967), plain bowl. Dimensions: 2-11/16″ long, 3/16″ diameter; bowl — 1/2″ wide, 1/2″ long; tip of handle — 1/2″ long with Fleur-de-lis design. See entry 400/156 Ladle for more info.
400/616	Salt Set, Individual (1948-1951), 16 pc. (1948 Price List). Consists of 400/61 Salt Dips (8), 4000 Salt Spoons (8) — same as 400/616 Salt Spoon according to Price List 10-18-48.
400/623	Mayo Set (1960-1966), 2 pc. Consists of 400/165 Mayo Ladle with 3-bead handle, 400/183 6″ 3-toed Bowl.
400/650	Ash Tray Set (1957-1967), 3 pc., square, nested. Consists of 400/651 3-1/4″ Ash Tray, 400/652 4-1/2″ Ash Tray, 400/653 5-3/4″ Ash Tray. All ash trays have large-bead edges.
400/651	Ash Tray (1957-1967), 3-1/4″, square. Part of 400/650 3 pc. Square Nested Ash Tray Set.
400/652	Ash Tray (1957-1967), 4-1/2″, square. Part of 400/650 3 pc. Square Nested Ash Tray Set.
400/653	Ash Tray (1957-1967), 5-3/4″, square. Part of 400/650 3 pc. Square Nested Ash Tray Set.
400/655	Jar Tower (1960-1965), 3 sections, 2-bead finial on cover. Colors: Verde (green), Charcoal, Crystal.
400/656	Candy Box, Cover (1961), section from jar Tower.
400/680	Lamp, Twin Hurricane (1943-1950), 5 pc., footed, 2 arms. Patented: 9-29-42. Consists of 400/152 Peg Adapters (2), 400/152 Chimneys (2), Base with 2 arms with candle cups. Reported: with red trim; frosted.

400/701	Condiment Set (1941-1943), 5 pc. Consists of 400/29 6-1/2″ Oblong Condiment Tray, 400/70 4 oz. Cruet, 400/71 6 oz. Cruet. Cruets are handled and have 3-bead stoppers.
400/733	Salad Dressing Set; Syrup (1950-1954), 2 pc. Pitcher from Imperial's Svelte Line but used with Candlewick. Consists of 400/23D 7″ Plate with Seat, 400/330 14 oz. Pitcher. See entry 400/330 for more info on pitcher.
400/735	Salad Set (1943-1955), 3 pc. Consist of 400/75 Fork and Spoon Set, 400/73H 9″ Handled Heart or 400/49H 9″ Heart without handle.
400/750	Tid-Bit Set; Ash Tray Set; Hearts (1943-1963), 3 pc. Consists of 400/172 4-1/2″ Mint Heart, 400/173 5-1/2″ Nut Heart, 400/174 6-1/2″ Bon Bon Heart. Color: Doeskin (frosted); Milkglass — see entry 1950/750.
400/920F	Console Set (1943-1951), 3 pc. Consists of 400/92F 12″ Float Bowl, 400/100 Twin Candleholders (2). Reported: with gold beads.
400/925	Salad Set (1943-1951), 4 pc. Consists of 400/75 Fork and Spoon Set, 400/92B 12″ Bowl, 400/92D 14″ Plate (Early price list shows 400/92V 13-1/2″ Cupped Edge Torte Plate).
400/1004B	Console Set (1939-1943), 3 pc. Consists of 400/100 Twin Candleholders (2), 400/104B 14″ Belled Bowl.
400/1006B	Console Set (1939-1951), 3 pc. Consists of 400/100 Twin Candleholders (2), 400/106B 12″ Belled Bowl.
400/1112	Relish Set; Relish and Dressing Set (1941-1963), 4 pc. Consists of 400/89 Marmalade Bowl and Cover, 400/112 10-1/2″ 3 or 4 sectioned Relish Tray with center well and handles (early — no handles), 400/130 Marmalade ladle, 3-bead. Variations: 1948 HOUSE BEAUTIFUL magazine shows ad with 3 sections and well but no handles, the same for 1942 SUNSET magazine (May edition); later came 5 sections and well and 5 tab handles. Reported: in birchwood tray; with gold beads.
400/1474	Console Set (1943), 3 pc. Consists of 400/104B 14″ Belled Bowl, 400/147 3-lite Candleholders (2).
400/1476	Console Set (1943-1951), 3 pc. Consists of 400/106B 12″ Belled Bowl, 400/147 3-lite Candleholders (2).
400/1503	Lazy Susan (1947-1951), 3 pc. Consists of 400/151 10″ Tray (round), 400/151 Base, Ball Bearing ring. All three round ash trays (400/150, 400/133, 400/440) have been used with this set as a base. The 4″ 400/440 has an indented edge on the bottom of the base which the bearing ring fits over; the 5″ 400/133 has a groove into which the bearing ring fits perfectly; the 400/150 6″ Ash Tray also fits but not as well — no groove. I feel that Imperial used the 6″ at one time and maybe changed at a later date; Imperial may also have used all three

at different times. A point to remember: the tray has a stippled center to cover the area where the ball bearing ring is placed so it cannot be seen from the top of the tray. The bearing-ring fits into the groove in the center of the "Ash tray" bottom and also the tray bottom allowing the tray to revolve. Price List from 1-1-51 gives the Base number as 400/151.

400/1510 Lazy Susan Condiment Set (1947-1951), 8 pc. Consists of 400/89 Marmalade Jar and Cover, 400/130 Ladle (or 400/165), 400/274 4 oz. Cruets (2), 400/275 6 oz. Cruets (2), 400/1503 3 pc. Lazy Susan Set.

400/1531B Console Set (1941-1943), 3 pc. Consists of 400/115 3-way Candleholder (2), 400/131B 14" Oval Bowl with flat base.

400/1567 Condiment Set (1943-1950), 5 pc. Consists of 400/119 6 oz. Cruets (2), 400/148 Tray with Seats (1948 and 1950 Price Lists show the 400/159 Tray), 400/167 Salt and Pepper Set. The difference between the two trays mentioned is that the 400/148 has 4 seats to hold the condiments; the 400/159 does not; they are the same 9-1/4" X 5-1/4" tray.

400/1574 Condiment Set (1943-1951), 5 pc. Consists of 400/159 9-1/2" Oval Tray, 400/164 4 oz. Cruets (2), 400/167 Salt and Pepper Set.

400/1589 Twin Jam Set (1943-1960), 3 pc. Consists of 400/89 Covered Marmalade Jars (2) with 3-bead Ladles (2), 400/159 9-1/2" Oval Tray. Reported: on rectangular stainless steel tray with shield and vine design, stamped "Faberware, New York."

400/1596 Condiment Set (1943-1950), 5 pc. Consists of 400/96 Salt and Pepper Set, 400/119 6 oz. Cruets (2), 400/159 9-1/2" Oval Tray.

400/1630 Wine Set (1943-1951), 8 pc. Consists of 400/163 Decanter with Stopper, 400/190 5 oz. Dinner Wines (6).

400/1639 Wine Set (1943-1951), 8 pc. Consists of 400/163 Decanter and Stopper, 400/19 3 oz. Wines (6). 1948, 1950, 1951 Price Lists and Catalogs C and D call this set "Liquor Set with Liquors;" it was listed as 7 pc.

400/1752 Candleholder, Prism (1947-1955), 3-bead stem. Consists of 400/152 Adapter, 400/175 Candleholder, Prisms.

400/1753 Lamp, Hurricane (1947-1955), 3 pc., with prisms. Consists of 400/26 Chimney, 400/152 Adapter, 400/175 6-1/2" Candleholder, Prisms.

400/1769 Condiment Set (1943-1950), 4 pc. Consists of 400/96 Salt and Pepper Set, 400/119 6 oz. Oil Cruet, 400/171 8" Tray. Shown in ad in BETTER HOMES AND GARDENS magazine, November 1949, page 198.

400/1786 Condiment Set (1943-1960), 4 pc. Consists of 400/89 Covered Marmalade Bowl, 400/96 Salt and Pepper — chrome tops, 400/130 Marmalade Ladle, 400/171 8" Tray.

400/1929 Cigarette Set (1943-1960), 6 pc. Consists of 400/19 Individual Ash Trays (4), 400/19 3 oz. Wine as Cigarette Holder, 400/29 Tray. In 1948, the 400/19 Old Fashion was advertised as the Cigarette Holder, also Catalogs C and D.

400/1930 Cocktail Set (1943-1950), 11 pcs. Consists of 400/139/1 Covered Snack Jar, 400/190 4 oz. Cocktails (8), 400/255 Small All Glass Punch Ladle. 1948 Price List shows 400/139/2 Bowl with notched cover.

400/1989 Marmalade Bowl, Cover (1941-1968), 2 pc., low footed, beaded base, 2-bead finial. Part of 400/1989 3 pc. Marmalade Set.

400/1989 Marmalade Set (1941-1968), 3 pc., low footed, beaded base. Consists of 400/130 3-bead Marmalade Ladle, 400/1989 Covered Bowl — 400/19 Old Fashion with lid. 1941 Newhouse Brochure and Catalog B show long spoon, ribbed bowl, with 3 beads on handle. Catalogs C and G show short ladle with 3 beads. 1953 Imperial Component Parts List for Candlewick shows the 400/1989 Jar as the 7 oz. 400/19 Old Fashion.

400/2296 Cream, Sugar, Tray Set (1943-1950), 3 pc. Consists of 400/96T 5″ Tray, 400/122 Cream and Sugar Set.

400/2696 Hospitality Set (1961-1963), 6 pc. Consists of 400/269 6-1/2″ Individual Servers. Also called Tid-Bit. See entry 400/269 for more information.

400/2701 Tid-Bit Set (1947-1968; 1973; 1977-1978), 2-tier, chrome handle — early: oval ring at tip of handle; 1973 Catalog: triangular ring. Consists of 400/270 7-1/2″ Tid-Bit Plate with center hole, 400/271 10-1/2″ Tid-Bit Plate with center hole, 400/2701 Chrome Handle. Both plates are cupped. Reported: with 12″ lower plate and triangular ring; with flat plates — in Emerald Green with triangular ring.

400/2769 Condiment Set (1947-1960), 4 pc. Consists of 400/96 Salt and Pepper Set with chrome tops, 400/171 8″ Tray, 400/275 Vinegar Cruet and Stopper.

400/2794 Oil and Vinegar Set (1947-1960), 3 pc. Consists of 400/29 6-1/2″ Oblong Tray, 400/274 Oil Cruet and Stopper, 400/275 Vinegar Cruet and Stopper.

400/2796 Condiment Set (1947-1960), 5 pc. Consists of 400/96 Salt and Pepper Set — chrome tops, 400/159 9-1/2″ Oval Tray, 400/274 Oil Cruet and Stopper, 400/275 Vinegar Cruet and Stopper.

400/2911 Oil, Vinegar Set (1943-1950), 3 pc. Consists of 400/29 Tray, 400/119 6 oz. Cruets with Stoppers (2).

400/2930 Cream, Sugar Set (1941), 3 pc. Early number and old style cream and sugar. Same as 400/29/30.

400/2946 Oil, Vinegar Set (1943-1950), 3 pc. Consists of 400/29 Tray, 400/164 4 oz. Oil, 400/166 6 oz. Vinegar. No handles on

cruets.

400/2989 Twin Jam Set (1943-1950), 3 pc. Consists of 400/29 Tray, 400/89 Covered Marmalade Jar (2), 400/130 Marmalade Ladles (2).

400/2990 Condiment Set (1943-1950), 5 pc. Consists of 400/29 Tray, 400/109 Salt and Pepper Set, 400/177 Cruets (2). Salt and Pepper have metal tops.

400/4272B Bowl Set (1943-1965), 4 pc., 2-handled, round. Consists of 400/42B 4-3/4" Bowl, 400/52B 6-1/2" Bowl, 400/62B 7" Bowl, 400/72B 8-1/2" Bowl.

400/4272D Plate Set (1943-1965), 4 pc., 2-handled, round. Consists of 400/42D 5-1/2" Plate, 400/52D 7-1/2" Plate, 400/62D 8-1/2" Plate, 400/72D 10" Plate.

400/4975 Salad Set (1943-1951), 4 pc. Consists of 400/49H 9" Heart Bowl, 400/75 Spoon and Fork Set, 400/92V 13-1/2" Torte Plate with cupped and beaded edge (1948 Price List shows 400/75V 12-1/2" Cupped Plate).

400/5629 Mustard, Ketchup Set (1943-1950), 3 pc. Consists of 400/29 Tray, 400/156 Covered Mustard (2) with spoons — look like 4000 Salt Spoons.

400/5996 Condiment Set (1943-1950), 5 pc. Consists of 400/89 Covered Marmalade Jar, 400/96 Salt and Pepper Set, 400/119 6 oz. Cruet, 400/130 Marmalade Ladle, 400/159 9-1/2" Tray.

400/6300B Console Set (1941-1951), 3 pc. Consists of 400/63B 10-1/2 Belled Bowl, 400/100 Twin Candleholders (2).

400/7375 Salad Set (1943-1951), 4 pc. Consists of 400/73H 9" Handled Heart, 400/75 Fork and Spoon Set, 400/92V Cupped-edge Plate. Also shown with 400/75V 12-1/2" Cupped-edge Plate and 400/92D 14" Flat-edge Plate.

400/7570 Console Set (1943-1951), 4 pc. Consists of 400/75F 11" Float Bowl, 400/150 6" Ash Tray with 1/2" indent to receive bowl, 400/170 3-1/2" Candleholders (2).

400/7796 Oil, Vinegar Set (1943-1955), 3 pc. Consists of 400/96T 5" Tray, 400/177 4 oz. Oil Cruet, 400/177 4 oz. Vinegar Cruet.

400/8013B Console Set (1937-1941), 3 pc. Consists of 400/13B 11" round Centerbowl, 400/80 3-1/2" low-footed Candleholders (2). Color: Viennese Blue.

400/8013F Console Set (1938), 3 pc. Possibly consists of 400/13F 10" Bowl, 400/80 3-1/2" Candleholders (2). Color: Viennese Blue.

400/8063B Console Set (1941-1951), 3 pc. Consists of 400/63B 10-1/2" Belled Bowl, 400/80 3-1/2" low-footed Candleholders (2).

400/8075B Console Set (1939-1941), 3 pc. Consists of 400/75B 10-1/2" Bowl, 400/80 3-1/2" Candleholders (2) — no handles.

400/8113B Console Set (1937), 3 pc. Possibly consists of 400/13B 11" Centerbowl, 400/81 Candleholders (2). Color: Viennese

	Blue.
400/8613B	Console Set (1937-1941), 3 pc. Consists of 400/13B 11″ Centerbowl, 400/86 Mushroom Candleholders (2). Colors: Satin-Trimmed; Viennese Blue.
400/8692L	Console Set, Mushroom (1937-1943), 3 pc. Consists of 400/86 Mushroom Candleholders (2), 400/92L 13″ Mushroom Centerbowl.
400/8918	Marmalade Set (1947-1963), 3 pc. Consists of 400/18 7 oz. Old Fashion, 400/89 Cover with 2-bead finial, 400/130 3-bead Marmalade Ladle. 1953 Component Parts List for Candlewick lists the 400/8918 Jar as the 400/18 Old Fashion.
400/9266B	Cheese, Cracker Set (1937-1951), 2 pc. Called Buffet Set in Catalog D. Consists of 400/66B 5-1/2″ Compote — no beads on stem, 400/92D 14″ Flat-edge Plate. Lombardo Brochure shows 6″ Cheese Compotier — I believe the compote/compotier is the same. Reported: gold decorations with roses; yellow beads; blue; frosted beads.
400/9275	Console Set (1943-1951), 4 pc. Consists of 400/92F 12″ Float Bowl, 400/150 6″ Ash Tray with 1/2″ indent on bottom to receive bowl, 400/175 3-bead Candleholders (2).
400/9279FR	Console Set (1941-1951), 3 pc. Consists of 400/79R 3-1/2″ Cupped-edge Candleholders (2), 400/92F 12″ Float Bowl. 1943 Price List shows 400/92R 13″ Rolled Mushroom Centrebowl; 1948 Price List uses the 400/92F Bowl and 400/79R Candleholders; the 1951 Price List uses the 400/92F Bowl — no FR listed after mould numbers on Price List.
400/51340	Salad Set (1937-1939), 13 oz. Also was listed as 400/15348. Consists of 400/5D 8″ Plate (8), 400/13D 12″ Plate, 400/13F 10″ Bowl, 400/40 3 pc. Mayo Set. 400/13D and 400/13F can also be listed as 400/13FD Salad Set — plate and bowl. 1937 Price List shows 400/51348; 1938 and 1939 Price Lists show 400/51340.
3400	Goblet (1937-1982), 9 oz., 7-1/4″ high, 4-bead stem. Patent #107,030; applied for 3-9-37; received 11-16-37. Variations: foot flat; foot slightly domed; beads definite; beads blend in; beads out of round; wafer small; wafer more defined. Colors: Ruby bowl, clear stem and foot; black, late 1970's; Nut Brown, Sunshine Yellow, Ultra Blue, Verde (green), all 4 made 1977-1979. Reported: gold etched banding; light green; amethyst; bright yellow bowl with clear stem and foot; encrusted with gold and etched with Wild Rose pattern — believed during the 1940's. Made with Optic designed bowl (vertical lines) in 1937-1938.
3400	Saucer Champagne; Tall Sherbet (1937-1982), 6 oz., 5″ — 5-1/4″ high, 4-bead stem. Colors: Ruby; Nut Brown, Sunshine Yellow, Ultra Blue, Verde (green), all 4 made 1977-1979.

Reported: pale green bowl with clear stem and foot; Emerald Green. Made with Optic designed bowl (vertical lines) in 1937-1938).

3400 Wine (1937-1982), 4 oz., 5-1/2″ high, 4-bead stem. Colors: Ruby; Nut Brown, Sunshine Yellow, Ultra Blue, Verde (green), all 4 made 1977-1979. Reported: in Crackle Glass — Imperial experimented with Crackle Glass in 1951. Made with Optic design bowl (vertical lines) in 1937-1938.

3400 Cocktail (1937-1967), 4 oz., 4-1/2″ high, 4-bead stem. Colors: Ruby Bowl with clear stem and foot; Ritz Blue bowl with clear stem and foot. Made with Optic designed bowl (vertical lines)in 1937-1938.

3400 Cordial (1937-1967), 1 oz., 4-1/2″ high, 4-bead stem. Color: Ruby bowl with clear stem and foot. Reported: Crackle Glass with 2 gold bands on top and 1 on base — Imperial experimented with Crackle Glass in 1951; without wafer between the beads — beads touch without divider. Made with Optic designed bowl (vertical lines) in 1937-1938.

3400 Claret (1937-1967), 5 oz., 6-1/8″ high, 4-bead stem. Color: Ruby bowl with clear stem and foot. Made with Optic designed bowl (vertical lines) in 1937-1938.

3400 Tumbler, Iced Tea (1937-1982), 12 oz., 6-1/2″ high, 1-bead stem. Colors: Ruby bowl with clear stem and foot; Nut Brown, Sunshine Yellow, Ultra Blue, Verde (green) — all 4 made in 1977-1979. Made with Optic designed bowl (vertical lines) in 1937-1938.

3400 Tumbler, Water (1943-1973), 10 oz., 5-7/8″ high, 1-bead stem.

3400 Tumbler (1937-1943), 9 oz., 1-bead stem. Color: Ruby bowl with clear stem and foot. Made with Optic designed bowl (vertical lincs) in 1937-1938.

3400 Tumbler, Juice (1937-1967), 5 oz., 4-3/4″ high, 1-bead stem. Shown in ad in BETTER HOMES AND GARDENS magazine, January 1952. Color: Ruby bowl with clear stem and foot. Made with Optic designed bowl (vertical lines) in 1937-1938.

3400 Sherbert, Low (1937-1973), 5 oz., 1-bead stem. Two styles: both have 2 wafers — above and below bead on stem; early — 3-1/2″ high, 3-7/8″ d. bowl — more tapered to stem, 1937-1966; later — 3-5/8″ high, 4″ d. bowl, some 6 oz., 1966-1971. Color: Ruby bowl with clear stem and foot. Made with Optic designed bowl (vertical lines) in 1937-1938.

3400 Parfait (1947-1973), 6 oz., 6-1/4″ high, 1-bead stem. Variation: some more flared at top rim than others.

3400 Seafood Cocktail; Icer; Fruit (1939-1961), 2 pc., 4-1/2″ high, 9 oz., 1-bead stem. Same insert as 3800: 4-1/4″ d., 1-3/4″ high, 3-1/2 oz. Insert is ridged around top flat edge ("dip" in cen-

	ter of flat surface); dimple in bottom of insert. Variations reported: slightly domed base; wafer only between bead and base.
3400	Cocktail, Oyster (1937-1963), 3-3/8″ high, 4 oz., pyramid style stem, flared rim. Part of 400/91 2 pc. Cocktail Set. This Cocktail is also Pattern #176 Imperial Continental — shown in 1953 general catalog. Color: Ruby bowl with clear stem and foot. Reported: cobalt.
3400	Bowl, Finger (1937-1960), footed, no beads, no stem. 1938 Lombardo Brochure shows finger bowl on 7″ plate with "tufted rim." Color: Ruby bowl with clear stem and base. Made with Optic bowl (vertical lines) in 1937-1938.
3800	Goblet (1938-1943), 9 oz., 2-bead stem — largest at base, top rim turns in slightly. Colors: Ruby; Ritz Blue; both have clear stem and foot. Made with Optic bowl (vertical lines) for Hunt Glass Works, Corning, NY in 1938.
3800	Cocktail, Oyster (1943). Offered on Imperial Price List 1-1-43 — listed as 3400, also used as 3800. See 3400 Oyster Cocktail for more information.
3800	Cocktail (1938-1943), 4 oz., 2-bead stem — largest at base, top rim turns in slightly. Colors: Ruby; Ritz Blue; both have clear stem and foot. Made with Optic bowl (vertical lines) for Hunt Glass Works, Corning, NY in 1938.
3800	Sherbert, Tall; Champagne (1938-1943), 4 oz., 2-bead stem — largest at base, top rim turns in slightly. Colors: Ruby; Ritz Blue; both have clear stem and foot. Made with Optic bowl (vertical lines) for Hunt Glass Works, Corning, NY in 1938.
3800	Sherbert, Low (1941-1943), 1-bead stem, top rim turns in slightly. Colors: Ruby; Ritz Blue; both have clear stem and foot. Made with Optic bowl (vertical lines) for Hunt Glass Works, Corning, NY in 1938.
3800	Claret (1939-1943), 2-bead stem — largest at base, top rim turns in slightly. Colors: Ruby; Ritz Blue; both have clear stem and foot. Made with Optic bowl (vertical lines) for Hunt Glass Works, Corning, NY in 1938.
3800	Wine (1938-1943), 4 oz., 2-bead stem — largest at base, top rim turns in slightly. Colors: Ruby; Ritz Blue; both have clear stem and foot. Made with Optic bowl (vertical lines) for Hunt Glass Works, Corning, NY in 1938.
3800	Cordial (1938-1943), 1 oz., 2-bead stem — largest at base, top rim turns in slightly. Looks identical to 4000 Cordial; 3800 1/4 oz. smaller. Colors: Ruby; Ritz Blue; both have clear stem and foot. Part of 400/82 10 pc. Cordial Set. Made with Optic bowl (vertical lines) for Hunt Glass Works, Corning, NY in 1938.
3800	Tumbler, Iced Tea (1938-1943), 12 oz., 1-bead stem, top rim

	turns in slightly. First offered in Crystal on Imperial Price List March 1, 1941. Colors: Ruby; Ritz Blue; both have clear stem and foot. Made with Optic bowl for Hunt Glass Works, Corning, NY in 1938.
3800	Tumbler (1938-1943), 9 oz., 1-bead stem, top rim turns in slightly. Colors: Ruby; Ritz Blue; both have clear stem and foot. Made with Optic bowl (vertical lines) for Hunt Glass Works, Corning, NY in 1938.
3800	Tumbler (1938-1943), 5 oz., 1-bead stem, top rim turns in slightly. Colors: Ruby, Ritz Blue; both have clear stem and foot. Made with Optic bowl (vertical lines) for Hunt Glass Works, Corning, NY in 1938.
3800	Brandy (1941-1943), 2-bead stem — largest at base, top rim turns in slightly. Part of 400/111 Tête-a-Tête.
3800	Icer, Seafood; Fruit Cocktail (1939-1943), 2 pc., 12 oz., bowl is 3-15/16″ d. and 4-1/2″ high, 1-bead stem, top rim turns in slightly. For description of insert see 3400 Seafood Cocktail. Bowl also made with Optic (ridged) design in 1938 for Hunt Glass Works, Corning, NY.
3800	Fingerbowl (1938-1943), 8-9 oz., no beads. Dimensions: 2-1/2″ high, 4-1/4″ d. top rim, 2-7/8″ d. base, 13-5/8″ top rim circumference. Colors: Ruby; Ritz Blue; both have clear base. This is also the "Imperial Continental" pattern. Made with Optic bowl for Hunt Glass Works, Corning, NY in 1938.
4000	Cocktail (1947-1960), 4 oz., 3-bead stem — largest at base, rounder bowl than 3800 series, bowl turns in slightly at rim.
4000	Wine (1947-1960), 5 oz., 3-bead stem — largest at base, rounder bowl than 3800 series, bowl turns in slightly at rim.
4000	Sherbert, Tall (1947-1960), 6 oz., 3-bead stem — largest at base, rounder bowl than 3800 series, bowl turns in slightly at rim.
4000	Goblet (1947-1960), 11 oz., 3-bead stem — largest at base, rounder bowl than 3800 series, bowl turns in slightly at rim.
4000	Iced Tea; Hiball (1947-1960), 12 oz., 1-bead stem.
4000	Cordial (1950-1960), 1-1/4 oz., 2-bead stem — largest at base. Dimensions: 3-1/4″ high, 1-3/4″ d. top rim, 1-1/16″ d. base. Looks identical to 3800 Cordial — 4000 1/4 oz. larger.
4000	Knife; Butter Cutter (1939-1941), 8-1/2″ long, came gift boxed. Before this knife was identified as Imperial Candlewick, glass knife collectors called it "Hearts and Buttons". The 4 "buttons" are flat and are centered in the "hearts".
4000	Spoon, Salt (1941-1968), 2-5/8″ long ribbed bowl. On an Imperial Component Parts Price List, 1-1-56, the 400/156 and the 4000 are listed as the same. Price List, 10-18-48, lists 4000 same as 400/616.
14994	Lamp, Hurricane (1973-1979), 2 pc. Also Imperial number 10/22. Consists of 400/150 6″ Ash Tray, 14995 12″ Hurricane

	Chimney, a 2″ x 9″ candle.
14995	Shade, Hurricane Lamp; Chimney (1979-1984), 12″. Part of 14994 2 pc. Hurricane Lamp.
14996	Lamp, Hurricane (1978-1984), 2 pc. Consists of 500/170 3- 1/2″ Low Candleholder, 14998 14″ Hurricane Shade.
14998	Shade, Hurricane Lamp; Chimney (1970-1984), 14″ Part of 14996 2 pc. Hurricane Lamp.
1950/45	Compote, Jelly. 5″, milkglass, Doeskin finish (matte). Not made with Candlewick mould, but has Candlewick beaded edge. Shown in Imperial's Milkglass Catalogs B through E. Some collectors collect the 1950 Milkglass series because of the Candlewick edging.
1950/75C	Bowl, Crimped Fruit. 11″, milkglass, Doeskin finish (matte). Flower and leaf design on inside of bowl. Shown in Imperial's Milkglass Catalog B. Made in Candlewick mould.
1950/75D	Plate, Buffet; Wall. 11″, milkglass, flower and leaf pattern in center. 2 finishes: Doeskin (matte), and glossy. Shown in Imperial Milkglass Catalog B. Made in Candlewick mould.
1950/75F	Bowl, Couped Apple. 11″, milkglass, flower and leaf design in bottom. 2 finishes: Doeskin (matte), and glossy. Shown in Imperial's Milkglass Catalog B. Made in Candlewick mould.
1950/75H	Bowl, Heart; Fruit; Dessert. 9″, milkglass, flower and leaf design in bottom. Made in Doeskin finish (matte). Shown in Imperial's Milkglass Catalog B. Made in Candlewick mould.
1950/103	Bowl, Fruit. 10″, flower and leaf design, footed. Made in Doeskin (matte) and glossy finishes. Shown in Imperial's Milkglass Catalogs B through E. Made in Candlewick mould. Colors: Custard Opaque; Blue Opaque; Turquoise Opaque; White Milkglass.
1950/170	Candleholder, Low (1950-1971). Mushroom shaped, leaf design around candle cup, large beads around bottom, milkglass. Shown in Imperial's Milkglass Catalogs C through F. Made in both finishes: Doeskin and glossy. Made in 400/170 Candlewick mould. Reissued for Imperial Glass Collectors Society. Top candle cup was removed; new cup indented; leaf design around indented candle cup; Club logo under base. Colors of reissue: 1978 Ultra Blue, 300 made, has IG mark; Marigold Carnival, 24 made, IG mark; 1984 White Carnival, 250 made; 1978 Pink Carnival, 250 made. Milkglass.
1950/196	Epergne Set. 10″, 2 pc. — footed bowl and lily, milkglass, flower and leaf pattern. 2 styles: plain or beaded scalloped-rim on lily. 2 finishes: Doeskin (matte) and glossy. Colors: white; custard. Shown in Imperial Milkglass Catalogs B through E. Made in Candlewick mould.
1950/750	Ash Tray; Tid-Bit Set. Heart shaped, 3 pc. Exactly like 400/750 but in Milkglass. Consists of pieces made from these

	Candlewick moulds: 400/172 4-1/2″ Mint Heart, 400/173 5-1/2″ Nut Heart, 400/174 6-1/2″ Bon Bon Heart.

1950/776 — Cigarette Holder, Federal. Footed, milkglass. Does not resemble any pieces of Candlewick, but is used with the 1950/1776 Milkglass Ash Tray (see next entry). Two finishes: Doeskin (matte) and glossy. Shown in Imperial Milkglass Catalogs B and C. Eagle design on bowl.

1950/1776 — Ash Tray, Federal Eagle. 6-1/2″, milkglass, same as 1776/1 only in milkglass. 2 finishes: Doeskin (matte) and glossy. Shown in Imperial Milkglass Catalogs B and C. Used with 1950/776 Cigarette Holder. See previous entry.

51675 — Cake Cover. 10″, not Candlewick. Cover has 1-bead finial (open bubble), listed as "Giftware" by Imperial in 1979 Catalog, used with 400/103D Candlewick cake stand.

111 — Cocktail Glass (1941-1948), not considered Candlewick by Imperial, but collectors "adopted" it. 3″ d., 3-3/4″ tall, 4 oz. No wafer above 1-bead stem; wafer above flat base — below bead. Reported: amber. Part of 400/97 2 pc. Cocktail Set, 400/139 11 pc. Cocktail Set.

139 — Ladle, Punch (1943), 1 pour spout. Shown in 1943 Imperial Bulletin pages. Same as 400/139 — see that entry for more information. Part of 400/63/104 19 pc. Chilled Fruit Set, 400/139 11 pc. Cocktail Set, 400/139/77 11 pc. Family Punch Set.

160/130 — Ladle, Marmalade. 4″ long, 2 beads on handle — smallest at tip. Collectors claim it as Candlewick, but it is a Cape Cod piece — the 160 prefix is the Cape Cod mould identification number.

160/165 — Ladle, Mayo. 1 bead on tip of handle; used with early sets in Candlewick. This is another Cape Cod item.

176 — Coaster. These were offered by Imperial in 4 colors. Shown on a Bulletin page with "176 — 10 oz." coasters. The picture shows Candlewick ash trays with 10 oz. goblets sitting in the ash trays. No other information.

176 — Stirrer, Cocktail (1943), 12″, round bead at tip. Part of 400/19 40 oz. Cocktail Set (Martini Pitcher).

530 — Sherbet Lining, Icer (1950-1955), not a Candlewick piece but used with Candlewick. Part of 400/53/3 3 pc. Icer Set.

530 — Tumbler (1950-1955), 5-1/2 oz., not Candlewick but used with Candlewick 3 pc. Icer Set 400/53/3.

615 — Ladle, Mayo (1938-1941), no beads, early, 5″ long, 3/4″ deep, 1-3/4 " d. bowl rim. On Imperial Price Lists in 1941. Reported: Viennese Blue. Part of 400/23 3 pc. Mayo Set, 400/52BD 3 pc. Mayo Set, 400/84 3 pc. Mayo Set, 400/94 4 pc. Salad Dressing Set (Buffet Salad Set) — only used with these sets from dates listed above.

701	Fork, Spoon Set (1937-1938), 9″, ribbed handle, no beads, fan-ridged tip. Part of 400/17 4 pc. Salad Set, 400/13FD 4 pc. Salad Set. Reported: light blue; satin handles; black — found with relish 400/209 in chrome tray.
760/C261	Salt, Pepper Set (1938), also listed as #760 Plain. The C in the number meant it had a cut pattern. This set was illustrated by Imperial as if it was Candlewick, but it is not; it pre-dates all the Candlewick salts and peppers, but used with some early sets. Earliest Candlewick Salt and Pepper Set is shown in 1939 Catalog A.
777/1	Eagle Glass Adapter, Peg (1942-1950), 5-1/2″ high, 5″ wing span, candle cup. Peg is 3/4″ in diameter. Patent #134,312; applied for 6-24-42, received 11-10-42. Peg fits into candleholder; candle fits into candle cup in back of eagle. Reported: black eagle adapter.
777/2	Eagle Glass Adapter (1942-1950), 5-1/2″ high, 5″ wing span, same as previous entry except no candle cup in back of eagle. See previous entry for more information. Part of 400/79R/2 Eagle Candleholder, 400/80/2 Eagle Candleholder, 400/81/2 Eagle Candleholder — handled, 400/100/2-2 Twin Candleholder, 400/115/1 Eagle Candleholder — 3-lite, 400/155 Eagle Candleholder. 2 styles of base: straight peg — fits into candleholder without lip; peg has lip — fits into candleholder with lip (this info reported by collectors).
841	Tumbler, Juice. 4 oz., on Price List 1-1-43, in Catalog G. Part of 400/23B Juice Set.
1776/1	Ash Tray, Eagle (1942-1950, 1966-1967), 6-1/2″, has 13 raised stars in center of tray; small raised dots or beads surround the inside circle outlining the ash tray proper. 400/44 Cigarette holder fits into ash tray to form a 2 pc. Smoking Set referred to (early) by Imperial as 1776/2. Offered in 1966-1967 in Crystal. Some found with old IG (Imperial Glass) mark. Colors reported: Ruby; Ultra Blue; Frosted White (Satin Finish); Milkglass White; both dark and light blue; gold; Black Suede; Cobalt; Marbleized Pigeon-blood Slag; Antique Blue (1965); Doeskin (matte); Crystal.
1776/2	Picture Frame, Eagle (1942-1950), 6-1/2″ center base of picture frame is smooth. Color: gold.
1776/3	Mirror, Eagle (1942-1950), 6-1/2″, mirror is 4″ and convex. Colors: frosted (satin); Antique Blue; black.
1776/5	Mirror,Eagle. 6-1/2″, mirror 4″, same as last entry except in gold. From GIFT AND ART BUYER magazine, October 1942: "Gold finished Federal' mirror with 4″ reduction mirror." In the November 25,1942 IMPERIAL NEWS, a pair of gold frames with convex mirrors are shown as wall decorations. They are termed "Federal" accessories introduced by

Imperial.

— Ash Tray; Candy; Nut Dish. 6″, round.

— Bottle, Lotion; Cologne (1940-1942), 6-1/2″ — 7-1/2″ high. Made for Irving Rice & Co., 15 W. 34th St., N.Y. Uses "IRICE" label. Large beads surround base; stopper has 4 beads — largest at bottom. Probably used mould 400/25 Bud Ball Vase for bottle. Part of Boudoir Set. Reported: gold beads, also on stopper; all gold.

— Boudoir Set (1940-1942), 4 or 5 pcs. Consists of 2 6-1/2″ Tall Cologne Bottles, Puff Jar, 4″ Clock, Tray (sometimes) — 400/151 with mirrored bottom. Shown in the following ads: BETTER HOMES AND GARDENS magazine, December 1940 and June 1942.

— Bowl. 4″ high, 8-1/2″ d., 27″ top circumference, 3 rounded toes, equal size beads on rim.

— Brick, "Save Imperial" (1984), red, 4″ long, 1-7/8″ wide, 1-7/16″ high. Bottom is smooth; rest is "simulated" rough to represent brick. "Save Imperial 1984″ in raised letters on top — a few have gold lettering; approximately 300 made; manufactured by Viking Glass Co., New Martinsville, West Virginia. These commemorative bricks sold in stores and banks in Bellaire, Ohio, to help the Save Imperial Committee purchase the company. Sale to Committee did not materialize.

— Brick. Started selling bricks from factory building at 1993 National Imperial Glass Collectors Society Convention. Bricks came from section of building being torn down. Printed in white on side of bricks: IMPERIAL; regular red bricks.

— Calendar, Desk (1947-1953?), beaded edge, 5-1/4″, rectangular, feet are 2 large beads, question mark handle (like cups) for stand. Dates are listed as such because calendars have been found with these dates. Some variations have been reported: advertising sign under the calendar; tops of some calendars have "Imperial" letters in the glass; some tops are plain and have an Imperial sticker. Colors: Frosted; Gold; gold beads; Ruby.

— Christmas Ornament, Imperial (1985), green.

— Clock, Boudoir (1940-1942), 4″ d., large beads surround face; also found using 400/34 4-1/2″ round Plate. Large-bead clock apparently made from 400/440 Ash Tray. Marked New Haven, Made in U.S.A. on face. Also found with small beads surrounding face. Reported: in electric; with double row of beads. Part of Boudoir Set.

— "Junior Place Setting" (1951), 5 pc. Stated on box in caps: "Proudly created by Fathers and Mothers who produce fine

handmade Crystal at Imperial Glass Corporation." Consists of 400/3D 7″ Salad Plate, 400/42B 4-3/4″ 2 handled Bowl, 400/77 Cup and Saucer, 400/190 5 oz. Wine. This set was never found on Imperial's Price Lists or Catalogs.

— Light Fixture, Ceiling. Consists of 400/155 lamp base made for Lightolier Lighting Company. Shade is Depression Glass Iris pattern.

— Mirror, Desk. Round, 2 large beads are feet, beaded edge, question mark stand like coffee cup handle. Mirror surface is 4-1/2″, magnifying, made for IRICE — see Bottle, Lotion entry for info on IRICE company. Some mirrors found with spring-wire to hold mirrors in; others are glued in.

— Mirror, Flip (IRICE #E55), made with 400/18 base for IRICE Co., see Bottle, Lotion entry for more info on IRICE. Some found with 2 or 3 bead stem, others without beads on stem. One side of mirror is magnified.

— Mirror, Hand. Made for IRICE company, see Bottle, Lotion entry for more info on IRICE Co. 4-5 bead swivel handle; mirror magnifies. Round wafer where glass fits into metal fitting.

— Paperweight. Round, Imperial logo inside clear glass, with dark blue glass used for the label background. "U.S.A.", "Handcrafted," "Imperial" are in white as well as the shape of a cocktail glass (not Candlewick). The logo inside the weight is the exact replica of an Imperial paper label. Helen Clark, a former Imperial employee, said the Imperial logo paperweight was a promotional item mailed to all Imperial customers around 1949-1950. She helped mail them; each employee also got one. The weights were not made by Imperial but for Imperial by a West Virginia glassmaker.

— Paperweight (1972), oblong, souvenir of Bellaire Glass Festival of 1972. Shows picture of Imperial factory and a penny, and an outline of the state of Ohio.

— Peg Float Bowl. 10-1/2″, has silver base about 5″ high. Maybe this is the 400/251 because 251D is the Peg Cake Plate 11-1/2″ by Monmouth Silver.

— Peg Bowl (Peg Lily). Height 6-7/8″ overall, base 4-1/2″ d., bowl 5-1/4″ d. Looks like combination of 400/170 Candleholder with 400/75N Lily Bowl sitting on top. Several have been reported.

— Peg Nappy. Divided, 6″ bowl, 3-1/2″ high overall; base 2-3/4″ across and 1″ high. Marked "Crown Sterling Weighted" base. Possibly 400/52 6″ 2-handled Nappy without handles.

— Peg Nappy. 5-3/4″ d., 3-1/2″ high base. Marked "Crown Brass."

— Peg Nappy. Chrome base, Marlene Coil (Washington, Ohio) gave this description of her piece: 5-1/2″ bowl, 2-13/16″ base

of stem, 5-1/4″ height, 3-1/4″ stem. Written on bottom of base: CONTINENTAL SILVER CO., INC. 3768."

— Peg Plate. 9″. No other info.

— Peg Plate. 6-3/4″, low brass base.

— Picture Frame. Desk Mirror without mirror, concentric circles on picture area, 4-1/2″, round, beaded edge, 2 feet — each a large bead, question mark handle for stand.

— Puff Jar. 3-bead finial on lid, made for Irving Rice Co, — see Bottle, Lotion entry for more info on IRICE Co. Bottom: 2-1/8″ high, 3-7/8″ wide at rim. This is NOT the 400/19 Sherbet. Sherbet is 2-1/16″ high, and 3-3/4″ wide at rim. Reported: with gold bands and accents. Part of Boudoir Set.

— Ringholder. Marked LIG on top of base — in glass on inside of rim near ring holder. In 1980 200 of the 10 spoke 400/78 Coasters were transformed into ringholders.

— Salad Set (1937-1944), 12 pc. Shown in 1938 Brochure and on a 1943 ad. Consists of 400/5D 8″ Salad Plate (8), 400/84 6-1/2″ Divided Bowl, 400/92D 14″ Plate, 2 Glass Spoons -no beads.

— Shade, Lamp. 5-1/4″ d., 3-3/4″ — high, round, designed. Reported: 5-1/4″ d., 2-1/2″ high, #2 Cutting.

— Shade, Lamp. 6-1/2″ d., 2-1/2″ high, round. Imperial Number found intact: G-107. See entry 400/1A for another Shade in the G series.

— Sign. Oblong, size of calendar, 5-1/4″, beaded edge, rectangular, 2 large beads are feet, question mark handle stand, like cup handle. Company logo is at top of sign in center. Sign reads: CANDLEWICK CRYSTAL. Some are combined advertising sign AND calendar.

— Sign. "Imperial", oval, frosted, words in blue, looks like replica of Imperial sticker.

— Spoon, Fork Set (1937-1941?), flat, round tip at end of handles, 9″. Used with early sets. Part of 400/13F Salad Set, 400/13FD Salad Set.

— Tray, Perfume. For Bottle Ensemble, 20″ x 10″, oblong, mirrored. Made of IRICE Company; their # X 278. Glass beads on the handles are the size of the largest bead on the puff jar and are screwed onto the tray from the bottom. Six beads in the straight line constitute each handle, placed near the farthest edges; 18″ between handles.

— Tray, Perfume. For Bottle Ensembles, 15-1/2″ x 9″, oblong, mirrored. Made for IRICE Company; their # E 287. Each of the two handles consists of 10 graduated beads — in sets of 5 beads in a straight line — with the largest beads toward corners of the tray. The two sections of each handle are held together with a brass coupling or fitting; 14″ between han-

dles.

— Tray, Perfume. For Bottle Ensembles, 10-1/2″ in diameter, round, mirrored, uses 400/151 Tray, no handles. Made for IRICE Company; their # E 666.

— Tray, Perfume. For Bottle Ensembles, 19″ x 9-1/4″, oval, mirrored. Made for IRICE, their stock # E 917. Handles: each consists of 9 graduated beads with largest in center of semi-circle form; fits outside of curved edge of tray.

— Tin Box, Bunte Candy. 8-1/2″ high, picture of 400/40/0 Basket filled with Bunte Candies on 2 sides of box.

— Community Plate, "Twilight" Set. 2 pc., pattern patented in May 1956. Consists of 400/60 6″ Candlewick Ash Tray, Community Silverplate butter knife or spoon. Boxes are found in both blue and green; "Community Twilight" is printed on the box.

— Community Plate, "Ballard" Set. 2 pc., pattern patented in December 1957. Consists of 400/49H 5″ Candlewick Heart Nappy, Community Silverplate ladle. The fancy box is black and silver. An Oneida Community sticker on the box states "Ballard in Community, The Finest Silverplate."

— Community Plate, "South Star" Set. Consists of 400/268 8″ oval Relish, fork and spoon labeled Community. These match the utensils in the "South Seas" Set. The red-lined box is imprinted with "Community, the Finest silverplate."

— Community Plate, "South Seas" Set. 2 pc. Consists of 400/54 6-1/2″ Relish with handle, knife with "South Seas — Community." In small yellow box — on bottom a sticker states: "Famous Barr Co. — $2.00." Imprinted on box: "South Seas in Community (the finest silverplate)."

— Community Plate, "Morning Star" Set. 2 pc. Consists of 400/54 Relish, pickle fork labeled: Community "Morning Star". Pattern patented August 1948.

— Community Plate, "South Star" Set. 2 pc. Consists of 400/54 6-1/2″ Relish, knife and spoon marked "South Star Community." The box is imprinted with "South Star Community, The Finest Silverplate."

— Farber Brother Set. 2 pc. Consists of 400/3D 7″ Candlewick Plate with cut fancy flowers, 5-1/2″ high chrome comport.

— Farber Brother Set. 2 pc. Consists of 8″ cupped Candlewick plate — possibly 400/123 Toast Plate, chrome underplate with cut-out fancy flowers.

— Farber Brothers Set. 3 pc. Consists of 400/23B Mayo Bowl, chrome ladle, fancy floral cut underplate.

— Farber Brother Set. 2 pc. Consists of Candlewick belled bowl 6-1/2‴″ d., 1-1/2″ high; fancy floral cut chrome underplate.

— Farber Brothers Set. 2 pc. Consists of 400/3D 7″ Plate with flo-

ral cut, chrome underplate.

— Farberware Set. 3 pc. Consists of 400/123 8″ Cupped Toast Plate — 4-1/2″ foot sits in seat in underplate; 9″ Faberware underplate with floral design on rim; Farberware domed lid, 7″ d., 2″ high. Mark on plate: FARBERWARE NEW YORK. NY.

— Farberware Set. 2 pc. Consists of 400/23 Fruit Bowl — 5-1/84, round lacy-patterned Farberware tray.

— Farberware Set. 2 pc. Consists of 400/159 9″ oval Tray, Farberware rectangular chrome tray. Tray has oval indent and a cut out lacy pattern on each of the 4 corners; some have been reported as having fancy cocktail forks.

— Farberware Set. 3 pc. Consists of 400/259 Candy box on Farberware lacy-patterned round tray, chrome lid.

— Farberware Set. 2 pc. Consists of blue, footed Candlewick Compote on Farberware tray.

— Farberware Set. 2 pc. Consists of 9″ oval Candlewick dish on Farberware tray.

— Hammered Aluminum Set. 2 pc.Consists of 400/55 8-1/2″ 4-part Relish which sits in indent (seat) in square hammered aluminum tray.

— Kromex Set. 2 pc. Consists of 400/209 13-1/2″ 5-part Relish which sits on Kromex lazy susan.

— Rogers "Baroque Rose" Set. 3 pc. Consists of 400/268 8″ sectioned Relish, 1881 Rogers "Baroque Rose" pickle fork and relish spoon. Pattern patented in 1971. Oneida purchased the 400/268 Relishes from Imperial 1969-1971.

— Viking Plate. 2 pc. Consists of 400/134/1 Ash Tray in fancy cut copper holder. Cut out design on handles on each end. Tray is marked "Viking Plate Made in Canada E. P. Copper."

CHAPTER 10
Price Guides

INTRODUCTION

As with all price guides, these are just that - guides. They are meant to help with pricing, but there are many other factors that must be considered. These include type of shop or show offering the item, section of the country, and the desire of the buyer. All play an important part in pricing.

These 3 guides are combinations of prices from many different sources: antiques malls, shows, shops, all types of advertisements including trade papers, and individual sales. Auction prices are not reflected in these guides because they are artificial.

In determining prices, the highest and lowest prices were eliminated to give the most realistic average price.

In some instances there has been no price activity because the piece is rare or no information was available. An asterisk (*) denotes these pieces.

New information has surfaced on some items in the past few years, so several mould numbers have been added to the original listing received from Imperial Glass Corporation's Marketing Manager, Lucile Kennedy, in 1979. These mould numbers are dealt with in individual chapters where appropriate.

There is a total of 1,029 entries in the 3 price guides: 753 entries in the general guide, 183 in the Colored Candlewick Guide, and 93 in the Cuts, Etches, and Decorated Candlewick Guide.

Acknowledgments

Many collectors and antiques dealers have given their knowledge and expertise to the development of these guides. Without them, the guides would be useless. Their help is extremely important in developing guides that are sensible and practical. It is impossible to mention all those who have helped. A special note of gratitude is given to the following:

Glass Clubs

MICHIANA ASSOCIATION OF CANDLEWICK COLLECTORS: 17370 Battles Road, South Bend, IN 46614
OHIO CANDLEWICK COLLECTORS CLUB: 613 S. Patterson St., Gibsonburg, OH 43431
NATIONAL IMPERIAL GLASS COLLECTORS SOCIETY: P. O. Box 534, Bellaire, OH 43906

Newsletters

THE SPYGLASS: Michiana Association of Candlewick Collectors
CANDLEWICK CAPERS: Ohio Candlewick Collectors Club
GLASSZETTE: National Imperial Glass Collectors Society
THE CANDLEWICK COLLECTOR: 275 Milledge Terrace, Athens, GA 30603. Editor: Virginia Scott.

Trade Papers

ANTIQUE TRADER WEEKLY: P. O. Box 1050, Dubuque, IA 52001
DEPRESSION GLASS DAZE: 12135 N. State, Otisville, MI 48463

Other

ANTIQUES MALL: "A Touch of Glass", Munster, IN
Various trade papers, antiques shows and shops, antiques dealers and collectors

MOULD	ITEM	PRICE GUIDE	
400	"Lighting Bowl," patent shows ceiling fixture 4/37	125.00 -	200.00
400/1A	Shade, oval, frosted, Cut #800	75.00 -	125.00
400/1D	Plate, Bread and Butter, 6″	7.00 -	10.00
400/1F	Nappy, Fruit, 5″	10.00 -	11.00
400/3D	Plate, Salad, 7″	8.00 -	10.00
400/3F	Bowl, Fruit, 6″	11.00 -	13.00
400/5D	Plate, Salad/Luncheon, 8″	9.00 -	12.00
400/5F	Bowl, 7″	24.00 -	30.00
400/7D	Plate, Luncheon, 9″	14.00 -	17.00
400/7F	Bowl, 8″	25.00 -	38.00
400/10D	Plate, Dinner, 10-1/2″	32.00 -	50.00
400/10F	Bowl, 9″	35.00 -	43.00
400/13	Luncheon Set, 15 pc.	126.00 -	179.00
400/13B	Bowl, Centerbowl, 11″	50.00 -	65.00
400/13D	Plate, Service, 12″	32.00 -	35.00
400/13F	Bowl, 10″	38.00 -	40.00
400/13F	Salad Set, 4 pc. (1937 -#701, 9″ fork/spoon) Also referred to as 400/13, 13F, 13FD.	95.00 -	110.00
400/13FD	Salad Set, 2 pc.	70.00 -	75.00
400/15	Tumbler, 6 oz., flat beaded base	25.00 -	50.00
400/15	Tumbler, 10 oz., flat beaded base	25.00 -	50.00
400/15	Tumbler, 13 oz., flat beaded base	25.00 -	50.00
400/16	Pitcher, 1 pint	155.00 -	175.00
400/17	Salad Set, 4 pc.	105.00 -	150.00
400/17D	Plate, Torte, 14″	39.00 -	46.00
400/17F	Bowl, 12″	45.00 -	65.00
400/17TB	Bon Bon Set, 2 deck	100.00 -	175.00
400/18	Old Fashioned, 7 oz.	25.00 -	45.00
400/18	Tumbler, Water, 9 oz.	35.00 -	40.00
400/18	Tumbler, Iced Tea, 12 oz.	46.00 -	48.00
400/18	Cocktail, 3-1/2 oz.	38.00 -	40.00
400/18	Sherbet, 6 oz.	35.00 -	40.00
400/18	Tumbler, Juice, 5 oz.	25.00 -	35.00
400/18	Parfait, 7 oz.	37.00 -	46.00
400/18	Bottle and Stopper, Cordial, 18 oz.	300.00 -	425.00
400/18	Cream and Sugar Set	120.00 -	150.00
400/18	Pitcher, Manhattan, 40 oz.	225.00 -	245.00
400/18	Jug, 80 oz., 5 pint	200.00 -	235.00
400/18F	Nappy, 10"	35.00 -	45.00
400/18TB	Snack Rack, 3 Hi		*
400/19	Egg Cup, 6 oz., 2 styles	30.00 -	38.00
400/19	Tumbler, Juice, 5 oz.	11.00 -	18.00
400/19	Old Fashioned, 7 oz.	24.00 -	28.00
400/19	Sherbet; Dessert, 5 oz.	14.00 -	16.00
400/19	Tumbler, Water, 10 oz.	11.00 -	17.00
400/19	Tumbler, Iced Tea, 12 oz.	15.00 -	19.00
400/19	Tumbler, Iced Tea, 14 oz.	18.00 -	23.00
400/19	Stein (Tumbler), 14 oz., free-form handle	150.00 -	200.00
400/19	Wine, 3 oz. (2 oz. - $95.00)	20.00 -	25.00

* Denotes no price activity

400/19	Cocktail, 3-3-1/2 oz.	17.00	-	22.00
400/19	Salt Dip, 2 1/4″	6.00	-	7.00
400/19	Ash Tray, 2 3/4″, 11 beads	7.00	-	11.00
400/19	Muddler, 4-1/2″, to stir drinks	24.00	-	25.00
400/19	Mustard and Cover (no other info available)			*
400/19	Pitcher, Lilliputian, 16 oz.	205.00	-	290.00
400/19	Pitcher, Cocktail/Milk/Juice, 40 oz.	185.00	-	195.00
400/19/89	Marmalade Set, 3 pc. (1941)	45.00	-	55.00
400/20	Punch Set, 15 pc.	225.00	-	275.00
400/20	Punch Set, 15 pc. Cut ″Jamboree, USA″			*
400/20B	Punch Bowl, 13″, 6 quart	75.00	-	90.00
400/20/D.E.	Punch Set, 15 pc., Gold Decorated & Etched	3500.00	-	5000.00
400/20D	Plate, Torte, 17″, flat edge	50.00	-	80.00
400/20V	Plate, Torte/Sandwich, 17″, cupped edge	50.00	-	55.00
400/21	Vase, 8-1/2″, flared edge	150.00	-	225.00
400/22	Vase, 10″, straight sides	100.00	-	150.00
400/23	Mayonnaise Set, 3 pc.	25.00	-	35.00
400/23B	Mayonnaise Bowl, 5-1/4″, (old style 4 3/4″, straight sides)	9.00	-	13.00
400/23B	Juice Set, 3 pc., bowl, plate, #841 Juice	30.00	-	43.00
400/23D	Plate with Seat, 7″-7-1/2″	12.00	-	18.00
400/24	Pitcher, Ice/Water, 80 oz., 5 pint	125.00	-	175.00
400/24/19	Cool Drink Set, 7 pc.	215.00	-	289.00
400/25	Bud Ball Vase, 3-3/4″ to 4″	40.00	-	48.00
400/25C	Bud Ball Vase, 3-3/4″ (# from 1948)	30.00	-	40.00
400/26	Hurricane Lamp, 3 pc.	650.00	-	750.00
400/27	Vase, 81/4″	150.00	-	230.00
400/28	Vase, 8-1/2″	55.00	-	100.00
400/28C	Bud Vase, 8-1/2″	60.00	-	85.00
400/29	Tray, 6-1/2″-7″, oblong, variations	13.00	-	17.00
400/29/6	Cigarette Set, 6 pc.	55.00	-	96.00
400/29/64/44	Cigarette Set, 6 pc.	70.00	-	95.00
400/30	Sugar and Cream Set	13.00	-	22.00
400/29/30	Sugar, Cream, Tray Set	22.00	-	25.00
400/31	Sugar, Cream Set, 8 oz., beaded foot	35.00	-	50.00
	beaded handle	18.00	-	32.00
400/32	Hurricane Lamp, 16″	180.00	-	300.00
400/33	Jelly; Ash Tray, 4″	9.00	-	13.00
400/34	Coaster/Plate/Individual Butter/Ash Tray, 4-1/2″	8.00	-	9.00
400/35	Tea Cup and Saucer	10.00	-	16.00
400/35	Saucer - Underplate for 400/89 - has ridge	7.00	-	9.00
400/35	Tea Cup, no beads on handle (1937-1940)	23.00	-	30.00
400/36	Plate, Canape, 6″-6-1/4″; 2″ or 2-1/2″ off -center seat	16.00	-	24.00
400/36	Canape Set, 2 pc.	30.00	-	40.00
400/37	Coffee Cup and Saucer	11.00	-	16.00
400/38	Plate, Salad, 9″, oval	25.00	-	40.00
400/39	Plate, Cocktail, 2-1/2″ off-center seat	14.00	-	20.00
400/40	Vase, Miniature, 4 styles	38.00	-	45.00
400/40	Mayonnaise Set, 3 pc.	30.00	-	35.00
400/40B	Bowl, Finger or Mayo, 5-1/2″ (1937)	15.00	-	18.00

* Denotes no price activity

400/40C	Candleholder, Flower, 5″, crimped	30.00	-	55.00
400/40CV	Candleholder, Flower (candleholder, vase)	75.00	-	95.00
400/40D	Plate, 7-1/2″, round, slanting sides, 1″ deep	18.00	-	24.00
400/40F	Candleholder, Flower, 6″, round	25.00	-	45.00
400/40H	Bon Bon Heart, 5″, handled	19.00	-	27.00
400/40HC	Candleholder, Flower, 5″, heart-shaped	50.00	-	90.00
400/40H/23D	Mayonnaise Set, 3 pc. (1941)	41.00	-	60.00
400/40/0	Basket, 6-1/2″, handled, variations	33.00	-	43.00
400/40S	Candleholder, Flower, 6-1/2″, square	35.00	-	55.00
400/40V	Vase, Peg, Miniature, 4 variations/same as 400/40	45.00	-	55.00
400/42B	Nappy or Fruit, 4-3/4″	11.00	-	13.00
400/42D	Plate, 5-1/2″, 2 open handles	10.00	-	12.00
400/42E	Tray, 5-1/2″, turned-up handles	12.00	-	20.00
400/42/3	Mayonnaise Set, 3 pc.	35.00	-	43.00
400/44	Cigarette Holder, 3″	25.00	-	30.00
400/45	Compote, 5-1/2″, 4-bead stem, old style	65.00	-	85.00
	new style	22.00	-	30.00
400/46	Celery Boat, 11″, oval	60.00	-	75.00
400/48F	Compote, 8″, 4-bead stem	75.00	-	100.00
400/49	Mayonnaise Set, 3 pc.	28.00	-	35.00
400/49/1	Fruit, 5″, heart-shaped	17.00	-	20.00
400/49H	Bowl, 5″, heart-shaped	18.00	-	25.00
400/49H	Bowl, 9″, heart-shaped	85.00	-	125.00
400/50	Plate with Seat, 8″, early, for soup	15.00	-	16.00
400/50	Cream Soup, 5″-5-1/2″, 2-handled	45.00	-	50.00
400/50	Soup Set, 3 pc. (1938 - soup, plate, underplate)	57.00	-	65.00
400/50/23	Cream Soup on Plate Set	53.00	-	55.00
400/51	Nappy or Mint Dish, 6″, vertical handle	20.00	-	25.00
400/51C	Candy, 6″, handled, crimped	25.00	-	35.00
400/51F	Mint, 6″ (same as 400/51)	20.00	-	25.00
400/51H	Bon Bon, 6″, handled, heart-shaped	15.00	-	30.00
400/51M	Tray, Card, 6″, handled	125.00	-	150.00
400/51T	Tray, Wafer, heart-shaped, center handle, 6″	22.00	-	27.00
400/52	Bowl; Jelly, 6″, divided, 2-handled	18.00	-	25.00
400/52B	Nappy; Bowl, 6-1/2″, 2-handled	16.00	-	24.00
400/52C	Tray; Plate, 6-3/4″, 2-handled, crimped	25.00	-	30.00
400/52D	Plate, 7-1/2″, 2-handled	12.00	-	16.00
400/52BD	Mayonnaise Set, 3 pc.	40.00	-	53.00
400/52E	Tray; Plate, 7″	19.00	–	21.00
400/52/3	Mayonnaise Set, 3 pc.	40.00	-	53.00
400/53	Bowl, 5-1/2″, fluted, beaded top rim	30.00	-	75.00
400/53C	Icer, flared bowl, 3 risers, beaded top rim	45.00	-	75.00
400/53H	Bowl, 5-1/2″, heart-shaped	14.00	-	18.00
400/53S	Bowl, Square, 5″, round bowl, square base	25.00	-	40.00
400/53X	Baked Apple, 6-1/2″	20.00	-	30.00
400/53/3	Icer Set, 3 pc.	95.00	-	110.00
400/54	Tray, Relish, 6-1/2″, 2 sections, 2-handled	12.00	-	25.00
400/55	Tray, Relish, 8-1/2″, 4 sections, 4-handled	18.00	-	30.00
400/56	Tray, Relish, 10-1/2″, 5 sections, 5-handled	45.00	-	63.00
400/57	Pickle/Celery, 7-1/2″, oval (6″ - 1937)	26.00	-	35.00
400/58	Pickle/Celery, 8″-8-1/2″, oval	17.00	-	23.00

400/59	Candy Box and Cover, 5-1/2″-6-1/2″, round	35.00	-	54.00
400/60	Tray, Relish, 7″, round/beaded edge/slanting sides	15.00	-	18.00
400/60	Ash Tray, 6″, match book center	85.00	-	125.00
400/61	Salt Dip, 2″	12.00	-	13.00
400/62B	Nappy; Bowl, 7″, 2-handled	13.00	-	15.00
400/62BD	Plate and Bowl Set	25.00	-	31.00
400/62C	Plate; Tray, 8-1/2″, 2-handled, crimped	25.00	-	35.00
400/62D	Plate, 8-1/2″, 2-handled	12.00	-	16.00
400/62E	Tray, 8-1/2″, turned-up handles	20.00	-	25.00
400/63	Ice Tub, 7″-8″, 5-1/2″ deep	85.00	-	110.00
400/63B	Compote; Comport, 4-1/2″	50.00	-	51.00
400/63B	Bowl, Belled, 10-1/2″	40.00	-	60.00
400/63B/81	Console Set, 3 pc.	136.00	-	160.00
400/63B/170	Console Set, 3 pc.	68.00	-	92.00
400/63D	Cheese Compote (1938), possibly 400/66B			*
400/63/104	Chilled Fruit Set, 19 pc.	358.00	-	438.00
400/63/104	Punch Set, 13 pc. (1943)	238.00	-	310.00
400/64	Nut Cup/Nut Dish/Nut Dish/Sugar Dip/Ash Tray	8.00	-	12.00
400/65	Candy Dish and Cover, partitioned	80.00	-	139.00
400/65/1	Candy, Cover; Vegetable, 8″	145.00	-	165.00
400/65/2	Candy Box, Cover, 8″, partitioned (same as 400/65)	80.00	-	139.00
400/66B	Compote, 5-1/2″, 2-bead stem, variations	22.00	-	30.00
400/66C	Candleholder, Flower, 4-1/2″	55.00	-	80.00
400/66F	Candleholder, 4″	48.00	-	63.00
400/67B	Bowl, Fruit, 9″, 1-bead stem	90.00	-	95.00
400/67C	Bowl; Compote, 9″, crimped	95.00	-	110.00
400/67D	Banana Stand with 1-bead stem	900.00	-	1000.00
400/67D	Cake Stand or Salver, 10″	55.00	-	72.00
400/68D	Tray, Pastry, 11/-1/2″-12-1/2″, center heart handle	25.00	-	42.00
400/68F	Bowl, Fruit (or Fruit Tray), 10-1/2″	95.00	-	125.00
400/69B	Bowl, Vegetable, 8-1/2″, round	32.00	-	39.00
400/70	Cruet and Stopper, 3-4 oz., handle	50.00	-	55.00
400/70/71/29	Condiment Set, 3 pc. (Same as 400/701)	128.00	-	145.00
400/71	Cruet and Stopper, 6 oz., handle	65.00	-	75.00
400/72	Bowl or Jelly, 8-1/2″, 2 handles, divided	69.00	-	95.00
400/72B	Bowl, 8-1/2″, 2 handles	22.00	-	25.00
400/72C	Plate or Tray, 10″, 2 handles, crimped	23.00	-	33.00
400/72D	Plate, 10″, 2 handles	15.00	-	28.00
400/72E	Tray, 10″, turned-up handles	30.00	-	55.00
400/73DF	Bowl, 10-3/4″, deep (experimental?), 1 known			*
400/73/0	Basket, 11″-12″, handled	125.00	-	180.00
400/73H	Heart, 9″-10″, handled	95.00	-	118.00
400/73TB	Tid-Bit Set, 2-deck, wooden handle	75.00	-	150.00
400/74	Bowl, 3-toed (patent applied for 5/36)	60.00	-	75.00
400/74B	Bowl, 8″-8-1/2″, 4-toed, ribbed, round	65.00	-	85.00
400/74J	Bowl, Lily, 7″, 4-toed	150.00	-	200.00
400/74N	Bowl, Lily, 4-toed, turned in top rim, black	200.00	-	275.00
400/74SC	Bowl/Dish, 4-toed, fancy, square, crimped	60.00	-	80.00
400/75	Fork and Spoon Set	22.00	-	38.00
400/75B	Bowl, Salad, 10″	33.00	-	40.00
400/75B	Bowl, Peg, 10″-10-1/2″, silver base	125.00	-	150.00

* Denotes no price activity

400/75B	Salad Set, 4 pc.	69.00 -	85.00
400/75D	Plate, 13-1/2″, flat, possibly 400/75F with flat edge	45.00 -	55.00
400/75F	Bowl, Float, 10″-11″, cupped edge	34.00 -	40.00
400/75F/150	Bowl on Base Set (1948)	74.00 -	90.00
400/75N	Bowl, Lily, 7-1/2″, round beaded rim, plain base	225.00 -	450.00
400/75V	Plate, Torte, 12-1/2″-13″, cupped edge	22.00 -	28.00
400/76	Hurricane Lamp, 2 pc.	95.00 -	145.00
400/76	Chimney or Shade, used with 400/76 Lamp	50.00 -	55.00
400/77AD	After Dinner Cup and Saucer	18.00 -	28.00
400/77AD	After Dinner Cup and Saucer, Cranberry, 1994 Convention souvenir	16.00 -	20.00
400/78	Coaster, 4″-4-1/2″, designed bottom	7.00 -	8.00
400/79	Hurricane Candlelamp, 2 pc.	87.00 -	113.00
400/79B	Candleholder, flat	35.00 -	65.00
400/79R	Candleholder, low, 3-1/2″, rolled edge, some without lip	12.00 -	18.00
400/79R/2	Candleholder, Eagle, no handle	97.00 -	153.00
400/80	Candleholder, 3-1/2″, low-footed	10.00 -	18.00
400/80/2	Candleholder, Eagle, no handle	95.00 -	153.00
400/81	Candleholder, 3-1/2″, handled	48.00 -	50.00
400/81/2	Candleholder, Eagle, handled	123.00 -	160.00
400/82	Bottle, Cordial, 15 oz., handled	225.00 -	350.00
400/82	Cordial Set, 10 pc., bottle handled	465.00 -	750.00
400/82/1	Cordial Set, 10 pc. (same as 400/82)	465.00 -	750.00
400/82/2	Bottle, Cordial, Stopper, 15 oz., no handle	260.00 -	300.00
400/82/2	Decanter Set, 15 oz., bottle not handled, 9 pc.	500.00 -	700.00
400/83	Strawberry Set, 7″, 2 pc.	43.00 -	50.00
400/83D	Plate with Seat for Strawberry Set, 7″ (1943)	28.00 -	45.00
400/84	Nappy or Bowl, 6-1/2″, divided	18.00 -	32.00
400/84	Mayonnaise Set, 4 pc.	58.00 -	78.00
400/84D	Plate with Seat, 8″	16.00 -	20.00
400/85	Bowl, Cottage Cheese, 6″	24.00 -	25.00
400/86	Candleholder, Mushroom flat edge	28.00 -	33.00
400/86R	Candleholder, Mushroom, rolled, for 400/92R Bowl	35.00 -	50.00
400/87	Vase, 9″, not rolled or crimped, small-bead arched handles	38.00 -	55.00
400/87C	Vase, 8″, crimped, variations: rim beads/no beads	25.00 -	33.00
400/87F	Vase, 8″-8-1/2″, fan-shaped, variations	30.00 -	33.00
400/87R	Vase, 7″, 2 beaded handles	35.00 -	38.00
400/88	Compote, Cheese, 5-1/2″, flat base, 1-bead steam	20.00 -	25.00
400/88	Cheese and Cracker Set, 10″, 2 pc.	35.00 -	53.00
400/88D	Plate, 2-handled (same as 400/72D?) (1937)	15.00 -	28.00
400/89	Marmalade Bowl, Cover; variations: dimpled lid	24.00 -	29.00
400/89	Underplate (400/35 Saucer ridged for seat)	7.00 -	9.00
400/89	Marmalade Set, 4 pc.	35.00 -	50.00
400/89/3	Marmalade Set, 3 pc.	31.00 -	47.00
400/90	Candleholder, 5″, handled	40.00 -	50.00
400/91	Cocktail Set, 2 pc.	32.00 -	43.00
400/91	Ladle, Punch, large, all glass, no beads	33.00 -	35.00
400/92	Cheese and Cracker Set, 3 pc. (tray/compote/cover)	108.00 -	144.00
400/92B	Bowl, 12″	45.00 -	50.00
400/92D	Plate, 14″, round	35.00 -	50.00
400/92F	Bowl, Float, 12″	40.00 -	45.00

400/92F/150	Bowl on Base Set (1948)	80.00 -	95.00
400/92L	Centerbowl, Mushroom, 13″, flat edge	45.00 -	65.00
400/92R	Centerbowl, Mushroom, 12″, rolled edge	54.00 -	75.00
400/92V	Plate, Torte, 13-1/2″, cupped edge	35.00 -	50.00
400/93	Bowl, Mayo, 6-1/2″, divided (1938)	28.00 -	35.00
400/94	Buffet Salad Set, 4 pc. (tray, bowl, 2 ladles)	65.00 -	95.00
400/95	Salad Dressing Set, 4 pc. (tray, bowl, 2 ladles)	57.00 -	86.00
400/95	Cheese Set, Individual, 3 pc. (no other info)		*
400/96	Salt, Pepper Set, chrome/plastic tops, variations	10.00 -	16.00
400/96	Salad Set, 10 pc. (1940)	127.00 -	178.00
400/96	Salad Set, 12 pc. (1940)	137.00 -	186.00
400/96	Atomizer, for DeVilbiss, Crystal		90.00
400/96T	Tray, 5″	14.00 -	18.00
400/96/3	Salt, Pepper, Tray Set, 3 pc.	30.00 -	34.00
400/97	Cocktail Set, 2 pc. (tray, cocktail glass)	36.00 -	45.00
400/98	Plate with Seat, 9″, oval	11.00 -	19.00
400/98	Party Set, 2 pc. (tray, cup)	17.00 -	25.00
400/99	Snack Set, 2 pc. (oval tray, tumbler)	33.00 -	45.00
400/100	Candleholder, Twin	15.00 -	24.00
400/100/2-2	Candleholder, Twin Eagle, 2 eagle adapters	185.00 -	294.00
400/101	Bowl, Float, 13″, straight sides, 1-1/4″ deep	55.00 -	89.00
400/101/79B	Console Set, Float Bowl, 5 pc.	195.00 -	349.00
400/102	Tray, Relish, 13″-13-1/2″, 5 sections	70.00 -	75.00
400/103C	Compote, Fruit, 10″, 3-bead stem, crimped	100.00 -	175.00
400/103D	Cake Stand, 11″, 3-bead stem	59.00 -	85.00
400/103E	Banana Stand, 10″, 3-bead stem	900.00 -	950.00
400/103F	Bowl, Fruit, 3-bead stem	125.00 -	225.00
400/104B	Bowl, Belled, 14″-14-1/2″, shallow	70.00 -	80.00
400/105	Tray, Celery, 13-1/2″, 2 open handles	28.00 -	45.00
400/106B	Bowl, Belled, 12″	50.00 -	72.00
400/106B/75	Salad Set, 3 pc.	72.00 -	110.00
400/107	Vase, Bud, 5-3/4″, low-footed, 2 styles	50.00 -	80.00
400/108	Bell, Table, 4-bead handle	55.00 -	65.00
400/109	Salt, Pepper Set, Individual, chrome/plastic tops	12.00 -	18.00
400/109	Atomizer, for DeVilbiss		*
400/110	Candy Box, Cover, 7″, 3 sections, round	60.00 -	80.00
400/111	Tray, 6-1/2″, 2 seats, oblong (1943)	25.00 -	40.00
400/111	Tête-a-Tête (tray, cup, brandy)	60.00 -	93.00
400/112	Tray, Relish, 10-1/2″, variations	48.00 -	70.00
400/113A	Bowl, 10″, 2-handled, deep	135.00 -	145.00
400/113B	Bowl, 12″, handled	145.00 -	160.00
400/113C	Plate, 14″, 2-handled, crimped	36.00 -	75.00
400/113D	Plate, 14″, 2 open handles, round	40.00 -	65.00
400/113E	Tray, 14″, turned-up handles, round	36.00 -	75.00
400/114A	Bowl, 10″, handled, deep, divided	135.00 -	160.00
400/114A/2	Dessert Set, 3 pc. (bowl, 2 ladles)	215.00 -	290.00
400/114B	Bowl, 2 sections, 2 handles	145.00 -	160.00
400/115	Candleholder, 3-lite	100.00 -	125.00
400/115/1	Candleholder, Eagle, holds 1 lite and 2 eagles	250.00 -	345.00
400/116	Salt and Pepper Set, footed, 1-bead stem, plastic tops	60.00 -	95.00

* Denotes no price activity

400/117	Bottle, Bitters, with metal tube, 4 oz.	50.00 -	55.00
400/118	Ash Tray, B'tween Place, variations	8.00 -	11.00
400/118	Bridge Ash Tray Set, 4 pc.	20.00 -	35.00
400/119	Cruet and Stopper, 6 oz.	28.00 -	35.00
400/120	Plate, Salad, 8-1/2″, crescent-shaped	39.00 -	55.00
400/121/0	Cruet and Stopper, etched "Oil"	40.00 -	55.00
400/121/V	Cruet and Stopper, etched "Vinegar"	45.00 -	60.00
400/122	Cream and Sugar Set, Individual	15.00 -	18.00
400/122/29	Cream, Sugar, Tray Set	28.00 -	32.00
400/122/111	Cream, Sugar, Tray Set (tray has 2 seats)	40.00 -	58.00
400/123	Toast/Cheese/Butter, and Cover, 7 3/4″, round	235.00 -	350.00
400/124	Plate, 12-1/2″, oval	67.00 -	90.00
400/124A	Bowl, 11″, oval	140.00 -	195.00
400/124D	Platter, 12-1/2″-13″, oval	90.00 -	95.00
400/125A	Bowl, 11″, 2 sections, oval	150.00 -	210.00
400/126	Cup, Bouillon, 2 handles	40.00 -	45.00
400/126	Sugar and Cream Set (same as 400/153)	45.00 -	60.00
400/127B	Bowl, Belled, 7-1/2″, used as console base	75.00 -	125.00
400/127L	Console Set, 4 pc. (bowl/base/2 candleholders)	150.00 -	238.00
400/128	Punch Set, 15 pc.	245.00 -	340.00
400/128/D.E.	Punch Set, Gold Decorated and Etched, 15 pc.	4500.00 -	5700.00
400/128B	Bowl, Belled, 10″, used as punch bowl base	65.00 -	95.00
400/129R	Candleholder, Urn, 6″	65.00 -	125.00
400/130	Ladle, Marmalade, 4 3/4″, 3-bead handle	14.00 -	18.00
400/131B	Centrebowl, 14″, oval, flat bottom	195.00 -	250.00
400/131D	Platter, 16″, oval	170.00 -	205.00
400/132	Bowl, Rose, 7-1/2″, footed	350.00 -	500.00
400/132C	Bowl, 7-1/2″, footed, crimped, beaded base	350.00 -	600.00
400/133	Ash Tray, 5″, crystal, round	8.00 -	9.00
400/133	Ash Tray, 5″, Champagne-color, round (also Cranberry)	8.00 -	15.00
400/133	Ash Tray, 5″, WWII, amber, shield, stars, stripes	35.00 -	45.00
400/133	Ash Tray, 5″, WWII, white, shield, stars, stripes	50.00 -	75.00
400/134	Cigarette Box and Cover, 5 1/4″, oblong	30.00 -	60.00
400/134/1	Ash Tray, 4-1/2″, oblong	6.00 -	8.00
400/134/6	Cigarette Set, 6 pc.	45.00 -	75.00
400/134/440	Cigarette Set, 6 pc.	50.00 -	92.00
400/135	Ladle, Mayonnaise, 6 1/4″, 2-bead handle	12.00 -	15.00
400/135	Luncheon Sets: 15, 21, 27 pcs. (1937-8)		*
400/136	Console Set, 4 pc. (bowl/base/2 candleholders)	259.00 -	450.00
400/137	Compote, footed, oval, 1-bead stem	795.00 -	1450.00
400/138B	Vase, 6″, footed, 1-bead stem, beaded rim	95.00 -	125.00
400/139	Cocktail Set, 11 pc.	461.00 -	625.00
400/139	Ladle, small, all glass	35.00 -	50.00
400/139/1	Snack Jar and Cover, 5″ base, 6 1/4″ high	250.00 -	375.00
400/139/2	Punch Bowl, Cover, and Ladle	310.00 -	550.00
400/139/19	Cocktail Set, 11 pc.	481.00 -	776.00
400/139/65	Snack Jar and Cover (seems identical to 400/139/1)	250.00 -	375.00
400/139/77	Punch Set, Family, 11 pc.	400.00 -	545.00
400/140	Candy Box/Jar, Cover, footed, 1-bead stem, variations	185.00 -	250.00
400/142	Tumbler, Juice, 3-1/2 oz. (for 400/36 & 400/99)	15.00 -	25.00

* Denotes no price activity

400/142K	Bowl, Rose, 7″, beaded lip	195.00 - 300.00
400/142-K/H.L.	Hurricane Lamp, 15″, 3 pc.	350.00 - 445.00
400/143A	Vase, Flip, 8″, beaded rim	105.00 - 165.00
400/143C	Vase, Flip, 8″, crimped, beaded rim	60.00 - 90.00
400/144	Butter, Cover, 5-1/2″, handled, round	30.00 - 37.00
400/145	Cheese and Cracker Set, 2 pc.	64.00 - 105.00
400/145B	Bowl, 10″, 2-handled, round	45.00 - 48.00
400/145C	Plate; Tray, 12″, 2-handled, crimped	30.00 - 50.00
400/145D	Plate, 12″-12-1/2″, 2 open handles, round	23.00 - 30.00
400/145E	Tray, 11-1/2″, 2 turned-up handles	29.00 - 50.00
400/145H	Tray, Muffin, 11-1/2″, 2 open handles	225.00 - 400.00
400/147	Candleholder, 3-lite, 1-bead stem	24.00 - 28.00
400/147/2	Candleholder, Eagle, 3-lite	109.00 - 163.00
400/148	Tray, Condiment, 5-1/4″ by 9-1/4″	48.00 - 75.00
400/148/1	Condiment Set, 6 pc.	174.00 - 252.00
400/148/2	Condiment Set, 7 pc.	164.00 - 240.00
400/148/4	Condiment Set, 7 pc.	153.00 - 230.00
400/148/5	Condiment Set, 8 pc.	174.00 - 252.00
400/148/6	Condiment Set, 9 pc.	184.00 - 264.00
400/149D	Tray, Mint, 8″-9″, center heart handle	24.00 - 30.00
400/149F	Bon Bon, 7-1/2″, handled (1943), cupped base	140.00 - 250.00
400/150	Ash Tray, 6″, round, crystal, variations	8.00 - 12.00
400/150	Ash Tray, 6″, Cranberry, also Cobalt	14.00 - 20.00
400/150	Ash Tray, 6″, WWII, pink eagle on ball, 12 stars	18.00 - 27.00
400/150	Ash Tray, 6″, WWII, cobalt blue, eagle on ball, 12 stars	75.00 - 110.00
400/150	Base, 1/2″ deep indent in bottom to receive bowl	40.00 - 50.00
400/151	Tray, 10″, round, variations	40.00 - 55.00
400/151	Base for 400/1510, 400/1503 Lazy Susans	25.00 - 60.00
400/152	Hurricane Lamp, 3 pc.	110.00 - 150.00
400/152	Lamp Adapter	20.00 - 45.00
400/152	Lamp Adapter with prisms	90.00 - 100.00
400/152	Lamp Chimney, plain (crimped - extra)	75.00 - 100.00
400/152R	Hurricane Lamp, 14″, 3 pc.	132.00 - 188.00
400/153	Cream, Sugar Set (same as 400/126)	45.00 - 60.00
400/154	Deviled Egg Server, 11-1/2″-12″, center heart handle	95.00 - 155.00
400/155	Lamp Base, made for Lightolier Lighting Company	315.00 - 410.00
400/155	Candleholder, Eagle, 9-1/2″, 2 pc. (available - 1943)	390.00 - 520.00
400/155	Hurricane Lamp, 3 pc.	385.00 - 555.00
400/156	Mustard, low-footed, 2-bead finial	29.00 - 35.00
400/156	Mustard Spoon, 3-1/2″	8.00 - 12.00
400/157	Cheese; Jelly; Honey Compote, Cover, 4-3/4″	58.00 - 75.00
400/158	Candy Box, Cover, 7″, 3 sections	125.00 - 195.00
400/159	Tray, 9″, circular designed, plain, or mirrored	24.00 - 32.00
400/160	Plate, Birthday Cake, 13″-14″, for 72 candles	310.00 - 400.00
400/161	Butter, Cover, 1/4 lb., oblong	24.00 - 36.00
400/162	Vase, footed, 10-1/2″ (no other info)	*
400/163	Decanter, Stopper, 26 oz., beaded base	175.00 - 250.00
400/163	Wine Set, 9 pc.	335.00 - 450.00
400/164	Oil Cruet, Stopper, 4 oz.	28.00 - 30.00
400/165	Ladle, Mayonnaise, 3-bead handle	12.00 - 13.00

* Denotes no price activity

400/166	Vinegar Cruet, Stopper, 6 oz.	42.00	-	67.00
400/167	Salt, Pepper Set, 4-1/2″ high, chrome tops	17.00	-	22.00
400/168	Ice Bucket; Tub, 7″, 2 tab handles	160.00	-	175.00
400/169	Plate, 8″, oval	30.00	-	35.00
400/169	Sauce Boat	95.00	-	100.00
400/169	Sauce Boat and Plate Set, 8″, oval plate	125.00	-	150.00
400/170	Candleholder, low, 3-1/2″	14.00	-	16.00
400/171	Tray, 8″	35.00	-	45.00
400/172	Ash Tray; Mint Heart, 4-1/2″	10.00	-	15.00
400/172	Ash Tray, Souvenir, 4″, Bellaire Glass Festival			
	"First Annual All-American Glass Festival, 1973"			
	frosted (not Candlewick)	25.00	-	35.00
	"2nd Annual Glass Festival, Bellaire, OH, 1974" blue	20.00	-	30.00
	"3rd Annual Glass Festival, Bellaire, OH, 1975" green	20.00	-	30.00
	"4th Annual Glass Festival, Bellaire, OH, 1976" milk-glass	20.00	-	27.00
	"5th Annual Glass Festival, Bellaire, OH, 1977" amber	15.00	-	20.00
400/173	Ash Tray or Nut Heart, 5-1/2″	11.00	-	15.00
400/174	Ash Tray or Bon Bon Heart, 6-1/2″	13.00	-	20.00
400/175	Candleholder, 6-1/2″, tall, 3-bead stem	75.00	-	125.00
400/176	Ash Tray, 3-1/2″, square	10.00	-	30.00
400/177	Oil or Vinegar Cruet and Stopper, 4 oz. (also 2 oz.)	45.00	-	50.00
400/177	Luncheon Sets: 15, 21, 27 pcs. (1937-8)			*
400/178	Hurricane Lamp, 2 pc.	150.00	-	200.00
400/178	Candleholder, low, for 400/178 Lamp	50.00	-	125.00
400/178	Chimney or Shade for 400/178 Lamp	50.00	-	75.00
400/179	Bell, Table, 4″, 4-bead handle	40.00	-	100.00
400/181	Nappy, 6-1/2″, partitioned	55.00	-	75.00
400/182	Bowl, 8-1/2″, 3 toed	95.00	-	110.00
400/183	Bowl, 6″, 3-toed	40.00	-	60.00
400/185	Vase, Bud, 7″, dome-shaped foot	85.00	-	200.00
400/186	Vase, Bud, 7″, dome-shaped foot	200.00	-	245.00
400/187	Vase, Bud, 7″, dome-shaped foot	150.00	-	200.00
400/188	Ivy Bowl; Brandy; Vase, 7″, dome-shaped foot	135.00	-	195.00
400/189	Vase, Bud, 9″, same foot as 400/190 series	145.00	-	225.00
400/190	Goblet, 10 oz.	14.00	-	24.00
400/190	Cocktail, 3-1/2-4 oz.	18.00	-	25.00
400/190	Saucer Champagne/Tall Sherbet, 5 oz.	12.00	-	18.00
400/190	Wine, Dinner, 5 oz.	28.00	-	29.00
400/190	Cordial, 1 oz.	55.00	-	75.00
400/190	Seafood Icer; Cocktail; Coupette	50.00	-	60.00
400/190	Salt and Pepper Set, chrome tops	45.00	-	52.00
400/192	Vase, 10″, dome-shaped foot	125.00	-	175.00
400/193	Vase, 10″, dome-shaped foot	110.00	-	175.00
400/194	Vase, 10″, dome-shaped foot	110.00	-	175.00
400/195	Wine, 2 oz., beaded base, hollow stem	80.00	-	95.00
400/195	Cocktail, 4 oz., beaded base, hollow stem	75.00	-	95.00
400/195	Juice, 6 oz., beaded base, hollow stem	75.00	-	95.00
400/195	Dessert, 6 oz., beaded base, hollow stem	70.00	-	75.00
400/195	Old Fashioned, 9 oz., beaded base, hollow stem	70.00	-	75.00
400/195	Water, 11-12 oz., beaded base, hollow stem	60.00	-	65.00

* Denotes no price activity

400/195	Iced Drink, 14 oz., beaded base, hollow stem	65.00	-	70.00
400/195	Tumbler, 8 oz., flat, beaded base	35.00	-	40.00
400/195	Tumbler, 12 oz., flat, beaded base	30.00	-	35.00
400/195	Tumbler, 16 oz., flat, beaded base	40.00	-	45.00
400/196	Epergne Set, 2 pc.	175.00	-	200.00
400/196FC	Flower Candle Centerpiece, 9″	150.00	-	175.00
400/198	Vase, 6″, beaded top rim	225.00	-	275.00
400/200	Heart Set, handled, 3 pc.	85.00	-	135.00
400/201	Heart, 4-1/2″, handled	25.00	-	45.00
400/202	Heart, 5-1/2″, handled	30.00	-	45.00
400/203	Heart, 6-1/2″, handled	30.00	-	52.00
400/204	Tray, heart-shaped/may look triangular	175.00	-	250.00
400/204	Butter 'N Jam Set, 5 pc.	228.00	-	325.00
400/205	Bowl, 10″, 3-toed	120.00	-	140.00
400/206	Nappy, 4-1/2″, 3-toed	45.00	-	65.00
400/207	Candleholder, 4-1/2″, 3-toed	50.00	-	73.00
400/208	Relish, 10″, 3 sections, 3-toed	84.00	-	125.00
400/209	Relish, 13″, 5 sections	50.00	-	75.00
400/210	Punch Bowl, 10 quart	95.00	-	125.00
400/210	Base, Belled Bowl	65.00	-	85.00
400/210	Punch Set, 15 pc.	450.00	-	650.00
400/211	Cup, Punch, 5 oz.	20.00	-	35.00
400/213	Tray, Relish, 10″, 3-4 sections, oblong, handled	54.00	-	65.00
400/214	Covered Dish/Preserve/Cheesespread, 10″	180.00	-	350.00
400/215	Relish, 12″, 4 sections, oblong, handled	45.00	-	75.00
400/216	Dish and Cover, 10″, partitioned, oblong	180.00	-	350.00
400/217	Tray, Pickle, 10″, handles, oval	27.00	-	30.00
400/220	Compote, 5″, arched, beaded tri-stem	65.00	-	95.00
400/221	Tray, Lemon, 5-1/2″, center arched beaded handle	28.00	-	40.00
400/222	Tray, Bon Bon, 8″ (same handle as 400/221)	250.00	-	350.00
400/223	Tray, Cake, 12″, arched, beaded tri-stem	1000.00	-	2000.00
400/224	Candleholder, 5-1/2″, arched, beaded tri-stem	85.00	-	89.00
400/225	Goblet, 6-1/2″ high, arched, beaded tri-stem	125.00	-	200.00
400/226	Coaster with Spoon Rest	15.00	-	20.00
400/227	Vase, 8-1/2″, handle, flat, beaded base	125.00	-	300.00
400/228	Chip and Dip, 14″, 1 pc., divided center	350.00	-	625.00
400/231	Nappy, 5″, square	85.00	-	100.00
400/232	Nappy, 6″, square	100.00	-	125.00
400/233	Nappy, 7″, square	125.00	-	150.00
400/234	Relish, 7″, 2 sections, square	90.00	-	110.00
400/235	Relish, 8″ (possibly square)			*
400/236	Liner (could be for 3400 or 3800 seafood icers)	20.00	-	30.00
400/240	Peg Nappy (no other info)			*
400/240D	Peg Nappy, 7″	21.00	-	30.00
400/240F	Peg Nappy, 5-1/2″-6″, used on Crown Silver Base	25.00	-	50.00
400/241	Peg Nappy, partitioned	30.00	-	40.00
400/242	Rose Bowl with Flower Holder, insert, 6″	150.00	-	195.00
400/243	Saucer Bowl or Sauce Dish, 5-1/2″	30.00	-	50.00
400/244	Hostess Helper, 5 pc.	450.00	-	550.00
400/245	Candy Box and Cover, 6-1/2″, round	150.00	-	300.00

*	Denotes no price activity

400/247	Salt and Pepper Set, chrome tops, straight sides	15.00	-	27.00
400/247	Atomizer, for DeVilbiss, colors	55.00	-	77.00
400/250	Peg Nappy (no other info)			*
400/250B	Peg Bowl, 7-1/4″, silver base			*
400/251D	Peg Cake Plate, 11-1/2″, Monmouth Silver Base	65.00	-	100.00
400/251X	Peg Nappy; Bowl, 9-1/2″, small-bead edge	65.00	-	125.00
400/255	Ladle, Punch, small, no beads	40.00	-	65.00
400/256	Relish, 10-1/2″, 2 sections, oval, 2-handled	20.00	-	35.00
400/259	Candy Box, Cover, 7″, shallow, round	105.00	-	135.00
400/260	Candy Box, Cover, 7″, deep	125.00	-	148.00
400/262	Butter and Jam Set, 10-1/2″, 3 section, 1 pc.	125.00	-	175.00
400/262	Relish, 10-1/2″, oval, 3 sections (same as above)	125.00	-	175.00
400/264	Hurricane Lamp, 2 pc.	100.00	-	145.00
400/265	Lamp Chimney (for Lamp 400/264)	50.00	-	60.00
400/266	Plate; Tray, 7-1/2″, triangular (for 400/496 Mayo)			*
400/266	Tray, 6-1/2″, triangular, 6 make a circle			*
400/268	Relish, 8″, 2 sections, oval	18.00	-	22.00
400/269	Server; Tray, Individual, 6-1/2″	100.00	-	200.00
400/270	Tid-Bit Plate with hole, 7-1/2″ (for 400/2701)	28.00	-	35.00
400/270TB	Tid-Bit, 1 tier, 7-1/2″, triangle/oval - tip of handle	30.00	-	75.00
400/271	Tid-Bit Plate with hole, 10-1/2″ (for 400/2701)	25.00	-	40.00
400/271TB	Tid-Bit, 1 tier, 10-1/2″, triangle/oval-tip of handle	35.00	-	60.00
400/273	Basket, 5″, handled, variations	155.00	-	245.00
400/274	Oil Cruet and Stopper, 4 oz., no handle	33.00	-	48.00
400/275	Vinegar Cruet and Stopper, 6 oz., no handle	36.00	-	45.00
400/276	Butter and Cover, California	116.00	-	135.00
400/277	Salad Dressing Bottle, 1-bead Stopper	54.00	-	85.00
400/278	Cruet and Stopper, 4 oz., handled	50.00	-	65.00
400/279	Cruet and Stopper, 6 oz., handled	55.00	-	75.00
400/280	Candleholder, 3-1/2″, plain base, 1-bead stem	60.00	-	65.00
400/287C	Vase, 6″, crimped rim	30.00	-	45.00
400/287F	Vase, 6″, fan-shaped	35.00	-	60.00
400/289	Marmalade Bowl and Cover	26.00	-	35.00
400/289	Ladle, plastic/chrome	5.00	-	15.00
400/289	Marmalade Set, 3 pc.	29.00	-	40.00
400/311	Breakfast Set, 11 pc.	326.00	-	475.00
400/313	Breakfast Tray Set, 13 pc.	338.00	-	493.00
400/316	Luncheon Set, 16 pc.	123.00	-	179.00
400/322	Luncheon Set for 6, 22 pc.	165.00	-	249.00
400/328	Luncheon Set for 8, 28 pc.	203.00	-	305.00
400/330	Pitcher, 13-14 oz., no beads, short, round	85.00	-	120.00
400/416	Pitcher, 20 oz., no beads	35.00	-	45.00
400/419	Pitcher, 40 oz., no beads	30.00	-	50.00
400/424	Pitcher, 80 oz. (also 64 oz. - changed in 1974)	45.00	-	85.00
400/440	Ash Tray, 4″, crystal, round	5.00	-	8.00
400/440	Ash Tray, 4″, Aquamarine, round (also Champagne)	10.00	-	13.00
400/440	Ash Tray, 4″, WWII, pale blue, "V" with 12 stars	20.00	-	29.00
400/440	Ash Tray, 4″, WWII, ruby red, "V" with 12 stars	60.00	-	78.00
400/450	Ash Tray Set, 3 pc., nested, round, crystal	21.00	-	29.00
400/465	Ladle, Marmalade/Mayo (unknown - possibly plastic)			*

* Denotes no price activity

400/496	Mayonnaise Set, 3 pc.		*
400/550	Ash Tray Set, 3 colors, nested, round	32.00 -	48.00
400/550	Ash Tray Set, 3 pc., WWII, blue, amber, pink	73.00 -	101.00
	red, white, blue	185.00 -	263.00
400/616	Salt spoon, plain bowl	10.00 -	12.00
400/616	Salt Set, Individual (8 spoons, 8 dips)	144.00 -	216.00
400/623	Mayonnaise Set, 2 pc. (ladle, 3-toed bowl)	52.00 -	73.00
400/650	Ash Tray Set, 3 pc., square, nested	80.00 -	120.00
400/651	Ash Tray, 3-1/4", square	25.00 -	40.00
400/652	Ash Tray, 4-1/2", square	25.00 -	40.00
400/653	Ash Tray, 5-3/4", square	30.00 -	40.00
400/655	Jar Tower, 3 sections, colors: Verde, Charcoal	300.00 -	700.00
400/656	Candy Box and Cover (section from Jar Tower)	105.00 -	150.00
400/680	Twin Hurricane Lamp, 5 pc.	850.00 -	1000.00
400/701	Condiment Set, 5 pc. (same as 400/70/71/29)	128.00 -	145.00
400/733	Salad Dressing Set, 2 pc. (plate, pitcher)	97.00 -	138.00
400/735	Salad Set, 3 pc.	97.00 -	188.00
400/750	Ash Tray Set/Tid-Bit Set, 3 pc., heart-shaped	29.00 -	50.00
400/920F	Console Set, 3 pc.	70.00 -	93.00
400/925	Salad Set, 4 pc.	102.00 -	138.00
400/1004B	Console Set, 3 pc.	100.00 -	128.00
400/1006B	Console Set, 3 pc.	80.00 -	120.00
400/1112	Relish and Dressing Set, 4 pc. (tray variations)	70.00 -	89.00
400/1474	Console Set, 3 pc.	118.00 -	130.00
400/1476	Console Set, 3 pc.	98.00 -	128.00
400/1503	Lazy Susan, 3 pc. (ash tray base/tray/metal bearings)	100.00 -	135.00
400/1510	Lazy Susan Condiment Set, 8 pc.	276.00 -	368.00
400/1531B	Console Set, 3 pc.	395.00 -	500.00
400/1567	Condiment Set, 5 pc.	121.00 -	167.00
400/1574	Condiment Set, 5 pc.	97.00 -	114.00
400/1589	Twin Jam Set, 3 pc.	86.00 -	126.00
400/1596	Condiment Set, 5 pc.	90.00 -	118.00
400/1630	Wine Set, 8 pc.	343.00 -	424.00
400/1639	Wine Set, 8 pc.	295.00 -	400.00
400/1752	Prism Candleholder, 3-bead stem	155.00 -	220.00
400/1753	Hurricane Lamp with Prisms, 3 pc.	230.00 -	310.00
400/1769	Condiment Set, 4 pc.	60.00 -	66.00
400/1786	Condiment Set, 4 pc.	70.00 -	83.00
400/1929	Cigarette Set, 6 pc.	61.00 -	86.00
400/1930	Cocktail Set, 11 pc.	434.00 -	640.00
400/1989	Marmalade Bowl and Cover, low-footed, beaded base	40.00 -	50.00
400/1989	Marmalade Set, 3 pc.	29.00 -	48.00
400/2296	Sugar, Cream, Tray Set	22.00 -	28.00
400/2696	Hospitality Set, 6 pc. (6 - 400/269 trays)	1200.00 -	1800.00
400/2701	Tid-Bit Set, 2 tier	55.00 -	75.00
400/2769	Condiment Set, 4 pc.	81.00 -	106.00
400/2794	Oil and Vinegar Set, 3 pc.	76.00 -	95.00
400/2796	Condiment Set, 5 pc.	110.00 -	112.00
400/2911	Oil and Vinegar Set, 3 pc.	70.00 -	75.00
400/2930	Cream and Sugar Set, 3 pc. (same as 400/29/30)	22.00 -	25.00

* Denotes no price activity

400/2946	Oil and Vinegar Set, 3 pc., no handles (incl. tray)	83.00	114.00
400/2989	Twin Jam Set, 3 pc.	75.00	111.00
400/2990	Condiment Set, 5 pc.	115.00	135.00
400/4272B	Bowl Set, 4 pc., handles, round	62.00	77.00
400/4272D	Plate Set, 4 pc., handles	49.00	72.00
400/4975	Salad Set, 4 pc. (heart bowl, fork, spoon, plate)	142.00	213.00
400/5629	Mustard and Catsup Set, 3 pc.	87.00	111.00
400/5996	Condiment Set, 5 pc.	93.00	130.00
400/6300B	Console Set, 3 pc.	70.00	108.00
400/7375	Salad Set, 4 pc.	152.00	203.00
400/7570	Console Set, 4 pc.	102.00	122.00
400/7796	Oil and Vinegar Set, 3 pc.	104.00	118.00
400/8013B	Console Set, 3 pc.	70.00	101.00
400/8013F	Console Set, 3 pc. (1937)	58.00	76.00
400/8063B	Console Set, 3 pc.	60.00	96.00
400/8075B	Console Set, 3 pc.	53.00	76.00
400/8113F	Console Set, 3 pc. (1938)	145.00	166.00
400/8613B	Console Set, 3 pc.	106.000	131.00
400/8692L	Console Set, Mushroom, 3 pc.	101.00	131.00
400/8918	Marmalade Set, 3 pc.	60.00	70.00
400/9266B	Cheese and Cracker Set, 2 pc.	57.00	80.00
400/9275	Console Set, 4 pc.	230.00	345.00
400/9279FR	Console Set, 3 pc.	64.00	81.00
400/51340	Salad Set, 13 pc., 1937-listed as 400/51348	172.00	206.00
3400	Goblet, 9 oz., 4-bead stem	15.00	25.00
3400	Cocktail, 4 oz., 4-bead stem	14.00	29.00
3400	Claret, 5 oz., 4-bead stem	40.00	60.00
3400	Saucer Champagne/Tall Sherbet, 6 oz.	14.00	19.00
3400	Wine, 4 oz., 4-bead stem	22.00	26.00
3400	Cordial, 1 oz., 4-bead stem	25.00	43.00
3400	Tumbler, Juice, 5 oz., 1-bead stem	20.00	25.00
3400	Tumbler, 9 oz., 1-bead stem	18.00	25.00
3400	Tumbler, Water, 10 oz., 1-bead stem	15.00	20.00
3400	Tumbler, Iced Tea, 12 oz., 1-bead stem	15.00	20.00
3400	Sherbet, Low, 5 oz., 1-bead stem	13.00	19.00
3400	Parfait, 6 oz., 1-bead stem	40.00	45.00
3400	Oyster Cocktail, 4 oz., no beads, footed	16.00	19.00
3400	Finger Bowl, footed, no beads	25.00	35.00
3400	Seafood Icer or Fruit Cocktail, with Insert	45.00	110.00
3800	Goblet, 10 oz., 2-bead stem	25.00	45.00
3800	Tall Sherbet or Champagne, 4 oz., 2-bead stem	25.00	35.00
3800	Low Sherbet, 1-bead stem	25.00	35.00
3800	Claret, 2-bead stem	25.00	35.00
3800	Cocktail, 4 oz., 2-bead stem	20.00	25.00
3800	Wine, 2 oz., 2-bead stem	25.00	35.00
3800	Cordial, 1 oz., 1-bead stem	30.00	50.00
3800	Tumbler, 5 oz., 1-bead stem	25.00	35.00
3800	Tumbler, 9 oz., 1-bead stem	25.00	35.00
3800	Tumbler, 12 oz., 1-bead stem	25.00	35.00
3800	Finger Bowl, 8 oz., no beads	25.00	35.00
3800	Brandy, 2-bead stem	25.00	35.00

3800	Seafood Icer or Fruit Cocktail, 2 pc., 1-bead stem	30.00 -	80.00
3800	Oyster Cocktail, same as 3400 (1943)	16.00 -	19.00
4000	Goblet, 11 oz., 3-bead stem	35.00 -	40.00
4000	Tall Sherbet, 6 oz., 3-bead stem	32.00 -	35.00
4000	Wine, 5 oz., 3-bead stem	25.00 -	35.00
4000	Cocktail, 4 oz., 3-bead stem	18.00 -	35.00
4000	Iced Tea or Hiball, 12 oz., 1-bead stem	25.00 -	35.00
4000	Cordial, 1-1/4 oz., 2-bead stem	25.00 -	30.00
4000	Salt Spoon, ribbed bowl	12.00 -	15.00
4000	Butter Cutter, gift boxed	200.00 -	375.00
14994	Hurricane Lamp, 2 pc.	75.00 -	125.00
14995	Hurricane Shade, 12″, for 14994	40.00 -	55.00
14996	Hurricane Lamp, 2 pc.	75.00 -	100.00
14998	Hurricane Shade, 14, for 14996	40.00 -	55.00
1776/1	Eagle Ash Tray, 6-1/2″, milkglass/blue/crystal/frosted	40.00 -	65.00
1776/2	Eagle Picture Frame, 6-1/2″, gold, crystal	50.00 -	75.00
1776/3	Eagle Mirror, 6-1/2″, crystal	65.00 -	85.00
1776/5	Eagle Mirror, 6-1/2″, gold	70.00 -	75.00
1950/45	Compote, Jelly, 5″, milkglass, beaded top edge	30.00 -	45.00
1950/75C	Bowl, Fruit, 11″, milkglass, crimped, beaded edge	35.00 -	65.00
1950/75D	Plate, Butter or Wall, 11″, milkglass, beaded edge	45.00 -	70.00
1950/75F	Bowl, Couped Apple, 11″, milkglass, beaded edge	40.00 -	65.00
1950/75H	Bowl, Fruit/Dessert, Heart, 9″, milkglass, beaded edge	50.00 -	75.00
1950/103	Bowl, Fruit, 10″, milkglass, footed, beaded top edge	55.00 -	75.00
1950/170	Candleholder, Low, leaf design, milkglass	10.00 -	15.00
1950/170	Candleholder, 1978 Convention, 1-1/2″, "Low Leaf" pattern		
	Ultra Blue Carnival, IG mark, 300 made	35.00 -	45.00
	Marigold Carnival, IG mark, 24 made	70.00 -	80.00
1950/170	Candleholder, 1984 Convention		
	White Carnival, 250 made	25.00 -	40.00
	Pink Carnival	30.00 -	45.00
1950/172	Heart, Mint, 4-1/2″, milkglass	6.00 -	8.00
1950/173	Heart, Nut, 5-1/2″, milkglass	12.00 -	18.00
1950/174	Heart, Bon Bon, 6-1/2″, milkglass	6.00 -	8.00
1950/196	Epergne, 10″, 2 pc., milkglass, 2 styles	75.00 -	95.00
1950/750	Ash Tray/Tid-Bid Set, hearts, milkglass, 3 pc.	35.00 -	40.00
1950/776	Cigarette Holder, footed, Federal Eagle, milkglass, no beads	20.00 -	25.00
1950/1776	Ash Tray, Federal Eagle, 6-1/4″, milkglass	25.00 -	30.00
111	Cocktail, used with 400/97, 400/139 Cocktail Sets	22.00 -	25.00
139	Ladle, Large, no beads, used with 400/63/104	20.00 -	30.00
160/130	Ladle, Marmalade, 4″, 2 beads, Cape Cod prefix #160	12.00 -	16.00
160/165	Ladle, Mayonnaise, 1-bead, Cape Cod prefix #160	10.00 -	12.00
176	Stirrer, 12″, used with 400/19 Martini Pitcher	25.00 -	40.00
176	Coaster with 10 oz. Tumbler (Candlewick ash tray, round, 4 colors)	20.00 -	35.00
530	Sherbet Lining, for 400/53/3 Icer Set (not Candlewick)	20.00 -	22.00
530	Tumbler, 5-1/2 oz., for 400/53/3 Icer Set (not Candlewick)	20.00 -	25.00
615	Ladle, Mayonnaise (1938-1941) used with early sets, no beads	10.00 -	15.00
701	Fork and Spoon, early, ridged handle and tip, 9″	25.00 -	35.00
760	Salt, Pepper Set (Lombardo Brochure 1938)	10.00 -	15.00
777/1	Eagle, Peg, Adapter, 5-1/2″, candle cup	88.00 -	135.00

777/2	Eagle, Peg, Adapter, 5-1/2″, no candle cup (1943)	75.00 -	110.00
841	Tumbler, Juice, 4 oz., for 400/23B Juice Set	10.00 -	12.00
51675	Cake Cover, 10″ (used with 400/103D), not Candlewick	55.00 -	60.00
-	Ash Tray; Candy; Nut Dish, 6″, round	10.00 -	18.00
-	Ash Tray, Rodefer/Imperial, 1973 1st Annual Bellaire Glass Festival souvenir (see 400/172)	25.00 -	40.00
-	Atomizer, Perfume, green or amethyst	90.00 -	110.00
-	Basket, 400/40/0 in metal holder	40.00 -	48.00
-	Bottle; Cologne; Lotion, 6-1/2″	50.00 -	75.00
-	Boudoir Clock, 4″ diameter	175.00 -	275.00
-	Boudoir Set, 4 pc. (2 bottles/puff jar/tray)	185.00 -	255.00
-	Brick, from Imperial Hay Shed (1993)	10.00 -	20.00
-	Brick, Red, "Save Imperial" commemorative, 4″ long (1994)	10.00 -	15.00
-	Brochure, Imperial "Pick-up" (1941)	30.00 -	35.00
-	Calendar, beaded edge, rectangular	100.00 -	125.00
-	Centerbowl, 400/13B, 11″, clip-on wire/chrome handle	55.00 -	70.00
-	Christmas Ornament, Imperial, green (1985)	10.00 -	20.00
-	Comport, 5-1/2″, Sterling base	35.00 -	40.00
-	Cruet Sets, 2 or 3 cruets in silver base		*
-	Hostess Helper in silver frame, dip center		*
-	"Junior Place Setting," 5 pc. (400/77 Cup/Saucer, 400/190 Wine, 400/42B Bowl, 400/3D Plate)	115.00 -	145.00
-	Ladle, Mayonnaise/Marmalade, small, no beads	10.00 -	12.00
-	Ladle, 5″, 1-bead	8.00 -	10.00
-	Mirror, 4-1/2″, round, beaded edge, 2 feet, question mark handle for stand	85.00 -	120.00
-	Mirror, Hand, made for I. Rice Co.	125.00 -	155.00
-	Mirror, Make-up, 400/18 base, 1 side magnified	86.00 -	180.00
-	Paperweight, "Imperial" logo over blue	90.00 -	150.00
-	Paperweight, Imperial, with Ohio, penny, Bellaire Glass Festival souvenir 1972	55.00 -	95.00
-	Picture Frame, 4-1/2″, round, beaded edge, 2 feet, question mark handle for stand	85.00 -	120.00
-	Peg Bowl, Float, 10-1/2″, silver base - 5″ (400/251?)	65.00 -	95.00
-	Peg Plate, 9″	35.00 -	45.00
-	Peg Plate, 6-3/4″, low brass base	30.00 -	45.00
-	Puff Jar, made for I. Rice Co.	45.00 -	50.00
-	Ringholder, marked LIG (400/78 mould)	125.00 -	175.00
-	Salad Set, 12 pc. (1938 Lombardo Brochure)	145.00 -	202.00
-	Sign, oblong, size of calendar	125.00 -	185.00
-	Sign, Imperial, Lenox	65.00 -	90.00
-	Sign, Imperial, bent glass	80.00 -	125.00
-	Sign, Imperial, oval, frosted	80.00 -	125.00
-	Shade (G107 cutting #, round, 5″ d., 2-1/2″)	60.00 -	85.00
-	Spoon and Fork Set, no beads (1937)	20.00 -	25.00
-	Tin Box, Bunte Candies, 8-1/2″ hi, 400/40/0 Basket on sides of tin	30.00 -	45.00
-	Community Plate: "Twilight" Set, 2 pc. (400/60 Relish)	22.00 -	30.00
-	Community Plate: "Ballard" Set, 2 pc. (400/49H 5″ Heart)	22.00 -	32.00
-	Community Plate: "South Seas" Set, 2 pc. (400/54 Relish)	35.00 -	43.00

* Denotes no price activity

-	Farber Brothers: bowl/fancy-floral-cut chrome underplate	30.00 -	40.00
-	Farber Bothers: 40/23 Mayonnaise Bowl with chrome ladle and fancy-floral-cut underplate	40.00 -	50.00
-	Farber Brothers; 400/3D 7″ Plate (floral cut), chrome comport	30.00 -	40.00
-	Farberware: 400/123 8″ Toast Plate-cupped, 3 pc. set, Farberware domed top/9″ Farberware plate-floral decor		*
-	Farberware: 400/23 Fruit Bowl, 5-1/4″, on round, lacy-patterned tray		*
-	Farberware: 400/159 Oval Tray, 9″, on rectangular lacy-patterned tray	20.00 -	25.00
-	Farberware: 400/259 Candy Box on lacy-patterned round chrome tray/chrome lid		*
-	Farberware: blue footed-compote on tray	70.00 -	80.00
-	Farberware: 9″ oval dish on tray		*
-	Hammered Aluminum: 400/55 8-1/2″ 4-part round relish in indent in square tray		*
-	Kromex: 400/209 13-1/2″ 5-part relish on Kromex lazy susan		*
-	Viking Plate: 400/134/1 Ash Tray in fancy-cut copper holder (Canadian)		*

* Denotes no price activity

Colored Candlewick Price Guide

MOULD #	ITEM	COLOR	PRICE GUIDE	
400/1D	Plate, Bread & Butter, 6″	blue frosted	$22.00 -	26.00
400/1F	Nappy, Fruit, 5″	Viennese Blue	35.00 -	45.00
400/3D	Plate, Salad, 7″	blue sprayed edge	26.00 -	32.00
400/3F	Bowl, Fruit, 6″	green	120.00 -	130.00
400/5D	Plate, Salad/Luncheon, 8″	Viennese Blue	25.00 -	30.00
		painted flowers	20.00 -	29.00
400/5F	Bowl, 7″	Viennese Blue	42.00 -	55.00
400/7D	Plate, 9″	Viennese Blue	25.00 -	35.00
400/13B	Centerbowl, 11″	Viennese Blue	90.00 -	100.00
400/13D	Plate, Service, 12″	Viennese Blue	50.00 -	65.00
400/13FD	Salad Set, 2 pc.	Viennese Blue	145.00 -	155.00
400/17D	Plate, Torte, 14″	frosted beads	75.00 -	90.00
400/17F	Bowl, 12″	Viennese Blue	123.00 -	130.00
400/19	Tumbler, Iced Tea, 12 oz.	amber beads	65.00 -	95.00
400/19/24	Pitcher, 10 oz. Tumblers (4)	green beads	450.00 -	600.00
400/23	Bowl, Mayonnaise, 5-1/4″	Viennese Blue	18.00 -	25.00
400/23D	Plate with Seat, 7″	blue sprayed edge	15.00 -	18.00
400/24	Pitcher, Water/Ice, 80 oz.	silver overlay	155.00 -	195.00
400/30	Sugar, Cream Set, 6 oz.	Viennese Blue	40.00 -	50.00
		red flashed	40.00 -	65.00
		gold overlay	65.00 -	85.00
		Sterling bases	35.00 -	50.00
400/29/30	Sugar, Cream, Tray Set	gold	195.00 -	325.00
400/31	Sugar, Cream, 8 oz.	Viennese Blue	50.00 -	80.00
400/33	Jelly; Ash Tray, 4″	Viennese Blue	20.00 -	42.00
		silver overlay	10.00 -	15.00
400/34	Coaster; Plate; Butter, 4-1/2″	Viennese Blue	70.00 -	80.00

Number	Description	Variant	Low		High
400/35	Tea Cup, Saucer	gold beads, trim	15.00	-	40.00
400/35	Tea Cup, no beads on handle	Viennese Blue	42.00	-	45.00
400/36	Plate, Canape, 6″	Viennese Blue	18.00	-	32.00
400/37	Coffee Cup, Saucer	blue	70.00	-	80.00
	Cup	gold	95.00	-	125.00
400/40	Mayonnaise Set, 3 pc.	Viennese Blue	35.00	-	60.00
400/40B	Bowl, 5-1/2″, chrome stem	blue	65.00	-	80.00
400/40/0	Basket, 6-1/2″	Ruby	225.00	-	475.00
		gold	195.00	-	350.00
400/40C	Candleholder, Flower, 5″	Ruby	175.00	-	210.00
400/40H	Bon Bon Heart, 5″, handled	Ruby			310.00
		gold-birds and flowers			163.00
400/42E	Tray, 5-1/2″, turned-up handles	Viennese Blue	20.00	-	30.00
400/50	Cream Soup, 5″-5-1/2″	gold decorated	48.00	-	62.00
400/51T	Tray, Wafer, heart, 6″	Ruby	290.00	-	325.00
400/52	Bowl; Jelly 6″	blue	32.00	-	45.00
400/52B	Nappy; Bowl, 6-1/2″	Viennese Blue	37.00	-	48.00
400/52E	Tray; Plate, 7″	black	160.00	-	215.00
400/53/2	Icer Set, 2 pc.	gold beads	75.00	-	85.00
400/55	Tray, Relish, 8-1/2″	silver decorated	40.00	-	50.00
		gold trim	55.00	-	70.00
400/61	Salt Dip, 2″	gold beads	15.00	-	22.00
400/62B	Nappy; Bowl, 7″	Viennese Blue	32.00	-	59.00
		Ruby	175.00	-	210.00
400/62D	Plate, 8-1/2″	Ruby	110.00	-	195.00
		black-painted flowers	145.00	-	185.00
		Carmel Slag	120.00	-	170.00
400/62E	Tray, 8-1/2″	black	150.00	-	220.00
400/64	Nut Dip; Nut Cup; Sugar Dip	red flashed	18.00	-	22.00
		gold beads	15.00	-	18.00
400/66B	Compote, 5-1/2″	gold trim, beads	25.00	-	65.00
		Viennese Blue	50.00	-	62.00
400/67B	Bowl, Fruit, 9″	Viennese Blue	130.00	-	155.00
		Ruby	250.00	-	320.00
400/67D	Cake Stand; Salver, 10″	Viennese Blue	95.00	-	105.00
400/68D	Tray, Pastry, 11-1/2″-12-1/2″	Valley Lily in silver	75.00	-	105.00
		Ruby	375.00	-	495.00
400/72D	Plate, 10″	Viennese Blue	35.00	-	45.00
		black	145.00	-	185.00
400/72E	Tray, 10″	Viennese Blue	45.00	-	65.00
		black, gold trim	145.00	-	190.00
400/74B	Bowl, 8″-8-1/2″	Ruby	200.00	-	395.00
		black	225.00	-	290.00
400/74J	Bowl, Rose; Lily, 7″	black	210.00	-	270.00
400/74N	Bowl, Lily, turned-in top	black	200.00	-	275.00
400/74SC	Bowl; Dish, 4-toed	black	225.00	-	300.00
		Ruby	235.00	-	300.00
		Viennese Blue	130.00	-	175.00
400/75B	Bowl, Salad, 10″	gold beads	48.00	-	65.00
400/75B	Salad Set, 4 pc.	blue	92.00	-	115.00
400/77AD	After Dinner Cup, Saucer	black	150.00	-	225.00
		pink sprayed edge			200.00

Number	Description	Variation	Low		High
		gold beads	25.00	-	30.00
400/79	Hurricane Candle Lamp, 2 pc.	gold painted shade	145.00	-	300.00
		Cranberry flashed	125.00	-	145.00
400/79R	Candleholder, 3-1/2″	frosted base	45.00	-	55.00
400/80	Candleholder, 3-1/2″	gold beads	40.00	-	50.00
		blue stain with			
		silver overlay	28.00	-	55.00
400/81	Candleholder, 3-1/2″	Viennese Blue	81.00	-	90.00
400/84	Nappy; Bowl, 6-1/2″	blue	70.00	-	80.00
		gold beads	30.00	-	38.00
400/86	Candleholder, Mushroom	gold beads	30.00	-	40.00
		Viennese Blue	53.00	-	65.00
400/87C	Vase, 8″, variations	blue	87.00	-	91.00
400/87F	Vase, Fan, 8″-8-1/2″	yellow	160.00	-	170.00
		Viennese Blue	65.00	-	100.00
400/87R	Vase, 7″, handled	Viennese Blue	85.00	-	150.00
400/88	Compote, Cheese, 5-1/2″	Viennese Blue	38.00	-	55.00
		gold beads	43.00	-	50.00
400/92D	Plate, 14″	gold/silver overlay	75.00	-	85.00
400/96	Salt, Pepper Set	gold	50.00	-	60.00
		aquamarine	50.00	-	65.00
400/96	Atomizer	green			140.00
400/98	Party Set, 2 pc.	gold	225.00	-	275.00
400/103D	Cake Stand, 11″, 3-bead stem	painted roses	90.00	-	120.00
400/109	Salt, Pepper Set	gold beads	40.00	-	55.00
400/110	Candy Box, Cover	painted flowers	90.00	-	109.00
400/112	Tray, Relish, 10-1/2″	gold beads	70.00	-	80.00
400/113D	Plate, 14″	gold beads, rings	65.00	-	75.00
400/122	Cream, Sugar Set	Marigold	65.00	-	75.00
400/124D	Platter, 12″-13″	frosted beads			165.00
400/133	Ash Tray, 5″	opaline	170.00	-	180.00
		Carmel Slag	120.00	-	165.00
		silver	55.00	-	65.00
400/134	Cigarette Box, Cover	satin beads			200.00
		Cranberry flashed			125.00
		painted roses			165.00
		painted sea scallops and			
		pansies			125.00
400/143C	Vase, Flip, 8″	red flashed	200.00	-	275.00
		silver overlay			195.00
400/145B	Bowl, 10″	yellow beads	180.00	-	190.00
400/145D	Plate, 12″-12-1/2″	Carmel Slag	195.00	-	300.00
400/149D	Tray, Mint, 8″-9″	painted flowers	150.00	-	195.00
400/150	Ash Tray, 6″	Carmel Slag	125.00	-	165.00
		Cobalt Blue			55.00
400/152R	Hurricane Lamp, 14″	roses and leaves	155.00	-	165.00
400/159	Tray, 9″	silver roses	60.00	-	70.00
400/167	Salt, Pepper Set	amethyst	65.00	-	110.00
		light green	55.00	-	110.00
400/167	Atomizer	amethyst	65.00	-	95.00
		green	60.00	-	75.00

Item	Description	Color	Low		High
400/172	Heart, Mint; Ash Tray, 4-1/2″	Verde Green			20.00
400/174	Ash Tray; Bon Bon	Carmel Slag	125.00	-	195.00
		frosted pink	65.00	-	80.00
400/182	Bowl, 8-1/2″, 3-toed	Carmel Slag	225.00	-	295.00
400/183	Bowl, 6″, 3-toed	Carmel Slag	195.00	-	265.00
400/247	Salt, Pepper Set	Heather (purple)	65.00	-	90.00
		yellow	60.00	-	90.00
400/247	Atomizer	turquoise	55.00	-	75.00
400/256	Relish, 10-1/2″	Carmel Slag	175.00	-	285.00
400/440	Ash Tray, 4″, WWII	Ruby	60.00	-	78.00
400/550	Ash Tray Set	Ultra Blue	55.00	-	65.00
400/550	Ash Tray Set	Nut Brown	50.00	-	90.00
400/550	Ash Tray Set, WWII	pink, amber, blue	73.00	-	101.00
		red, white, blue	185.00	-	263.00
400/750	Ash Tray; Tid-Bid Set	Milkglass, Doeskin	40.00	-	60.00
400/2701	Tid-Bit Set	green	200.00	-	500.00
		Sterling post	170.00	-	180.00
		silver overlay			250.00
400/9266B	Cheese, Cracker Set, 2 pc.	Ruby	95.00	-	125.00
3400	Goblet, 9 oz.	Ultra Blue	35.00	-	45.00
		Verde Green	35.00	-	45.00
		Sunshine Yellow	35.00	-	45.00
		black			210.00
3400	Cocktail, 4 oz.	Ruby	95.00	-	120.00
		Ritz Blue	145.00	-	200.00
3400	Saucer Champagne/Sherbet	Ruby	100.00	-	130.00
		Ultra Blue	35.00	-	45.00
		Sunshine Yellow	29.00	-	35.00
		Verde Green	35.00	-	45.00
		gold trim	30.00	-	40.00
3400	Wine, 4 oz.	Ruby	75.00	-	95.00
		Nut Brown	36.00	-	45.00
		Sunshine Yellow	35.00	-	38.00
		gold trim	50.00	-	60.00
3400	Tumbler, 9 oz.	Ruby	110.00	-	125.00
3400	Tumbler, 12 oz.	Ultra Blue	30.00	-	40.00
3800	Goblet, 10 oz.	Ritz Blue	85.00	-	125.00
		Ruby	85.00	-	110.00
3800	Tall Sherbet/Champagne	Ruby	85.00	-	110.00
3800	Low Sherbet	Ruby	85.00	-	110.00
		Emerald Green			220.00
3800	Cocktail, 4 oz.	Ruby	75.00	-	90.00
3800	Wine, 2 oz.	Ruby	75.00	-	110.00
3800	Cordial, 1 oz.	Ruby	130.00	-	140.00
3800	Tumbler, 5 oz.	Ruby	95.00	-	110.00
3800	Tumbler, 9 oz.	Ruby	95.00	-	110.00
		Ritz Blue			95.00
3800	Tumbler, 12 oz.	Ruby	95.00	-	120.00
1776/1	Ash Tray, Eagle	Milkglass	45.00	-	60.00
		blue opaque	50.00	-	55.00
		frosted	50.00	-	70.00

1776/3	Mirror, Eagle	Antique Blue	55.00	-	65.00
		frosted	48.00	-	70.00
		black-gold accents			250.00
1950/196	Epergne Set, 2 pc.	Milkglass	75.00	-	95.00
701	Fork, Spoon, early	blue	80.00	-	90.00

Cut and Etched Candlewick Price Guide

MOULD #	ITEM	CUT/ETCH	PRICE GUIDE		
400/3F	Bowl Fruit, 6"	Dots Cut #100	$20.00	-	22.00
400/5D	Plate, Salad/Luncheon, 8"	Dots Cut #100	11.00	-	13.00
400/7D	Plate, 9"	cut	16.00	-	21.00
400/13B	Centerbowl, 11"	cut, stars	75.00	-	95.00
400/13D	Plate, Service, 12"	cut, stars	35.00	-	45.00
400/17D	Plate, Torte, 14"	cut, wheat	50.00	-	63.00
400/19	Tumbler, Iced Tea, 12 oz.	cut, floral	18.00	-	27.00
400/19	Sherbet, Dessert, 5 oz.	cut	18.00	-	23.00
400/20	Punch Set, 15 pc.	Mallard Cut	395.00	-	600.00
400/23	Mayonnaise Set, 3 pc.	etch, floral	35.00	-	45.00
		cut, wheat	28.00	-	43.00
400/24	Pitcher, Ice/Water	cut, stars	165.00	-	215.00
400/29/30	Sugar, Cream, Tray Set	Floral Cut #279	35.00	-	45.00
		cut, stars	30.00	-	38.00
400/31	Sugar, Cream Set	cut, swans	25.00	-	32.00
		cut, stars	44.00	-	50.00
400/36	Canape Set, 2 pc.	cut	28.00	-	50.00
400/37	Cup	cut	11.00	-	13.00
400/40H	Bowl, Heart, 5"	cut	28.00	-	30.00
400/42B	Nappy; Fruit, 4-3/4"	cut, wheat	15.00	-	18.00
400/42D	Plate, 5-1/2", 2-handled	cut; gold beads	23.00	-	28.00
400/48F	Compote, 8"	Winchester Cut #48	95.00	-	120.00
400/50	Plate with Seat, 8"	Fantasy Cut #801	25.00	-	30.00
400/52D	Plate, 7-1/2"	Floral Cut #279	20.00	-	25.00
400/53/3	Icer Set	Mallard Cut	145.00	-	185.00
400/55	Tray, Relish	cut, stars	30.00	-	40.00
		cut, floral	28.00	-	39.00
400/58	Pickle/Celery, 8-1/2"	Dots Cut #100	28.00	-	37.00
400/62B	Nappy, 7", 2-handled	Cut, stars	28.00	-	30.00
400/63B	Bowl, Belled, 10-1/2"	cut, floral	55.00	-	95.00
400/66B	Compote, 5-1/2"	cut, stars	25.00	-	35.00
400/67B	Bowl, Fruit, 9"	Fushia Cut	98.00	-	127.00
400/67D	Cake Stand, 10"	cut	73.00	-	85.00
400/68D	Tray, Pastry, 11-1/2"-12"	Valley Lily Cut #800	35.00	-	70.00
		Mallard Cut	42.00	-	73.00
		cut, wheat	55.00	-	65.00
		cut, stars	55.00	-	65.00
400/72	Bowl; Jelly, 8-1/2"	Dots Cut #100	85.00	-	104.00

400/72D	Plate, 10″	Dots Cut #100				
		Viennese Blue	45.00	-	60.00	
		cut, stars	28.00	-	37.00	
		cut, wheat	28.00	-	37.00	
400/74B	Bowl, Fruit, 8-1/2″, 4-toed	Fushia Cut	107.00	-	120.00	
		cut, floral			70.00	*
400/74J	Bowl, Lily, 7″, 4-toed	cut			210.00	*
400/74SC	Bowl; Dish, 4-toed	cut, floral	85.00	-	99.00	
400/75V	Plate, Torte, 12-1/2″-13″	Floral Cut #279	46.00	-	50.00	
400/79R	Candleholder, 3-1/2″	cut, floral	18.00	-	27.00	
400/84	Nappy; Bowl, 6-1/2″	Valley Lily Cut #800	35.00	-	55.00	
		Starlight Cut #108	30.00	-	55.00	
400/86	Candleholder, Mushroom	cut, wheat	25.00	-	39.00	
		etch			70.00	*
400/87F	Vase, Fan, 8″-8-1/2″	daisy and leaves	35.00	-	55.00	
		Starlight Cut #108	45.00	-	63.00	
400/92D	Plate, 14″	Mallard Cut			125.00	*
400/96	Salt, Pepper Set	Starlight Cut #108	35.00	-	40.00	
400/105	Tray, Celery, 13-1/2″	cut, floral	35.00	-	53.00	
400/106B	Bowl, Belled, 12″	Floral Cut #279	60.00	-	85.00	
400/118	Ash Tray, B'tween Place	Etch: glass worker	25.00	-	35.00	
400/122	Cream, Sugar, Individual	cut, floral	18.00	-	23.00	
400/134	Cigarette Box, Cover	Starlight Cut #108	48.00	-	75.00	
400/134/1	Ash Tray, 4-1/2″	cut, leaves	10.00	-	12.00	
400/143C	Vase, Flip, 8″, crimped	cut, floral	98.00	-	115.00	
400/144	Butter, Cover, 5-1/2″	cut, floral	35.00	-	47.00	
400/145	Cheese, Cracker Set, 2 pc.	cut	85.00	-	125.00	
400/147	Candleholder, 3-lite	etch	33.00	-	39.00	
400/149D	Tray, Mint, 8″-9″	cut, wheat	35.00	-	39.00	
400/169	Sauce Boat	etch: Trader Vic logo			450.00	*
	Sauce Boat Set	Floral Cut #279	200.00	-	279.00	
400/190	Salt Shaker	cut, cornflower	25.00	-	28.00	
400/270TB	Tid-Bit, 1-tier, 7-1/2″	Starlight Cut #108	75.00	-	93.00	
400/276	Butter, California	Canadian				
		"Cornflower" Cut	185.00	-	225.00	
400/330	Pitcher, 13-14 oz.	etch: Trader Vic logo			450.00	*
400/1989	Bowl, Marmalade, Cover	Canadian				
		"Cornflower" Cut	60.00	-	78.00	
400/8692L	Console Set, Mushroom	Floral Cut #279	156.00	-	175.00	
400/9266B	Cheese, Cracker Set	cut, floral;silver				
		accents	125.00	-	156.00	
3400	Goblet, 9 oz.	Valley Lily Cut #108	40.00	-	47.00	
		etch, floral	43.00	-	45.00	
		etch: Wild Rose	27.00	-	45.00	
3400	Wine, 4 oz.	cut	33.00	-	36.00	
3400	Saucer Champagne/Sherbet	Valley Lily Cut #108	28.00	-	35.00	
		Floral Cut #279	35.00	-	47.00	
		etch, floral	28.00	-	35.00	
		etch: Wild Rose	27.00	-	43.00	
		etch: Rose of Sharon	27.00	-	29.00	

* Denotes no other price activity

No.	Item	Description	Price Low	Price High
		cut, spider mum	35.00	- 43.00
3400	Cordial, 1 oz.	etch, all over	45.00	- 56.00
3400	Cocktail, 4 oz.	cut	16.00	- 27.00
3400	Tumbler, Iced Tea, 12 oz.	etch: Wild Rose	32.00	- 48.00
		Cut #601	35.00	- 45.00
3400	Oyster Cocktail, 4 oz.	etch	24.00	- 27.00
3400	Finger Bowl	Floral Cut #279	30.00	- 48.00
-	Bottle; Cologne; Lotion	Starlight Cut #108	48.00	- 88.00
-	Puff Jar	Starlight Cut #108	88.00	- 95.00

Cover of 1957 Imperial spiral Memo Calendar. See p. 126 for April/May page with Candlewick bowl. Courtesy of Myrna Garrison, Arlington, Texas,

ASH TRAYS AND SETS

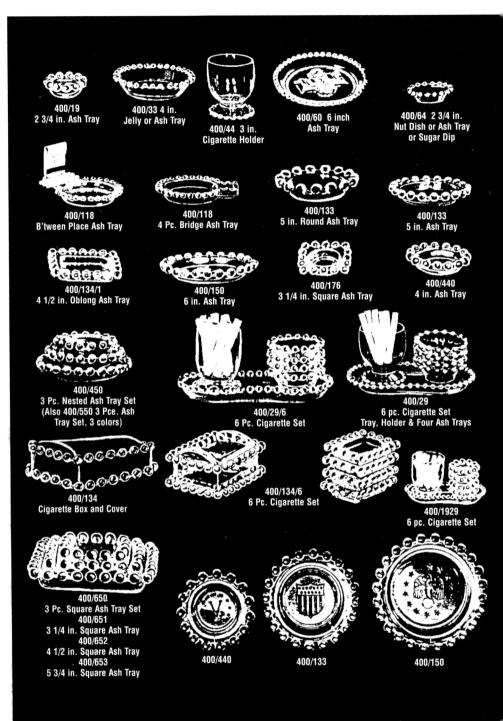

400/19
2 3/4 in. Ash Tray

400/33 4 in.
Jelly or Ash Tray

400/44 3 in.
Cigarette Holder

400/60 6 inch
Ash Tray

400/64 2 3/4 in.
Nut Dish or Ash Tray
or Sugar Dip

400/118
B'tween Place Ash Tray

400/118
4 Pc. Bridge Ash Tray

400/133
5 in. Round Ash Tray

400/133
5 in. Ash Tray

400/134/1
4 1/2 in. Oblong Ash Tray

400/150
6 in. Ash Tray

400/176
3 1/4 in. Square Ash Tray

400/440
4 in. Ash Tray

400/450
3 Pc. Nested Ash Tray Set
(Also 400/550 3 Pce. Ash
Tray Set, 3 colors)

400/29/6
6 Pc. Cigarette Set

400/29
6 pc. Cigarette Set
Tray, Holder & Four Ash Trays

400/134
Cigarette Box and Cover

400/134/6
6 Pc. Cigarette Set

400/1929
6 pc. Cigarette Set

400/650
3 Pc. Square Ash Tray Set
400/651
3 1/4 in. Square Ash Tray
400/652
4 1/2 in. Square Ash Tray
400/653
5 3/4 in. Square Ash Tray

400/440

400/133

400/150

BASKETS, BELLS, AND BOTTLES

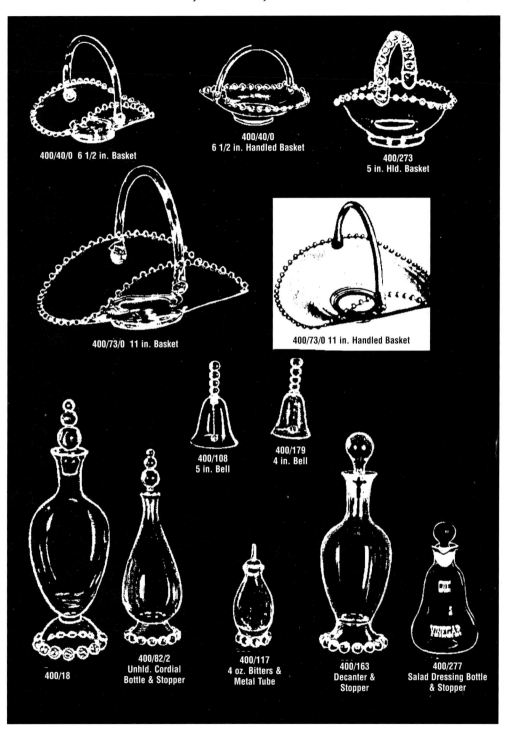

400/40/0 6 1/2 in. Basket

400/40/0
6 1/2 in. Handled Basket

400/273
5 in. Hld. Basket

400/73/0 11 in. Basket

400/73/0 11 in. Handled Basket

400/108
5 in. Bell

400/179
4 in. Bell

400/18

400/82/2
Unhld. Cordial
Bottle & Stopper

400/117
4 oz. Bitters &
Metal Tube

400/163
Decanter &
Stopper

400/277
Salad Dressing Bottle
& Stopper

BOWLS

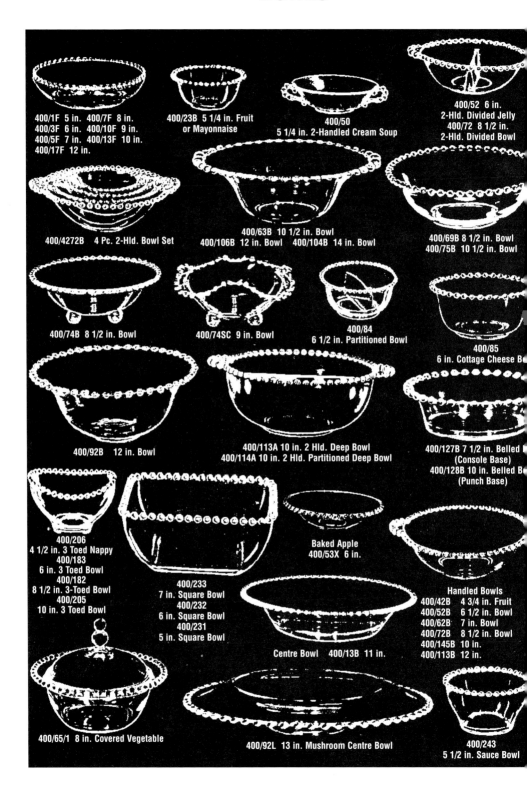

400/1F 5 in. 400/7F 8 in.
400/3F 6 in. 400/10F 9 in.
400/5F 7 in. 400/13F 10 in.
400/17F 12 in.

400/23B 5 1/4 in. Fruit
or Mayonnaise

400/50
5 1/4 in. 2-Handled Cream Soup

400/52 6 in.
2-Hld. Divided Jelly
400/72 8 1/2 in.
2-Hld. Divided Bowl

400/4272B 4 Pc. 2-Hld. Bowl Set

400/63B 10 1/2 in. Bowl
400/106B 12 in. Bowl 400/104B 14 in. Bowl

400/69B 8 1/2 in. Bowl
400/75B 10 1/2 in. Bowl

400/74B 8 1/2 in. Bowl

400/74SC 9 in. Bowl

400/84
6 1/2 in. Partitioned Bowl

400/85
6 in. Cottage Cheese Bo

400/92B 12 in. Bowl

400/113A 10 in. 2 Hld. Deep Bowl
400/114A 10 in. 2 Hld. Partitioned Deep Bowl

400/127B 7 1/2 in. Belled B
(Console Base)
400/128B 10 in. Belled B
(Punch Base)

400/206
4 1/2 in. 3 Toed Nappy
400/183
6 in. 3 Toed Bowl
400/182
8 1/2 in. 3-Toed Bowl
400/205
10 in. 3 Toed Bowl

400/233
7 in. Square Bowl
400/232
6 in. Square Bowl
400/231
5 in. Square Bowl

Baked Apple
400/53X 6 in.

Handled Bowls
400/42B 4 3/4 in. Fruit
400/52B 6 1/2 in. Bowl
400/62B 7 in. Bowl
400/72B 8 1/2 in. Bowl
400/145B 10 in.
400/113B 12 in.

Centre Bowl 400/13B 11 in.

400/65/1 8 in. Covered Vegetable

400/92L 13 in. Mushroom Centre Bowl

400/243
5 1/2 in. Sauce Bowl

BOWLS, BUTTERS, AND CAKE PLATES

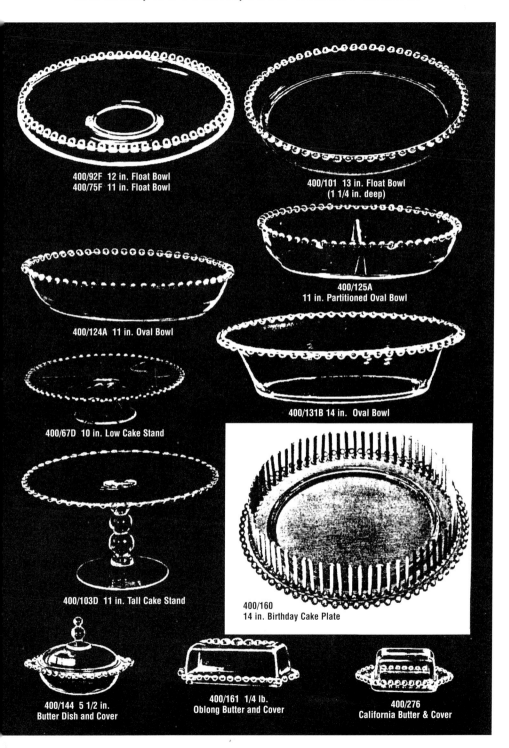

400/92F 12 in. Float Bowl
400/75F 11 in. Float Bowl

400/101 13 in. Float Bowl
(1 1/4 in. deep)

400/124A 11 in. Oval Bowl

400/125A
11 in. Partitioned Oval Bowl

400/67D 10 in. Low Cake Stand

400/131B 14 in. Oval Bowl

400/103D 11 in. Tall Cake Stand

400/160
14 in. Birthday Cake Plate

400/144 5 1/2 in.
Butter Dish and Cover

400/161 1/4 lb.
Oblong Butter and Cover

400/276
California Butter & Cover

CANDLEHOLDERS

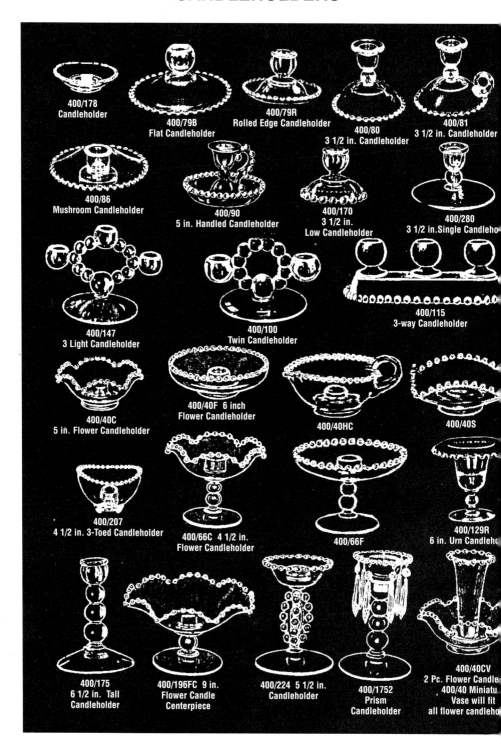

400/178 Candleholder

400/79B Flat Candleholder

400/79R Rolled Edge Candleholder

400/80 3 1/2 in. Candleholder

400/81 3 1/2 in. Candleholder

400/86 Mushroom Candleholder

400/90 5 in. Handled Candleholder

400/170 3 1/2 in. Low Candleholder

400/280 3 1/2 in. Single Candleho

400/147 3 Light Candleholder

400/100 Twin Candleholder

400/115 3-way Candleholder

400/40C 5 in. Flower Candleholder

400/40F 6 inch Flower Candleholder

400/40HC

400/40S

400/207 4 1/2 in. 3-Toed Candleholder

400/66C 4 1/2 in. Flower Candleholder

400/66F

400/129R 6 in. Urn Candleho

400/175 6 1/2 in. Tall Candleholder

400/196FC 9 in. Flower Candle Centerpiece

400/224 5 1/2 in. Candleholder

400/1752 Prism Candleholder

400/40CV 2 Pc. Flower Candle
400/40 Miniatu
Vase will fit
all flower candleho

CANDIES

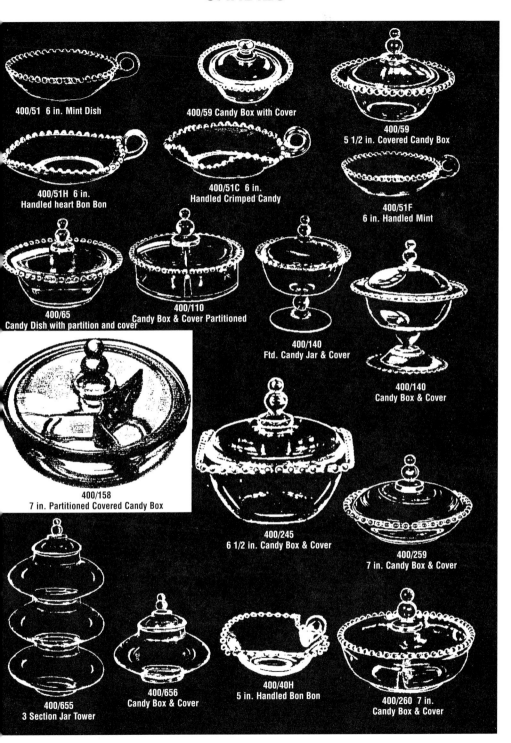

400/51 6 in. Mint Dish

400/59 Candy Box with Cover

400/59
5 1/2 in. Covered Candy Box

400/51H 6 in.
Handled heart Bon Bon

400/51C 6 in.
Handled Crimped Candy

400/51F
6 in. Handled Mint

400/65
Candy Dish with partition and cover

400/110
Candy Box & Cover Partitioned

400/140
Ftd. Candy Jar & Cover

400/140
Candy Box & Cover

400/158
7 in. Partitioned Covered Candy Box

400/245
6 1/2 in. Candy Box & Cover

400/259
7 in. Candy Box & Cover

400/655
3 Section Jar Tower

400/656
Candy Box & Cover

400/40H
5 in. Handled Bon Bon

400/260 7 in.
Candy Box & Cover

COMPOTES AND CUPS AND SAUCERS

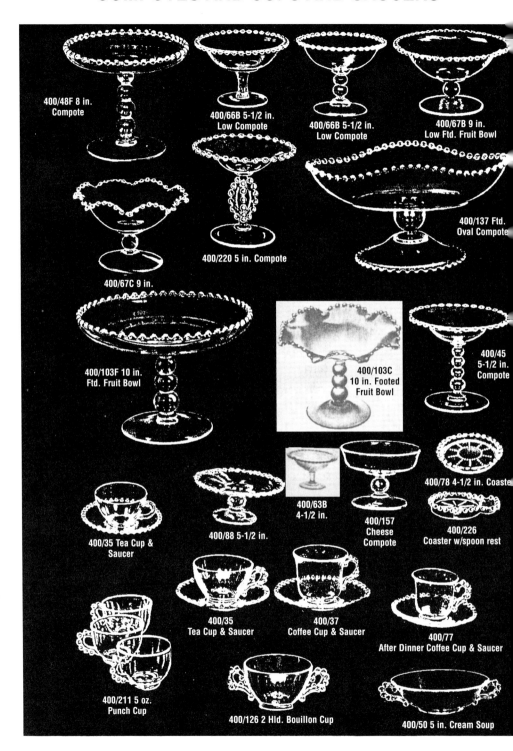

400/48F 8 in. Compote

400/66B 5-1/2 in. Low Compote

400/66B 5-1/2 in. Low Compote

400/67B 9 in. Low Ftd. Fruit Bowl

400/220 5 in. Compote

400/137 Ftd. Oval Compote

400/67C 9 in.

400/103F 10 in. Ftd. Fruit Bowl

400/103C 10 in. Footed Fruit Bowl

400/45 5-1/2 in. Compote

400/63B 4-1/2 in.

400/78 4-1/2 in. Coaster

400/157 Cheese Compote

400/226 Coaster w/spoon rest

400/35 Tea Cup & Saucer

400/88 5-1/2 in.

400/35 Tea Cup & Saucer

400/37 Coffee Cup & Saucer

400/77 After Dinner Coffee Cup & Saucer

400/211 5 oz. Punch Cup

400/126 2 Hld. Bouillon Cup

400/50 5 in. Cream Soup

CONDIMENTS

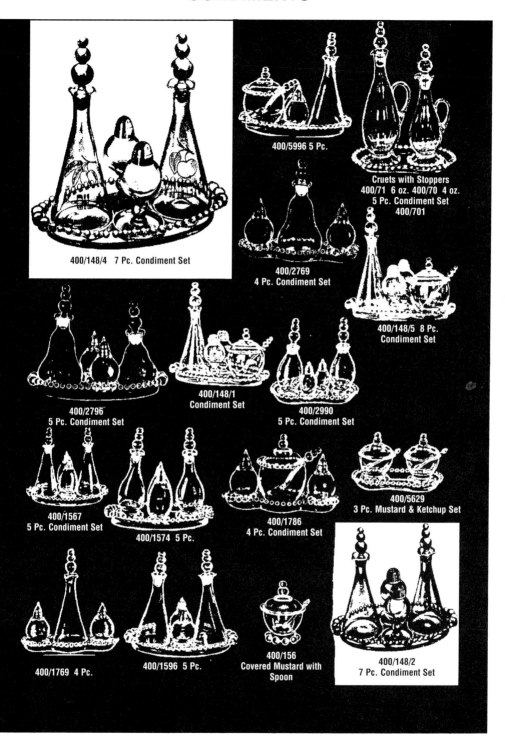

400/148/4 7 Pc. Condiment Set

400/5996 5 Pc.

Cruets with Stoppers
400/71 6 oz. 400/70 4 oz.
5 Pc. Condiment Set
400/701

400/2769
4 Pc. Condiment Set

400/148/5 8 Pc.
Condiment Set

400/2796
5 Pc. Condiment Set

400/148/1
Condiment Set

400/2990
5 Pc. Condiment Set

400/1567
5 Pc. Condiment Set

400/1574 5 Pc.

400/1786
4 Pc. Condiment Set

400/5629
3 Pc. Mustard & Ketchup Set

400/1769 4 Pc.

400/1596 5 Pc.

400/156
Covered Mustard with
Spoon

400/148/2
7 Pc. Condiment Set

CRUETS, OILS AND VINEGARS, AND DESSERT SETS

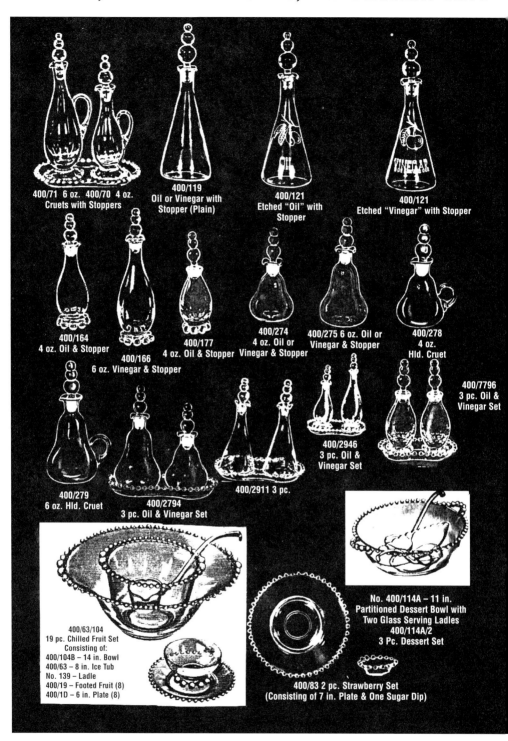

400/71 6 oz. 400/70 4 oz.
Cruets with Stoppers

400/119
Oil or Vinegar with
Stopper (Plain)

400/121
Etched "Oil" with
Stopper

400/121
Etched "Vinegar" with Stopper

400/164
4 oz. Oil & Stopper

400/166
6 oz. Vinegar & Stopper

400/177
4 oz. Oil & Stopper

400/274
4 oz. Oil or
Vinegar & Stopper

400/275 6 oz. Oil or
Vinegar & Stopper

400/278
4 oz.
Hld. Cruet

400/7796
3 pc. Oil &
Vinegar Set

400/2946
3 pc. Oil &
Vinegar Set

400/279
6 oz. Hld. Cruet

400/2794
3 pc. Oil & Vinegar Set

400/2911 3 pc.

400/63/104
19 pc. Chilled Fruit Set
Consisting of:
400/104B – 14 in. Bowl
400/63 – 8 in. Ice Tub
No. 139 – Ladle
400/19 – Footed Fruit (8)
400/1D – 6 in. Plate (8)

No. 400/114A – 11 in.
Partitioned Dessert Bowl with
Two Glass Serving Ladles
400/114A/2
3 Pc. Dessert Set

400/83 2 pc. Strawberry Set
(Consisting of 7 in. Plate & One Sugar Dip)

CONSOLE SETS

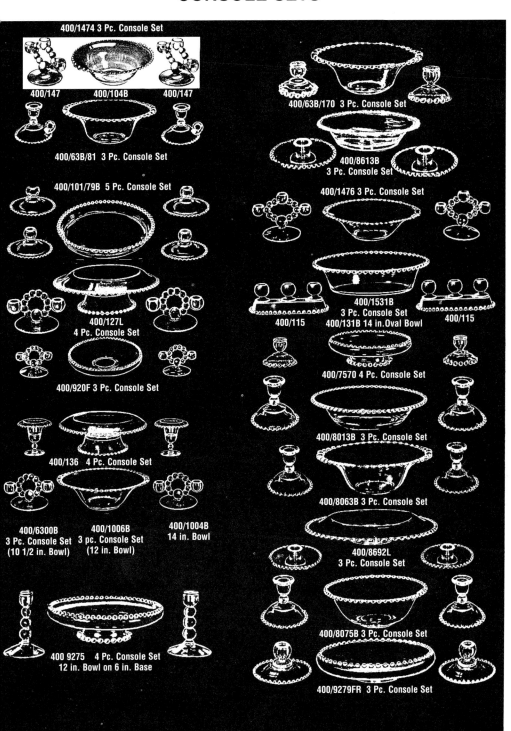

400/1474 3 Pc. Console Set

400/147 400/104B 400/147

400/63B/81 3 Pc. Console Set

400/101/79B 5 Pc. Console Set

400/127L
4 Pc. Console Set

400/920F 3 Pc. Console Set

400/136 4 Pc. Console Set

400/6300B
3 Pc. Console Set
(10 1/2 in. Bowl)

400/1006B
3 pc. Console Set
(12 in. Bowl)

400/1004B
14 in. Bowl

400 9275 4 Pc. Console Set
12 in. Bowl on 6 in. Base

400/63B/170 3 Pc. Console Set

400/8613B
3 Pc. Console Set

400/1476 3 Pc. Console Set

400/1531B
3 Pc. Console Set
400/115 400/131B 14 in. Oval Bowl 400/115

400/7570 4 Pc. Console Set

400/8013B 3 Pc. Console Set

400/8063B 3 Pc. Console Set

400/8692L
3 Pc. Console Set

400/8075B 3 Pc. Console Set

400/9279FR 3 Pc. Console Set

EAGLE DESIGNS

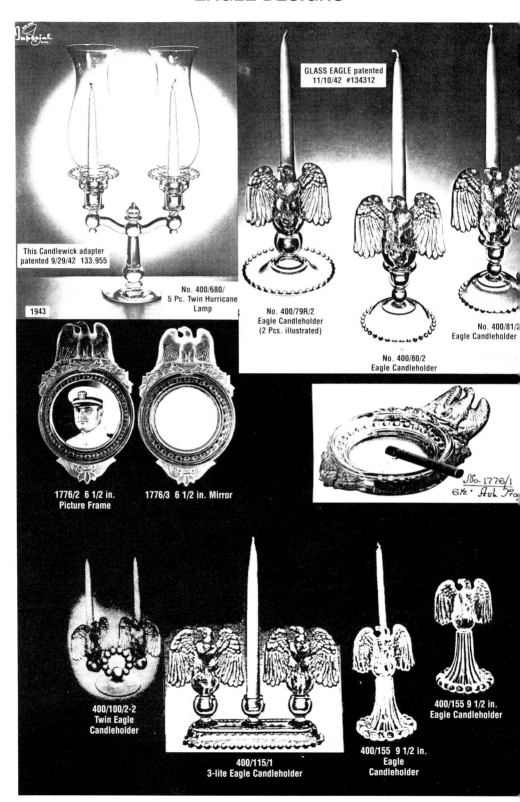

This Candlewick adapter patented 9/29/42 133,955

1943

No. 400/680/ 5 Pc. Twin Hurricane Lamp

GLASS EAGLE patented 11/10/42 #134312

No. 400/79R/2 Eagle Candleholder (2 Pcs. illustrated)

No. 400/80/2 Eagle Candleholder

No. 400/81/2 Eagle Candleholder

1776/2 6 1/2 in. Picture Frame

1776/3 6 1/2 in. Mirror

No. 1776/1 6½" Ash Tra

400/100/2-2 Twin Eagle Candleholder

400/115/1 3-lite Eagle Candleholder

400/155 9 1/2 in. Eagle Candleholder

400/155 9 1/2 in. Eagle Candleholder

HEARTSHAPES AND ICERS

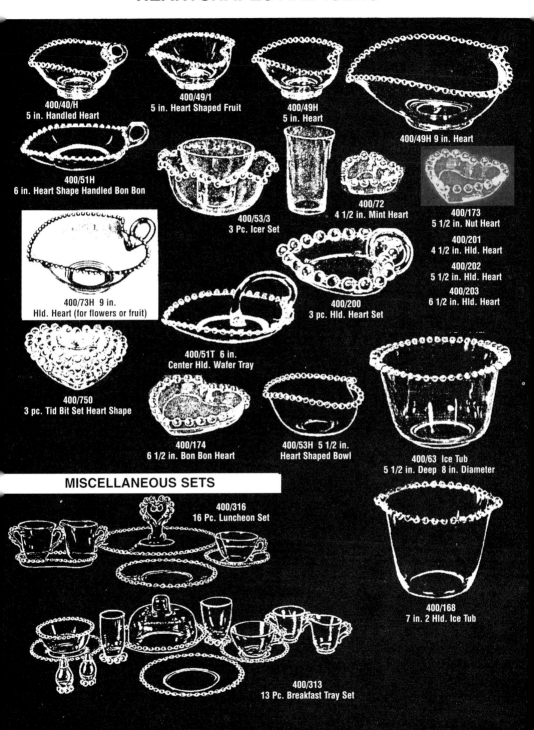

400/40/H
5 in. Handled Heart

400/49/1
5 in. Heart Shaped Fruit

400/49H
5 in. Heart

400/49H 9 in. Heart

400/51H
6 in. Heart Shape Handled Bon Bon

400/53/3
3 Pc. Icer Set

400/72
4 1/2 in. Mint Heart

400/173
5 1/2 in. Nut Heart

400/201
4 1/2 in. Hld. Heart

400/202
5 1/2 in. Hld. Heart

400/203
6 1/2 in. Hld. Heart

400/73H 9 in.
Hld. Heart (for flowers or fruit)

400/200
3 pc. Hld. Heart Set

400/51T 6 in.
Center Hld. Wafer Tray

400/750
3 pc. Tid Bit Set Heart Shape

400/174
6 1/2 in. Bon Bon Heart

400/53H 5 1/2 in.
Heart Shaped Bowl

400/63 Ice Tub
5 1/2 in. Deep 8 in. Diameter

MISCELLANEOUS SETS

400/316
16 Pc. Luncheon Set

400/168
7 in. 2 Hld. Ice Tub

400/313
13 Pc. Breakfast Tray Set

LAMPS

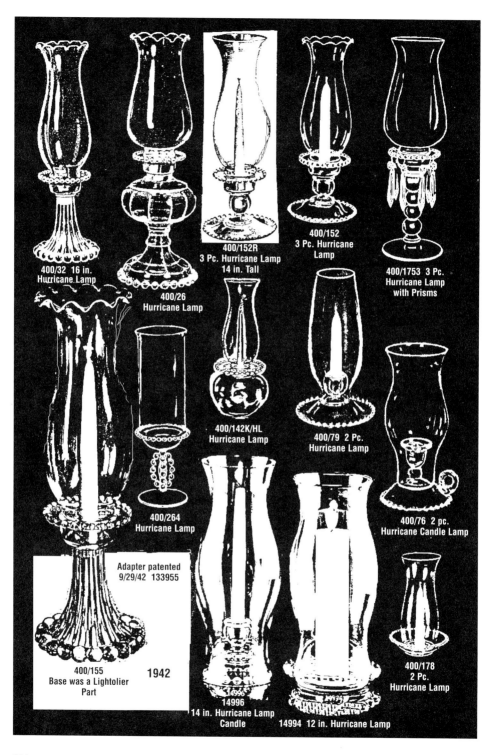

400/32 16 in.
Hurricane Lamp

400/26
Hurricane Lamp

400/152R
3 Pc. Hurricane Lamp
14 in. Tall

400/152
3 Pc. Hurricane
Lamp

400/1753 3 Pc.
Hurricane Lamp
with Prisms

400/264
Hurricane Lamp

400/142K/HL
Hurricane Lamp

400/79 2 Pc.
Hurricane Lamp

400/76 2 pc.
Hurricane Candle Lamp

Adapter patented
9/29/42 133955

1942

400/155
Base was a Lightolier
Part

14996
14 in. Hurricane Lamp
Candle

14994 12 in. Hurricane Lamp

400/178
2 Pc.
Hurricane Lamp

MARMALADES AND MISCELLANEOUS ITEMS

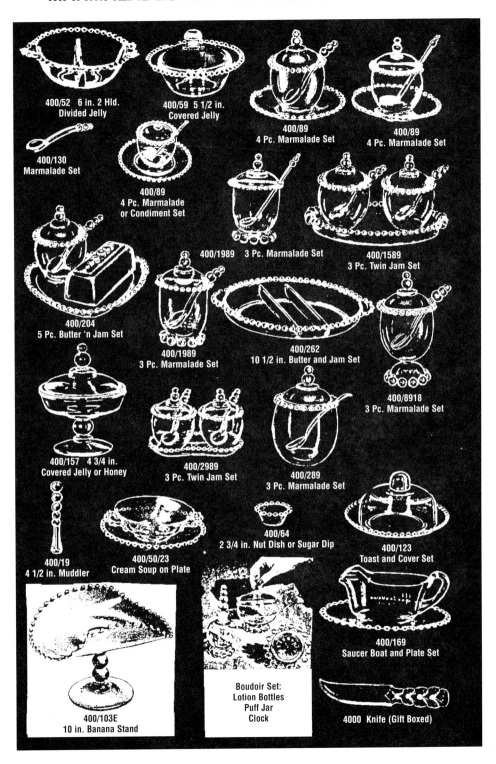

400/52 6 in. 2 Hld.
Divided Jelly

400/59 5 1/2 in.
Covered Jelly

400/89
4 Pc. Marmalade Set

400/89
4 Pc. Marmalade Set

400/130
Marmalade Set

400/89
4 Pc. Marmalade
or Condiment Set

400/1989 3 Pc. Marmalade Set

400/1589
3 Pc. Twin Jam Set

400/204
5 Pc. Butter 'n Jam Set

400/1989
3 Pc. Marmalade Set

400/262
10 1/2 in. Butter and Jam Set

400/8918
3 Pc. Marmalade Set

400/157 4 3/4 in.
Covered Jelly or Honey

400/2989
3 Pc. Twin Jam Set

400/289
3 Pc. Marmalade Set

400/64
2 3/4 in. Nut Dish or Sugar Dip

400/123
Toast and Cover Set

400/19
4 1/2 in. Muddler

400/50/23
Cream Soup on Plate

400/169
Saucer Boat and Plate Set

400/103E
10 in. Banana Stand

Boudoir Set:
Lotion Bottles
Puff Jar
Clock

4000 Knife (Gift Boxed)

MAYONNAISE SETS AND PITCHERS

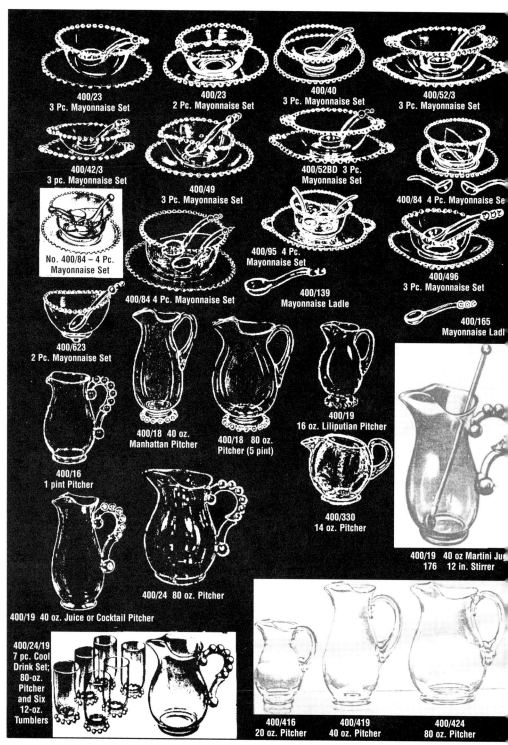

400/23
3 Pc. Mayonnaise Set

400/23
2 Pc. Mayonnaise Set

400/40
3 Pc. Mayonnaise Set

400/52/3
3 Pc. Mayonnaise Set

400/42/3
3 pc. Mayonnaise Set

400/49
3 Pc. Mayonnaise Set

400/52BD 3 Pc.
Mayonnaise Set

400/84 4 Pc. Mayonnaise Se

No. 400/84 – 4 Pc.
Mayonnaise Set

400/84 4 Pc. Mayonnaise Set

400/95 4 Pc.
Mayonnaise Set

400/139
Mayonnaise Ladle

400/496
3 Pc. Mayonnaise Set

400/165
Mayonnaise Ladl

400/623
2 Pc. Mayonnaise Set

400/18 40 oz.
Manhattan Pitcher

400/18 80 oz.
Pitcher (5 pint)

400/19
16 oz. Liliputian Pitcher

400/16
1 pint Pitcher

400/330
14 oz. Pitcher

400/24 80 oz. Pitcher

400/19 40 oz Martini Ju
176 12 in. Stirrer

400/19 40 oz. Juice or Cocktail Pitcher

400/24/19
7 pc. Cool
Drink Set;
80-oz.
Pitcher
and Six
12-oz.
Tumblers

400/416
20 oz. Pitcher

400/419
40 oz. Pitcher

400/424
80 oz. Pitcher

PARTY SETS

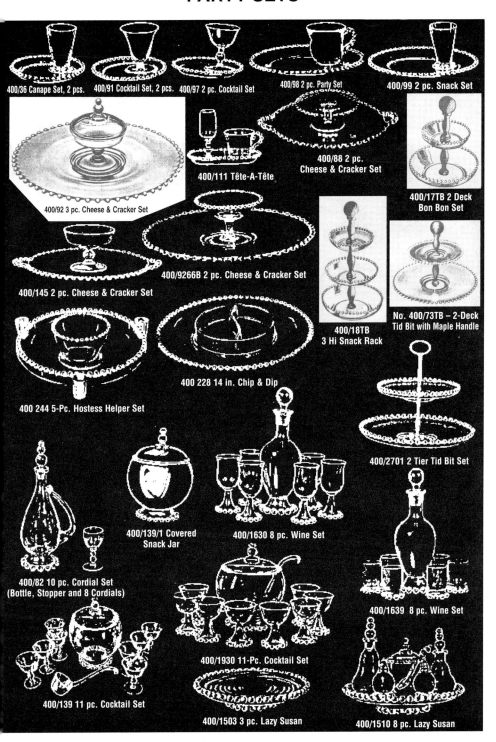

400/36 Canape Set, 2 pcs. 400/91 Cocktail Set, 2 pcs. 400/97 2 pc. Cocktail Set

400/98 2 pc. Party Set

400/99 2 pc. Snack Set

400/92 3 pc. Cheese & Cracker Set

400/111 Tête-A-Tête

400/88 2 pc.
Cheese & Cracker Set

400/17TB 2 Deck
Bon Bon Set

400/145 2 pc. Cheese & Cracker Set

400/9266B 2 pc. Cheese & Cracker Set

No. 400/73TB – 2-Deck
Tid Bit with Maple Handle

400/18TB
3 Hi Snack Rack

400 244 5-Pc. Hostess Helper Set

400 228 14 in. Chip & Dip

400/2701 2 Tier Tid Bit Set

400/139/1 Covered
Snack Jar

400/1630 8 pc. Wine Set

400/82 10 pc. Cordial Set
(Bottle, Stopper and 8 Cordials)

400/1639 8 pc. Wine Set

400/1930 11-Pc. Cocktail Set

400/139 11 pc. Cocktail Set

400/1503 3 pc. Lazy Susan

400/1510 8 pc. Lazy Susan

269

PLATES AND PUNCH BOWL SETS

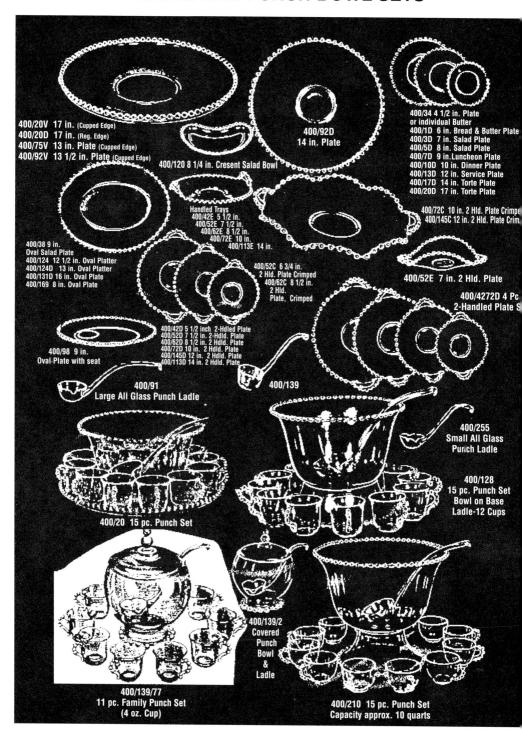

400/20V 17 in. (Cupped Edge)
400/20D 17 in. (Reg. Edge)
400/75V 13 in. Plate (Cupped Edge)
400/92V 13 1/2 in. Plate (Cupped Edge)

400/92D
14 in. Plate

400/120 8 1/4 in. Cresent Salad Bowl

400/34 4 1/2 in. Plate
or individual Butter
400/1D 6 in. Bread & Butter Plate
400/3D 7 in. Salad Plate
400/5D 8 in. Salad Plate
400/7D 9 in. Luncheon Plate
400/10D 10 in. Dinner Plate
400/13D 12 in. Service Plate
400/17D 14 in. Torte Plate
400/20D 17 in. Torte Plate

400/72C 10 in. 2 Hld. Plate Crimpe
400/145C 12 in. 2 Hld. Plate Crim.

Handled Trays
400/42E 5 1/2 in.
400/52E 7 1/2 in.
400/62E 8 1/2 in.
400/72E 10 in.
400/113E 14 in.

400/38 9 in.
Oval Salad Plate
400/124 12 1/2 in. Oval Platter
400/124D 13 in. Oval Platter
400/131D 16 in. Oval Plate
400/169 8 in. Oval Plate

400/52C 6 3/4 in.
2 Hld. Plate Crimped
400/62C 8 1/2 in.
2 Hld.
Plate, Crimped

400/52E 7 in. 2 Hld. Plate

400/4272D 4 Pc
2-Handled Plate S

400/98 9 in.
Oval-Plate with seat

400/42D 5 1/2 inch 2-Hdled Plate
400/52D 7 1/2 in. 2-Hdld. Plate
400/62D 8 1/2 in. 2 Hdld. Plate
400/72D 10 in. 2 Hdld. Plate
400/145D 12 in. 2 Hdld. Plate
400/113D 14 in. 2 Hdld. Plate

400/91
Large All Glass Punch Ladle

400/139

400/255
Small All Glass
Punch Ladle

400/128
15 pc. Punch Set
Bowl on Base
Ladle-12 Cups

400/20 15 pc. Punch Set

400/139/2
Covered
Punch
Bowl
&
Ladle

400/139/77
11 pc. Family Punch Set
(4 oz. Cup)

400/210 15 pc. Punch Set
Capacity approx. 10 quarts

SALAD SETS

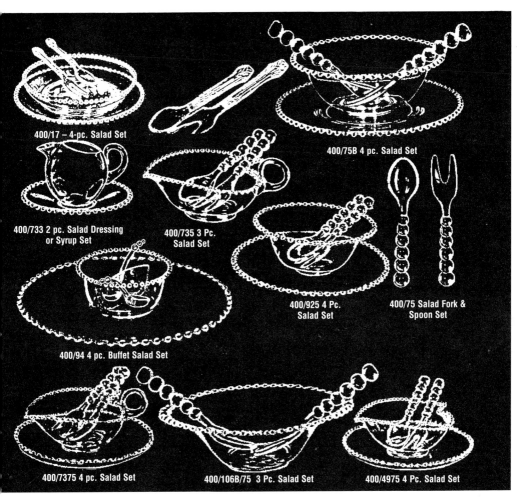

400/17 – 4-pc. Salad Set

400/75B 4 pc. Salad Set

400/733 2 pc. Salad Dressing or Syrup Set

400/735 3 Pc. Salad Set

400/925 4 Pc. Salad Set

400/75 Salad Fork & Spoon Set

400/94 4 pc. Buffet Salad Set

400/7375 4 pc. Salad Set

400/106B/75 3 Pc. Salad Set

400/4975 4 Pc. Salad Set

STEMWARE

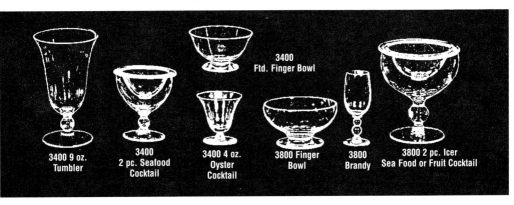

3400 9 oz. Tumbler

3400 2 pc. Seafood Cocktail

3400 Ftd. Finger Bowl

3400 4 oz. Oyster Cocktail

3800 Finger Bowl

3800 Brandy

3800 2 pc. Icer Sea Food or Fruit Cocktail

STEMWARE AND TUMBLERS

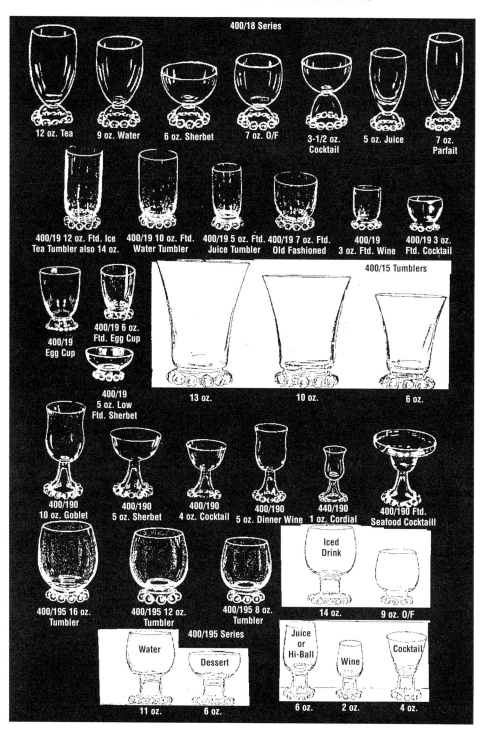

400/18 Series

12 oz. Tea

9 oz. Water

6 oz. Sherbet

7 oz. O/F

3-1/2 oz. Cocktail

5 oz. Juice

7 oz. Parfait

400/19 12 oz. Ftd. Ice Tea Tumbler also 14 oz.

400/19 10 oz. Ftd. Water Tumbler

400/19 5 oz. Ftd. Juice Tumbler

400/19 7 oz. Ftd. Old Fashioned

400/19 3 oz. Ftd. Wine

400/19 3 oz. Ftd. Cocktail

400/19 Egg Cup

400/19 6 oz. Ftd. Egg Cup

400/19 5 oz. Low Ftd. Sherbet

400/15 Tumblers

13 oz.

10 oz.

6 oz.

400/190 10 oz. Goblet

400/190 5 oz. Sherbet

400/190 4 oz. Cocktail

400/190 5 oz. Dinner Wine

440/190 1 oz. Cordial

400/190 Ftd. Seafood Cocktaill

400/195 16 oz. Tumbler

400/195 12 oz. Tumbler

400/195 8 oz. Tumbler

Iced Drink

14 oz.

9 oz. O/F

400/195 Series

Water

Dessert

11 oz.

6 oz.

Juice or Hi-Ball

6 oz.

Wine

2 oz.

Cocktail

4 oz.

STEMWARE

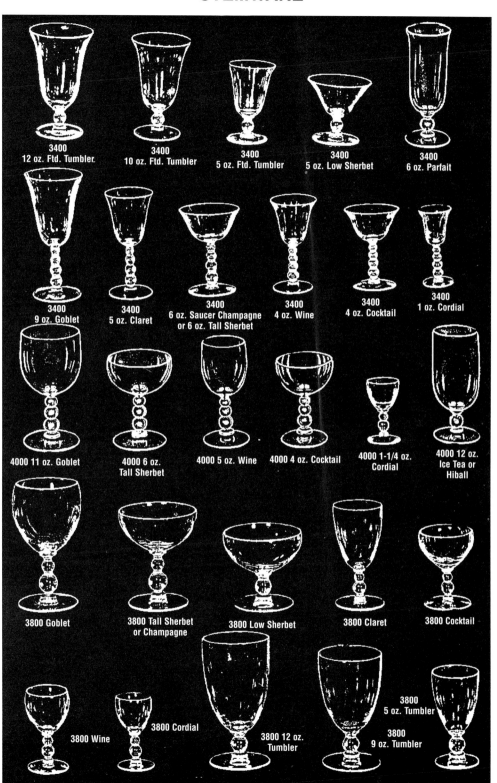

3400
12 oz. Ftd. Tumbler

3400
10 oz. Ftd. Tumbler

3400
5 oz. Ftd. Tumbler

3400
5 oz. Low Sherbet

3400
6 oz. Parfait

3400
9 oz. Goblet

3400
5 oz. Claret

3400
6 oz. Saucer Champagne
or 6 oz. Tall Sherbet

3400
4 oz. Wine

3400
4 oz. Cocktail

3400
1 oz. Cordial

4000 11 oz. Goblet

4000 6 oz.
Tall Sherbet

4000 5 oz. Wine

4000 4 oz. Cocktail

4000 1-1/4 oz.
Cordial

4000 12 oz.
Ice Tea or
Hiball

3800 Goblet

3800 Tall Sherbet
or Champagne

3800 Low Sherbet

3800 Claret

3800 Cocktail

3800 Wine

3800 Cordial

3800 12 oz.
Tumbler

3800
9 oz. Tumbler

3800
5 oz. Tumbler

SUGARS AND CREAMERS
MISCELLANEOUS ITEMS

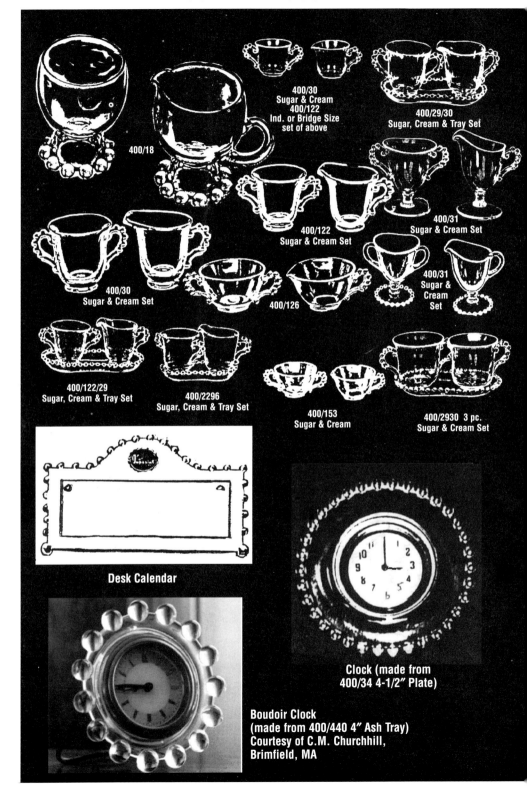

400/30
Sugar & Cream
400/122
Ind. or Bridge Size
set of above

400/29/30
Sugar, Cream & Tray Set

400/18

400/122
Sugar & Cream Set

400/31
Sugar & Cream Set

400/30
Sugar & Cream Set

400/126

400/31
Sugar &
Cream
Set

400/122/29
Sugar, Cream & Tray Set

400/2296
Sugar, Cream & Tray Set

400/153
Sugar & Cream

400/2930 3 pc.
Sugar & Cream Set

Desk Calendar

Clock (made from
400/34 4-1/2" Plate)

Boudoir Clock
(made from 400/440 4" Ash Tray)
Courtesy of C.M. Churchhill,
Brimfield, MA

SALT AND PEPPERS AND TRAYS

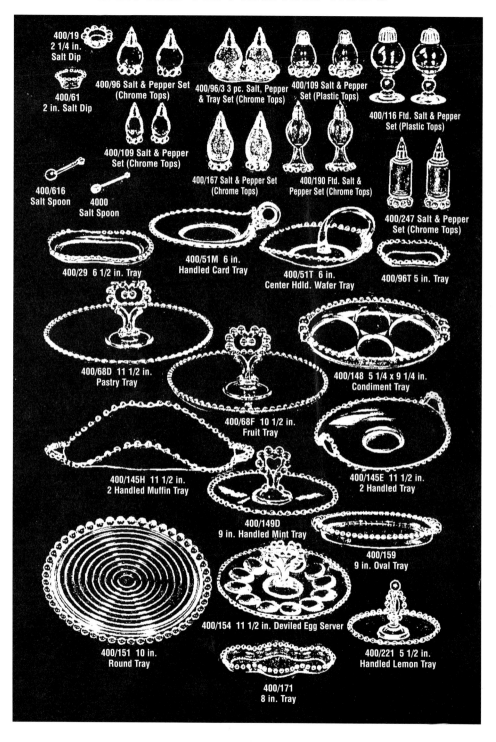

400/19
2 1/4 in.
Salt Dip

400/96 Salt & Pepper Set
(Chrome Tops)

400/96/3 3 pc. Salt, Pepper
& Tray Set (Chrome Tops)

400/109 Salt & Pepper
Set (Plastic Tops)

400/61
2 in. Salt Dip

400/116 Ftd. Salt & Pepper
Set (Plastic Tops)

400/109 Salt & Pepper
Set (Chrome Tops)

400/167 Salt & Pepper Set
(Chrome Tops)

400/190 Ftd. Salt &
Pepper Set (Chrome Tops)

400/616
Salt Spoon

4000
Salt Spoon

400/247 Salt & Pepper
Set (Chrome Tops)

400/29 6 1/2 in. Tray

400/51M 6 in.
Handled Card Tray

400/51T 6 in.
Center Hdld. Wafer Tray

400/96T 5 in. Tray

400/68D 11 1/2 in.
Pastry Tray

400/68F 10 1/2 in.
Fruit Tray

400/148 5 1/4 x 9 1/4 in.
Condiment Tray

400/145H 11 1/2 in.
2 Handled Muffin Tray

400/149D
9 in. Handled Mint Tray

400/145E 11 1/2 in.
2 Handled Tray

400/159
9 in. Oval Tray

400/151 10 in.
Round Tray

400/154 11 1/2 in. Deviled Egg Server

400/221 5 1/2 in.
Handled Lemon Tray

400/171
8 in. Tray

RELISHES

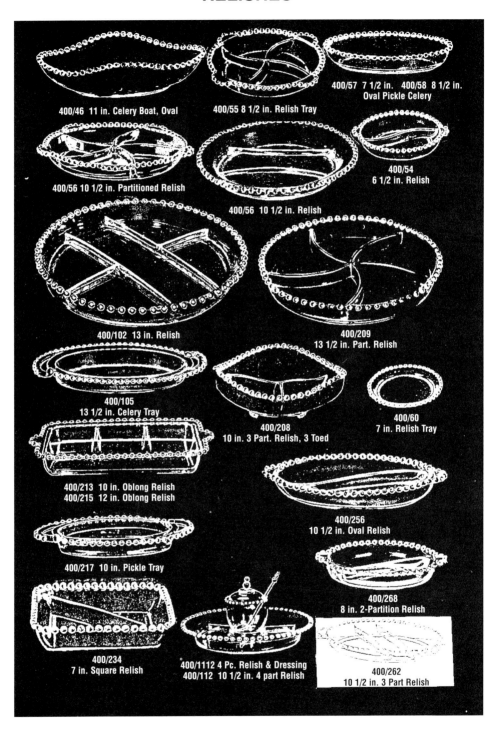

400/46 11 in. Celery Boat, Oval

400/55 8 1/2 in. Relish Tray

400/57 7 1/2 in. 400/58 8 1/2 in.
Oval Pickle Celery

400/56 10 1/2 in. Partitioned Relish

400/56 10 1/2 in. Relish

400/54
6 1/2 in. Relish

400/102 13 in. Relish

400/209
13 1/2 in. Part. Relish

400/105
13 1/2 in. Celery Tray

400/208
10 in. 3 Part. Relish, 3 Toed

400/60
7 in. Relish Tray

400/213 10 in. Oblong Relish
400/215 12 in. Oblong Relish

400/256
10 1/2 in. Oval Relish

400/217 10 in. Pickle Tray

400/268
8 in. 2-Partition Relish

400/234
7 in. Square Relish

400/1112 4 Pc. Relish & Dressing
400/112 10 1/2 in. 4 part Relish

400/262
10 1/2 in. 3 Part Relish

VASES

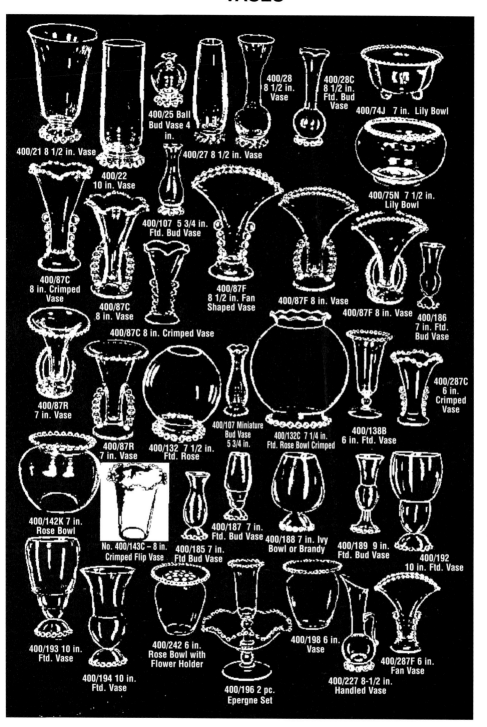

400/21 8 1/2 in. Vase

400/25 Ball Bud Vase 4 in.

400/27 8 1/2 in. Vase

400/28 8 1/2 in. Vase

400/28C 8 1/2 in. Ftd. Bud Vase

400/74J 7 in. Lily Bowl

400/75N 7 1/2 in. Lily Bowl

400/22 10 in. Vase

400/107 5 3/4 in. Ftd. Bud Vase

400/87C 8 in. Crimped Vase

400/87C 8 in. Vase

400/87C 8 in. Crimped Vase

400/87F 8 1/2 in. Fan Shaped Vase

400/87F 8 in. Vase

400/87F 8 in. Vase

400/186 7 in. Ftd. Bud Vase

400/87R 7 in. Vase

400/87R 7 in. Vase

400/132 7 1/2 in. Ftd. Rose

400/107 Miniature Bud Vase 5 3/4 in.

400/132C 7 1/4 in. Ftd. Rose Bowl Crimped

400/138B 6 in. Ftd. Vase

400/287C 6 in. Crimped Vase

400/142K 7 in. Rose Bowl

No. 400/143C – 8 in. Crimped Flip Vase

400/185 7 in. Ftd Bud Vase

400/187 7 in. Ftd. Bud Vase

400/188 7 in. Ivy Bowl or Brandy

400/189 9 in. Ftd. Bud Vase

400/192 10 in. Ftd. Vase

400/193 10 in. Ftd. Vase

400/194 10 in. Ftd. Vase

400/242 6 in. Rose Bowl with Flower Holder

400/196 2 pc. Epergne Set

400/198 6 in. Vase

400/227 8-1/2 in. Handled Vase

400/287F 6 in. Fan Vase

MISCELLANEOUS ITEMS

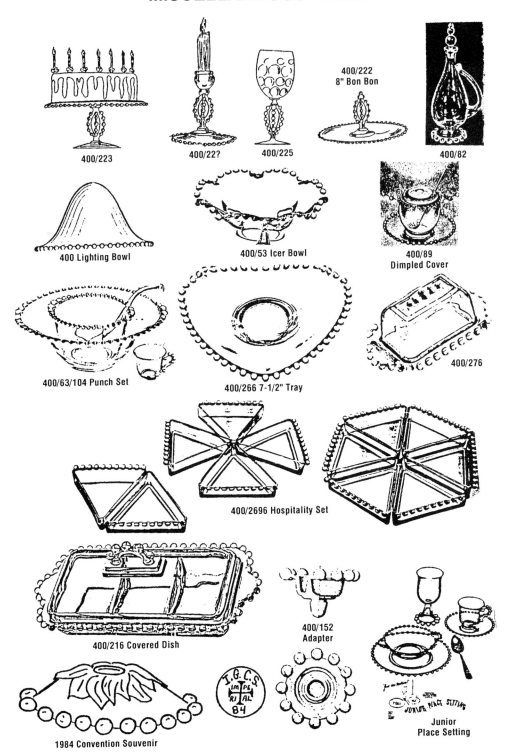

400/223

400/22?

400/225

400/222
8" Bon Bon

400/82

400 Lighting Bowl

400/53 Icer Bowl

400/89
Dimpled Cover

400/63/104 Punch Set

400/266 7-1/2" Tray

400/276

400/2696 Hospitality Set

400/216 Covered Dish

400/152
Adapter

1984 Convention Souvenir

Junior
Place Setting

EARLY CANDLEHOLDERS

400/224 Candleholder. Very Early-
Experimental? 1946?

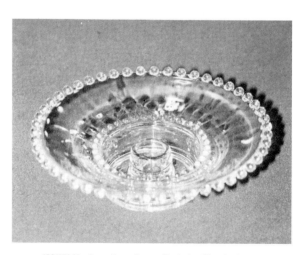

400/178 Hurricane Lamp Base with circle of interior beads.
Very early-1943?
Pictures Courtesy of Myrna & Bob Garrison,
Arlington, Tx.

INDEX

A

Adapter, 278
Advertising brochures, 40
Amber tint, 82
Anchor Hocking Glass Corporation, 138, 141
Anchor Hocking "Berwick" (Boopie), 138
Andlau pattern, 143
Antique blue, 90, 93-94
Aquamarine, 90, 93
Ash trays/sets, 60, 65, 66, 254
Atlas pattern, 148
Atomizers, 70, 76, 152-154, 246

B

Ballard pattern, 67, 102, 151, 229, 246: set, 246
Banana boat, 167, 267
Baroque Rose set, 230
Baskets, 64, 255
Bead green, 82
Beading, 108
Beer stein, 73
Bellaire Glass Festival, 11, 26, 67, 227, 246: souvenirs, 67
Bells, 255
Berwick pattern, 138, 141
Black Candlewick, 57-59, 81, 88-90, 154, 156
Black suede, 89, 154, 155
Block moulds, 32, 36: method, 32
Blue Candlewick, 60, 81-82, 90-95
Blue #75, 90, 93
Bluish tint, 82
Bohemia glass, 147
Bookends, 154, 155
Boopie, 138, 141
Bottles, 127-128, 226, 228, 246, 255, 278
Boudoir sets, 127-129, 226, 267
Boule, 133, 146

Boushka, John J., 39
Bowls, 52, 53, 55, 57, 60-62, 256, 257, 278
Boxed sets, 151-152
Boxed community silverplate, 102
Boxes, 169
Boyd, J. Ralph, 13-17
Boyd's Candlewick, 137-138
Boyd's Crystal Art Glass Company, 46, 48, 66, 137-138
Brass base, 163, 167
Brass, 139, 161, 163, 167
Brochures/catalogs, 33-34, 40
Brownish sun tint, 149
Bryce Brothers Glass Company, 141, 143, 147
Bunte Brothers candies tin, 64, 229, 246
Butters, 257, 278

C

Cake plates, 257, 278
Calendar, 68, 126, 226, 246, 253, 274
Cam-Bel Glass Works, 100, 102, 109, 121
Cambridge Arms pattern, 164-166
Cambridge Glass Company, 132, 142-143
Canadian corn flower cut, 121-122, 151
Candies, 259
Candleholders, 56, 60, 258, 278
Candlewick ads, 39-45
Candlewick Arms set, 165-166
Candlewick black, 88-90
Candlewick blues, 90-95
Candlewick clubs, 23
Candlewick color. See Colored Candlewick.
Candlewick in the 90's, 9-12: go-withs, 10; glass, 11-12
Candlewick (history of), 27-39
Cannonball pattern, 27-28, 31, 132, 148
Canton Glass Company, 139
Cape Cod pattern, 16, 156

Carmel slag, 61-62, 81, 95
Carmen pattern, 132, 142-143
Catalogs/brochures, 33-34, 40, 99
Ceiling fixture, 78
Centennial (Wheeling), 28-30, 32-33
Chandeliers, 158-161
Charleton hand-decorated, 106
Christmas ornament, 226, 246
Chrome base, 163, 227
Chrome underplate, 229
Chrome, 102, 139, 161, 163, 227, 229
Clocks, 127-128, 226, 246, 274
Coasters, 133, 145-146, 152, 157, 167, 228
Cobalt blue, 60
Cologne/lotion bottles, 127-128, 226, 246, 253
Colored beading, 108
Colored Candlewick Price Guide, 247-251
Colored Candlewick, 81-99: gold, 82-86; reds, 86-88; black, 88-90; blues, 90-95; carmel slag, 95; milk glass, 95-99
Colors, 81-99, 100
Community/Community silverplate, 67, 102, 151-152, 229, 246
Compotes, 49, 260
Condiments, 261
Confusing similarities, 69, 132-148: Dalzell-Viking Candlewick, 134-137; Boyd's Candlewick, 137-138; Anchor Hocking "Berwick" (Boopie), 138; pegged bowls/plates, 138-139; glass companies, 139-143; Lalique's Andlau pattern, 143; look-alikes, 143-146; Czechoslovakian relish, 146-147; references, 147-148
Console sets, 263
Consolidated Lamp & Glass Company, 144
Consolidated-Colony, 9, 17
Cookbooks, 10, 40
Copper, 103
Corn flower, 121-122, 151
Crackle glass, 167
Creamers, 51, 71, 75, 274
Cream Soup, 260, 267
Crimped bowl, 55
Crown Cut Glass Company, 109

Crown cut, 110-116, 118-119
Cruets, 262
Cups, 50, 56-58, 260
Cut crystal, 117
Cuts, Etches, and Decorated Candlewick Price Guide, 251-253
Cuts/cutting, 21, 56, 71, 74, 100, 109-122, 149, 251-253
Cutting wheels, 21
Cutting (bow), 56
Cutting (floral), 56
Cutting (starlight), 71
Czech ridge, 132
Czech 3-sectioned tid-bit, 146
Czechoslovakia, 26, 133, 145
Czechoslovakian relish, 146-147

D

Dalzell-Viking Candlewick, 134-137
Dalzell-Viking Glass Company, 45, 47-48, 134-137
Decorated Candlewick, 100-126: metals, 101-103; hand-painted, 103-107; satin-trimmed, 107-108; cuts, 109-122; etches, 122-126
Decorated stemware, 104-105
Decorating shop, 149
Depression glass Iris pattern, 158, 227
Depression green, 144
Desk calendar, 68, 226, 246, 274
Desk mirror, 71
Desk sign, 68
Dessert sets, 262
DeVilbiss atomizers, 76, 152-154
DeVilbiss Company, 152
Dots, 121
Dresser trays, 127
DuBarry, 121
DuBois, J. Morris, 16, 84, 102, 121
Duncan & Miller Glass Company, 147

E

Eagle designs, 264
Eagle mirror, 90

Eagle pattern, 46-48, 60, 83-84, 88-90, 93-94, 96-97, 99-100, 154-156, 264
Elite Glass Works, 109
Emerald green tid-bit, 70, 144, 168
Enameled gold/white/red, 57
Etch #436, 123, 124
Etches, 21, 74, 100, 122-126, 251-253

F

F series bowls, 150
Fantasy, 121
Farber Brothers, 102, 103, 229, 247: set, 229
Farberware, 102-103, 230, 247
Fixtures, 160, 161, 227
Flask brown, 82
Flashed-on-red, 55-56, 86-87: beads, 55-56
Flood 1936, 17, 32
Floral, 121
Flower perfume dispenser, 70
Forever crystal, 145-146
Former Imperial employees, 82, 146, 150
Franciscan dinnerware, 103, 106
Free-form handle, 73, 167-168
French Cannonball pattern, 27-28, 31, 132, 148
Frosted, 89, 100, 106-108, 226
Fruit compote 400/103C, 49

G

Garden Arbor etch, 85, 123, 124
Glass clubs, 22-23, 231
Glass, 11-12
GLASSZETTE, 18, 27, 89, 98-99, 109, 119, 123-124, 127, 144, 146
Globes, 158-160 (See Shades)
Gold beads, 226 (See Gold)
Gold decorations, 82-84
Gold, 50, 65, 74, 80-86, 89, 100-101, 106-107, 122, 124, 152, 154, 226
Gold-beaded ash tray set, 65
Gold-beaded, 65, 152 (See Gold)
Gold-on-glass, 50, 80-82, 84-85, 101, 122, 124

Go-withs (Candlewick), 10, 65, 75
Gray cut, 121
Green tid-bit, 70 (See Emerald Green)
Green, 70, 144, 167-168
Grinder wheel marks, 149
Gunderson-Pairpoint Glass Company, 128
Gustkey, Carl W., 17

H

Hammered aluminum, 230, 247
Hand cutting, 109-122
Hand mirrors, 127, 129, 246
Hand-painted compote, 49
Hand-painted roses, 75
Hand-painted, 49, 75, 88, 90, 103-108
Handles (dresser trays), 127, 129-131
Hanging lamp fixture, 78, 158-161
Hay Shed, 17-18, 89, 95, 246: plaque, 17-18
Heart shapes, 53, 67, 265
Heather, 82
History of Candlewick, 27-39: the name, 27; new Candlewick, 28-33; catalogs/brochures, 33-34; patents, 34-38; initial pieces, 35-36, 38-39; Jewel Tea Company, 39; Candlewick ads, 39-40; Imperial ads, 41-45; moulds, 45-48; photographs, 49-80
History (Imperial Glass Corporation), 13-26: owners, 17; Hay Shed, 17-18; memories, 21; Save Imperial 1984 red brick, 21; Imperial labels, 21-22; National Imperial Glass Collectors Society, 22-23; Candlewick clubs, 23; Lenox, 23-25; Rodefer Glass Company, 24-26
Hostess helper, 126, 246, 278,
Hunt Glass Works, 119
Hurricane lamp (miniature), 54

I

Icers, 156-157, 265
Imperial ads, 39-45
Imperial catalogs, 34
Imperial etch #436, 85, 123, 124

Imperial Glass Corporation, 9-10, 13-26:
 history, 13-26
Imperial Glass employees, 82, 146, 150
Imperial labels, 21-22
Imperial Map of America, 20
Indiana Glass Company, 140, 143, 169
IRICE. SEE Irving W. Rice and Company.
Iris light fixture, 158
Iris pattern, 227
Irving W. Rice and Company, 127-131,
 144-145, 226-229, 246; boudoir sets,
 127-128, 267; bottles, 128, 267; clocks,
 128, 274; puff jar 129, 265; mirrors,
 71, 129; trays, 129-131; salt and
 pepper,131

J

Jeanette Glass Company, 139-140, 143
Jewel Tea Company connection, 39
Joint mould, 31, 36
Junior place setting, 226, 246, 278

K

Kennedy, Lucile J., 75, 129, 162, 231
Knife 4000, 267
Kolb, Willard, 24, 27-33, 100, 109, 119,
 128, 149
Kromex, 230, 247

L

Labels, 21, 169
Ladles, 156, 167, 246
Lalique, 128, 133, 143, 154
Lamp base, 227
Lamps, 133, 156, 158-161, 227-228, 266,
 278,
Lazy Susans, 269
Lenox Glass Company, 9, 17, 23-25, 167,
 169, 246
Libbey Glass Company, 147
Light fixture, 77, 78, 160, 161, 227
Lightolier lamp, 158, 266
Lightolier Lighting Company, 158, 227

Lily bowl, 162, 167, 277
Liquidation (Imperial), 9-10
Look-alikes, 79, 132-148
Lorch, Arthur, 9, 17, 23
Lotion bottles, 71, 127-128, 226, 246, 253
Lotus Glass Company, 84, 100, 102, 109,
 121, 148

M

Magazine ads, 10, 39-45
Mallard cut, 121
Marmalades, 267, 278
Maroon Enterprises, 10, 17, 48
Maroon, Anna, 46
Marshall Field and Company, 30, 35, 82
Matchbooks, 10, 65
Mayonnaise sets, 268
Metals, 100-103, 121, 138-139, 161-163
Milk glass, 95-99, 133, 144, 169, 223, 224,
 245
Mirror Images, 47-48, 134
Mirrors, 127-131, 144-145, 167-168, 227,
 246
Miscellaneous items, 267, 274, 278
Morgantown Collectors of America, 125
Morgantown Glass Company, 31-33
Morgantown Glass Works, 125-126, 148
Morning Star pattern, 152, 229: set, 229
Mould marks, 31-32
Mould numbers, 169
Moulds, 10, 26, 31-32, 35, 45-48, 134, 137,
 150, 154, 166, 169
Muddler, 267
Muhleman, Ed, 13-15

N

National Glass Company, 13-14
National Imperial Glass Collectors
 Society, 18, 22-23, 26, 39, 45-46, 48, 86,
 99-100, 103, 119
Nested ash tray set, 66, 213, 214, 242, 243
New Candlewick (Dalzell-Viking), 134-137
New Imperial Candlewick line, 28-33
Newsletters, 22, 23, 231

Newton, Earl W., 15-17, 27-28, 30-33, 82, 132

NIGCS. SEE National Imperial Glass Collectors Society.

Nob Hill pattern, 147

Novelty Stamp Company, 109

Nucut glassware, 15

Numerical listing, 169-230

Nut brown, 63, 81, 250

Nut Dish, 267

O

Oak Harbor Plant glass patterns, 120, 122

Oils and vinegars, 262

Oneida Community, 151, 229

Optic pattern, 73, 119-120

Owners (Imperial Glass Corporation), 17

P

Paden City Glass Manufacturing Company, 139-140

Paint, 100

Paperweights, 10, 227, 246

Party sets, 269

Patents (Candlewick), 34-38

Peg adapter, 161, 278

Pegged bowls/plates, 66, 138-139

Pegs, 66, 138-139, 154, 161-166, 166, 227, 246, 228

Perfume bottles, 70-71, 127-128, 144, 145

Perfume trays, 129-131, 228-229

Pick-ups, 34, 246

Picture frames, 71, 228, 246

Pitchers, 268

Planetarium cut, 119

Plates, 270

Platinum, 54, 101

Polished dots, 121

Potpourri information, 149-168: F series bowls, 150; square/round bowls, 151; boxed sets, 151-152; coasters, 152; DeVilbiss atomizers, 152-154; Imperial Eagle, 154, 156; icer sets, 156; ladles, 156; lamps/shades, 156, 158-161; pegs, 161-166; tid-bits, 166; unusual items, 166-168

Price guides, 231-253: colored Candlewick, 247-251; cut/etched Candlewick, 251-253

Princess, 121

Puff jars, 71, 127, 129, 228, 246, 253, 226

Punch bowl sets, 80, 270, 278

Q

Quaker Oats Company, 17

R

Rainbow Glass Company, 86-87

Red brick (Save Imperial 1984), 21, 51, 226, 246

Red Candlewick, 86-88

Red, 21, 51-53, 55, 81-82, 86-88, 167, 226

Red-flashed beads, 56, 86, 167

Regal red, 86

Relishes, 61, 62, 276, 278

Reproduction, 134-138, 144

Ringholder, 167, 228, 246

Ritz blue, 63, 90, 93

Rock crystal, 114-116, 121

Rodefer Glass Company, 24-26, 128, 246

Rogers Baroque Rose set, 230

Roses, 49, 106, 146

Ruby Candlewick, 51-53, 55, 86, 88, (also see Red)

Ruby glass bricks, 21, (see Red Brick)

Ruby red, 21, 51-53, 55, 81-82, 86-88, 226

S

S.W. Farber, Inc., 102 (see Farberware)

Salad sets, 133, 271

Salt and peppers, 72, 131, 275

Sand, 11-12
Sand-blasted, 107
Satin-trimmed Candlewick, 100, 106-108
Saucer Boat, 267
Saucers, 56, 57, 58, 260
Save Imperial 1984 red brick, 21, 51, 226, 246
Seneca Glass Company, 140-141, 148
Shades, 77-78, 156, 158-161, 227-228, 246, 278
Signs, 10, 68, 228, 246
Silver base, 162, 163, 227
Silver City Glass Company, 100, 102
Silver overlay, 55, 72, 100-102, 121
Silver, 55, 71-72, 100-102, 107, 121, 138-139, 161-163, 227-230
Silver-on-brass, 161
Silver-on-glass, 101 (see Silver)
Silverplate, 139, 229
Single-plate tid-bits, 73, 157, 166, 211, 242
South Seas set, 102, 229, 246
South Star set, 152, 229
Souvenirs (Bellaire, Ohio Glass Festival), 67, 205, 240
Splatter paint, 107
Spoon and fork, 55, 69, 228, 246
Square/round bowls, 151
Stahl, Robert, 9, 17
Standing mirrors, 127 (see Mirrors)
Starlight cut, 121, 128, 159
Stein, 73, 168, 232
Stemware, 51, 54, 57, 58, 63, 73, 74, 104-105, 271-273, 278
Sterling silver, 55, 71-72, 101-102, 138-139, 161-163, 227
Stoppers, 128, 144-145
Sugars, 51, 71, 75, 274
Sugar Dip, 262, 267
Summit Art Glass Company, 46
Sunshine yellow, 63, 81

T

Table signs, 10
Tags, 169

Tid-bits, 70, 73, 145, 157, 166, 211, 242
Tin box, 64, 229, 246
Toast, 267
Trader Vic etched logo, 125-126
Trays, 53, 127-129, 131, 226, 228-229, 275, 278
Tumblers, 51, 63, 271-273
Twilight pattern, 102, 151, 229, 246

U

Uhrmann, Carl J., 17, 32-33, 36, 81
Ultra blue Carnival, 60, 91
Ultra blue, 60, 63, 81, 91, 94
Unusual items, 166-168

V

Valley Lily, 121
Vases, 277
Verde green, 63, 81
Viennese blue, 60, 90-93, 144
Viking Glass Company, 226
Viking plate, 103, 230, 247

W

W.J. Hughes & Sons Ltd., 151
W.J. Hughes Company, 121
Wall fixture, 77, 159
Westmoreland Glass Company, 96
Wheeling Centennial, 28-33
Wheeling Decorating Company, 100, 109
White/gold/red flowers, 57, 59, 90
Wicke, Victor G., 14-16
Wild Rose etch, 50, 74, 85, 100-101, 122
Wooden, 168
Woolworth (F.W.) Company, 14, 138
World War II era, 60, 168, 254
Wreath cut #406, 119
Wreath, 119, 121

THE END OF AN ERA
Imperial Glass Factory's West Side. Building Will Be Razed Spring 1995.